POINTS of LIGHT

POINTS *of* LIGHT

A Celebration of the American Spirit of Giving

Robert Goodwin
President, Points of Light Foundation

and

Thomas Kinkade
America's "National Ambassador of Light"

and Pam Proctor

Foreword by

GEORGE BUSH
41st President of the United States

CENTER
STREET.

New York Boston Nashville

Center Street

Warner Books
1271 Avenue of the Americas, New York, NY 10020

Center Street and the Center Street logo are registered trademarks.

Book design by Fearn Cutler de Vicq
Printed in the United States of America

First Edition: June 2006
10 9 8 7 6 5 4 3 2 1

Library of Congress Cataloging-in-Publication Data

Kinkade, Thomas, 1958–
Points of light : a celebration of the American spirit of giving / Thomas Kinkade and
Robert Goodwin and Pam Proctor.— 1st ed.
p. cm.
Includes bibliographical references.
ISBN-13: 978-1-931722-73-5
ISBN-10: 1-931722-73-0
1. Voluntarism—United States. 2. Helping behavior—United States. 3. Caring.
I. Goodwin, Robert (Robert K.) II. Proctor, Pam, 1945– III. Points of Light
Foundation. IV. Title.
HN90.V64K54 2006
361.3'70973—dc22
2005029334

Dedicated to Gordon Purdy and Jeanne Goodwin,
two bright Points of Light whose lives
epitomize the spirit of giving.

Contents

Acknowledgments

It's no accident that our collaboration began in the spirit of giving. At the time we met, Bob—who is president of the Points of Light Foundation, initiated by former President George Bush—was on the board of the Salvation Army. Thom—who was serving as the official artist of the Salvation Army—had just won the coveted Booth Award, named for the founder of the organization.

From our very first meeting, we were in sync professionally and personally. Conversations about the importance of service, about the need to encourage others to get involved in their communities, and about the sheer joy that comes from giving to others flowed naturally from our lips. Both of us had come from families who, despite their modest circumstances, believed fervently in the Golden Rule. We were raised with the notion that doing unto others wasn't a choice, but an imperative. As we entered the world of work—Thom as an artist and Bob as a minister, college educator, and government official—we each carried with us the conviction that the spirit of giving was integral to our purpose in life.

Ultimately, Thom's mission to spread the light of encouragement through his paintings coalesced with Bob's mission to har-

ness the power of volunteers to meet serious social needs. Before long, we had forged a powerful partnership, with Thom serving as the National Ambassador of Light for the Points of Light Foundation.

With this new partnership, we hope to ignite a flame of excitement about giving and the dramatic difference volunteer service can make in the lives of the sick, the poor, the abandoned, the lonely, and the forgotten.

Early on, Rolf Zettersten, publisher of Time Warner Book Group's new Center Street division, embraced our vision, and *Points of Light: A Celebration of the American Spirit of Giving* was born. Rolf enlisted the talents of Christina Boys, a superb editor whose commitment to the project matched our own.

Many people were responsible for bringing this book to fruition, but first and foremost among them is writer Pam Proctor. Her passion to uncover the intensely human dimension behind the stories highlighted in this book is evident on every page of the manuscript.

Thanks are also due to the staff of the Points of Light Foundation, especially Richard Mock, whose years of work in the nonprofit sector have made him the ultimate source on the subject. Bill Bentley, Greer Stephens, Dr. Rennie Dutton, and Chris Toppe each contributed to making the book a rich resource for volunteer action.

At the Thomas Kinkade Company, Denise Sanders, manager of Thomas Kinkade Studios–Ivy Gate, kept everyone on target with her irrepressible enthusiasm. Adelle Gabrielson, Vu Myers, Stacey Dier, and Linda Mariano helped provide creative direction for the book's visual format. Artist Anna Killion created the pen and ink drawings as well as the lively portraits that bring to life the inspiring individuals whose stories grace these pages.

Finally, we wish to thank former President George Bush for setting in motion a national movement to make the spirit of giving part of every citizen's consciousness. By awakening Americans to the "thousand points of light" in our midst, he tapped into the private sector and brought together government, corporate giants, community organizations, and individuals to work hand in hand to change lives for the better.

"Our problems are large, but our heart is larger," he said in his Inaugural Address. Out of his large heart—and the goodness of the heart of America—have come the Points of Light Foundation and the stories in this book.

Robert Goodwin, Washington, DC
Thomas Kinkade, Morgan Hill, California

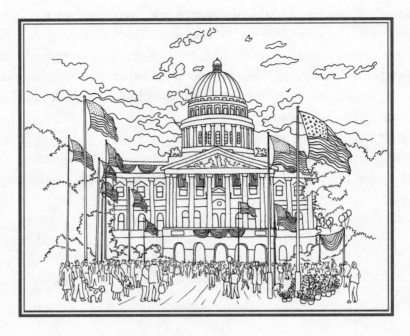

The old ideas are new again because they are not old——they are timeless: duty, sacrifice, commitment, and a patriotism that finds its expression in taking part and pitching in.

——GEORGE BUSH, *INAUGURAL ADDRESS, JANUARY 20, 1989*

George Bush

41st President of the United States
Honorary Chairman, Points of Light Foundation

Americans have always been known for their generosity and willingness to help those in need. In fact, the rights to assemble, to speak freely, and, by implication, to form organizations for the public good are built into the very fabric of the Constitution and our historic tradition. Over the centuries, we have taken full advantage of our fundamental right and duty to volunteer. You might even say that our nation was founded, at least in part, on the principle of reaching out to the needy and downtrodden.

In 1988, when I accepted the nomination for the U.S. presidency, and later when I delivered my Inaugural Address, I high-

lighted the importance of volunteers and their countless organizations in our society. I called them "a thousand points of light . . . spread like stars" across the firmament of our nation, as they immersed themselves in good and sacrificed for others.

But I couldn't remain content merely to acknowledge this great American tradition with words. So early in my administration, we established several action-oriented institutions to put our principles of volunteer service into practice. These included:

✧ The White House Office of National Service, which recognized individuals and groups who were engaged in direct and significant volunteer service that focused on solving serious social problems. During my administration, 1,020 Daily Points of Light Awards were given to honor their work.

✧ The Commission on National and Community Service, which brought bipartisan support from Congress and the White House for financial and technical assistance to community service programs.

✧ The National Center for Community Risk Management and Insurance to reduce legal liabilities that may discourage community service.

✧ The Points of Light Foundation to implement the overall community service strategy.

Although I'd always known that Americans were the most caring and giving people in the world, I was still inspired by the stories we heard through the Daily Points of Light Awards. Their wonderful examples gave me an even stronger appreciation for how much Americans care and do for those most in need.

I was moved by such accounts as:

✧ The doctor and nurse from Oklahoma City who both suffered from the effects of multiple sclerosis. Despite their health problems, they developed a free medical clinic in a crumbling neighborhood.

✧ The man from Indiana who overcame his inability to read through GED classes—and became a literacy advocate and teacher.

✧ The three young Michigan sisters who regularly visited, assisted, and played with severely physically and mentally disabled children.

✧ The newly arrived Kurdish refugee from Iraq who—despite a serious back injury—used his knowledge of several languages to help other refugees who had settled in his South Dakota community.

This spirit of caring and giving emerged dramatically throughout the nation following the 9/11 attacks. As the world watched, Americans across the nation responded to the horror of the terrorist onslaught by offering many, many helping hands.

Trained volunteer rescue workers in the area responded within minutes, some of them making the ultimate sacrifice when the towers collapsed on them. Restaurant owners opened their doors to the rescue workers. People lined up for blocks to give blood.

Nor was the desire to help limited to New York or Washington, which had been the focus of the attacks. Children in South Carolina raised money to replace a fire truck. A group of Baptists from the South came to southern Manhattan to clean area apartments belonging to people they'd never met. The points of light that shine in these stories stretch out endlessly toward the American horizon and beyond. And whenever I encounter one of those beacons, I am inspired anew.

Barbara and I were honored to be asked to serve as the honorary chairs of the Points of Light Foundation's Unity in the Spirit of America initiative, through which Americans volunteered to honor those who were lost in the 9/11 attacks. Over an eighteen-month period, half a million Americans volunteered through separate projects in every state in the nation to honor and remember those who had lost their lives.

A similar response from generous volunteers surfaced after the killer tsunami swept ashore from the Indian Ocean in December 2004. When the president asked former President Clinton and me to lead the American response to this tragedy, neither of us hesitated. We both understood that, even though the disaster was half a world away, individual Americans would step up and do what they could to help. And we were right. In four months, Americans responded by giving more than $1 billion out of their pockets to help people they had never met begin to rebuild their lives.

Just eight months after the tsunami hit, Hurricane Katrina pummeled the Gulf Coast in what has become the greatest natural disaster in America's history. And yet, in the midst of that horrific tragedy—which was quickly followed by Hurricane Rita in a one-two punch—Americans poured out their resources at an unprecedented rate of giving, according to *The Chronicle of Philanthropy*. Within two and a half weeks of the disaster, U.S. charities had raised more than $1.06 billion dollars, and the donations are still coming in. Once again, President Clinton and I got behind the relief effort, raising more than $100 million dollars in the first weeks of September alone.

Even more impressive to me than the monetary gifts was the response of thousands of Americans who dropped everything that they were doing to care for the hurricane victims personally. Some flew to the disaster site to search for survivors; others pro-

vided clothing, food, and medical care at evacuation centers; still others offered shelter in their own homes.

Without a question, these volunteers are among the "thousand Points of Light" who are keeping alive the American spirit of giving.

But it's important to recognize that the "points of light" concept might well have remained just a concept had it not been for the vision and hard work of Bob Goodwin, president and CEO of the Points of Light Foundation. Bob's inspirational leadership has taken an idea and built it into an organization that is making a difference in millions of lives across the nation. Through his guidance, the foundation and the Volunteer Center National Network have made it possible for more than two and a half million volunteers to find meaningful ways to make a difference in their communities every year. In short, Bob has been instrumental in transforming my own "points of light" dream into a practical reality.

This book, *Points of Light: A Celebration of the American Spirit of Giving*, beautifully depicts the enduring and uniquely American spirit of volunteering—and the deeply embedded impulse we each have to reach out to those in every sort of need. As a long-time admirer of Thomas Kinkade's art, I have always been impressed by his rare ability to capture in his paintings a palpable sense of warmth—and a special, transcendent light. It's also apparent that when he paints, he is inspired by a love for images and ideas that have made our nation great—such as home and community, family and faith, and patriotism and self-sacrifice.

Those are also some of the images that come to my mind when I think about volunteers. While government must play a significant role in caring for its people, it can never take the place of the army of caring individuals in our great land who give freely of their time and money to assist those in need.

When Thom Kinkade was named recently by the Points of Light Foundation as its "Ambassador of Light," I was delighted, but not simply because he is an inspiring artist. What is less well known about Thom is his personal generosity. He's one of those people who believe in the importance of giving back from the blessings they have received. A deeply spiritual man, Thom understands that his talent is God-given and that he can use it to help others. Over the years, through the sale of his art, Thom has raised millions of dollars to support a wide variety of charities, including the Points of Light Foundation and the Volunteer Center National Network. So in many respects, the stories in this book are also his stories—practical, personal expressions of volunteering and giving that serve as driving forces in his own life.

But it's important not to hold up Thom, Bob, or any of the other inspiring individuals in these pages as paragons of generosity who are beyond the reach of ordinary Americans. In fact, Thom, Bob, and the others in this book represent what's possible for every single average American I know. To realize *your* inborn capacity for service and altruism, meditate on each of these stories—and then plan ways to use your everyday actions to write your own story of giving and service.

I've often said that any definition of a successful life must include service to others. So if you know how to read, find someone who can't—and start tutoring. If you've got a hammer and some nails—find a house that needs building. If you're not hungry, not lonely, not in need, you should certainly be thankful—but also, find someone who is hungry, lonely, or in need. You'll be surprised at how good it will make you feel to respond to someone else, with no thought of receiving a thing in return.

POINTS of LIGHT

*The vocation of every man and woman
is to serve other people.*

LEO TOLSTOY, *WHAT IS TO BE DONE?*

Foot Soldiers
in the Army of Light

Y ou see them all around you: in the checkout line at the grocery store, behind the counter at the post office, in the next cubicle at work, and in the adjacent pew at church or synagogue. They are America's Points of Light: ordinary people who, as volunteers in many areas of life, have shaped our country's character. These volunteers—young and old, rich and poor—constitute an extraordinary Army of Light that has made America a beacon of hope for the world.

Perhaps you are one of these light-bearers—one of the sixty-four million Americans, an astonishing 28.8 percent of the population,[1] who give of themselves to serve others. Or maybe you want to become a Point of Light yourself. In either case, this book is about you.

It's about the eighty-year-old retiree in New York's Chinatown who volunteers daily as a translator at a hospital. It's about the prison guard in Wisconsin who works with inmates after hours to help free them from abusive behavior toward women. It's about the man in Maine who helps clear neighbors' driveways after every snowstorm, the salesclerk in Charlottesville who visits nurs-

I

ing home residents on her day off every week, and the Connecticut college student who created a film on homelessness to awaken his friends and community to the dire needs at their doorstep.

These are people who exemplify our country's culture of caring, a disposition to give and serve others that was present from the foundation of our nation. From the moment colonists set foot on our soil in Jamestown, Plymouth, or St. Augustine, they recognized their need to pitch in and work together for the good of the community. In fact, their very survival depended on it. So they gathered together for barn raisings, and husking bees, and grain harvesting, ready to lend a helping hand to neighbors in need.

Back then, the colonists understood that America represented a new beginning. In the hard, demanding wilderness, they found a place where they could be free—free to worship as they chose, free to rise above the limitations of the old social order, and free to grab hold of opportunities for work and education.

Our founding fathers embraced these hopes and dreams and articulated them in the law of the land, proclaiming boldly in the founding documents that America was different from anything known before. Ours became a culture devoted to life, liberty, and the pursuit of happiness for every man, woman, and child, a paradigm that was radically different from the culture of submission and monarchy that the colonists had left behind.

Out of this open, optimistic approach to human society grew the American spirit of giving, a volunteer spirit that continues unabated to this day. We see it in the outpouring of millions of dollars from the pockets of truck drivers, teachers, and stockbrokers to the victims of the tsunami and Hurricane Katrina, or in the simple gift of time bestowed on a troubled teen in an after-school program or at a juvenile detention facility.

During his travels in America in the 1830s, the French aristo-

crat Alexis de Tocqueville was deeply impressed by the penchant of Americans to contribute to society by forming voluntary associations. In his *Democracy in America,* he wrote:

> Americans of all ages, all conditions, and all dispositions, constantly form associations. They have . . . associations of a thousand . . . kinds—religious, moral, serious, futile, general or restricted, enormous or diminutive. The Americans make associations to give entertainments, to found seminaries, to build inns, to construct churches, to diffuse books, to send missionaries to the antipodes; they found in this manner hospitals, prisons, or schools. If it be proposed to inculcate some truth, or to foster some feeling by the encouragement of a great example, they form a society.[2]

As Tocqueville observed, Americans have always cared passionately about their own future and about each other. That passion for betterment, for improvement, remains our greatest natural resource. It inspires us to give rather than to take, to encourage rather than to beat down, to reach out rather than to withhold. It inspires us always to seek the light, rather than to cower in the darkness. And it inspires us, when we hear the call resonate in our hearts, to *be* the light for those in deep distress.

Turn the page and you'll learn practical lessons in how to share your own skills and gifts from some of the people next door who have heeded the call: the call of America's spirit of giving, and the call to be a Point of Light. For all of them, the beams of light they share are unique to their individual talents and personal histories—beams of hope, compassion, encouragement, joy,

THOMAS KINKADE

faithfulness, or forgiveness that reach into the darkest corners of human hearts to illuminate the spirits of those they serve.

Are you hearing the call? Are you ready to test your mettle as part of the Army of Light? All that is needed for you to embark on this exciting new way of life is a willingness to take the first step—a step that starts with love.

✰ ✰ ✰ ✰ ✰ ✰ ✰ ✰ ✰

Letters of Light

As an artist, I'm drawn to visual symbols that capture the essence of an abstract idea. And so, when I think of what it means to be a point of light, I immediately picture the word emblazoned on a billboard:

L I G H T

Each letter seems to hold a message. As I spell the word to myself, I begin to sense the possibilities. In my mind's eye, light is no longer just a five-letter word, but an acronym for a series of challenges, a road map for a lifelong adventure in serving others.

I think of the meaning of light in the here and now:

Love Initiates Generous Help Today

I consider the future potential of light:

Love Is Going to Help Tomorrow

I also ponder the power of light in community:

Love Is Giving Hope Together

Try meditating on your own translation of the letters of *light*. If you do, you just may find yourself on a path that leads to love—love in action.

—Thomas Kinkade

*A sublime hope cheers ever the faithful heart, that
elsewhere, in other regions of the universal powers,
souls are now acting, enduring and daring, which can
love us, and which we can love.*

—RALPH WALDO EMERSON

The Light of Hope

Hope springs from affirmation. Each of us *craves* affirmation. It may be the greatest of human needs. We want to know that we matter and that our lives are important.

That's why the act of giving is so essential. When you give of yourself to another person, you are communicating a powerful message without saying a word. You are communicating your respect and acknowledging that the other individual is *valued*. You are saying that you care enough to pause in the midst of your busy life to see who that person really is: perhaps someone with deep hurts, fears, failures, and losses.

And you are telling that needy individual, "You are, indeed, lovable." By your very act of giving, you are saying that you want to reach out boldly to touch another with the light of hope that is in your heart.

That affirmation means more than any tangible gift you may offer. Often, a simple act of affirmation can become a source of hope that enables a person to move from a position of need—where he feels isolated and cut off from others—to a position of stability and connection with the wider community.

☆ ☆ ☆ ☆ ☆ ☆ ☆ ☆ ☆

Silver and Gold Have I None

I pass many homeless people on the streets in my daily walk to work at the Points of Light Foundation, and often I pull out the change in my pocket and put it in their hands.

One winter day, I was passing the corner of Fourteenth and H Streets when I spied a homeless man who was a fixture on the street. He was in his early sixties, with a matted beard and hair down to his shoulders. Although he was hatless, I noticed that he had managed to find a tattered coat and work boots to ward off the cold.

I didn't know his name. But I had seen him many times before, and often I had given him some change or perhaps a little more. As I approached the corner, I could see him looking toward me expectantly. In his outstretched hand, a paper sack that he used as his begging receptacle stood ready to collect whatever coins I might deposit.

Walking at a steady pace, I took off my glove and reached into my coat pocket to find some change. But I didn't have a dime, not one penny to put in that sack on a cold winter morning.

I could have simply shrugged to myself and passed him by, determined to help him out the next time. But as I drew in front of him, something told me to stop. I looked him in the eye and said, "I'm sorry, my brother. I don't have anything to give today."

His eyes brightened and his lips turned up in a slight smile.

"Oh, but you already did," he responded. "You called me brother."

—Robert Goodwin

The poets would have us believe that hope is ever-present, that it cannot be compromised. "Hope springs eternal in the human breast," the poet Alexander Pope intoned. "While there's life, there's hope," Cervantes wrote in *Don Quixote*.

But the poets are wrong.

Throughout our culture, there are people whose hope has been extinguished. Teens are dropping out of high school because they can't read. Senior citizens are languishing without visitors in nursing homes. Families are searching for lost children, and couples shiver in the cold because their only shelter is a log shack or rusty automobile. These individuals may have life, but they don't have hope, because no one has affirmed their existence.

But when someone—a friend or stranger—takes the time to be a tutor, pay a visit, reach out to comfort, or help build a house, something may change. A broken heart starts mending. Poor self-esteem turns into confidence. Expectancy replaces loneliness. In short, hope is reborn.

To those in despair, the merest sliver of light can be transforming, as it is for those whose lives have been touched by the search and rescue efforts of Texan Timothy Miller. Here, in his own words, is his story.

A Man Called Mr. Hope

My wife and I were at a friend's house eating Christmas dinner when the phone rang. A sergeant with the sheriff's department in Houston had tracked me down, and he was distraught. His brother, who was mentally challenged, was missing.

"I need your help," he said. "Please come as quickly as you can."

My mind went into a tailspin. *I can't leave now*, I thought to myself. *It's Christmas.*

TIMOTHY MILLER

I looked over at my wife, GeorgeAnn, whose arched eyebrows reminded me that *this* time I needed to stop.

For the past few years, I had been running at a feverish pace trying to keep on top of the demands to help find missing children and adults. Texas EquuSearch, the mounted search and rescue team I had founded sixteen years after the death of my daughter, Laura, was simply too successful. At any hour of the day or night, the phone rang with calls from desperate families in Texas, Louisiana, and elsewhere.

But financially, the program was killing me, and my time wasn't mine anymore. I had pretty much halted my construction business in order to respond to the needs that seemed never-ending.

She's right, I thought. *We can't plan anything personal anymore. Here it is Christmas, and I'm still getting calls.*

I was just about to tell the sergeant that his problem would

have to wait when he started pouring out the story of *his* Christmas the year before.

"We found my other brother dead in a ditch," he said. "He had been mugged and robbed, and his body had been tossed as though he were a piece of garbage."

I could feel something tugging inside: *What is my Christmas, when this man has suffered so much?*

What finally propelled me out the door was the sergeant's other Christmas story—about his mother. Two Christmases before his brother was killed, the sergeant and his family had stopped by his parents' house after church. His mom had gone in her room to take a nap, and when he went to wake her to say good-bye, he found her dead in her bed.

I had heard enough. "I'll be right there," I told him. Then I sucked in my breath and looked over at my wife.

"You're not going to like this," I said, "but I have to do a search."

By the time I arrived in Houston, it was nightfall, but that didn't deter me. That's because more than eighty volunteers from our call list had responded to my request for help and were waiting for me when I arrived.

. . . *even on Christmas,* I thought, amazed.

Over the next three hours, we blanketed the neighborhood with flyers, got the word out to the news media, and moved search teams with infrared equipment into wooded areas to look for the missing man.

Late that night, we got a call from a man who had seen one of our flyers. He had been driving by Houston's Intercontinental Airport when he spotted a man who looked confused.

"I knew I had to stop," the driver said. "I didn't know if he was the person on the flyer, but I had to find out."

The sergeant's brother had been found alive. I knew that if it hadn't been for that man seeing the flyer and being willing to stop

for a stranger, the young man might not be alive today. Then another thought stopped me in my tracks. If someone had mobilized the community for my own daughter years ago, she might be alive today.

✦ ✦ ✦

My sixteen-year-old daughter, Laura, disappeared in 1984. We had just moved into a new house in League City, Texas, and because the phone wasn't hooked up, my wife drove Laura to a pay phone to call her boyfriend, Vernon. The conversation seemed to be dragging on, and my wife, who was on her lunch hour from work, asked her to hurry.

"Don't worry, Mom," Laura said, waving her off. "I can walk—we're only half a mile from home."

Later that afternoon, when I returned home from work around the same time as my wife, there was no sign of Laura. At first, we didn't think anything of it.

"Maybe Vernon came over and they went for a walk," I said to my wife.

About half an hour later, Vernon poked his head in the door: "Where's Laura?" he asked. "We talked at noon and agreed to meet here tonight."

That's when we started to get concerned. Laura had suffered from seizures since she was a baby, and we knew she couldn't go for more than a few hours without her medication.

I've got to find her, I thought. *What if she had a seizure on the way home from the pay phone and is curled up somewhere off the road?*

I could feel the anxiety building as I hopped in the car and retraced the route she might have followed from the pay phone.

No Laura.

Next, I headed toward the homes of each of Laura's friends.

House after house, the answer was the same: "Laura isn't here. We haven't seen her."

By the time I reached home, my mind was spinning with worst-case scenarios: *Maybe she got hit by a car. Maybe she was abducted. Maybe . . .*

I crawled into bed and tried to pretend that everything was okay. *She'll just sneak in at night and slip into her bed,* I told myself. *Tomorrow, we'll be back to normal.*

But down deep, I didn't believe it. Lying awake with my senses on overdrive, I strained to hear any hopeful sound: the creak of a door opening, or a footfall on the floor.

But there was nothing. When the redbird started singing at daybreak, I tiptoed into her room, only to find her bed fully made, lying empty.

That's when I knew something was terribly wrong. Laura, my fragile baby, had disappeared without a trace.

The police saw it differently. When I went down to the station that morning to file a missing person report, the officer on duty just patted me on the back.

"She'll turn up," the officer said nonchalantly. "She's just a teenager having some fun."

But his answer didn't convince me. I remembered how, a few months earlier, the body of a young woman had been found near Calder Drive.

"What about her?" I said, pressing him. "Could you please check out that area?"

The officer rolled his eyes. "That girl worked in a bar. Someone probably took her out to have sex with him, and when she wouldn't do what he wanted, he killed her. It's an isolated case.

"Go home, Mr. Miller," the cop said again. "She'll turn up."

Laura didn't turn up, not the next day, or the next, or the next.

To keep myself occupied, I tried to dig up any information I could find. Within days, I discovered two disturbing pieces of news: the murdered bar girl had lived only four blocks away, and the case was still unsolved.

I picked up the phone and called the cops. "Laura hasn't come home yet. Could you *please* search that property on Calder Drive?"

By this time, the officer was getting testy. "I told you before that that was an isolated incident. Wait by your phone. Laura is going to come home!"

And so I waited. Every time the phone rang, every time someone pulled into my driveway or slowed down in front of the house, I felt my heart racing. *It's good news!* I thought as I ran to the phone for the first few calls that came in. But as time wore on, my response changed: *It must be bad news,* I thought more often than not.

The call I was waiting for never came.

Finally, one day, seventeen months after Laura's disappearance, I was reading the *Houston Chronicle* when a headline on page two screamed out: "Remains of Two Females Found in League City Field." According to the article, some boys had been riding dirt bikes in an area near Calder Drive when they smelled a foul odor. Walking toward the smell, they discovered the body of a girl who had been missing for a month. When the police came to investigate, they uncovered the remains of a second girl sixty feet away.

I know that's Laura, I thought to myself. *I've known it all along.*

Jumping out of my chair, I rushed down to the League City police station, waving the newspaper in the air. "Is there any chance this girl could be my daughter?"

Nobody could answer that question, because someone had lost Laura's missing person report. The police had to start from scratch to piece together her case. First, they requested some of her sweaters and winter clothes to check for hair samples. Next, they asked for

dental records. The following day, the police confirmed that the unidentified body was Laura.

A wave of grief swept over me, followed by an indescribable sense of relief.

It's finally over, I thought to myself. But I felt strangely empty inside. For so many months, I had been yearning and hoping, and then suddenly it was over. Just like that. The days of waiting by the phone, of not knowing, of keeping my life on hold, were finished. Now I could go on with my life. *Or could I?*

On the one hand, I was still angry at law enforcement for not checking out the area sooner. On the other, I knew in my heart that in Laura's case, no matter what I might have done, she might not have been found alive.

The police never did give me the name of the other dead girl or her family. I could only speculate if her family felt the same way I did—isolated and alone. I could only wonder if things might have been different for them, and for me, if someone had made a connection, if someone had shown that he cared.

Laura's mother and I divorced six months after her body was found, and eventually I remarried and started my life again. But it took me twelve years to recover from Laura's death. During those twelve years, every time a story came on the news about a missing person or a newly discovered body, I would pore over the details of the case to see if there were any similarities.

Abductions of young women were rife in the I-45 corridor from Houston to Galveston, and I made it my business to check on as many as I could. All told, there were more than 250 young women killed in that part of Texas during that time, and—as in Laura's case—many of the murders remained unsolved.

In a search for answers, I started meeting with the families of victims to find information. I would listen to their story and tell

them mine, and do what I could to help give comfort. But all the while, I was fixated on one thing: finding out who had killed Laura.

I need to know the answer, I told myself.

But one phone call in 1996—twelve years after Laura's death—set me on a different quest, a quest away from bitterness, judgment, and unanswered questions, a quest toward healing and hope.

✦ ✦ ✦

"My eleven-year-old daughter is missing," said a tearful woman on the other end of the line. "*Please* come. I need your help."

I rushed over to the house, and the minute I saw the looks in the parents' eyes, I knew I was peering deep into my own soul. I glimpsed fear, hopelessness, and frustration. Pain was written all over their faces.

My God, I thought. *This is how I must have looked for seventeen months.*

For the first time, I had eyes to see the depth of another family's pain. And suddenly, I began to understand the role I might fill: *I have to* do *something for this family.*

That night, I started putting together a flyer with the girl's picture, and together with her parents I papered the neighborhood. Two days later, the little girl was found safe and alive.

Found! Alive! A surge of joy overwhelmed me. I couldn't believe how good it felt to have helped someone else. I couldn't bring Laura back, but perhaps I could do something to find others like her. Perhaps, I could light the way for other families to grasp the hope that had eluded me for so long.

But as excited as I was by my new feelings, I soon learned that I still wasn't quite ready to reach out. I had a lot more healing to do. That truth didn't surface until I embarked on another search, this one for a girl named, ironically, Laura. For a couple of days, I

joined in the massive hunt that had been undertaken by her parents. I helped dig up information and even met with the police department.

But every time I heard the name Laura, I found myself tensing up. In my mind's eye, I saw *my* Laura's face. I saw her lounging around the house, listening to Vernon play the guitar, or going to the mall with her friends. Soon the memories became too painful, and after a few days I withdrew. The other Laura's body was found nineteen days later.

As it happened, though, it was this other Laura's parents who sparked the idea that would change my life. They had created the Laura Recovery Center, a search program to help other families, and every now and then over the next couple of years I helped out. A few times, I even brought my horses to probe deep into the woods for a missing child.

"Why don't you start a mounted search team?" they suggested.

The idea clicked. And so, with a couple of horses and a handful of interested friends, I started Texas EquuSearch Mounted Search and Recovery Team, the rescue mission that has since consumed my life. Our very first search was for a forty-six-year-old African American woman named Marion who had disappeared in a tough part of Houston where there are many wooded areas. For a week, we brought in horses and a four-wheeler and combed the neighborhood. Eventually, Marion's body was found at a dump site.

From the start, what got me hooked wasn't the outcome, but the impact. "I can't guarantee anything," I had told Marion's family when we started the search. "But I promise you that we will work as hard as we can until she is found."

I saw their frustration melt into relief when I told them that we would be with them until the end. I sensed how much good that assurance did, if only to let them know that we cared and were doing everything possible.

I kept my promise to Marion's family and stayed with them—even through the funeral. I've been going to funerals ever since, often serving as a pallbearer.

After our search for Marion, the phone calls and offers of help started pouring in.

"I don't have a horse, but I have a boat and I'm a certified diver," offered one person.

"I've got an airplane and a helicopter, and I'd like to join up," said another.

Before long, we had amassed a team of hundreds of potential volunteers with tracking dogs, boats, airplanes, divers, infrared equipment, and horses.

At the start of Texas EquuSearch in August 2000, I figured we'd do three to four searches a year. Instead, we're up to case number 451 and counting. Half of those missing persons have been recovered safely. I'm convinced that many of the runaways and many of those who are mentally challenged or who have Alzheimer's would have been dead if we hadn't been there.

The greatest thing we can hope for is to find people, get them home, and reunite them with their loved ones. The second best thing we can do is find their bodies in a timely way when there's still some evidence, so that the detectives can do their work.

The very worst feeling in the world is to work a search so hard but then to have to walk away from a family and say, "There's nothing else we can do."

Still, we never leave them totally alone. If we get a new lead, we go out, no matter how hopeless it seems. Take the case of twenty-year-old Larry, who went missing a couple of years ago. His car had been found abandoned, and we put together a massive manhunt. Ground searches, flyers, four-wheelers, and horses failed to turn up any leads, but afterward, I stayed close to his sister, Kim. A few months later, she called to say there was word on

the street about where his body might be found. We searched for a couple of days and came up empty. Five months later, she called again, but we still had no luck.

Finally, twenty-one months after Larry's disappearance, we located a body on an old road littered with rusty refrigerators and beat-up furniture. It was just the kind of place that you could pull into, dump a body, and get back out without being noticed.

We found the remains underneath a tree. The bones were scattered, but one of the searchers uncovered a key piece of evidence that linked the deceased to Larry.

"It's him!" shouted a volunteer. "I've got his cell phone!"

I looked up to see Larry's sister, Kim, standing at a distance with her head buried in her hands. I walked over to her and gave her a hug.

"Honey, I think we all knew the outcome wasn't going to be good," I told her. "But at least now you can start the healing process."

Later on, I helped Kim and her mom with the paperwork to get victims' compensation. The money helped pay for the funeral. I was there, along with several other members of our search team.

"Your life will never be the same," I told Kim. "But you are not alone."

Kim and I talk every now and then, and when we do, I remember why I keep going week after week to search for those who are missing. I remember why I went to a seedy motel in Louisiana to rescue a boy abducted by a so-called mentor. I know why I led a rescue team to Sri Lanka for ten days after the 2004 tsunami to help recover the bodies of 220 villagers in Ampara, the area worst hit. I know why I sent rescue teams to the Gulf Coast after Hurricane Katrina and spent days at Houston's Astrodome comforting evacuees. And I understand why I flew to Aruba to join in the search for Alabama teen Natalee Holloway.

☆ ☆ ☆ ☆ ☆ ☆ ☆ ☆ ☆

From Hopelessness to Hope

I reach out to others because I have always understood—even well before the tragic death of my daughter—what it means to have no hope. You see, when I was six months old, my mother stuffed me in a dresser drawer, tucked my brother in his bed, set the house on fire, and walked out. I never saw her again. After that, I was shunted around from children's shelters to various relatives, who were drowning themselves in alcohol.

It wasn't until my aunt sent me away to a farm in Ohio one summer that my life started turning around. I was a streetwise city kid stuck in the middle of nowhere on a big farm, where I baled hay and milked cows morning and night. But it was glorious. The family I stayed with was warm and welcoming, and for the first time in my life I had some stability and love.

The family took me in full time when I was a freshman in high school. My "dad" was always there for me, even to the point of going to every basketball game. If it weren't for this family, I'd be in prison or dead today.

That family gave me the courage to have some kind of hope. Until I met them, I was literally hopeless. But they came to me at a critical time in my life. They went out of their way to reach out and take me in. With all my losses, somebody gave me a chance— somebody was willing to come alongside me, care for me, and love me.

My work today with families who are helpless and hopeless over the loss of their loved ones is the very least that I can give back.

—Timothy Miller

When my own daughter was lost, I felt totally alone. So I know what it's like for other families. And I have promised God that if there is any way I can help, I will never let a family be alone again.

✧ ✧ ✧

You may not be called to give others the kind of affirmation that Tim Miller offers hundreds of hurting families. But there's something you can do every single day of your life to direct the light of hope to those who cross your path.

Searchlight:

Do you seek ways to affirm at least one person in your life every day?

Your Point of Light:

Look in the eyes of the people you meet this week and make a connection. Whether it's the painter who is redoing your kitchen, the pizza delivery boy, or the woman behind the counter at the deli, let them know how important they are and that they are not alone.

And we are put on earth a little space
That we may learn to bear the beams of love.

—WILLIAM BLAKE

The Light of Love

The spirit of giving is inseparable from acts of love. Love is the forward motion of our care for others. It is active, not passive. It is a motivating force that causes us to care about our neighbors, our community, and our world.

If we are to become truly giving people, we can't keep our love bottled up. When we walk out the door every morning, we have to be ready to express love whenever the opportunity crosses our path, to "bear the beams of love" that poet William Blake describes. We have to keep the eyes of our hearts open to see the needs that are all around us. Then, like a volunteer firefighter or an emergency responder, we have to be ready to jump in and act—to serve, in effect, as a one-person response squad for love.

Consider the response of Timothy Radcliff, a teenager who as a seven-year-old was deeply inspired as he witnessed his older brother train a Seeing Eye dog.

TIM RADCLIFF

Puppy Love

It wasn't just the dog that grabbed Tim Radcliff's heart; it was
also the potential to show love for another human being. From the
moment he saw his brother take on the task of training a puppy
that would become the eyes for a blind adult, he yearned to train
a dog of his own.

"I thought it was a neat thing to be able to have that kind of re-
sponsibility," said Tim. "Here was something I could give that
would actually help someone else."

Not long after his tenth birthday, Tim got his wish: a golden
retriever named Logo. Logo was just seven weeks old when he ar-
rived at Tim's house one May evening in a van from The Seeing
Eye, Inc., of New Jersey.

Tim had been watching out the window since breakfast. When
he saw the van drive up, he sprinted to the door, flung it open, and
saw his charge for the first time—a tiny puppy cradled in the arms
of the puppy placement woman, who was walking briskly up the
path straight toward him.

Tim could feel his heart pounding.

"I couldn't wait to get started," he said.

After introductions, the woman placed the bundle of blond fluff in Tim's lap, and instantly the boy was hooked. For the next year, Logo was his to love, and to cherish, and to prepare for the biggest challenge of a canine's life: qualifying as a Seeing Eye dog.

From the outset, Tim knew his job would be tough, but he also clearly understood his role. "My job was to raise a nice dog that knew exactly what it was supposed to do to make everything easy for a blind person," said Tim. To guide him, he had a manual of helpful tips and dos and don'ts that provided the practical methods he'd need to help Logo learn the rules.

But there was no manual for the other part of Tim's job—the *inner* part. The boy had to make an emotional commitment to a dog who would never be his. Ultimately, the job of raising Logo would demand not only human love, but also a capacity to share that love with a total stranger, one who desperately needed a smart dog to provide substitute eyes.

Could he do it? Could he love this dog as his own, and then give him up? Tim didn't know the answer to that question. He *couldn't* know, until he was put to the final test. All he knew right now was that he was willing to try.

At first, the job seemed easy.

"Logo liked to sleep a lot," Tim recalled.

Typically, Tim would be doing homework, only to look up and see the puppy lying outstretched on the floor, dozing in doggy dreamland.

Things got more complicated as the dog grew older and Tim started teaching him basic commands such as "sit" and "down" and "rest." Logo also had to learn good manners around the house, like not sleeping on the bed and not relieving himself inside.

Tim's first task was to teach him to sit. "Seeing Eye dogs have to sit to get their food so that they don't jump on the blind person," Tim said. "Logo learned that one pretty fast. It took only about a week."

Housebreaking was another story.

"Because he was so little, I was constantly putting him outside," said Tim, who as a home-schooled student was able to work with Logo throughout the day. Some days, housebreaking actually did take all day long, because even when Logo was relieving himself, Tim had to be at his side.

"I had to keep petting him, because that's what a blind person would do to keep track of the dog's position," Tim explained. "But Logo didn't like it. He kept running in circles to get away from my hand."

Hour by hour and day by day, though, Tim stuck with it. He patiently ushered the puppy outside, standing steady as the dog ran around on a six-foot leash, and petting him when he finally settled down. "It took about two weeks to control him, but finally Logo realized I wasn't going to stop."

Even harder for Tim was quelling Logo's natural exuberance, a quality that the boy knew could cause trouble for his future owner. "He was a very happy dog," said Tim. "Sometimes he'd get so happy he would just run around the house. If you tried to calm him down, he would get even more excited."

Even worse, whenever Tim and Logo were out for a walk and another dog passed by, Logo would fly into a passion and give chase. "Training him to overcome that was my biggest challenge," said Tim.

Still, Tim couldn't help but love Logo's joie de vivre. That special doggy exuberance was one of the things that drew them close. For example, whenever Tim was feeling low after pitching a bad

game in Little League, it was Logo who would sidle over, nuzzle his hand, and bring him back up again. Once, during an especially important game, Tim brought the dog into the dugout to serve as his personal cheering squad.

"That day, I didn't throw very hard, and I gave up a lot of hits," said Tim. "We lost the game."

Dejected, Tim plopped down on the bench near Logo, who immediately began to lick his hand. "It didn't seem to matter to Logo that I didn't pitch well." Within minutes, Tim's spirits lifted, and by the time he and Logo headed for the car to go home, the game was a distant memory.

As the months went by, Tim and Logo behaved more and more like members of an intimate family. At any time of the day or night, Tim could be found at Logo's side, teaching him, grooming him, and cuddling him. Logo responded with obedience to his young master's commands and with the kind of affection only a dog can express.

Typical were the mornings that Logo started licking Tim's face at eight o'clock to signal it was time for a walk. Slathered in dog-kisses, Tim would jump out of bed, pull on his clothes, put Logo on a leash, and head for the door.

Another time, Tim was sitting on the couch, only to feel the warm body of his charge snuggling up against his legs. Before long, Logo was sound asleep on top of his feet.

"I loved it," said Tim. "It was pretty cool to have this little guy at my feet. He was growing so close to me, almost like a little brother."

But Tim knew it couldn't last. As the months passed, he began noticing a dull ache in his heart. He was becoming more and more aware that one day soon, the puppy placement woman would return. And when she left, Logo would depart with her.

Tim's mind drifted to all those cozy winter afternoons with Logo at his feet and all those sunny wake-up kisses before breakfast. Soon those moments would fade into memory.

And so as winter turned into spring, Tim tried his best to keep his emotions in check by throwing himself into Logo's training. With every command he uttered, every walk he took, every biscuit he bestowed as a reward, he focused on one thing: preparing Logo to be the perfect companion—for someone else.

A month before Logo was scheduled to leave, Tim started preparing himself for the dog's departure. "I thought about how sad I would be when he left." But most of all, he worried about the dog and how he would perform under pressure.

"I hoped he would make it," said Tim. "I hoped he would actually be able to help a blind person."

But would Logo pass the test? Tim was aware that some dogs didn't make the cut at the Seeing Eye organization, where they had to take the next step of training after a year in a private home like his.

"Some dogs don't make it if they have problems physically," he explained. "Others don't make it because they're afraid of shadows. Still others don't make it because they're not confident walking through the street when there are cars going by. And there are dogs that pull really hard on a leash, or don't listen, or behave roughly in the house."

As the day of Logo's departure drew nearer, Tim tried even harder to make sure the dog was ready. "When I took him for walks, I pretended that I was blind to see if he could lead me. To make it easy for him, I took us down straight roads so that all he had to do was walk straight ahead. He did pretty well."

Tim tried to pretend that Logo's last day was just like any other. He got up early, fed his canine "little brother," combed him,

LOGO

and took him outside for his morning constitutional. But when they reached the yard, Logo seemed unusually quiet. He didn't chase after the blue jay that perched on the fence. And he didn't bolt when a dog barked a few houses away.

Tim wondered, *Does he have a premonition that he's leaving?* Looking into the dog's eyes, the boy mused, *Can he sense the tension inside me, or feel the heaviness of my heart?*

Then, taking a deep breath, Tim led Logo inside, where the two of them sat quietly and waited.

"You're a good dog," he whispered to Logo. "You're going to do just great."

It wasn't long before the puppy placement woman pulled up in her van. Silently, Tim and his family brought Logo outside, and they all gathered around to bid the dog farewell. Like guests at a graduation, the family started snapping pictures to remember the event. There was a shot of Logo getting into the van; another of

Logo in the van; and one of Logo's face with his eyes looking straight out, fixed on Tim.

"Logo looked like he was wondering what I was doing," said Tim. "He wasn't used to being in a van separated from me. He had his head cocked to one side, and he was panting. He didn't know what was going on."

Tim felt helpless. He wanted to grab the dog and hold him and tell him how much he loved him. But he couldn't move. It was almost as if something were holding him back, keeping him from asserting his will, his desires, his needs so that Logo's purpose might be fulfilled.

Tim knew that Logo had never been completely his. He really had no right to claim him. So, although his heart was breaking for the dog and for the companionship he had worked so hard to fashion, all he could do was try to encourage him for the next step of his journey.

"You *have* to do a good job, because you're my first dog," the boy said softly, a wetness now clouding his eyes.

Logo looked at Tim as though he understood. With that, Tim's dad closed the door, and the van pulled away.

"I watched until it turned the corner," said Tim. "But I felt alone. And I worried for him. I didn't know if he was going to make it or not."

The next few days were difficult for Tim. With his constant companion now absent, he felt a massive void in his life. It was hard to study, to enjoy his sports, or to refocus his attention on other projects and people. As an antidote, he soon asked to raise another Seeing Eye dog, and within a few weeks he was back in his familiar dog-training routine.

A couple of months later, Tim got a letter inviting him to see Logo perform at a "town walk" in Morristown, New Jersey. The

dog's Seeing Eye trainer would be walking Logo through the town as a test run, to determine if he was ready to become an official Seeing Eye dog. Tim and his family could walk a block behind Logo and the trainer—far enough so that the dog wouldn't see or smell them—to monitor his progress.

On the appointed day, Tim, his parents, and two brothers showed up at Morristown for the event. It was a one-dog show: Logo was the only performer.

As Tim watched the trainer put the dog through his paces, he felt his chest swell with pride: "Logo was listening to the instructor, and whenever there was an obstruction, he walked around it just as he would if he were leading a blind person so that the person wouldn't be in danger."

Tim could tell that the dog had learned many of the subtleties of his job. When the six-foot trainer walked toward a doorway that was too low for him, Logo steered away from it, preventing the man from hitting his head. Clearly, Logo had learned to sense the trainer's height and knew what doorways to avoid.

A few minutes later, as the duo was crossing a street, a car turned in front of them. Logo immediately stopped and backed up protectively, preventing the trainer from getting hit by the vehicle.

"Good job! Good job!" Tim whispered under his breath. He looked at his watch and smiled. Logo had only five minutes to go before the forty-five-minute town walk was over.

Tim was about to break into a celebration when he spotted potential trouble. Two other dogs were coming straight toward Logo, and he knew instinctively how the dog would react.

Tim's muscles tightened. He had tried so hard to keep Logo calm at times like these, but the dog was irrepressible. Logo was such a social animal that the minute he met another dog, he became overly excited and tried to give chase.

This time was no different. With a sinking feeling in his heart, Tim watched as Logo lurched forward on the leash toward the dogs. The trainer tugged and strained, but nothing would stop Logo from his goal.

"I knew he had blown it," said Tim.

The phone call came a few days later.

"He was a good dog, but he was distracted too easily by other dogs," the puppy placement woman told Tim. "We just couldn't take a chance."

Tim admitted he felt "a little sad" for Logo, as well as for himself. "He was the first puppy that I had raised, and I wanted the first one to be really successful," he said. Although Tim wanted to adopt Logo, he had already begun to train a new puppy, and his family just couldn't take on two dogs. As it turned out, Logo was adopted by a local family and after a speedy adjustment to his new home, he's living an active, happy life.

Like Logo, Tim was undaunted. Now sixteen, he has raised seven more dogs—and all but one have made the cut as full-fledged Seeing Eye dogs. Also, today he sees that Logo didn't fail. Rather, Logo may have been the biggest success of all, because he set the stage for every one of the dogs that came after him. He taught Tim how to love and let go so that another person might live life more fully. In effect, Logo had been *Tim's* trainer in a course for which there is no pass or fail—a crash course in spreading the light of love.

☆ ☆ ☆ ☆ ☆ ☆ ☆ ☆

Loving and Letting Go

I've never written letters to the Seeing Eye dogs I've trained. That's because I've always assumed that the dog has moved on to live with someone else.

They are never really my dogs. I'm supposed to take care of them and love them, but when I give them up, they become someone else's. I have learned the hard lesson of letting the new owners love the dog totally and feel that they are the *only* owners.

I saw one of my dogs with a blind person only once. The dog I raised had done such a good job that the Seeing Eye program put her with a blind person rather than a trainer for a "town walk" around Morristown, New Jersey.

While they were walking around town, the dog, whose name was Jenna, kept looking up at the lady, and the woman kept telling her that she was doing a really good job. Whenever they stopped at a curb or in front of an obstacle, the woman leaned over to pat Jenna's head.

Even though I was walking at a distance, I could hear the woman saying to Jenna, "You're such a *good* dog."

I could tell that this person really loved Jenna, and that's all I could have asked for. The only thing I've ever wanted was for my dogs to be with someone who really loved them.

—Timothy Radcliff

Searchlight:

At least once a week, do you hear yourself saying, "I want to do this because it's best for another person"?

Your Point of Light:

Make a choice to help out at a nursing home, or visit an acquaintance in the hospital, even if it means giving up a morning you had set aside for yourself.

The quality of mercy is not strain'd,
It droppeth as the gentle rain from heaven
Upon the place beneath. It is twice bless'd:
It blesseth him that gives and him that takes.
—WILLIAM SHAKESPEARE, *MERCHANT OF VENICE*

The Light of Compassion

Compassion can be cultivated. It grows out of an attitude of thankfulness for the blessings that have been heaped upon us. It thrives through awareness that our material resources, however modest, cannot be taken for granted.

Often, the process begins this way: You see or hear about a need; your heart stirs; and immediately, you roll into action. A little girl in town needs chemotherapy, and you donate to the fund. An elderly woman needs a new refrigerator, and you give her the extra one in your garage. A family's house needs rebuilding after a tornado, and you hop in your car to help.

Then, once the light of compassion is in your heart, it feeds on itself. What's more, it's contagious. Your children model it, your friends share in it, and even strangers catch the spirit. Before long, you may discover that an initial, simple act of compassion has snowballed into a network of caring that transforms your family and community and forever changes your life.

That's the way it was for Molly Banz, an English immigrant and Napa, California, restaurant owner, whose gut response to a Mexican family's plight generated a volunteer movement that has become "Molly's Angels."

MOLLY BANZ

Compassion Insurance: $1 in the Pickle Jar

Molly Banz couldn't believe what she was reading.

"Grandmother Has No Money for Funeral," cried the head-line in the *Napa Register*. "Daughter and Two Children Die in Blaze," wailed the drophead.

Even before she read the rest of the story, Molly could feel the outrage building.

This would never happen in England, she thought to herself. *Back home, everything would be taken care of.*

Molly's eyes grew large as she scanned the article for details. A deadly fire had swept through the house of a family of four, killing a young mother and two of her children—a twenty-five-day-old baby and a toddler. The only ones left alive were the grand-mother, a school bus driver who was the sole provider for her fam-ily, and her four-year-old granddaughter, whom she had hurled through a window to safety.

This poor woman! thought Molly. *For her to have to worry about money at a time like this is a tragedy.*

Without wasting a minute, Molly picked up the phone and called the newspaper editor.

"If everybody in town brings me $1, I'll get this family on its feet," she promised. "Please put that in the paper."

Hoping for a miracle, Molly planted a giant pickle jar on the counter next to the cash register at the restaurant she owned, and waited.

The very next day, the newspaper printed Molly's appeal, and within a week the pickle jar was stuffed with dollar bills.

"You couldn't believe the money coming in," said Molly. "People I didn't even know came in the door just to put their money in the pickle jar. Old folks, teenagers, businessmen—the flood of people never stopped."

Before long, Molly had collected more than $27,000 from the community. The money, which was set up in a trust fund for the grandmother and her granddaughter, paid for the funeral and for the down payment on a modest house. Molly went to the funeral and still stops by to see the woman when she can.

"She's a good lady—drives a bus for disabled kids," said Molly. "It was heartbreaking for her, losing those children."

But out of the heartbreak of the fire and the community's response to the pickle-jar appeal, an idea took flight.

"Why don't you start a nonprofit organization?" said Molly's friend Debbie Norris, who works for the district attorney's office. "I'll organize it and we'll find a way to keep it going." Four other friends—all senior citizens—got on board, and in 1999 an outreach program was born. They dubbed the organization Molly's Angels.

The idea was simple: invite families throughout Napa County to donate $1 a month to a fund that could provide a kind of compassion insurance to those in distress.

"There are 250,000 people in Napa County," Molly noted. "One dollar a month, $12 a year—it's very little. But it's something everyone can do."

With these $1-a-month funds, Molly's Angels hoped to be ready to respond at a moment's notice to families or individuals who, because of a catastrophe in their lives, were in dire distress.

From the beginning, Molly wanted to keep the program streamlined. "No bureaucratic red tape," she said. "We wanted to pay bills, give out clothes, buy food, and provide goods and services, but not give out cash—except in rare emergencies."

With their organization and philosophy in place, the Angels were ready. But for a year, "things were real quiet," said Molly. "We didn't get any calls for help."

Then tragedy struck. A young architect who was building his dream house was crippled by a massive stroke, destroying his livelihood and his hopes of a mountaintop refuge for his family. Someone who had heard about the tragedy called Molly.

"Can the Angels do *anything?*" the caller asked. "How about building a house?"

"No problem," said Molly. She swung into action, calling a contractor friend and others she knew who were willing to lend a hand. Before long, the house on the mountain was rising board by board, and brick by brick. Donnie and Marie Osmond picked up the story for their TV show, and Molly's Angels took off.

From every corner of Napa, the donations flooded in, sometimes bringing unexpected windfalls.

"A friend of mine wants to donate $5,000 to the Angels," said an acquaintance of Molly.

"Why would she want to do that?" Molly asked, dumbfounded that a perfect stranger would make such a generous offer.

Nevertheless, Molly gave her acquaintance a copy of the An-

gels' newsletter and a video to pass along to the interested donor. Not long afterward, a check came in the mail with an added surprise: an extra *0* after the *5* made the check worth $50,000, instead of the $5,000 that had been promised.

Molly didn't find out why until a year later, when she invited the donor to a Christmas party. As it turned out, the woman had inherited a considerable sum from her "aunt," a prominent Englishwoman who was an artist. The minute the prospective donor saw the Angels' video and heard Molly's English accent, she was touched.

"If my aunt were alive, she would give you a million dollars," said the woman, who dug even deeper into her pocket for an additional $75,000 for the Angels' mercy mission.

But Molly is just as grateful for the twenty-three hundred people in town who give $12 a year. "Every dollar makes something happen.

"I've never been into big money," continued Molly, who grew up "poor but happy" in Peterborough, England, as the daughter of a railroad worker. "As long as we can make it and do what's needed, that's enough for me."

Like the biblical jug of oil that never ran out for the widow who fed the prophet Elijah, the coffers of Molly's Angels never seem to come up empty. Instead, the donations have flowed in along with the requests for help, creating a never-ending circle of compassion:

✧ A woman who was left wounded and homeless after her estranged husband shot and killed their daughter needed a place to live.

Molly's Angels came to the rescue with a small mobile home, which they renovated through donated funds. A

few years later, they helped the woman move into a larger mobile home provided by the Napa Flood Control Project, and today the woman is working and raising her grandchild.

✧ A five-year-old boy, found buried under three hundred pounds of bricks after an earthquake, required multiple operations.

The Angels raised more than $50,000, enabling his family to remain at his hospital bedside during his weeks of recovery.

✧ A teenage boy with cerebral palsy was so badly burned in a mobile-home fire that his right arm had to be amputated.

With his home in ashes, Molly's Angels helped replace the mobile home—and furnish it—through donations.

✧ A gravely ill father of four, whose family was crammed into a tiny travel trailer, had no insurance to pay for a liver transplant.

After the Angels paid for his insurance, another "angel" appeared to take care of the family's housing needs: a woman whose mother had just died had inherited a trailer lot and mobile home. Today the father is on the mend and the family lives on the lot in the donated double-wide trailer.

✧ A grandmother called to relay the dying wish of her twelve-year-old grandson, who had been diagnosed with an inoperable brain tumor.

"I want to give toys and clothes to all the homeless children in Napa," said the boy.

After the Make-A-Wish Foundation granted his wish at a party in his honor, Molly's Angels went a step farther: They raised more than $10,000 through a fund-raising dinner to send the boy to Little Rock for an operation that they hoped would save his life. Volunteers used their connections to obtain free airline tickets and a free hotel room for his family. Now, after more than twelve surgeries, the boy is cancer-free and back in school.

✧ The family of an eight-year-old with muscular dystrophy needed a wheelchair-accessible vehicle.

The Angels passed out flyers in front of Wal-Mart requesting $1 donations, and in a single day collected $1,600.

"It's amazing what a dollar will do!" says Molly.

Homeless families, kids with cancer, crime victims—so many have been touched by Molly's Angels. But equally impacted are the scores of Napa neighbors, including real estate agents, secretaries, airline attendants, waiters, dentists, caterers, and even residents of a veterans' home, who pitch in together to make things happen.

"We've got so much energy," Molly boasted. "Our vice president is an eighty-year-old. She's had two strokes, but she's still going."

But the glue that holds the organization together is sixty-seven-year-old Molly, who sold her restaurant a few years ago and now devotes herself full time to Molly's Angels.

"I've always been a helpful person," she noted. "As a child, I used to look after little kids and help the neighbors. But my mother was a stubborn old gal who thought I was too outgoing.

"'Stop working so much for other people!' she would tell me. 'Look after yourself.'"

But Molly couldn't contain her instinct to care. These days, like a mother hen, Molly has taken the entire town of Napa under her wings and carefully nurtures the community's sense of compassion. Through her monthly TV show and newsletter, which feature the good deeds of individual "angels," she spreads the gospel of giving to all who will hear it:

"George Altamura, bless his heart, came through with donated space every Friday night at the Chefs' Fair, where we raise money through our wine tastings," Molly told her TV audience.

"Dorothy Lind helped get a free room at the Peabody Hotel in Little Rock for the family of a boy who was having brain surgery," announced one newsletter.

"Betty Hagedorn, who is going into retirement, offered us all the Christmas trees on the two acres of her Christmas Tree Farm," said another.

"Our thanks to Piner's Ambulance Service as well as the Cinedome Theater for giving a boy with terminal cancer his last wish to see *Harry Potter*," said yet another.

"When you give, it's like having a gift growing inside you," Molly says.

Just like those dollars, growing one by one in the pickle jar.

☆ ☆ ☆ ☆ ☆ ☆ ☆ ☆ ☆

Molly's Miracle

I had just moved back to Napa, California, in 1986, when a flood swept through a mobile-home park in town, leaving dozens of senior citizens stranded.

"You've got to go down and take a look at that place," a friend told me. "Everyone has lost everything. The community is devastated."

The minute I heard his words, something touched me inside. I could picture the poor old folks, lost and helpless, walking aimlessly around their belongings.

I've got to help, I thought, as I drove out to the park.

The scene was even worse than I had imagined. On one side of the park, an elderly man stooped over a pile of rubble, poring over family pictures that were stuck together, many of them ruined. Across the road, a frail old lady with vacant eyes sat slumped in a white plastic lawn chair, unable to speak or move.

All their memories—gone, I thought. *They've got nothing left.*

"Where are you going to feed them?" I asked a Salvation Army volunteer.

The woman shrugged, and then an idea formed in my mind: "Bring them to my friend's bar and I'll feed 'em," I said, referring to the place where I worked. "I only have enough money for a couple of days' worth of food, but I'll take care of them."

At the bar, I regularly cooked up fish-and-chips, the kind we loved in England where I grew up. I never did much business, maybe $50 a day, but I figured that was enough for at least one day.

After that . . . well, I'll worry about that later, I thought.

Back at the bar an hour later, a group of Hell's Angels was sitting at the counter polishing off a round of beers when sixty-seven senior citizens started pouring through the door.

"Will you take a look at *that!*" a mean-looking character with a black bandanna grunted sarcastically.

"Shut your mouth!" I ordered him. "These poor people have lost everything they own. I have only enough money to feed them one day. Don't you say another word!"

The big guy gave me a hard stare and slowly reached in his pocket.

He's got a gun! I thought. *Now I've gone and done it.*

Out came his hand with a wad of bills.

"Here, sweetheart," he said. "Here's some money for the old folks."

With that, he turned to his buddies at the bar.

I fed the senior citizens for a week on the money those boys dished out. Other people found out about it, and the money started flowing in—enough to feed everyone for seven weeks. Later on, we had a big party as a fund-raiser and split the money among the senior citizens to help them get back on their feet.

Most of the seniors are dead now, but every now and then one of them shows up. Always, the greeting is the same:

"Molly, you're an angel."

—Molly Banz

Searchlight:

Does your heart skip a beat when you hear on the news about a family or a child in trouble?

Your Point of Light:

Keep alert for opportunities to show compassion to someone in need. Remember that extra microwave in your garage? Donate it to a teen center in the inner city. How about that dividend check you just received unexpectedly in the mail? Mail it to the fund being set up to send a child to a prominent cancer center. Once you start looking and listening for ways to help, the needs will cry out— and you'll have ears to hear them.

That best portion of a good man's life,—
His little, nameless, unremembered, acts
Of kindness and of love.

—WILLIAM WORDSWORTH

The Light of Kindness

Kindness creates community. A thoughtful word, a timely phone call, a gentle touch—none of these actions in and of itself may seem like much. But together these threads of kindness weave a rich tapestry of giving that binds us together.

Whenever we reach out to another person in a simple act of kindness, we establish a bond that brings us in touch with a wider world. For a brief moment, we step away from our own narrow interests—that cute dress at the mall, the hot new TV show, a golf handicap, or the boat we are yearning to buy—and make a vital connection that can change the way we think and act toward our neighbors.

That's what happened when two teenagers found a couple of simple but elegantly creative ways to connect in kindness with those outside their usual realm of contacts and comfort zones.

One of these young people, sixteen-year-old Merritt Kinkade, made a spontaneous decision one Christmas morning to "bake cookies for the old folks' home." The result was an open door to deepened relationships with a very unusual "extended family."

MERRITT KINKADE

Merritt's Cookie Connection

We were about to go for a family walk on Christmas morning when I suddenly got a brainstorm: "Let's make cookies and deliver them to the old folks' home!"

For my family, baking cookies is like breathing. At the drop of a hat, my mom, my sisters, and I will stop what we're doing and bake. But on Christmas morning, something told me we should do something more. After my sisters and I had opened our gifts—iPods and sweaters and piles of other stuff that we had wanted—I sensed something was missing. And apparently, so did my sisters.

As soon as I made the suggestion, my sisters—Chandler, fourteen; Winsor, ten; and Evie, seven—gathered around me at the island in the middle of the kitchen and pitched in to help make our favorite, chocolate chip.

An hour later, we were ready. We piled the freshly baked cook-

ies on a big Christmas tray and headed up the hill toward the old folks' home. We reached the top of the hill and just around the corner on a little street right in the middle of town stood the teal-blue house that was home to about twenty older people, most of whom are mentally impaired. I could see the small patio out front surrounded by trees, where the residents liked to sit and watch the passersby. But today the patio was empty.

Walking up to the door, I peeked in the window and saw the backs of little bald heads lined up as usual like bowling balls along the wall inside. The sight had scared off more than one friend, and even my youngest sister used to be frightened.

"I don't want to go in," she would say after peering in the window.

But this time, she and the rest of us walked up to the door boldly and gave a loud knock. Within seconds, the door swung open, and there was the "greeter," Mary, a little lady with no teeth who immediately shook our hands. Behind her, a group of old folks was sitting in chairs in front of a big TV watching football.

"Merry Christmas!" we called out.

Before we knew it, the residents had crowded around us, eagerly eyeing the cookies. I watched the pile of cookies dwindle as thin, bony hands reached in to grab three or four at a time. When I looked up, I saw that the chocolate, which was still warm and melted, had gotten all over their faces.

One of the regulars, "Uncle" Herman, a sweet old guy who is tall and thin with eyes as big as saucers, had chocolate smeared on his cheeks and nose. But he didn't care. He was just so happy to be eating cookies and chattering away with company on Christmas that how he looked didn't matter to him at all.

The excitement was contagious. All around the room, I could see eyes brighten, even among people who could barely lift up

their heads. Those who couldn't talk seemed totally absorbed in every word we said. Others couldn't wait to ask questions or blurt out compliments about our blond hair, or our clothes, or my shaggy UGG boots.

"I've always wanted a pair of those," said a statuesque woman named Laura.

By the time we were ready to leave, everyone in the place had the Christmas spirit, despite the fact that those cookies were the only gift any of them had received that day. Everybody passed around lots of hugs, and when we finally walked out the door and waved good-bye, I knew that we would be back.

After that, I started going regularly to the old folks' home, sometimes with my sisters, and sometimes with friends. One Saturday, when three friends came over and we were hanging out with nothing to do, I announced: "Let's bake cookies and bring the extras to the old folks' home."

One friend shot me a look that said, *You're pretty weird.* But eventually she shrugged and went along.

The minute we walked in the door, we were greeted by a chorus of "Hi, Merritt!"

At first, my teenage friends were a little intimidated, because on the surface the old people can seem hard to love. With their gap teeth and wrinkled skin, they do look a little different from high school students. But I introduced my young friends to the residents one by one, and before long they all were shaking hands, sharing hugs, and giggling at Uncle Herman's jokes. "My teeth are on too tight," he quipped at one point, triggering an outbreak of smiles and laughs.

A few weeks later, on Valentine's Day, my once reluctant friends pitched in to deliver some special gifts: baskets of cookies with handmade Valentines that I had assembled the night before.

✫ ✫ ✫ ✫ ✫ ✫ ✫ ✫

Taxi Testimonial

On a freezing night in New York City, my family and I jumped into a taxi after a formal event and headed down Fifth Avenue toward our hotel. After a few blocks, the cab got stuck in traffic, and because my dad doesn't like to be cooped up, he rolled down the window to get some air.

"Someone, please help me!" we heard a voice yelling. "I'm really cold!"

We looked out the window and saw a homeless man sitting in the snow by the side of the road. Covered with nothing but a flimsy blanket, he was rocking back and forth trying to keep warm.

"I'm going to freeze!" he yelled again.

My dad didn't waste a minute. "Can you pull over?" he asked the taxi driver.

As soon as the cab pulled up to the curb, Dad jumped out, ripped off his topcoat—the stylish new one that he had bought in an expensive men's store in California just for this trip to New York—and wrapped it around the man's shoulders.

But Dad didn't stop there. Patting the man on the back, he leaned over and started engaging him in conversation.

"Are you okay?" I heard him ask. I couldn't catch the rest, but I could see that my dad and this stranger seemed to be relating to each other as naturally as if they were old friends.

After a few minutes, Dad shook the man's hand and started walking toward the taxi. He got back in the cab and, without saying a word to any of us about what had just happened, told the driver, "We can go to the hotel now."

Watching my dad that night, I learned an unforgettable lesson about giving: It's not about looking good, or about doing something in public so that everybody knows. It's about the quiet things, actions that come from your heart.

—Merritt Kinkade

Each Valentine was addressed personally to one of the old folks, thanks to my dad, who had gotten a list of the residents' names a few days earlier.

There were cards for Butch and Bruno, two of the World War II veterans . . . for Dawn, the seventy-five-year-old lady with Down syndrome . . . and, of course, for Uncle Herman, Mary, and Laura. I wanted to let them all know that they were cared for individually.

"Happy Valentine's Day!" each card said. "You are loved. Much love, the Kinkade Family."

Sometimes I wonder what my life would be without the old folks' home. If I lacked my connection to Uncle Herman and Dawn and Laura, I'd be totally unaware of the needs of elderly people. But now, when I'm at the grocery store and see a senior citizen, I make it a goal to smile and say hello. Even a simple smile can change someone's day. It's a small act of kindness. But it makes a huge impact.

ROBYN STRUMPF

Robyn's Books and Blankies

You might also take a page from the book of Robyn Strumpf, an eighteen-year-old Trustee Scholar at the University of Southern California, who created a small but potent program called Project Books and Blankies when she was in junior high. Through the project, Robyn donates a handmade quilt and a basket of books to schools and homeless shelters to encourage reading.

"I had always loved doing community service," she said, "things like repainting a barn at a nearby college, or wrapping gifts for needy kids. But by the time I got to seventh grade, I wanted something to call my own."

Searching for her special Point of Light, she remembered her struggles learning to read as a child, and something clicked.

"I didn't read until third grade," she said. "Up until then, I just didn't get it. Whenever I was forced to read something, I would scream and run away."

To keep her calm and focused, Robyn's parents would sit down with her in a corner with a book and a cozy quilt and read her a story.

"Finally it all made sense," she said, "and from then on, I loved reading. I love mysteries. I love biography. Whenever I have free time, I love to read."

Her passion for reading—and the memory of the quilts that comforted her during her frustrating battle to make sense of the words on a page—led her naturally to Project Books and Blankies.

"I associated the two—a cozy quilt and a book." She started by making a couple of quilts and soliciting books from publishers and bookstores. Within months, the books started rolling in. "Sometimes I'd get five, and sometimes twenty," she said.

Robyn's first donation was to Head Start, using books donated by Borders Books in Valencia, California. "I brought in a basket of books with one of my quilts and explained to the children why I was there. I wanted to show them that I had wrestled with the same problem they had, and let them know that if I could learn to read, anyone could."

That very first day, she met a young boy named Joel, who asked her if he could read one of the books aloud.

"It was one of those counting books," said Robyn, "one dog, woof . . . two dogs, woof woof." As it turned out, Joel didn't know how to read. "Holding the book upside down, he invented the story," she continued. "But it was incredible to see his pure joy in holding a book that he could call his own. From then on, I was hooked."

Robyn's project mushroomed from one basket to another, and another, until by the time she reached high school she found herself managing a major outreach movement. Once, on National Youth Service Day, which is sponsored by *Parade* magazine and

the Points of Light Foundation (see appendix C), she brought her entire softball team to a homeless shelter. They set up a library in the shelter's Learning Room, where tutors could help kids with their homework. The team brought a quilt and a basket of more than 150 books, including a set of 75 core books, some fiction and some nonfiction, which Robyn made available to several homeless shelters.

"That way, if a child switched shelters, he would know there was some consistency in the books in the Learning Room library," she said.

Along the way, Robyn learned how to write and solicit grants (she received $10,000 in donations that she turned over to other organizations she worked with). She recruited professional athletes (former LA Dodger Wes Parker showed up at one of her sites to help her promote reading). And she got over her fear of making phone calls ("I have trouble calling and asking for financial donations," she said).

"It's a one-woman operation," she explained. "My friends are willing to help, but I'm the one running it."

Through her one-woman show, Robyn has given away more than two hundred quilts and seventeen thousand books locally, nationally, and internationally. Not long ago, she capped off her eighteenth birthday by turning nonprofit. Project Books and Blankies is now an official 501(c)3 organization, with Robyn as president and CEO.

"Chapters are being set up all over California," said Robyn, who is working closely with schools, youth groups, and quilt guilds to mentor their efforts. To help those who want to start a similar project in other states, she's developed Literacy Starter Kits. And while she's at college, Robyn, a budding engineer, is not only expanding her program but also developing a new one called

Project Books, Blankies, and Beakers that will be focused on science literacy.

As for others searching for a volunteer niche, she advised, "Sit yourself down and make a plan of what you want to do. Who do you want to reach? Find something that's your passion, something that really means something to you—and go for it!"

Searchlight:

At least three times a year, do you step out of your comfort zone to show kindness to a total stranger?

Your Point of Light:

Do something that doesn't come naturally, such as volunteering at a homeless shelter, teaching in a prison, or visiting someone in a hospice. You may discover that the very thing you thought was most difficult becomes your entrée to an exciting adventure in giving.

He who forgives an offense seeks love. . . .

—PROVERBS 17:9 (REVISED STANDARD VERSION)

The Light of Forgiveness

If we want to live life passionately for others, we must first forgive. Forgiveness frees us from bonds of hatred, bitterness, and anger and turns our hearts, as the Proverbs tell us, toward love. Furthermore, when we truly forgive those who have wronged us, we tap into one of the greatest secrets to a successful life: the power of a positive spirit to marshal our energies toward life-giving enterprises.

Consider the experience of Winston Churchill, who was constantly under siege from the press, from political opponents, and even from friends and acquaintances. No matter how vicious the attack or egregious the betrayal, he seemed capable of forgiving instantly, putting the matter behind him and moving on.[3]

The result was a man who kept his focus sharp throughout the dark years before and during World War II, a single-mindedness that helped save England—and the world—from tyranny. We can only speculate on how different our lives might be if the British prime minister had failed to forgive his enemies and thus bound himself with petty concerns, rather than freeing himself to give wholeheartedly to the nation he loved.

MELANIE WASHINGTON

You may not be in a position to save the planet, but you can make a powerful difference in your particular niche, *if* you learn to forgive. That's what happened to Melanie Washington, a Los Angeles woman who learned a profound lesson about forgiveness that turned personal tragedy into triumph for herself and for the young man who had destroyed her dreams.

Love Your Enemies

I wanted to be angry. I wanted to be mad. I wanted my son's murderer to *pay*. Every instinct in me wanted death for the sixteen-year-old who had snuffed out the life of my son Dee.

Dee was my middle child, the heart of my heart. He was a brilliant young man who looked a lot like me.

"He's Melanie all over again," people told me.

Dee was smart, but he was rebellious. He dabbled in gangs, and although I wouldn't let him join one, he couldn't shake that gang mentality.

"I'm from Com-ton," he told new kids he met, pretending that he was from a part of LA known for its crime and gang warfare.

"You never lived in Compton!" I said accusingly. "You don't even know how to spell it!"

But something kept drawing him toward the gangs.

"Why don't you find out how to help these kids, rather than becoming one of them?" I kept telling him.

But he wouldn't listen. When he was nineteen, he moved out of the house with his two little children to live near the marine base where my oldest son was stationed. Before Dee moved, I checked out the area, and everyone I spoke to was reassuring: "It's a good neighborhood," people said.

What no one told me was that just a few blocks away, the Bloods had taken control. Even worse, one of the gang members was an acquaintance of Dee's from juvenile hall, where they had been incarcerated for ten days a few years earlier.

Once Dee moved into his new home, his friend became a constant companion. So did members of the Bloods and Crips. Dee had followed my advice and begun working with these kids to get them to call a truce and stop the fighting. Often, when I dropped by to see my grandchildren, I found gang members hanging out in Dee's living room.

"Boys, you've got to get your lives right with the Lord," I said bluntly. I tried to tell them about Jesus, about how he could turn their lives around as he had mine.

Although most of them listened politely and allowed me to pray with them, I could tell by the ambivalent looks in their eyes that they wanted to change but weren't yet ready.

But there was one sixteen-year-old boy whose eyes told a dif-

ferent story. I sensed a fierce anger burning inside him, and I could tell he had an agenda.

"That boy doesn't look right to me," I told Dee. "You'd better watch out—he has something going on with him."

"Why pick on him?" Dee retorted. "You love kids. Why go after him?"

We battled back and forth, but instead of heeding my warning, Dee took the boy into his house and treated him like a younger brother. Every time I showed up, the boy was there, glaring at me so intensely that I had to avert my eyes.

Something's not right with that boy, I thought.

✦ ✦ ✦

The sound of the telephone jarred me awake. I looked over at the clock and saw that it was just past midnight.

Why would anyone want to call me at this hour? I wondered as I rolled out of bed and picked up the phone.

"Mom," said the voice on the other end. It was Dee, and I could tell from the agitation in his voice that he was scared.

"I had a dream," he said. "I saw myself being shot twice in the face. Am I going to die?"

As the words tumbled out of his mouth, I could feel my heart racing. *This is crazy,* I thought. *Shot? Die?* I knew Dee was captivated by the whole gang scene, but he had never been part of it. There was no way the dream could be real.

"No, son," I said, trying to keep my voice calm. "I don't think so."

With that, Dee grew quiet and started reminiscing about his life. In a stream of consciousness, the words spilled out . . . his remorse over the mistakes he had made . . . the things he wanted to do . . . how much he loved his kids and wanted a better life for them.

As I listened to him speak, I sensed a new maturity in him, a self-awareness that seemed to come from someplace *outside* this combative middle child of mine.

This is a different Dee, I thought to myself. *This isn't a kid struggling with who he is. This is a man, who finally seems to understand himself and is at peace.*

"Mom," he added, "when I look at you, I see Jesus. I want to see him face-to-face."

I could feel my body grow tense, as the implications began to hit me.

"You're going to lose this son," I heard a voice telling me in my spirit.

No, God! I protested.

"You're going to lose him," the voice said again.

I can't lose him! I cried inside. *I can't!*

A week later, Dee was dead.

He had been out rapping late one night with three friends. Then one of them—the sixteen-year-old with the anger in his eyes, the very boy I had warned Dee against—lifted his gun. He shot my son four times. Twice in the back and, just as Dee's dream had predicted, twice in the face.

I was beyond anger, beyond tears. But somehow, I knew I had to forge ahead. That night I went to church and sang in the choir.

I'm not going to break, I told myself. *I'm singing because that's what Dee would have wanted me to do.*

Three days later, the police found the killer and the two boys who had been with him. Because they were underage, the three ended up in the prison system of the California Youth Authority, awaiting trial. Two of the teenagers were facing twenty-five-year sentences. The boy charged with Dee's murder was looking at life imprisonment or the death penalty. It came out later that the boy

shot Dee simply because he was jealous of Dee's easygoing personality and the loving family that surrounded him.

I want them all to pay, I said to myself.

✧　　✧　　✧

I had been weaned on blame. From the time I was a child, I had experienced so much pain and suffering in my life that the only thing I knew was to point the finger of accusation. But the person I blamed most was myself.

When I was ten years old, I had watched my stepfather pull out a gun in the kitchen and shoot and kill my mother. Two weeks earlier, I had confessed to my mother that he had raped my sister and molested me. After she had confronted him and kicked him out of the house, he had stormed back home in a rage and gone on a killing spree.

He tried to shoot me, too, but the gun didn't go off, and so I slipped away and went to my brother's room to wake him up and hide. My sister wasn't so lucky. When she ran into the living room to call the police, he came after her.

"No, Daddy, don't!" she screamed.

Those were the last words I heard her cry as the gun went off.

Things didn't get much better for me after that. For a while, I lived with my real father in a two-bedroom house with eight kids, and then I moved in with my grandmother, whose own life was like a soap opera.

By the time I reached high school, I couldn't concentrate. I had witnessed so many things I couldn't live with that schoolwork didn't mean much. I barely made it out of Dorsey High School in Los Angeles, and a few weeks after graduation I got married to a guy who turned out to be an abuser. He beat me every day. I took it because I thought I was being punished for snitching on my stepfather and causing my mother's death.

Two children came out of that marriage, and Dee was the second. After five years, though, I had had enough. When I was twenty-three, a friend of mine who was in real estate helped me and my kids escape from my husband and move into an abandoned house. My friend introduced me to a man named Dale, who turned out to be the best thing that happened to me and my children. With Dale, I knew I was safe from my husband. He wanted to marry me, but my husband said, "I'll never divorce her."

I had another child by Dale, and he gave us a good life, with a beautiful home, fast cars, and lots of love. Dale's kindness made me overlook the truth that I only discovered later: He was, as he liked to say, "a player." I had assumed he was a pimp, with a stable of girls working the streets. But apparently, he had been much, much more.

He was murdered three years after we first met.

"The black mafia," said the police. "A drug deal gone sour."

Dale's death left me on my own to support three little kids aged five, three, and fifteen months. For the first six months, I was so devastated I couldn't do a thing. I got rid of the Cadillacs to pay the bills, and when the money ran out, I went on the county welfare rolls to take care of my kids.

Then one day, I woke up and went back to my job at the liquor packaging company where I had worked before Dale died. Just before his death, I had gotten a raise and been promoted to machine operator, and fortunately, the company took me back.

For the next ten years, I worked hard to support my kids and keep myself afloat. But inside, I was drowning. I turned to drugs and alcohol as a way to cope with my own self-loathing. I had the alcohol to bring me down, and the cocaine to bring me up. I wanted to kill myself, but for some reason, I just didn't succeed.

For all those years, I was a functional alcoholic, drug addict— and mother. My kids never knew that I got high. Somehow, I

managed to shield them from it. We didn't live in fancy places, but they were always nice, clean houses, in low-income areas that I could afford. Sometimes I worked two jobs to keep everything going. One night when I was tending bar at my second job, a man from an aerospace company saw how hard I worked and hired me as a stock clerk. I kept alert and invented a little box that prevented microchips from bending during shipping, and my career took off.

But still, I was a mess inside: I continued to blame myself for all the things that had gone wrong in my life. In March 1990, I tried to kill myself with an overdose of drugs and alcohol. Wavering near death in a semiconscious state, I heard a voice calling out to me.

"Melanie!" the voice said.

I must be hallucinating, I thought.

"Who are you?" I asked.

"I am Jesus," the voice said. "If you follow me, I'll show you the way."

Who the heck is Jesus? I asked myself. I wasn't really into church. I was into drugs and alcohol and raising three kids. I did know a little about God, because out of desperation I had always prayed to God. But Jesus? I had never spoken to this guy Jesus. All I knew was that he died on a cross; that was about it.

He's dead, and I'm going to go with him, I thought to myself. *I've finally killed myself, and I'm outta here.*

But twenty-four hours later, I found myself still alive. I was sick and hurt, but I didn't die.

Over the next few weeks, I kept thinking about that voice I had heard in my stupor. It had been so kind, so gentle. Wondering what it all meant, I picked up the phone and called my sister.

"I think I have to go to church," I told her.

But something held me back. A few times in the past, I had gone to a large church in Los Angeles with my sister, but all the people struck me as being very uptight and prissy. They weren't at all friendly, in contrast with the warm voice I had heard when I was so near death.

My sister took me to another big church in LA. I felt a little uncomfortable until the middle of the service, when the pastor announced, "Everybody hug somebody."

One by one, people I didn't know came up to me and gave me a hug. They had huge smiles on their faces and bear hugs so big that I felt small as a child. Little by little, I could feel myself letting down my guard, and by the time I sat down my body felt warm all over. I felt wanted . . . loved. No matter what I had done or how much I might have hated myself, somebody loved me.

I ended up going to that church every week for a year. Every Sunday, I felt the love pouring out of that place. Men stood up to volunteer to help single mothers with their sons. Women raised their hands to offer food to shut-ins or to visit the sick in hospitals. These were people who *cared,* and they showed it in the way they lived.

A year after I first walked in the door, I felt something urging me to become a member. From that day on, I helped out at the church as much as I could. I joined a support group for people addicted to drugs and alcohol. For the first time, I heard terms like *co-dependency* and *addictive personality,* and instantly I recognized those tendencies in myself. I had never felt appreciated, never felt like I was worth anything. I could see that I had become addicted to the point of hurting myself.

But still, I couldn't let go of my habits. There was so much pain and hurting inside that nothing could stop me, until finally I sat down one night and prayed: "Dear God, show me the way."

The very next day, I tried to light my pipe to get a hit of dope, and it wouldn't light. Just like that, I couldn't hit it. I threw away the pipe and never picked up another one again. I've never had a craving for it since.

The next thing to go was the liquor. Wine . . . champagne . . . gin and tonic—I loved them all. I could drink a 1.75-liter jug of gin in one weekend. Gradually, I weaned myself off the gin and gave up drinking completely.

The whole time, God was working through me. He became my liquor, my drug, my boyfriend, my husband, my friend.

Soon I found myself getting involved in the Sunday school, starting with a sixth-grade class of two kids. Three months later, the class had mushroomed to twenty-six.

"You should hear this lady talk," the kids would tell their friends. "She knows about stuff you won't believe."

But as I was teaching the children in Sunday school, God was teaching me, too. In the stories of the healing of the lepers, or the woman at the well, I learned about his love, his goodness, and his kindness. The better acquainted I got with God, the more I shared with the students in my Sunday school classes. After a while, I had graduated from teaching sixth grade, to seventh grade, to eighth, until finally I became superintendent of the Sunday school.

But there was one student I couldn't quite reach, at least not in the way I wanted: my son Dee. He lived on the edge, seeking fulfillment in all the wrong places. It wasn't until that fateful phone call the week before his death in December 1995 that I sensed he was in a new place.

"Heaven is beautiful, Mom," he had told me that night, as we read Revelation together on the phone. "It's just like you," he'd said. "I look at you, and I see Jesus."

Weeping inside, I sensed that there was nothing more I could do for Dee, nothing but pray.

❖ ❖ ❖

After Dee's death, my first instinct was to lash out. All the Sunday school lessons in the world couldn't keep me from wanting revenge on the boys who had robbed me of my son.

But there was another part of me that was confused.

Why have all these things happened to me? I wondered. *My mother and sister, murdered . . . rape . . . molestation . . . Dee shot dead. There has to be something in this, something I don't understand.*

For six months, I went into retreat. At night, I lived on the streets like a homeless person. By day, I continued to work at my job at an aerospace company to keep my mind occupied.

Alone each night, I questioned God. "Why did you allow my son to be killed? Why *him*?"

Like Jacob wrestling with the angel, I kept after God, until late one night I got an answer: "Your son is with me," I heard a voice say in my spirit. "But because of him, you will be the mother of many. He was a sacrifice, just as mine was. I, too, gave up my Son, and I know how you feel."

I thought about Jesus . . . what he went through on the cross . . . what God must have gone through as he watched him suffer . . . all for me.

"Forgive me," I cried, falling to the floor. "Please forgive me."

When I came up off that floor, I was a new person. I was filled with a sense of purpose, a determination to get to the root of the problems that had led to Dee's death.

A few weeks later, I found myself at a mayor's conference on gang violence. A single question consumed me: *Why are we losing our young men?* Some, like Dee, were dying, while others, such as the

gang members involved in the killing, were facing long jail terms or life imprisonment. Something wasn't working for these boys, and I wanted answers.

"You say you have all these resources to help," I said angrily, "but where? Where's the help for the mothers whose sons are in gangs? How do they get help for their children?

"My son was killed six months ago," I blurted out. "What are you doing to prevent this from happening again?"

The help came from an unexpected source: a man from the California Youth Authority, who offered to put me in touch with two of the teenagers who were present at Dee's murder. Charged as accomplices, they were in prison awaiting sentencing.

Perhaps these boys hold the answers I'm looking for, I thought to myself.

A week later, I found myself at the prison, face-to-face with two of the young men involved in Dee's murder. As they walked slowly into the room with their heads down and their eyes staring at the floor, they had shame written all over them.

But I also saw in them something more: a potential that had been snuffed out by their own poor choices and lack of direction.

These are just kids, I thought as I looked first at one, then the other. *They could have done so much with their lives, if only . . .*

. . . If only someone had shown them the way. I could feel something stirring inside, something pushing me to say what needed to be said:

"I forgive you," I told them. "From the bottom of my heart, I forgive you."

Then I gave it to them straight: "You boys need to get your education and get it together. You need to do better. When you come back on these streets, do something good for your neighborhood."

With eyes wide in amazement, they nodded: "Yes, ma'am."

Dee's killer was harder to forgive.

As long as I could, I tried to run from making my peace with him. But the longer I delayed, the louder the voice cried inside me: "You *have* to forgive him! You *have* to love him!"

Finally, I realized I had no choice. There was something in my life that was greater than my anger and greater than my pain: God's mercy. I myself should have been dead a couple of times, but I was still alive. God had been in my life when I didn't even know him, and now, more than anything, I wanted to keep walking in his mercy every single day.

And so, when it came time for the young man's sentencing, I knew how I would respond.

"Does the victim's mother want death or life in prison?" the judge asked.

"I can't see killing this boy for killing my son," I said. "We may have a chance to save him."

The boy was sentenced to life plus fifteen years. I started writing to him in prison a year after Dee's death. With my very first letter, I sent him a book about Jesus and told him, "I want you to read this book and know that I forgive you."

He didn't answer. I cried alone, sometimes, realizing how much he must be hurting. But I kept writing, and before long he started writing back.

"So, why are you bothering me?" he wrote in his first letter.

"I can't hate you," I told him. "Dee loved you, and so I must love you, too."

Gradually, he started writing more, I guess to see if I was for real. His letters moved from questioning, to acceptance, and finally to repentance.

"I'm sorry," he said. "I'm so sorry."

Today he calls me Mom and writes to me often. As for the two boys who were with him the night of the murder, they finished

☆ ☆ ☆ ☆ ☆ ☆ ☆ ☆

Poetic Justice

From the moment I met Giang,* he was angry. Barely fifteen years old, the Vietnamese boy was serving time in prison for attempted murder and robbery. It was clear that he didn't think much of the Bible study I was leading in the prison library one Saturday afternoon in 1999.

"Who do you think you are?" he snarled. "God?"

Actually, he said some things that were a lot worse, but I didn't pay much attention. I had seen plenty of young men like Giang, and I was determined to show them a better way to live.

The group that day was small, about three teenagers, and as I told them my story, a story of murder, betrayal, and abuse that went back to my childhood, everyone listened wide-eyed—everyone, that is, except Giang. It wasn't until I talked about my son Dee and his murder the previous year that Giang started listening up. When I explained how I had forgiven Dee's killer, Giang started squirming.

I've touched a chord, I thought to myself. *Something's gotten to him.*

The next time I showed up at the prison, Giang handed me a poem he had written about Dee. Every line brought up emotions that I had tried to keep buried: guilt, grief, blame, love, anger, anguish. Giang had captured them all, baring his soul—and mine.

For the next couple of years, Giang continued coming to my twice-a-week mentoring program, learning practical skills such as interviewing for jobs or applying to school that could help him

* The individual's name has been changed to protect his privacy.

once he got released. He was a star pupil, and I was sure he was ready for the world "outside."

But two days after his release from prison, he called in a panic. "I'm in a halfway house with a black eye," he said. "Two guys beat me up because I wouldn't deal drugs."

Immediately, I found him a job with a company I knew in San Diego. With the money he earned, Giang supported his parents and three younger sisters. His work ethic impressed his boss so much that the boss started grooming him for bigger things.

Today Giang is still on the job, married, and continuing to support his parents. With a newly minted high school diploma, he now has his sights set on college.

—Melanie Washington

school in prison with 4.0 averages. They said their lives turned around the day I forgave them.

Forgiving those young men has turned my life around, too. During my visits to the prison, I started talking to other inmates. Before long, I found myself going regularly to give Bible studies and teach life skills such as public speaking or interviewing techniques to anyone who would listen. When one of my young men was about to leave prison, I'd buy him clothes and shoes and a church outfit so that he could make it in the real world. I'd help him get into college or a high school GED program, and I'd help his parents prepare for his new life at home. Once he was released, I'd take him to places he had never been, such as Disneyland, or Hollywood, just to expose him to the possibilities in front of him.

Most of the money came out of my own pocket. I was deter-

mined to keep as many kids as I could from slipping back into the gang mentality, to break the cycle of violence that had killed my own son.

Working out of my garage, I expanded the program with the help of a $5,000 grant from the Boeing Corporation, where I work full time as a senior materials analyst. Thanks to Steve Chesser, a manager at Boeing, I turned my program into a full-fledged nonprofit organization called Mentoring—A Touch From Above. Today we have eight volunteers mentoring in the prisons after work or on Saturday, and five helping in the office.

In more than six years, nearly 900 young men have come through our program, including 580 who are still in prison and 300 who have been released. Of those, a majority are working or in school, including seven in college. I've lost five young men to murder, and about twenty have ended up back in prison, giving us a recidivism rate of only 8 percent—dramatically lower than the 55 percent average in the state of California.

When I think of all these young men I've met and mentored over the years and reflect on the way my life has unfolded, I can't help but see the hand of God. Today I am, indeed, the "mother of many," and I see now that God was preparing me for this work from birth.

As for my son Dee, I know that he is smiling every day. "That's my mom," he's saying. "She's getting out and making something happen. She's making sure I didn't die for nothing."

Searchlight:

Is there someone you need to forgive today?

Your Point of Light:

Pick up the phone and make a call or, better yet, go visit the person who has wronged you. Say the words out loud: "I forgive you." Then make a promise to yourself that you will never revisit the offense again—ever.

A cheerful heart is a good medicine,
but a downcast spirit dries up the bones.

—PROVERBS 17:22 (REVISED STANDARD VERSION)

The Light of Encouragement

Encouragement expands our options. It's an elixir that keeps us moving forward, a tonic that picks us up and infuses us with a sense of life's possibilities.

Without encouragement, we can dry up, close down, and shrink into despair, resigning ourselves to a dim fate and limiting our own potential. But when someone or something sparks our imagination, we begin to grab hold of a positive vision that can cheer our hearts. An upbeat word, a person we can emulate, or even an article in a newspaper can set our lives on an upward trajectory.

Consider one African cabdriver in Washington, DC, who was brimming with enthusiasm for his new life in America.

"Back home in Mozambique, most people have given up on the thought of a better life," he said. "They have resigned themselves to poverty. But not me!"

The cabbie explained that he got the courage to break free of a negative mind-set and immigrate to America after reading a magazine article about an impecunious young man from Maputo who had gone to the United States, studied hard, and become a doctor.

"I believe you can create a better world for yourself," he said.

That's a lot like the attitude that two wounded Vietnam veterans—Fred Downs and Jim Mayer—bring to the bedside of amputees at Walter Reed Hospital during regular visits to Ward 57, the rehab wing for soldiers maimed in Iraq and Afghanistan. Downs—a former army infantry lieutenant who lost an arm during a land mine explosion in Tam Ky, Vietnam, nearly four decades ago—knows exactly what he's talking about when he gestures with his prosthetic arm to encourage today's heroes.

Look for the Silver Lining

There were no silver linings in the clouds the morning of January 11, 1968, when Lieutenant Fred Downs stepped on a "bouncing betty." In an instant, he felt himself being hurled through the air like a human cannonball.

Careening toward the ground, Fred instinctively threw out his arms and was horrified by what he saw: A jagged white bone jutted out from his left shoulder. Below the spot where his elbow should have been was nothing—nothing at all. From what he could tell, his right arm seemed intact, though from the elbow all the way to the wrist, he could see clear down to the bone.

There was no time to consider the implications. Seconds later, twenty-five feet from the site of the explosion, Fred landed on his feet with a thud. Then his knees gave out and he fell to the ground in a heap.

My men, he thought. *How about my men?* He knew that the land mine had been designed to explode waist-high, to kill as many people as possible on impact, and he feared the worst for the soldiers in his platoon. Straining to look around, he saw bodies strewn beside him.

FRED DOWNS

"Six of us were wounded when I stepped on that thing," he said, "but I was the worst."

The blast had damaged not only his arms but also his legs, which had been shredded by shrapnel from the small of his back down to his feet. Lying in pain on the jungle floor, he just barely stayed conscious, waiting for his rescuers.

Finally, he heard the *chop-chop* of the helicopter blades whirring overhead. Fred relaxed a little, grateful to be safe for the moment. Medics hustled him and his wounded men onto the chopper and evacuated them to a field hospital in Chu Lai, where doctors from the Second Surgical Unit were standing by.

"The last I remember, I was on the operating table giving my name, rank, and serial number," said Fred. "Then I blacked out."

✧ ✧ ✧

Fred's heart had stopped—cold.

"We've lost him!" someone screamed.

Even though the field hospital had only the basics, the one un-derstaffed surgeon wouldn't give up on the wreck of a man stretched out before him. His job was to keep him alive.

Pounding on his heart, the surgeon pulled Fred Downs back from the dead. For the next few hours, the doctor worked fever-ishly to stanch the massive hemorrhaging and salvage as much as he could of the lieutenant's shrapnel-studded body. He needed to get Fred stabilized long enough to be evacuated out of Chu Lai to a hospital at the Eighty-fifth Evacuation Unit in Qui Nhon, where another round of surgeries awaited him.

After a few days in Qui Nhon, Fred's life was still hanging by a thread. "I had lost so much blood and had such massive wounds that my body wasn't recovering quickly," he said. "But the Tet Of-fensive was getting cranked up, and they were trying to rush me back to the States as soon as possible."

Lying in bed in Qui Nhon, he felt helpless, unable to do any-thing for himself. His left arm was nothing but a stump. His right arm and hand were so useless that he was in danger of having them amputated. And as infections ravaged his legs, there was a chance he might lose them, too.

It's the end of my life, he thought.

Some days, he wallowed in depression, thinking of all the peo-ple he wanted to thank, all of the loved ones he wanted to see one more time: his mom, brothers, and sister in Terre Haute, Indi-ana . . . his wife, daughter, and stepdaughter in Illinois.

"You think about your home and your family a lot," said Fred. "You have no idea what the future will be, and so you're up and down, trying to get your thoughts in order."

Even worse than the fear of death, the specter of living with only part of a body haunted Fred. He had been an athlete in high school, running track and playing on the football team. Now that life was a distant memory.

What if I have no legs? he thought. *How can I function without an arm, or maybe with no arms at all? How can I possibly live with a hook?*

Lurking deep within him were the biggest questions of all: *What will become of me? Will I be a sorry individual out on the street selling pencils? Will I be a failure?*

✧ ✧ ✧

One day, a nurse slipped in quietly beside his hospital bed at the Eighty-fifth Evacuation Unit in Qui Nhon. Clutched in her hand was a stack of photos.

"I thought you might like to see these," she said simply. "They might give you some encouragement."

Photos? Fred thought. *I'm stuck here in this dismal hospital with one arm blasted away, and she thinks a bunch of pictures will make a difference.*

Sensing his discomfort, the nurse hesitated a moment, and then gently she pushed ahead. "Here, look at this," she said, holding up a photo in front of his face.

Reluctantly, Fred looked at the photo. It was the picture of an older man, pushing a lawn mower.

Nothing special, really, he thought. Then he looked closer. The man didn't have any hands. He was pushing the mower with two hooks!

"He lost both arms in World War II," the nurse explained, holding up one photo after another.

Fred watched, amazed, as the pictures passed in front of his face: one of the same man cooking dinner, another of him riding a bike, and yet another of him picking up his granddaughter—all using his hooks.

If this guy can do it, I can do things with a hook, too, Fred thought.

From that moment on, he was determined to make it. "I realized then that my life wasn't over. Those pictures gave me my first glimmer of encouragement."

Over the next month, he bounced from hospital to hospital, going from the Philippines . . . to Japan . . . and finally, to Fitzsimmons Army Hospital in Aurora, Colorado, where he arrived exactly a month to the day since he had been wounded. He stayed at the hospital for a year, first as an inpatient for six months, and then as an outpatient. All told, he battled through more than fifty-six operations, surviving with as many lives as a cat.

"I nearly died more than once," he said.

Drawing on his childhood on an Indiana farm, where he learned always to make do with what he had, Fred tried to focus on keeping positive. But it wasn't easy. Battling through months of torturous physical therapy, painful skin grafts, and even a divorce that took place during his hospitalization, he persevered. "I had to teach myself to overcome adversity, to not feel sorry for myself."

Always in the back of his mind, keeping him focused, was the image of the World War II veteran in those photos, a picture of a man vibrant, full of life, and still going strong years after his injuries.

Spurred by the memory, Fred pushed himself to be self-sufficient. As he lay there in his hospital bed, he tried to figure out how to eat without assistance from an aide, and how to go to the bathroom by himself—anything to be independent.

"These are little things in life, but they are big things when you can't do them," he said.

Itching to be free of the hospital, Fred's fighting spirit took over, and little by little he improved. "I was tired of lying around, tired of being tortured by the physical therapists, tired of being hooked on drugs, and tired of being miserable."

Finally, a year after he entered the hospital, Fred had his body and his life back in order. Doctors had managed to salvage his legs and his right arm and hand. Sporting a new prosthetic left arm

☆ ☆ ☆ ☆ ☆ ☆ ☆ ☆

Jim Mayer: Alive Day

Alive Day was April 25, 1969, the day I got blown up in Vietnam.

A twenty-three-year-old PFC infantryman with the Twenty-fifth Division of the U.S. Army, I was just returning to our fire support base after breaking up an ambush when I stepped on a mine in a rice paddy. I heard a *click* and then a *boom* blew me straight up in the air. I did a somersault, landed on the ground, and took one look at my legs.

My left leg was gone below the knee, and the right one, though still attached below the knee, was bent to form an L-shape.

I heard someone shout, "Medic!" and I remember the tourniquets, morphine, and chopper ride back to the hospital at the Twelfth Evac Unit in Chu Chi, a short plane hop from Saigon.

I had seen others lose legs, and I had told myself, *If that ever happens to me, I'm going to take my rifle and shoot myself.* But now that it had happened to me, I found I wanted to live, not die.

The surgeons took off my remaining leg below the knee, and two days later as I regained consciousness, I got some good news. A chaplain leaned down and whispered, "James, I talked to the surgeons, and they say the shrapnel stopped low enough so that you'll be able to raise a family."

"Thanks, Father," I said. "Do you have anybody in mind?"

He jerked his head toward the beautiful nurse who was tending to me and said to her, "This soldier's going to be fine."

A little later, while I was still under the influence of the morphine, that same nurse asked, "What are you going to do when you go home?"

"If I'm still alive," I said offhandedly, "I'm going to have a

party every year on the day I was blown up. Would you like to come to the party?"

Funny, but I never forgot my reply to her, even through the brutal surgeries, traction, and other rehab procedures. Finally, the very first year after I returned home—when I was well on my way to recovery—I threw my first Alive Day party in my hometown, and the tradition has continued ever since.

Many years later when the Gulf War started, I got involved volunteering with the amputees at Walter Reed Hospital, where I became known as the Milk Shake Man because I supplied the guys with milk shakes. Also, I decided I should host my special Alive Day party at a local steak house, where I handle the transportation for the amputees once a week. About a hundred people attended my latest party, including eighteen amputees from Walter Reed. The party raised more than $6,500 to help send disabled vets to the National Disabled Winter Sports Clinic in Colorado.

Volunteering feeds on itself, and so I know I'll continue volunteering as long as they'll let me. I've logged in 360 visits to Walter Reed since April 2003, and I've been to Bethesda Naval Hospital 48 times. And I don't see any end to it.

When I went into the army, all I wanted when I got out was to be a traveling salesman who made a good living. But now I've gone the other way. I work on what I care about, and that's led me into volunteering with veterans' groups, moving to DC, and working for the VA. Money isn't the real deal with me. If I hadn't been so severely injured, I don't think I would ever have figured out what makes me tick.

—Jim Mayer

JIM MAYER

with a hook for a hand, he went back to college with VA support, earned an MBA, got remarried, and started working in private industry.

But by the time he hit thirty, he began to feel restless. Something was pulling him back to the Veterans Administration and to the fellow amputees he had met during his months of hospitalization.

"I felt like serving," he said simply. "I liked my mission. I liked the army. I liked leading men. The VA was an opportunity to work with soldiers and veterans again."

Today, after thirty-one years with the VA, he is national director of prosthetics and sensory aids service, or "arms and legs" as he likes to call it. He sets the policy, formulates the budget, and administers a nationwide program for veterans who need prosthetic devices. He's been an adviser to the Department of Defense on

developing procedures for handling casualties in the Iraq war, and he also serves as a troubleshooter on prosthetic devices for the State Department for countries in civil strife, such as Cambodia or Sri Lanka.

But Fred also does something more. From the time he got his prosthetic hook, he has spent his spare time showing others how to live creatively with a disability, whether it's schoolkids at show-and-tell, doctors and nurses, or fellow amputees. Since the Gulf War, he's been serving as a volunteer amputee peer adviser at Walter Reed Army Hospital and the National Naval Medical Hospital in Bethesda, Maryland.

"Whenever there's a war going on, if there are amputees there, I'll be there," said Fred.

At least once a week, you can find him on Walter Reed's Ward 57, where he visits one-on-one with young men and women whose wounds are still fresh from the battlefields in Iraq or Afghanistan.

"Sometimes they're in depression. Sometimes they're quiet." But all of them, Fred said, have the same unspoken questions: *What will people think of me? What kind of person am I going to be? Will I ever be the same?*

Fred hits the questions head-on, as he did recently for one young veteran of the Iraq war who, like Fred, had lost an arm above the elbow. From the pained look in the young man's eyes, Fred could tell he was having trouble adjusting to the idea of life with a prosthetic arm. So Fred launched into his litany.

"If you're comfortable with yourself, people will be comfortable with you," he told the young man. "You're the same person you were the week before you were injured. Were you a hard worker? Optimistic? Did you make friends easily? That's what you'll be after you get out of the hospital. If you were negative or cynical, you'll be the same way—only now you'll have an excuse!

"Your life took a fork in the trail, that's all," he added, making eye contact with the soldier. "It will be just as rich and full as it would have been if you had headed in the other direction."

But as encouraging as Fred's words may be, it isn't so much what he says that makes an impact on the young amputees. It's what he does. Using a bag of tricks that includes such gadgets as a buttonhook and a rocker knife, Fred demonstrates how easily he can unbutton his shirt or cut meat.

"I try to be an example," he said. "I've had so many parents tell me that their son or daughter turned around after seeing me wearing the hook or demonstrating how to get dressed."

Four decades ago, Fred found his encouragement in those photographs in Qui Nhon, Vietnam. Today's soldiers may find theirs in an amputee named Fred Downs, who boldly brandishes his hook and boasts: "I run marathons. I go skiing. I ride a bike. I have a pilot's license. I was out working with a chain saw the other day. I held the saw with my hook and the trigger with my right hand. I do everything.

"Look for that silver lining," Fred said. "It's always there."

Searchlight:

Have you been a source of encouragement to at least one person today?

Your Point of Light:

Give a boost to someone who needs to know that there is a silver lining ahead: a sick neighbor, a friend who has lost a job, a student who has failed an exam. Your encouragement will be good medicine not only for them, but also for yourself.

Words are easy, like the wind;
Faithful friends are hard to find.

—RICHARD BARNFIELD

The Light of Faithfulness

Faithfulness may be the ultimate act of giving. To keep forging ahead when the way seems tough or even impossible requires an open-ended commitment, a willingness to stick with a person or a project under any and all circumstances. In short, faithfulness demands that we never give up.

Many of us may think of ourselves as faithful, and we may be, up to a point. We may be faithful to our families, to our jobs, and to our friends. But when it comes to strangers, well, that's another story. When obstacles loom or the prospects for success seem dim, many of us may find ourselves pulling back. With our resolve weakened, we run away from the challenge and turn instead to someone or something that offers a more immediate payback.

But there are some people who never give up once they commit themselves to others. For them, success lies not merely in the goal, but also in the act of giving itself. One of those people is Phil Stevens, a Californian whose work with American Indians for nearly four decades earned him the nation's two top awards for volunteering. In 1996, he received the President's Service Award, the highest volunteer award given by a US president. And in 2004, he received the Lenore and George W. Romney Citizen

PHIL STEVENS

Volunteer Award, presented to one person annually by the Points of Light Foundation. Phil's personal saga, a parable of perseverance, shows why faithfulness may be the most powerful component of effective giving.

Thirty-six Years—and Still Giving

"You're going to feel a lot of pain, Phil," my dad warned the day I told him I wanted to help our people, the Lakota Sioux.

It was 1969, and I watched mesmerized as activists Russell Means and Dennis Banks invaded Alcatraz to call attention to the plight of American Indians. As I saw their raised fists and hard, determined faces plastered all over the news, I found myself stirred into action.

But I was no rabble-rouser, at least not back then. I was an

entrepreneur, with a degree in engineering and a start-up business working with the aerospace and automotive safety industries. All I knew is that for the first time in my life, I wanted to help.

"But *legally*," I assured my dad.

"You're an outsider," Dad reminded me. "They don't want outsiders on the reservation. People have exploited them, mistreated them, and misled them so many times. It will take years for you to gain their trust."

I looked at Dad and smiled. *That won't happen to me*, I thought. *I can make a difference. I know I can.*

Dad was right that I was an outsider. Other than the stories he had told me when I was a kid about watching his grandfather make arrows and arrowheads, the Sioux had never been much a part of my life. I had never even met any other American Indians until high school, when I played against a kid from another tribe in basketball.

Dad, on the other hand, was one tough warrior, a boilermaker and welder from East Los Angeles. He was a grandson of Standing Bear, a full-blooded Sioux warrior who had fought at the Little Big Horn. His granddad had married a French Indian, and so Dad's roots ran deep. He really understood the culture.

Nevertheless, I was too sure of myself to take his warning seriously.

After all, I was a guy who could get things done. Growing up poor in East LA, with pieces of cardboard to cover the holes in my shoes, I got a ticket out of the slums through a basketball scholarship to the University of Redlands. After that, I earned a master's in engineering from UCLA and landed in the missile business, where I rapidly moved into the management ranks. I ended up as technical director of the US Air Force's Minuteman III Intercontinental Ballistic Missile Program.

Compared with that, helping people on the reservation should be easy. Or so I thought.

At first, it *was* easy. I joined a group that enabled me to serve as an adviser to American Indian businessmen who were getting started as entrepreneurs. For the next seventeen years, as I was building my fledgling engineering business, I was also building relationships with tribes large and small on the West Coast.

As my name started getting around, I began to get calls from local tribes asking for help with land disputes or with contractual problems with major companies that wanted use of reservation land. In one case, I helped California's Chemehuevi tribe get back twenty-one miles of shoreline along the Colorado River that was rightfully theirs. In another, I was asked by the White House to help negotiate a mining contract between the Crow and the president of a coal company.

"Don't ask me to help if the tribe doesn't want me," I said—in terms that reflected my standard operating procedure.

The tribe was willing, and I walked into the coal negotiations with a team of two lawyers and a set of tough demands that resulted in a strong financial deal for the Crow.

Along with the deal making, I helped as much as I could with humanitarian aid for the needy or educational support for talented young teens. But none of these successes prepared me for the challenges I faced in the land of my forefathers, the Lakota Sioux. Nearly two decades after I began my outreach efforts with the American Indians, I received a call from a group of Sioux elders in Pine Ridge, South Dakota.

"We've heard about your work in California," they said. "Please come and see what you can do for us."

❖ ❖ ❖

The minute I set foot on the Pine Ridge Reservation in South Dakota, I experienced culture shock. Back home in California, I lived in a lovely home near the ocean, with nearly every amenity.

Here, people lived in such squalor that even the tiny house in East Los Angeles where I grew up seemed like a palace.

To my right, a 240-square-foot log hut with no indoor plumbing housed nine members of the Little Boy family. A woodstove was all they had for heating and cooking.

Off to my left, a tar-paper-covered shack no bigger than a closet was home to two little girls, aged seven and eleven.

Down the road, a cave house barely two feet high sheltered a middle-aged man from the subzero temperatures and sixty-mile-an-hour winds that blew across the plains.

Across the way, a family stored its meager food supply outside the house in a hole covered by a piece of yellow foam rubber.

Each house I visited held similar stories: five kids sleeping on a mattress with rain coming down through the ceiling; a mother going hungry so her kids could eat; kids without coats in the dead of winter.

I had lived the American dream, but it was clear these kids didn't have a ghost of a chance at it because of their dire poverty. They needed a decent break in life, but they weren't going to get it unless something changed.

Up against these overwhelming needs, I was stymied: How could one man even hope to make an impact?

I decided to start small. Whenever I could, I visited a reservation and walked from house to house, getting to know the people—*my* people. Typically, I'd come into a house and sit down for a while to hear about their families, their daily lives, and their individual and family histories.

I never arrived empty-handed. Sometimes my wife and I would bring a truckload of coats we had collected. At other times, we'd bring food, school supplies, blankets, or medical supplies—anything to show we cared.

For several years, I walked the Sioux reservations in North

Dakota, South Dakota, and Montana: Pine Ridge . . . Rose-
bud . . . Standing Rock . . . Cheyenne River . . . Crow Creek . . .
Lower Brule . . . Fort Peck. I walked every inch of them, until I
got to know the families and the leaders.

Gradually over the years, the people on the reservation got to
know me, too. They knew that I didn't want a thing from them,
not a penny. I wanted only one thing: to help.

What tugged at me most were the children. When I looked into
their sweet eyes, I saw nothing but hurt, and I could hear the voice
of my dad echoing in my heart: *You're going to feel a lot of pain, Phil.*

By 1986, I had become so committed to my work with the
American Indians that I started a nonprofit organization to en-
courage others to get involved. The impetus was a request by
seven priests at the Red Cloud Indian School, a Jesuit facility in
Pine Ridge, South Dakota, to raise money for new computers.

There was no way I could refuse seven men of God, and before
long I found myself holding a major fund-raiser in LA for the
school. Fifty of the best tribal dancers in the country, all of them
young people, showed up to perform, and afterward we took them
to Disneyland and put them up at the Hilton. None of them had
ever been off the reservation, and we couldn't get them out of the
pool! For years afterward, kids would come up to me to say thanks.

Another year, after I saw a ten-year-old boy coming off the
school bus in subzero weather wearing nothing but a T-shirt, we
held a coat drive for the Red Cloud Indian School. The boy's
name was Johnny, and when the coats came in, I found a yellow
parka that I thought would fit him perfectly.

"Give this to Johnny," I told one of the priests as I sent off the
coats. That parka changed Johnny's life.

"He got off the bus every day wearing the parka and a big
smile," said the priest. "Before that, he never smiled—ever."

As excited as I was by stories like this, I still wasn't satisfied. As a businessman, I was always looking for ways to leverage my investments, and my volunteer work was no different. I knew there had to be a way to go beyond fund-raisers and coat drives to do something more, something that could help not only Johnny—but also hundreds, and perhaps thousands like him.

Whatever it was, I didn't yet know. But I was willing to wait—and soon my answer came.

On a sweltering July day in 1987, I found myself standing in a field at the Pine Ridge Indian Reservation amid one thousand American Indians who had shown up for a naming ceremony in my honor.

With my heart pounding, I watched as Chief Royal Bull Bear, the leader of the Great Eagle Society, cleared a large circle in the middle of the crowd and invited me into the center. I walked slowly into the middle of the circle and faced him.

"We present you with this battle shield as a symbol of protection," he said, handing me a large leather shield. "But we give you your name, Watta Canka Uha Mani, Walking Shield, because your body is the shield of the Sioux people. You are a 'walking shield' that will protect the Sioux people. We stand behind you and support you and we seek your support and protection."

Watta Canka Uha Mani. Walking Shield. As I said the words over and over to myself, I realized that this name wasn't just some colorful tribal nickname meant to make me feel good for the work I had done in the past. It was a name that carried weight, responsibility, and deep portent for the future—not only for them, but for me as well.

The minute I walked out of the circle, every cell of my body came alive. I felt like a new man, a living shield, ready to defend the Sioux from encroachments on their rights and protect them

from the evils of poverty, poor health care, squalid housing, and limited educational opportunities that were destroying them.

The Sioux must have sensed the depth of my commitment, because seven months later, leaders of the Sioux Nation announced that they wanted to appoint me as an Itancankel, a special chief of the Sioux Nation—a position unprecedented in Sioux history. But I told them that I couldn't accept such a great honor until I'd had a chance to reflect on the implications. I explained that I was running a $155-million-a-year company with twelve hundred employees—a position that required me to work, on average, twelve hours a day.

But on the flight home, I made my decision. After gathering my family around me, I informed them that I wanted to sell my engineering company and devote myself full time to helping the Sioux, provided that was all right with them—and it was.

So on a cold day in March 1988, I found myself on the Rosebud Sioux Indian Reservation in South Dakota, standing before Sioux chiefs and leaders from all over the Sioux Nation. As news crews from the United States, Great Britain, Germany, and Italy covered the event, the honoring ceremony culminated with Chief Oliver Red Cloud, chief of the Oglala Sioux tribe, placing the traditional Sioux warbonnet on my head. He then presented me as Chief Phil Walking Shield Stevens, Special Chief of the Great Sioux Nation.

With the blessings of my wife and children, I sold my company and turned my attention full time to my mission. At the top of my agenda, I wanted desperately to help the Sioux get back more than 7.3 million acres of land in the Black Hills that had been confiscated by the US government more than a century earlier. The US Supreme Court had called this takeover the "most ripe and rank case of dishonorable dealing in the history of the US."

✩ ✩ ✩ ✩ ✩ ✩ ✩ ✩ ✩

The night Sarah Swift Hawk froze to death, my passion for the cause deepened even farther.

"The temperature dropped to forty-five below," Chief Homer Whirlwind Soldier told me on the phone the day after Sarah died. Sarah, a grandmother, had lived with her daughter, son-in-law, and three grandchildren in a house with no heat—and only two blankets to keep all six of them warm.

According to the report, after Sarah fell asleep, her daughter covered her with one of the blankets. She tossed the second blanket over her three children, who were huddled together on the floor. Then she and her husband slipped under the blanket and covered the children with their bodies, hoping that their body heat would provide an extra measure of warmth to survive the night.

The next morning when the daughter awoke, she immediately checked on her mother. She found Sarah dead, frozen like a brick.

This should not be happening in this country, I thought—and I vowed to do something about it.

—Phil Stevens

For the next few years, I pushed and fought and lobbied in Washington to help the Sioux regain their rightful property. We even got a bill introduced in Congress that would have given the Sioux Nation 1.3 million acres of unoccupied federal land, along with monetary compensation for the damages inflicted by the US government. But sadly, the project became mired in politics and bureaucracy, leaving me—and the Sioux—empty-handed.

Sarah Swift Hawk's death prompted me to write to the White House and organize seven Sioux tribes to declare a "State of Emergency" to bring national attention to the abominable condi-

tions of housing on the reservations. The problems were monumental:

✧ 59 percent of Native Americans lived in substandard housing.
✧ 85 percent living on reservations were unemployed.
✧ 29 percent were homeless.

When it came to health care, the picture was even grimmer. The life expectancy of American Indians was eleven years shorter than that of other Americans.

The more I analyzed the problems, the more I realized that housing and health care were interrelated. In a house with no heat or running water, people like Sarah Swift Hawk died, kids got sick, and disease rates soared.

It's all about housing, I thought. *That's the issue.*

But it wasn't until a Christmas party for three hundred kids in the gym of the Pine Ridge Indian Reservation in December 1994 that I stopped *talking* about the issue of housing and started to think creatively about what I could *do* about it personally.

As I stood outside in the snow just moments before the party, I watched the kids streaming out of their houses and heading for the gym. From the looks of it, each house was worse than the last, with broken windows, leaky roofs, outhouses, and tarps instead of doors.

I knew that for these poor kids to hope to function in the twenty-first century, they would need an education. But how could they get any education at all without a good night's sleep? If they were sleeping huddled together to keep warm, with rain dripping down on them in the middle of the night, how could they hope to concentrate in school?

Right in front of the gym, I made a vow: *If the government can't get them a decent place to live, I will do everything I can to help solve the problem.*

In the days after the party, my engineer's mind started spinning with ideas related to what I knew best: the defense industry. From my years of work with defense contractors, I knew the capabilities of the military in the areas of engineering and construction. I also knew that the military regularly deployed troops abroad for training exercises.

Why not deploy some troops to the reservations? I thought. *Why not marry the capability of the military with the needs of American Indians?*

I had the idea, but now I needed a platform to launch it. The opportunity came a few months later, when I heard that the US Air Force was modernizing its base in Grand Forks, North Dakota. As it happened, more than four hundred base houses were scheduled for demolition.

With a few phone calls to the base commanders and local congressmen, I stopped the demolition. "I can save the air force and the American taxpayer the cost of bulldozing the houses and removing debris," I said. "We'll pick up the houses and bring them to the Indians who desperately need them, and you can save money in the process."

There were just two problems: Some of the neediest Indian reservations were six hundred miles away, and I hadn't yet figured out how to move the houses.

But I knew it could be done. The Pentagon gave permission for a trial run and dubbed the project Operation Walking Shield— and I was off and running. Working with the Department of Housing and Urban Affairs, the Pentagon, and local congressmen, we cobbled together enough resources to pull off the move. The air force kicked in by sending airmen to lay the foundations

for the houses; the army sent seven hundred combat engineers to repair washed-out roads; and the navy dispatched Seabees to help with construction.

With that first effort, we shipped eighty-eight three-bedroom, two-bath, twelve-hundred-square-foot houses to families on eleven reservations in North and South Dakota. The houses weren't mobile homes. Rather, they were sturdy prefab structures with six-inch walls, forced-air heating, and double-paned windows.

If Sarah Swift Hawk had lived in a house like that, she'd still be alive, I reflected.

Operation Walking Shield has been in business ever since, orchestrating what has become the largest housing relocation program in the history of the United States. In the eleven years since the program started, we've provided more than one thousand housing units to more than six thousand homeless and needy American Indians in four states and fourteen different Indian reservations. But we've also done something more: We've helped spearhead an ongoing collaboration with the military that has brought doctors and nurses to the reservations to treat more than eighty thousand sick children and adults.

Housing and health care. They are working hand in glove to give Native American kids a chance at a better life—a life that seemed impossible to most of them just a few years ago.

"You can do anything you set your mind to," I tell the kids as I walk from house to house on the reservations. "I was poor. I worked hard and became an engineer. You have to work hard, too."

Now that many of these kids have a decent roof over their heads, with heat and water and basic comforts, I know that my exhortation isn't mere wishful thinking. Not long ago, a young man came up to me and said, "Mr. Stevens, you told me I could do anything I wanted to. I want you to know that I've become an engineer. I just graduated from the University of North Dakota."

If my dad were alive today, I'd tell him that whatever pain I've felt over the past thirty-six years has been worth it. Some people might say that I've lost a lot—by selling my business, giving up a lucrative income, and throwing in my lot with the American Indians.

But I don't look at it that way. It isn't what I've lost: It's what I've gained because I've refused to give up.

Searchlight:

Have you persevered with a person in trouble or a program in need, even when the payoff wasn't obvious or immediate?

Your Point of Light:

Make an effort to volunteer regularly to help one individual or cause. Your faithfulness over weeks, months, or even years may be life changing for you and for someone else in ways you don't expect.

I want, by understanding myself,
to understand others.

—KATHERINE MANSFIELD

The Light of Empathy

Empathy creates a connection with others that extends beyond space and time. It's a special capacity, often predicated on personal experience, that enables us to see deep into another's heart and understand that person's past, present, and future all at once.

You see a teenager in trouble with the law, and instantly you have a picture of his emotional torment. You meet a child struggling to read, and you know the depth of her frustrations. You hear about a neighbor's difficulties coping with an aging parent, and you feel his heartache.

"I've been there," you say. "I know what he's feeling, what she's thinking, and what he's hoping."

Some of us might stop there, acknowledging our connection but never taking a step beyond mere expressions of sympathy for another's plight. But the truly empathetic use their insight as a platform for healing. With a broad vision borne of their own struggles, they jump in to help hurting strangers—not as dewy-eyed idealists, but as battle-tested soldiers.

One of those empathetic warriors is Lynn Price, a Colorado woman whose unusual summer camp program, Camp To Belong,

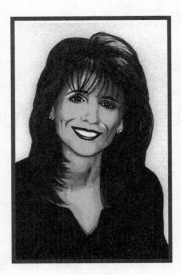

LYNN PRICE

brings together siblings separated by foster care. Lynn, who became part of the foster care system when she was only eight months old, exhorts kids not to dwell on past losses. Instead, she challenges them to take charge of their bright future together as sisters and brothers.

Let's Make a Memory

Lynn Price didn't know she had a sister until she was eight years old.

She learned the truth one day in second grade, when she ran into the house after school to find her dad home early from work and her parents sitting tensely on the sofa.[4]

"Honey," her dad said. "We have something to tell you. We've

been wanting to share this information for some time, but the moment just never seemed right."

What's so right about now? Lynn thought in a panic, sensing that he was about to break some terrible news.

"You see," her dad said, "we are not your parents . . ."

As Lynn's mind swirled in confusion, she shouted, "Mom, tell him to stop!"

"Lynn!" said her mom, in a tone that brooked no opposition. "We are *not* your real parents. We are your foster parents."

Foster parents? Lynn had never heard of such a thing as foster parents. *What does this mean? What did I do to deserve this?*

Lynn felt anger welling up in her. She wanted to lash out, to scream, to punch her parents and hug them all at once.

"But you're my parents!" she shouted. "Why are you making up this story?"

Gently, her father explained that when she was a baby, her real father had abandoned the family, leaving her mother so distraught that she had ended up in a mental institution.

"At the time, there was no one in your family to take care of you and your sister," he said.

"Sister?" cried Lynn, dumbfounded. "I don't have a sister. I have a *brother. You're* my family!"

"Your sister is a year and a half older than you," her dad explained. "Her name is Andi. The agency wouldn't let us take both of you, and so she lives with a different foster family across town."

As the reality started to sink in, Lynn started sobbing. Her body shook so hard she could barely focus on the other revelations that came spilling out of her mother's mouth.

"Your real mom . . .

". . . no longer in the hospital . . .

". . . wants to meet you and your sister . . .

". . . may want you back."

Unable to stand the truth another minute, Lynn ran to her room, threw herself on the bed, and hid under the covers.

The very next day, Lynn's parents drove her to the rendezvous that would change her life.

❖ ❖ ❖

JEWISH CHILDREN'S BUREAU read the sign over the door.

With her eyes staring at the floor, Lynn struggled to walk into the agency behind her parents. She felt as if she were going to her execution.

Moments later, a social worker led them down the hall and ushered them into a small, stark room. It was there that Lynn learned another secret: Her name wasn't Lynn at all, but rather Jackie, the same name as that of her foster mother. Her mom explained that according to Jewish tradition, a daughter couldn't take the same name as her mother. And so when she came into the family, they started calling her by her middle name, Lynn.

Before Lynn could even process that information, there was a knock on the door, and in walked a petite brunette with hair like Cher and lips painted ruby red.

"Jackie," said the social worker, looking straight at Lynn and calling her by her real name, "this is your mother, and this is your sister."

Lynn stared. Then her eyes fell on a slightly older girl standing beside the woman, and she felt her muscles tighten.

"She's *not* my sister!" Lynn blurted out. "She's *not* my sister!"

With every ounce of her being, Lynn recoiled at accepting the two strangers standing in front of her. She wanted to cling to the old life she knew—a warm, cozy life with a loving mom and dad and brother. She didn't want anyone encroaching on her world, even if they were blood relatives.

I don't belong with these people, she thought. *I belong with Mom and Dad. Or do I?*

For the next few years, Lynn remained with her foster family, but she tried to distance herself emotionally from her mother, Bernyce, and her sister, Andi, who remained with her own foster family as well. Dutifully, she met with them fairly regularly for official visits with a social worker or for special events such as family weddings, but she hated the forced attempts at relationships. To Lynn, her mother always appeared overbearing and self-centered, bitter over the past and never showing any genuine interest in eliciting what Lynn was thinking or feeling.

As for her sister, "I wouldn't give her the time of day," said Lynn. "We seemed so different, there was no incentive for me to try to get to know her. She wore jeans, while I wore dresses. Her hair was curly, and mine was straight. Everything about us seemed a mismatch.

"We had two different lives, and I wanted to keep mine all to myself. I didn't want anyone to know that I was a foster kid or that my parents were foster parents. I wanted to keep it a secret."

It wasn't until Lynn's junior year in high school that things changed—literally overnight. One day out of the blue, Lynn got a call from Andi, inviting her to spend the weekend with her at college. The sisters had never spent time alone together, and Lynn was still on guard. But eager for adventure and a taste of college life, she accepted.

The minute she stepped out of the car and saw the big smile on Andi's face, Lynn's heart melted.

"Can I introduce you as my little sister?" Andi asked. Lynn was so overwhelmed by her sister's loving gesture that all she could do was nod yes.

"For all those years, I had ignored her, and yet, here she was, ready to embrace me," said Lynn.

The rest of the weekend was a whirlwind. "I was like a celebrity," said Lynn. "Andi had told all her friends about me, and they couldn't wait to meet me."

As the girls shared stories and feelings in the wee hours of the morning, they learned what they had in common: "Neither of us had any resentment over being placed in the foster care system," Lynn explained. "We both had great foster families who had raised us in environments where we could thrive."

Even more important, the two girls discovered that their personalities were completely in sync. "We were both witty and compassionate, and we were quick to show unconditional love for our friends."

From then on, Lynn and Andi became best friends. Hardly a day went by that they didn't talk on the phone. Even after they got married, started families, and pursued careers, they kept in touch and made time to see each other several times a year.

To keep the relationship flourishing, Lynn invited Andi along on her business trips for the thriving telecommunications company she had started. Over the years, as they rode bikes together on Venice Beach, hiked through the redwood forests north of San Francisco, or sunbathed in Miami, they forged a bond that had eluded them in childhood—a bond of belonging sealed by shared memories that they were creating for themselves.

✧ ✧ ✧

Lynn's story might have ended there, if it hadn't been for a move to Las Vegas when her husband was transferred. Lynn sold her company to become a full-time mom, and, with some extra time on her hands, she decided to volunteer. Researching volunteer opportunities, her eye was inexorably drawn to programs that involved kids—especially kids at risk. She signed up to work at a

children's shelter and also to be trained as a CASA, a court-appointed special advocate. In this role, she would act on a child's behalf in the courts and with social service departments.

"I didn't really know what I could offer, but I just knew I needed to be in the trenches of kids' lives," said Lynn.

On her very first day as a CASA, she was assigned to two sisters who had been raised in different homes.

Just like Andi and me! she thought. Lynn arranged with the judge for the sisters to start meeting regularly, and she even got permission for them to take a trip together to a reunion with their biological family—all as starting points to build their relationship. "I longed for these girls to have what Andi and I had missed out on," she said.

The longer Lynn worked in the system, the more she realized that there were thousands more sisters and brothers who needed to make a lasting connection. "Of the six hundred thousand kids in foster care, 75 percent are separated from at least one sibling."

But what could she do about it? It wasn't until she met a little girl one day at the children's shelter that an idea started to gestate in her mind. Sitting with the girl in the courtyard, Lynn followed the child's gaze until it rested on a young boy across the yard.

"Do you know him?" Lynn asked.

"He's my brother," the little girl replied. "He lives in the cottage over there."

Lynn looked at the cottage and sighed. The physical distance between the two children was small—just a stone's throw. But she sensed that the gap in their relationship was huge.

How can I help kids like them? What can I do to ensure that more sisters and brothers get to share time together in childhood?

She kept asking herself those questions until March 1995, when a "big idea" propelled her into action.

I'll start a camp! she thought. *I'll bring foster brothers and sisters together in a camp!*

She called the project Camp To Belong, a name that celebrated the message of belonging that she wanted to impart to each child. "Everyone wants to belong somewhere," she said, remembering her inner conflicts as a child, when she felt outside her biological family and not quite inside her foster family.

Within weeks of her brainstorm, she had a nonprofit organization in the works and the contract for a facility that would house her first Camp To Belong summer program. At this camp, there would be no social workers scrutinizing the children's every move, and no tug-of-war between biological parents and foster parents. "I wanted to give kids quality time together among people who would give them unconditional acceptance," said Lynn.

The first year, thirty-two children recommended by the Nevada Division of Child and Family Services showed up for the weeklong camp program, which was held at the University of Nevada, Las Vegas. But this was no ordinary camp. Lynn had created the program with special events designed to encourage and cement the sibling bond.

For example, as a special art project, kids created "sibling pillows" inscribed with loving messages that their brothers or sisters could bring home from camp as mementos to hug at night. For a mock birthday party held toward the end of camp, the siblings had a chance to shop for each other, make a birthday card, and decorate the room as wildly as they wanted. Then together with their brother or sister, they blew out the candles on a "sibling cake."

"Most of these kids never had a chance to celebrate birthdays together," said Lynn. "Throughout most of their lives, they haven't had a chance to relate to each other in a meaningful way.

☆ ☆ ☆ ☆ ☆ ☆ ☆ ☆

The Marine Who Just Wanted to Belong

"Why are you letting Randy come to camp?" someone asked. "He just joined the marines."

Randy, who had just turned eighteen, had been "emancipated" from the foster care system and was officially on his own. But he had begged me to let him come to camp with his two younger sisters.

"I haven't spent any time with them since I was thirteen," he said. "I know I'm too old, but I want to be with my sisters before I start my training."

I didn't have the heart to say no. It was because of kids like Randy that I had started Camp To Belong, a place where foster brothers and sisters could share experiences for at least one week of their lives. And so I relented.

From the day camp started, it was clear I had made the right decision. Randy and the girls took one look at each other and ran into each other's arms, as tears streamed down their faces. For the rest of the week, Randy and his sisters were joined at the hip. Every time I bumped into him, the girls were right by his side, joking and laughing, prodding him to get involved in their games.

One day down at the stables, I saw Randy standing by a horse, looking uncomfortable.

"I'm not getting on that horse," he said emphatically—until one of his sisters tugged at his sleeve.

"Please go with me," she said.

Without hesitating a second, he helped her on a horse, jumped on the one behind her, and followed her down the trail.

After he left camp, Randy reported to the US Marine Corps base at Camp Pendleton, but he didn't forget us. He called his old social worker to tell her about Camp To Belong, and when he got to Japan, he called me from his barracks to say hello. The next year, he took leave to be a counselor, and before he left for Iraq, he allotted part of his paycheck to the camp. Now one of his sisters is a camp spokesperson.

Randy got back from Iraq not long ago, and whenever I see him, he never fails to tell me how much camp meant to him.

"My sisters and I have a relationship now," he says. "At camp, we found a place where we could feel like we belonged."

—Lynn Price

They may attend the same school or the same religious institutions, but when they go home at night, they are in different families. They don't fight over who's first in the bathroom, or argue over who's going to do the dishes.

"I wanted these siblings to have great stories to laugh about together when they're older, stories about their first horseback ride, or their first time river rafting," said Lynn. "Shared experiences create memories and bonds."

Since the very first camp more than a decade ago, Camp To Belong has exploded. More than two thousand children have come through the program, which is now held at weeklong sessions in Colorado, California, Maine, Massachusetts, and Canada.

As for Lynn, Camp To Belong has become a consuming passion that has transformed her life and that of her family. During

the year, she spends her days advocating child-friendly legislation, recruiting campers and counselors, and seeking out educational opportunities for children in foster care. She also works with child welfare professionals and prospective adoptive and foster families to ensure that siblings remain together in the same household.

Her own three children—her daughter, Jamie; her sons, Addison and Tanner—have been involved from the start, helping at camp and playing host to scores of campers or kids in foster care who show up at their home for overnight or extended visits. The three are so on board that they quickly embraced as a brother a nineteen-year-old former camper named Bryan, whom Lynn wanted to adopt after he became an adult.

"Bryan visited me at camp soon after he became eighteen and emancipated from the foster care system," said Lynn, who had grown close to him years earlier when she'd served as his court-appointed special advocate. "He started talking about his high school graduation and his future, about what his life would be like after he got married and had children.

"'Who's going to be there for all those events in my life?' he asked me."

Lynn knew the answer. She officially adopted him last July.

"A lot of people don't realize what they get back when they give to others," she noted. "They don't understand how addictive it is to give, or how much meaning it puts into your life. It can give you direction, it can give you approval.

"People come up with all sorts of reasons not to volunteer, but I say, just do it 'be-cause.' I believe that for us to 'be,' we need a 'cause.' For me to be who I am, I need a cause, and my cause is Camp To Belong."

Whenever Lynn feels overwhelmed and threatens to give up the cause and pull back on her hectic pace, she remembers the

plea of her sixteen-year-old son Tanner: "Mom, you *can't* give this up, because this is our legacy."

She also remembers the reason she started Camp To Belong—her relationship with her sister, Andi.

"Brothers and sisters are truly your longest relationships in life," said Lynn. "When your parents pass away, it's your siblings you keep relating to."

Every summer, she and Andi get a chance to deepen their relationship at camp, where they work side by side as counselors.

"Finally, we get to share a bedroom!" said Lynn.

Searchlight:

Have you taken time to mentor a needy child or teenager one-on-one?

Your Point of Light:

Commit yourself weekly to working with a young person who may be yearning for a special friendship. Check with your house of worship, a local orphanage, or an agency that deals with foster kids to find out who needs you most.

We never know how high we are
Till we are called to rise;
And then, if we are true to plan,
Our statures touch the skies.

—EMILY DICKINSON

The Light of Confidence

Confidence begets confidence. It ignites a can-do spirit that sets our sights on the stars and emboldens us with a sense of limitless possibilities. Show a child that you believe in him, and suddenly his chest swells, his eyes brighten, and before long he starts believing in himself. Tell a friend that she can meet the challenge of a high-powered new job, and soon she is on her way to running the company.

At some time in our lives, each of us needs a boost to get over the walls of fear and uncertainty that are boxing us in and holding us back from being all we can be. What we need is a vision, a vision of the expansive life that awaits us on the other side of the wall—and the courage to get there.

More often than not, the vision comes through the eyes of someone who cares enough to walk alongside us and show us the way, pouring out confidence with every step. For a special group of inner-city girls in Washington, DC, that someone is Judge Mary Terrell, a mentor who pours out confidence—from a teapot.

MARY TERRELL

Courting Confidence at Teatime

Judge Mary Terrell lays down the law, but not always in the way you might expect. By day, she's a superior court judge in Washington, DC, appointed by the president to mete out justice to corporations and individuals involved in civil disputes.

By night and on weekends, she imparts the rules of civility to girls who have never been exposed to the finer disciplines of an educated life. Through the High Tea Society, a program she rolled out in 2000, young schoolgirls learn such disciplines as good table manners, polite conversation, appropriate clothing, proper behavior at the ballet—and even the experience of high tea.

"All the social skills you need to know in a civil society, you can learn at afternoon tea," explained Judge Terrell, who invites the girls to formal teas at some of Washington's classiest hotels.

"I want the girls to be as comfortable in the White House as

they are in their own house," she said. "The High Tea Society is all about exposure. The differential between people in a civil society and those who feel locked out of society is exposure to opportunities. Without that exposure, people can't see how they fit into a global community."

Through the High Tea Society program, girls have a chance to dress up in fancy hats, gloves, and dresses for afternoon tea at such hotels as the Four Seasons, which underwrites teas several times a year. Every Saturday, they focus on academic and cultural enrichment: tutorials with Howard University students; field trips to museums and plays with professional women who serve as mentors; lifestyle speakers on such topics as journaling, public speaking, and nutrition; and tours of college campuses—all designed to heighten the girls' expectations.

As a finishing touch, a two-week etiquette camp in the summer teaches the girls how to carry themselves, how to greet people, how to eat a nine-course meal, and how to write social correspondence.

From the beginning of her program, Judge Terrell targeted girls who needed a little push in order to be successful.

"I didn't want superstars, but rather kids who were teetering, those who could fall down in the abyss without support or rise up if they had help," explained the judge. "A child's grade point average didn't matter to me. I was dealing with potential. I believed that if you set high expectations and put children in an environment that is holistic and supportive, you would see positive behavioral changes and academic success."

Judge Terrell's own confidence was honed at an early age through her upbringing in a conservative Baptist home in Ohio, where clear rules by loving parents set a high standard of behavior.

"We were accountable for our actions," she said. "We were monitored almost twenty-four hours a day, seven days a week. If

we went out to play, we had to stay within a block, so that we could hear our parents' voices. Later on, we were expected to work and to have a job. There was a very strong work ethic."

Such values "are the missing variables in the community today," said Judge Terrell. "Since the 1970s, everything changed."

Encouraged by her mother, Judge Terrell struck out on her own after high school and headed for Howard University, where she became the first person in her family to go to college.

"I was determined I wasn't going to spend my life sitting on the porch in Ohio wondering what the world was like," she said. "I had this spirit where I wanted to explore the greater community."

That inquisitive spirit led her to the Peace Corps in India, where her exposure to the genteel art of tea heightened her own vision. "There was a certain civility that went along with the tea experience," she recalled. "Whenever I went to someone's home, no matter how poor they were, they offered me tea. Along with the tea came conversation and a sense of mutual respect.

"My exposure to those experiences gave me a different perspective on life and a different perspective on who I was." The judge no longer saw herself as just a girl from Ohio, she said, but rather as a woman of the world who could operate confidently in any environment.

After her stint in India with the Peace Corps, Judge Terrell returned to Washington, where she threw herself into teaching. Ultimately, she became head of the Washington Urban League Dix Street Academy, an alternative school for students who had been kicked out of the public schools.

"These were children who had no options," said Judge Terrell. "They had bottomed out of life. Most of them were hanging out on the streets. Since their home situations weren't suitable, they had gotten caught up into negative groups, which became their extended family."

But once inside the street academy, the teenagers changed.

"We disarmed them," said the judge. "We taught them social skills that led to positive behavior."

As for academics, many of the teenagers came to the school reading at a first-grade level. "But they had a readiness for learning," she explained, "as long as they felt there was trust and that someone cared."

Using an ungraded, skill-based curriculum that gave students confidence as they moved forward step by step, the school paved the way for many of the teens to earn high school diplomas and go on to college.

"These kids would have been dead or in jail if they hadn't come to the street academy," said Judge Terrell, who, in a quest to understand and advocate further for these troubled youth, decided to go back to law school at night. A five-year stint as a criminal prosecutor with the US attorney's office reinforced her commitment to finding the root of the problems that led young people astray.

"I realized that the optimum place to meet these children is on the front end, and not when they're dead or in the criminal justice system," she said.

But where could she meet them? How could she communicate her vision of confidence and empowerment in an enticing and palatable way? The answer for Judge Terrell was simple: "Take them to tea!"

With the backing of the St. Regis Hotel, which hosted the very first afternoon tea more than five years ago, she launched the High Tea Society with a group of twenty junior high students.

When the girls first joined the program, said Judge Terrell, "their vision was limited to their immediate environment. Their clothes were inappropriate. They had no exposure to the opera or the symphony. They were bound by a negative worldview, where

✩ ✩ ✩ ✩ ✩ ✩ ✩ ✩

Hats Off to Letitia

From the moment I met Letitia,[*] I knew she lacked confidence. At thirteen, she was tall and statuesque, and yet she walked hunched over, as though she had something to hide. When she talked, the sassiness in her voice fairly screamed disrespect—for me and for herself.

Without the proper attention, this girl could easily be pulled into negative relationships, I thought.

Letitia was just the kind of girl I wanted for my High Tea Society, an experiment in social behavior that I hoped would change young women's lives. I hoped that by inviting girls to afternoon tea in an elegant setting, they could find themselves—their best selves—through an experience of comfort, serenity, gentility, trust, and the art of conversation.

With any high tea, a hat is de rigueur, and so with our first tea scheduled for the St. Regis Hotel one Sunday in June 2000 I took Letitia on a shopping trip.

She wasn't much of a talker. As I drove to the hat store, I plied her with questions, but all I got back were one-liners. I had just about lost all hope for this expedition until we walked into the hat store. There, in a profusion of pastels like an impressionist painting, hats perched on the wall and on every counter.

Letitia took one look at the hats and her eyes lit up with excitement. She almost ran to the counter, where she picked up a pink straw confection and started trying it on. For the next hour,

[*]The individual's name has been changed to protect her privacy.

she tried on hats, tilting one this way and another that way, giggling as she posed in front of the mirror. From the twinkle in her eyes, I could tell she knew how pretty she looked.

Finally, she settled on a cream-colored straw, and when she walked out of the store with hatbox in hand, she seemed to be standing a little taller. Letitia turned out for the tea party at the St. Regis looking like the classy young woman I knew she could be, in a white sheath, a string of pearls, pearl-drop earrings, and her new straw hat.

That hat set Letitia on a course for success. At the tea, along with other members of the High Tea Society, she promised to earn good grades, avoid pregnancy, and set a good example. And in the years since, she's lived up to her pledge—and more. She's affected her siblings and her friends as a model of civility. Now she's in college, working toward a degree in psychology.

These days, I recognize her instantly by her walk: She's the one standing straight up with her head high and a stride that lets you know she's going somewhere—anywhere in the world she wants.

—Judge Mary Terrell

drugs, violence, teenage pregnancy, and dropping out of school were the norm."

Now poised and confident more than five years after they started the program, ten of the young women have already graduated from high school and entered college. Following on their heels are more than fifty girls, many of whom started the program when they were in elementary school.

The girls, who hail from some of Washington's toughest and

most economically challenged neighborhoods, are selected by their school principals. But that is just the first step in a rigorous application process designed by Judge Terrell.

To become a member of the High Tea Society, each girl is required to attend an orientation program with her parents, write a letter explaining why she wants to be part of the society's program, undergo a personal interview, and sign an agreement to abide by the society's guidelines. The agreement is co-signed by her school, her parents, and the society to underscore the magnitude of the commitment involved.

"The program doesn't work if you don't have the support of a parent or guardian who gives it a priority," said Judge Terrell. "If the parents don't think it has value, then the children won't give it value."

As for the society's guidelines, each girl in the program pledges to uphold a set of ten guidelines designed by Judge Terrell to inspire the highest standards of personal decorum and achievement.

But the girls are not left to execute these guidelines on their own. Once a girl makes a commitment to the program, the High Tea Society makes a reciprocal commitment to nurture her development to graduation—and beyond. To that end, each girl is paired with a female mentor whose job is to keep in touch weekly and introduce new experiences, whether it's picking strawberries at a berry farm, attending a ballet, or going to camp.

But the centerpiece of the program is high tea itself and all of the social graces that go with it.

"Before they come to tea, the girls are exposed to etiquette," said Judge Terrell. "They are trained in what to do with a napkin, how to pass the scones, how to pick up the cup."

They're also primed on the niceties of conversation, such as

☆ ☆ ☆ ☆ ☆ ☆ ☆ ☆

High Values for High Aspirations: Ten Guidelines

Each girl in the High Tea Society vows:

To be a positive role model for other girls.

To strive to do her best every day.

To project a positive self-image in dress, language and attitude.

To make a positive contribution to her school and community.

To have a value system that lets her know the difference between right and wrong behavior.

To establish high standards of achievement for herself.

To refrain from the use of drugs or behavior that will lead to school suspension.

To honor her body and not become pregnant.

To be respectful of others and herself.

To attend school regularly.

how to introduce themselves and how to make an oral presentation. "We don't want to embarrass them," the judge explained. "We want to create the ambience, the surroundings, the tranquility, and the elegance that create a climate that allows us to engage them in conversation."

Along with preparing the inner girl for the experience of high tea, the society also makes sure the outer girl is dressed to the nines. "We make it clear that they are going to be exposed to a

new cultural experience where they're expected to dress a certain way. That means wearing a dress, hat, and gloves. If they don't have proper attire, we'll take them shopping."

The teas themselves are elegant, two-hour affairs that draw up to two hundred guests, including the girls, who are seated at different tables to encourage conversation.

"Looking out over a tea is like being in an English flower garden," said Judge Terrell. "There are colors all in array, and with smiles all around, it's nothing short of enchanting."

But what enchants Judge Terrell the most isn't the sight of a girl in a pastel dress and straw hat stirring her tea with a silver spoon. Rather, it's the handwritten thank-you note she received from one of the young women she mentored.

"Dear Judge," the girl wrote. "I do not know how you have been able to put up with all my ups and downs and strange situations. I could not have done that. I would have booted me to the side. You have some kind of strength inside. I would have said, 'she has too many problems.' I am glad you stood by me."

These days, the High Tea Society has become so successful that Judge Terrell and her supporters are rolling out a companion program for boys called the Blue Chip Society, which focuses on the rules of sportsmanship to prepare young men to become gentlemen.

"As a judge, I can detain and deter and use enforcement, or I can intervene and try to make a difference. I know these children have the potential to become great. Some get lost along the way, and all they need is someone to give them a hand—someone to reach out and give them confidence to enter civil society.

"Come with your teacup," she exhorted potential mentors. "Come ready to share your experience and help a child succeed by teaching through tea."

Searchlight:

By your words or actions, have you sought to instill confidence in a child, a friend, or a family member today?

Your Point of Light:

Think of seven ways you could build up another's confidence—and then initiate one of them every day this week.

Behold, I do not give lectures or a little charity,
When I give, I give myself.

—WALT WHITMAN

The Light of Generosity

Generosity means sacrifice. True generosity involves more than just writing a check, though that is important. It means more than serving for an hour or two on a committee, though that may be critical.

If we are to be truly generous, we must give more than either time or money—we must give *ourselves* totally and unreservedly, with our hearts fully engaged in the concerns of another. Furthermore, that kind of engagement can't take place at a distance. It often requires a personal touch, a face-to-face involvement that can transform our giving from a humdrum duty into a sheer delight.

For some people, and even for some organizations, the delight of generosity starts with a daring decision, a commitment to share significant resources, time, or more with others who are in need. That's the kind of generosity that John Sainsbury learned through Habitat for Humanity.

JOANNE & JOHN SAINSBURY

Two Hearts, a Hammer, and an RV

I never expected to become a gypsy. My wife, Joanne, and I liked our quiet, comfortable lives in Indian Harbor Beach, Florida. During the week, we worked hard at our jobs, mine as a tax auditor for the state, and hers as a neurotechnologist. On weekends we devoted ourselves to church and to volunteering to work on low-income houses for Habitat for Humanity.

From the very start of our work with Habitat in 1986, Joanne and I were hooked. We loved the notion that we were involved in an ecumenical Christian ministry that helped the working poor get "a hand up, not a hand out," as Habitat describes it. As a finance guy, I especially liked the idea that young families shut out of bank mortgages could get a new house that they could pay back, interest-free, in level payments over twenty to twenty-five years. A house was part of the American dream, and I believed

everyone deserved a chance to reach for the kind of life Joanne and I had enjoyed with our five children.

And so when Saturday came along, Joanne and I didn't head for the mall or the beach. Instead, we looked at each other and said, "It's time to build!" Out we'd go, hammer in hand, to the latest house going up through our local Habitat affiliate in Brevard County.

One Saturday in 1995, as I was fielding questions from new volunteers, someone asked, "How many affiliates does Habitat have?"

Back then, there were about twelve hundred, and as I threw out the answer, I said as an afterthought, "It would be neat to work with an affiliate in every state."

I forgot all about the idea until Habitat founder Millard Fuller came to town for a house dedication and buttonholed me.

"I hear you want to work in every affiliate," he said. He put us on a mailing list for a Habitat group called the Care-A-Vanners that caravanned around the county in recreational vehicles. Three years later, we were ready to roll.

Joanne and I retired from our jobs, bought a thirty-six-foot Dolphin RV, packed up two grandkids who signed up for the first part of the adventure, and headed west. After a tour of the national parks, we put the kids on a plane home, went to Reno, and looked up Habitat in the phone book. Our first "build" on the road was Truckee Meadows, Nevada. We worked for two weeks hanging Sheetrock, and then we headed for Bend, Oregon, where we hooked up to a campground and worked with the local Habitat for another two weeks.

California came next: Sacramento, Fresno, Santa Maria, Piru, Indio—towns big and small became our backyard for anywhere from two weeks to a month. We were just two people with a mo-

tor home and a dream: help Habitat in every one of the fifty states. As we went from state to state, Joanne kept a log of our journeys, with the names of the construction supervisor, the volunteers, and the families we met along the way. By the time we hit Arizona a year into our journey, we had helped build 125 houses, and then we stopped counting.

My favorite stop was Tucson—not the city the tourists see, but the underside of Tucson that might show up on a movie screen. The minute we pulled into what the Habitat affiliate called "the yard," an area that housed their warehouse and cabinet shop, we sensed we were in for trouble.

YOU ARE ENTERING A KNOWN DRUG TRAFFICKING AREA AND YOUR LICENSE PLATE WILL BE RECORDED BY POLICE, warned a sign just outside the Habitat compound.

That night, awakened by the whirring of a helicopter, we peeked out the window to see the lights of police cars encircling a van in what we figured was a major drug raid. The next day, Joanne wrote to her mom, "We are living in a gated community with helicopter and police surveillance."

But the danger didn't bother us. Wherever we hooked up—whether it was a churchyard, a campground, or the Tucson "yard"—we felt incredible peace, because we believed that God had called us to do this work. For us, the risks were worth it, because through our travels Joanne and I became as close as any two people could get.

✧　　✧　　✧

I didn't have a hint that Joanne was sick until we hit Hagerstown, Maryland. We had been on the road for nearly two years, and she had never complained of anything. But one day she admitted she was having physical problems.

"There's some blood in my stool," she said simply.

When the local doc-in-a-box turned her away because he wouldn't take our insurance, we stopped at a gas station so that she could call the insurance company for a reference.

"Go to Washington County Medical Center Urgent Care Facility," said an insurance rep.

That lead turned out to be a godsend. When it was Joanne's turn to see a doctor, the physician did a quick checkup and said, "It sounds like irritable bowel syndrome." But he didn't leave it at that. "There's a gastroenterologist on the floor," he said. "Let me see if he can take a look at you."

The specialist examined Joanne, sent her to his office for a prescription, and set up a colonoscopy at seven o'clock the very next morning.

"It's colorectal cancer," he said. Joanne's bowel was pretty much closed up. "Very advanced," the doctor said. He didn't say how advanced, but from the sound of it, her prognosis wasn't good.

"We've got to go home," Joanne said. In our two years on the road, we had covered twenty-seven states and more than forty affiliates, but it was clear that for the time being it was time to stop.

As soon as we got back to Florida, she said, "Let's have a pity party on the beach, where we can vent our emotions about this thing."

We headed for the beach, and after an hour sitting quietly as the waves rolled in, she turned to me, ready to face whatever came next: "It's in God's hands," she said.

At first, the news from the local doctors was grim. "She has five lesions on her liver and six months to live," said the surgeon. After a round of chemo, the lesions disappeared. But four months later, twice as many returned. That's the way it went: She'd re-

spond to chemo and get well, and then the drugs would stop working.

But no matter what her condition, we kept working for Habitat, often in Vero Beach, Florida, which was about an hour away from our home. Typically, we hooked up our RV behind the Habitat office on US 1 in Vero for a couple of weeks, and on Tuesday, Joanne would drive an hour and back to her doctor for chemotherapy. The very next day, she'd be back on the job in Vero.

Stopping work with Habitat was never a question for us. That's not the way we are. There was just too much at stake. There were families to take care of—families such as the young African American couple with three kids who were working their tails off to keep afloat. The husband had been working three jobs and the wife working two, just to pay the bills. But after they moved into their Habitat house, the wife was able to quit one of her jobs and go back to school. She became a teacher, and with the extra money she made, her husband was able to quit two of his jobs and go back to school as well. Now he's a teacher, too. The last we heard they had moved to Gainesville, where they were doing so well they took on a full-blown bank loan with a mortgage.

Habitat had transformed their entire lives, and Joanne and I had played a part in it. That's why we couldn't give up. We had an unspoken promise to help these families come out of poverty and grab their opportunities. That was our hope for every family whose house we helped build.

And so, we kept working. As one year turned to two, and then three, we hopped from one Florida Habitat project to the next in places like Vero Beach, Jacksonville, and Green Cove Springs. But the day after Labor Day in 2003, I knew that Joanne's work with Habitat had finally come to an end.

As we were working on the final dress-out of a local Habitat

house, putting the finishing touches on a residence for a family of five, I noticed Joanne resting more than she was working. Usually, we worked from eight until two, taking short breaks every now and then. But on that particular day, Joanne painted a little bit of door and then sat down. Then she painted a little more and sat down again. It went on like that the whole day.

I knew enough to leave her alone. "It's in God's hands," she had said, and I had to trust him, even then.

Back home that night, she didn't say anything, but I could tell she knew she was dying. She had been off chemo for six months, and there was no other treatment left. A few months earlier, she had started with hospice, yet even knowing she was near the end hadn't kept her from showing up with her paintbrush to finish the Habitat house.

Joanne died a little over a month later, on October 10, 2003. She died at home, with me by her side. Although she had drifted in and out of a coma, she had been able to talk with each one of our kids as they came home to see her. We had been married forty-seven years and forty days.

Nine days after Joanne died, I was back working on a Habitat house—a green-and-white one halfway down the right side of the street in a new development called Grace Groves in Vero Beach. It's what Joanne would have expected. We had even talked about it a few days before she died.

"There's a build down in Vero Beach in a few weeks," she had said. "You need to be there."

I cried a lot as I worked on the house that day. In the past, Joanne would have been right there with me. In my mind's eye, I could see her, with her brown hair and hazel eyes, equaling any man with her tool kit. She had been one heck of a framer. I remembered one house we had worked on years earlier where some

☆ ☆ ☆ ☆ ☆ ☆ ☆ ☆

Building Generosity in One Small City

It's no accident that one of John Sainsbury's favorite places to build is Vero Beach, a small city in central Florida. The city's Habitat for Humanity program ranked thirtieth out of seventeen hundred in the nation in terms of numbers of homes built in 2004. But when it came to generosity, the program was right at the top. The Florida affiliate tithed more that year than any other Habitat group in the country—a whopping $200,000—outstripping affiliates in such cities as New York, Atlanta, and Miami.

"Tithing is one of the founding principles of Habitat for Humanity," said Andy Bowler, executive director of the Indian River Habitat for Humanity in Vero Beach. "Each affiliate is expected to contribute 10 percent of its cash contributions to a Habitat program abroad."

In the case of Vero Beach, the money went directly to Romania, where Habitat International has been working for about seven years. The Romanians, in turn, said Andy, tithed their income to places such as Malawi, Kyrgyzstan, and the Philippines.

"The average pro-rated cost of building a house overseas is $4,200, compared with $45,000 in Florida," said Andy. "By giving away that money, we were able to build forty-eight homes in Romania, on top of the twenty-two we built in the same period of time in Vero Beach.

"I don't resent giving away money one bit," he added. "We're a one-world community these days. I regard it as forty-eight more families getting a decent place to live."

Paradoxically, tithing has actually increased his local program's momentum. "We've experienced our biggest growth during a period when we were giving away the largest amount of money," he noted.

With a twenty-eight-home subdivision, Grace Pines, finished in 2004, the Vero group has launched an even more aggressive project, Grace Groves. When completed, this new development will boast eighty-one homes nestled around two small retention ponds. Thirty houses are already occupied.

In addition, the group has just completed a massive thirty-thousand-square-foot warehouse and Home Center Store, which sells donated furniture, appliances, and building materials to the public to supplement Habitat's income. Major land purchases are also in the works for additional subdivisions. And to keep volunteers happy, Andy has created full RV hook-ups for ten motor homes, to accommodate the teams of roving Habitat Care-A-Vanners scheduled to come through town.

"I think we've been truly blessed," said Andy. "You can't outgive God."

guys were struggling to put up a wall. They kept bending nails one after the other—until I called Joanne over.

"These guys are having a problem putting a nail in this two-by-four," I told her.

She walked over, and with two hits whacked the nail in there and got the job done.

That's just the way she was. When it came to Habitat, Joanne never stopped giving. Not long ago, when I heard the news about an electrician who had died of a heart attack on a Habitat site, my thoughts immediately went heavenward—to Joanne.

She's still giving, I thought. *I guess she just finished her Habitat house up there and needed an electrician.*

Searchlight:

Do you spend at least 10 percent of your available time in activities that benefit people other than your family?

Your Point of Light:

Make a commitment to give away a portion of your time and money over and above what's comfortable. As the Good Book says, "Give and it shall be given to you; good measure, pressed down, shaken together, running over, will be put into your lap. For the measure you give will be the measure you get back" (Luke 6:38).

Every joy is gain,
and gain is gain, however small.

—ROBERT BROWNING

The Light of Joy

J oy can surprise us in a burst, a moment of pure energy, when we experience a long-awaited reward. Or it can radiate softly inside us, warming us daily with a steady, sure sense that our life has meaning and purpose.

For many of us, joy can be found in the simple things: an orchid unfurling into flower, a jeep ride with a loved one on a sunny Saturday, or a phone call from an old friend.

But as Arizona retiree Robert Springer has discovered, the greatest joy of all may come from giving of ourselves—specifically, preparing a child to succeed in an increasingly complex world. For Robert, joy can be summed up in a simple equation: Child + Skills = High School Diploma.

The Math of Joy

R obert Springer, PhD, finds joy in small problems—small math problems. For the retired engineer and experimental psychologist, seeing a child master the multiplication tables and pass Arizona's

ROBERT SPRINGER

state-mandated AIMS test is all the reward he needs for the hours he devotes to his tutoring program, Project Catapult. But what tickles him even more is watching the synapses start firing in a ten-year-old brain as a child starts to figure out that math can actually be fun.

"It's incredible when a child factoring numbers or doing decimals says to me, 'Hey, I get this!'" said Robert. "A little mind just advanced one cog, and that's exciting."

Robert started tutoring math in 1998, not long after moving to SaddleBrooke, a retirement community near Tucson, Arizona.

"I had always wanted to teach," he said, "and I was finding it difficult just to do tennis all day. When there was no voice mail to check or e-mail to read, it didn't take long for me to start consulting and volunteering at the local GED center."

Offering his services as a math and physics tutor at a high

school in a largely Hispanic neighborhood, Robert was snapped up by the school principal and quickly found himself tutoring advanced math classes three times a week.

"I wanted to tutor in a subject that was fundamental to a student's getting into college," said Robert. But he soon discovered that a high percentage of the students in his classes couldn't multiply eight times seven. "They didn't know their multiplication tables and they couldn't do decimals or fractions. They lacked the basic math skills they should have learned in junior high or elementary school."

Not only were most of the students unprepared for high school, but college wasn't even on their radar screens. "This community is not one that has sent a lot of people to college," explained Robert. "The parents don't understand the importance of higher education. These are people who work incredibly hard in terribly difficult jobs. They have a strong work ethic, and yet the thought of sending a child off to school for four years without the child getting paid is very foreign."

As a result, "Many of the kids wanted to work in the local mines because it was quite lucrative. It was a hard sell to convince them why they needed to learn math."

That was just the kind of challenge Robert warmed to. He circulated a flyer in SaddleBrooke, a community filled with retired engineers, mathematicians, and business professionals. Soon he had recruited fifteen tutors for San Manuel High School, which was thirty miles away. Once a week, the tutors drove to the school to work with the students one-on-one during six one-hour periods.

But it was an uphill struggle. "It was easy to teach the math," said Robert, who observed that students possessed the intelligence to grasp the concepts. "But it was hard to get the students to *want* to learn. A lot of them had been failing so long they just gave up."

With the closing of a major copper mine in 1999 and the pending introduction of a new state-mandated graduation test known as AIMS (Arizona Instruments Measure Standards), Robert knew that the students would be facing a crisis—if he didn't step in with a radical solution.

"Students no longer had a choice about studying," said Robert. Because few jobs were available, if students wanted to graduate from high school, they would have to pass the high school AIMS test, which would become mandatory for graduation with the class of 2006.

How can we step up the timetable for teaching math? he wondered. For help, he turned to Renaissance Learning Corporation, a company in Wisconsin that had a track record in computer-based learning. Using software Renaissance had created for elementary grades, geometry, and algebra, Robert convinced the company to put up a substantial amount of money in programming time to develop software for individualized math instruction for the high school AIMS test. He and four math teachers from San Manuel High School assisted in the effort.

With the software ready to go, Robert turned back to the classroom, where he expanded his tutoring program into the elementary schools. There, using computers purchased with private funds donated by SaddleBrooke Community Outreach, the local charitable organization that supports his work, Robert and his tutors helped students master math concepts step by step.

"The teacher picks out the concepts, and after he or she gives a lesson, the computer prints out a piece of paper with a set of multiple-choice problems," Robert explained. "The students fill in their answers on an optical bubble ticket, insert the ticket in the computer, and in less than ten minutes, we know if they understood what they were taught."

Students who score 80 percent or better get to move on to the next concept. For those who need extra help, two or three tutors are available in the classroom to sit down with them one-on-one and show them how to work the problems. Then it's back to the computers for more concepts and more math problems.

But the lessons don't stop with the computers. Robert's tutors also teach multiplication the old-fashioned way—with flash cards. They send each child home with a deck of multiplication flash cards, to encourage parents to get involved in the learning process.

With nearly eighty math tutors now involved at three elementary schools and two high schools in the San Manuel school district, Robert noted that his effective reach is six hundred students annually. But he doesn't compute success in terms of the numbers of students he's reaching. For him, the only numbers that count are the hard-and-fast statistics that answer the question, *Are we making a difference in the math scores?*

To find out, he conducted a controlled pilot study during the 2003–2004 school year—two years before the state AIMS test became mandatory for graduation—involving forty eleventh graders who had failed the previous year's AIMS test. One group was tutored every day for the entire school year, while the other group received no tutoring at all.

"These kids were stuck back in fourth-grade arithmetic," said Robert. "We had to teach them an entire seven years of math in one year."

Even worse, he continued, the students resisted learning every step of the way. "A lot of the kids didn't want any part of it. They fought us all the time. The only reason they took the class was because the principal forced them into it."

Even after the year of tutoring, the teens were so unmotivated that Robert had to offer those in both the tutored and control

groups $50 each if they passed the test, so that they wouldn't just sit there doodling during the exam.

But the money—and the yearlong effort—turned out to be worth it. According to Robert, 60 percent of the group that was tutored passed the AIMS test, compared with 14 percent of the untutored control group.

Buoyed by these results, Robert expanded his program to two high schools during the 2004–2005 school year for juniors who had previously failed the AIMS test. For these students, passing the test was a do-or-die situation: If they didn't pass the test, they wouldn't graduate.

After tutoring, an amazing 90 percent of the students in Robert's AIMS Preparation Class at San Manuel High School passed the test, while 93 percent of those in a similar program at Ironwood Ridge High School came out winners. These results far outstripped the 60 percent pass rate on the AIMS test for juniors statewide.

Now that he's tasted success with his math program at two high schools, Robert is aiming to export the AIMS Prep Class to other schools throughout the state of Arizona. Such basic math skills are essential, he insisted, if students are to compete in this global economy.

"It's painful to go forth in the world if you're not prepared," said Robert. "Kids have no idea the incredibly competitive world that awaits them—a world that is much more threatening than when I was a kid.

"Today, when I have a problem with my computer, I pick up my phone and speak to someone in India. An engineer in China can design something and send it by electronic means to a US company without seeing the person he's working with. That's the way the world is working.

"This is really a crisis, and the kids and their parents don't realize it."

To make sure the message gets out, Robert has lobbied before the state board of education and the governor's office to expand his tutoring program throughout the state.

"Every one of our high schools needs this program," he said passionately. But he's not stopping with math. He's got forty tutors in four junior high and elementary schools working on reading, and now he's setting his sights on solving an even bigger problem—poor attendance. Under the federal government's No Child Left Behind policy, he said, schools with attendance rates below 94 percent could lose federal funding.

To solve that problem, he's going for broke with an unusual lottery. As an experiment, he plans to offer the parents of high school students a chance to win free washing machines and refrigerators if their son or daughter maintains an average of C or better and attends school at least 94 percent of the school year.

"The strategy is really an excuse to meet with the parents," he said. "When we tell them that they can win a new appliance if their child attends school, they will understand.

"I've taken a lot of flak by trying yet another bribe," he added wryly. "But these are underachieving kids. Do you want to save them or not? You have a choice: give them no help, or give them whatever it takes to become successful citizens."

If the lottery doesn't work, you can bet that as long as he's able, Robert will be on to another creative idea to help Arizona's kids succeed. "My insurance company has figured out that statistically I should be around until I'm eighty-six," said Robert, who is now in his early sixties. "I've always had a desire to make a difference during the finite time I have on this planet. Helping kids get an education is as good a difference as any.

✩ ✩ ✩ ✩ ✩ ✩ ✩ ✩ ✩

From an F to a PhD

I nearly flunked out of high school. With a 2.1 GPA, I always did just enough to get by. Although I loved math and science, when it came to everything else, I was totally unmotivated. One of my teachers even sent me for a psychiatric evaluation, because he couldn't understand why someone with A's and B's in math and physics was failing German.

But it was simple: I didn't know the importance of studying because no one had made it crystal clear to me. I try to remember that now, when I'm tutoring kids in math.

What would have motivated me? If I had had to pass a test in English or history in order to graduate, you can bet I would have studied a lot harder to avoid the disgrace of not getting a high school diploma.

But nothing would have been as good as having parents who were college graduates and pushing me every chance they got. Nobody in my family had ever been to college. My dad didn't even graduate from high school. His father pulled him out of school to work in the family clothing business in New York. He became a purchasing agent during the war and went to a naval weapons development base building armaments. He worked his way up to senior management in the aerospace industry and finally earned his GED while he was a manager.

Without someone to push me, I floundered. Although I managed to graduate from high school, my grades weren't good enough for admission to the University of California. And so I started out at a junior college.

To earn my way, I worked at a chicken farm at minimum wage, because I couldn't get a job doing anything else with the kind of grades I had. Finally, I wised up and transferred to a state college, but still, I didn't get it. I received an F in chemistry because I was doing math problems for fun during class and playing around all hours of the night.

It took me an entire year before a lightbulb went on: *If I don't get on the stick, I'm going to flunk out!* Once I had my epiphany, I was literally scared straight.

From that point on, I never got anything less than an A. I earned a 4.0 the rest of my time in college. I transferred to California State University at Los Angeles, where I studied math and psychology. Then, after a few years working in the aerospace industry, I went to the University of California at San Diego, where I earned a PhD in experimental psychology. I wanted to become a user-interface engineer whose job was to make it simple for humans to operate machines and computer applications.

Even before I finished my doctorate, I went to work for Xerox, and it was there that I learned another valuable lesson. Although I had completed a rough draft of my dissertation by the time I started working, I started loving my work so much that I dragged my heels on finishing my degree.

One day my boss turned to me and said bluntly, "I hired a PhD, and next year I'm going to have one. There's nothing you could do that's more important than finishing that dissertation. One year from now, if your diploma is not in your hand, your desk will be occupied by someone else."

Four months later, my dissertation was finished.

My boss did me a major favor that day, and now I'm giving it

back. I want kids to know what's important and to have the tools to face the competitive world that's ahead of them.

—Robert Springer, PhD

"I've had all kinds of accolades," Robert concluded, "but the only thing I find meaningful is seeing the scores go up. I can tell that we're making a difference. The opportunity to influence people to gain an education gives me a personal burst of joy."

Searchlight:

Have you experienced the joy of helping a child or adult succeed?

Your Point of Light:

Devote yourself to one person or nonprofit project until you can feel a burst of joy.

A man without passion is only a latent force, only a possibility, like a stone waiting for the blow from the iron to give forth sparks.

—HENRI-FREDERIC AMIEL

Discovering
Your Point of Light

Through the pages of this book, you've met people from all walks of life and every corner of America who have discovered a passion, a Point of Light that has generated tremendous power in the lives of others.

You've encountered Tim Miller and his Texas EquuSearch . . . Melanie Washington and her teen prison inmates . . . Molly Banz and her Angels . . . Phil Stevens and his military housing for American Indians . . . and many more.

The single-minded focus of each one of these individuals may seem extraordinary and even awe inspiring, far beyond anything you could imagine for yourself. But are their accomplishments really so out of reach?

Think a moment about yourself. What is *your* passion? What is the gift or ability that will light up your world? We invite you now to probe deep within yourself and your interests to discover the one thing that will set you on fire for others. To help you identify your Point of Light and determine where you can shine brightest, try the following simple self-test.

Discovering Your Point of Light:

✧ Twelve Questions

1. What is your passion? What do you like to do best or care about most?

2. How do you think your passion can be used to help others?

3. Have you faced any personal challenges that have prepared you to use your passion for others?

4. What type of service in the past has made you feel good?

5. If you could do one thing for the rest of your life, what would it be?

6. What group or organization do you think might help you reach that goal? If no group comes to mind, consider how you might start one through an existing nonprofit that you could locate through the Points of Light Foundation's Volunteer Center National Network.

7. What personal qualities do you possess that could make a dramatic difference in the life of an individual or organization? Think about your personal gifts of compassion, encouragement, sensitivity, patience, leadership, or team spirit.

8. What particular set of experiences and skills might help you serve others—for instance, secretarial, medical, construction, teaching, public relations, counseling, networking, fund-raising, finance, athletic, or artistic?

9. Where would you feel most comfortable serving—in a school, prison, office, hospital . . . or anywhere else you could be used?

10. What confirmation or feedback have you received from

others or from past experiences that leads you to believe
you should serve others in a particular way?

11. Now it's time for a decision: What is your Point of Light?

12. How will you start letting it shine—today?

Once you have an inkling of what your Point of Light might
be, then it's up to you to take the first step . . . and the next . . .
and the next . . . to find out where and how you can put your pas-
sion to work. But how do you get started?

Your Point of Light Action Plan

Activating your Point of Light is not as difficult as you might
think. By following a few simple strategies that have worked for us
personally and for many of the nearly 30 percent of Americans
who volunteer in this country every year, you'll be on the path to
a lifetime of active giving.

✧ Know Where to Volunteer

All across America, more than 350 Volunteer Centers are
waiting for your call. Simply by dialing 1-800-VOLUNTEER,
you'll be connected directly to a Volunteer Center in your area
that will match your interests to a local organization that needs
help. Alternatively, log on to www.1800volunteer.org, punch in
your zip code, and you'll be referred to a Volunteer Center near
you. You can also connect to the Points of Light Foundation web-
site, www.pointsoflight.org, where a map will direct you to the
Volunteer Centers that cover 58 percent of the country.

These Volunteer Centers, many of which have been around

since the end of World War I, are linked through the Volunteer Center National Network and the Points of Light Foundation. Although each center operates independently, they all provide connections for people like you to give hands-on service.

Typical is the Volunteer Center of Bergen County, New Jersey, which has been serving the metropolitan New York area for thirty-nine years. Every year, the center refers twenty thousand young people and adults to local day care centers, senior centers, hospitals, and other organizations that are desperate for help.

"We try to make it as easy as possible for the person who wants to volunteer," said the center's executive director, Janet Sharma.

Most volunteers get connected through calls to 1-800-VOLUNTEER or through the organization's website, www.bergenvolunteers.org, which offers a database with thousands of service opportunities in the Bergen County area. Simply by plugging in a key word, geographic location, or agency name, volunteers can find a service project that suits their passions.

In addition, the center supervises 650 volunteers, many of whom provide direct service as mentors to teen mothers, girls at risk for pregnancy, and women who have been reported for child abuse or who are moving from welfare to work. Other volunteers perform home repairs for the elderly. Still others work with local nonprofit organizations through one of the center's major outreach programs: the Retired and Senior Volunteer Program, and Volunteer Ventures, a group of busy working adults.

As if those programs weren't enough, the center trains nonprofits in volunteer management and coordinates the Northern New Jersey Business Volunteer Council, an alliance of thirty-four companies with thirty-five thousand employees who participate in various volunteer projects to benefit children and families.

"For a prospective volunteer, we're nothing less than one-stop shopping," said Janet Sharma.

✮ ✩ ✩ ✩ ✩ ✩ ✩ ✩

Quick Tips to Get Started

If you don't know where to start as a volunteer, try these tips offered by Bill Bentley, vice president of the Points of Light Foundation.

✧ Call 1-800-VOLUNTEER.

You'll be connected directly to a Volunteer Center in your area that will link you to groups that need your help. If there's no Volunteer Center near you, you'll be given information on various national days of service when you can volunteer.

✧ Go online at www.1800volunteer.org or www. pointsoflight.org.

Type in your zip code, and a contact number for a Volunteer Center in your area will pop up. Fifty-eight percent of the country is served by centers that are connected to the Points of Light Foundation and its Volunteer Center National Network, and more are in the works.

✧ Contact your house of worship.

Faith-based organizations have always been a conduit for service. Forty-two percent of Americans are working through churches, synagogues, mosques, and other religious organizations.[5] You'll find that faith-based soup kitchens, shelters, thrift shops, schools, and hospital visitation teams always need your help.

✧ Check with your company's human resource department.

Workplace volunteering is increasing as companies un-

derstand the benefits to their employees and to the bottom line. Companies such as Disney, Shell Oil, KPMG, and UPS are leading the way, with programs that often give workers time off to volunteer. If your company doesn't have a program, start one. For information, log on to www.pointsoflight.org.

✧ **Sign on for a National Day of Service.**

Eight days throughout the year have been earmarked for special volunteer action in communities across America. Check appendix C for a list of dates and ideas on how you might serve.

✧ *Make Giving a Family Affair*

"But I don't have time to volunteer!" you protest. "I work all week and I need to be with my family on weekends."

The remedy: Take your family with you. You'll discover that volunteering together at the local environmental center, Habitat for Humanity, or soup kitchen will not only strengthen family relationships but also sow seeds of giving in your children. Research has shown that 66.8 percent of adult volunteers got started as young people.[6] But more important than the statistics is what those figures represent: a process of character formation that nurtures in each child an unshakable spirit of giving.

Take the Kinkade family. The entire family not only pitches in with Merritt's cookie projects for the old folks' home and volunteers to serve at countless community and church fund-raising events annually, but also incorporates giving into family vacations. One summer, the family trekked off to Guatemala to help World Vision in its efforts to build a family shelter for homeless kids who

literally lived in the city dump. Another year, they all headed for Latvia to work in an art camp for orphaned children.

"These kids were so appreciative and excited about their chance to be creative and hold a crayon in their hand—things that Americans take for granted," said Merritt. "Because I've had these experiences, I now dream of getting a job after college working with children in countries all over the globe."

ROBERT GOODWIN

☆ ☆ ☆ ☆ ☆ ☆ ☆ ☆

A Bowl of Soup Feeds a Lifetime of Service

My mother liked to say that "service is the price we pay for our room and board on earth." At 102 years old, Jeanne Goodwin is not only the family matriarch but also the matriarch of the city of Tulsa, where her volunteer exploits are legendary.

She saw to it that each of her eight children was exposed to her outreach projects from the time we were small. My earliest memory of volunteering was the day I helped her deliver soup to a sick woman not far from our home. The woman lived in a house warmed by a potbellied stove with an outhouse out back. I was only five, but the vision of my mother stirring the soup and feeding it to the woman is seared in my consciousness.

From then on, I was involved in service. First, I volunteered at the Jack and Jill Club, a cultural enrichment and service organization in the black community where we made greeting cards for the homebound or visited senior citizens' centers. Next, in junior high and high school, I conducted food drives and fund-raising campaigns. Later, in college, I was involved in a wide range of service and ministry activities that took me literally around the world with student teams.

Without that early inspiration from my mother, I might not be serving as president and CEO of the Points of Light Foundation today. I believe we have to be conditioned to give. If we nurture our children with notions of respect, compassion, and community, we will counter the selfishness of popular culture—what I call "the coarsening of America"—with brighter, nobler ideals that will shape our children's and our country's character for years to come.

—Robert Goodwin

CHRIS TOPPE

✧ *Let Your Light Shine at Work*

Increasingly these days, corporations are recognizing that volunteer service is not only good for their employees and good for their communities, but also good for business. Statistics indicate that 52 percent of Americans are "inclined to start or increase their business due to corporate citizenship."[7] As a result, corporations ranging from giants such as UPS to smaller firms like Tucson Electric Power Company have created outreach programs that encourage staff participation by providing days off and recognition programs for those who volunteer. A good example is the tutoring program for first graders started for employees of the Points of Light Foundation by staff member Chris Toppe, a senior social scientist. Spurred by the desire to establish a program that could make an impact but was simple to execute, he set up an eight-week pilot project in Watkinsville Elementary School in Gaithersburg, Maryland.

"We work with kids who have been identified by teachers as needing help with basic skills, such as math, spelling, and oral language," said Chris, who dubbed the project Partners in Education.

What makes the program work, he added, is that "we're teaching something we're comfortable teaching."

From the start, Chris wanted to make the program as accessible as possible for the volunteers, all of whom have full-time jobs at the Points of Light Foundation. "People needed to know clearly where to go, what they were expected to teach, how they would relate to the teacher, and what materials were available." The volunteers also needed *time,* and so the Points of Light Foundation kicked in with one day off per month for those who wanted to participate.

The pilot project's format was straightforward: Three mentors were assigned to a first-grade classroom for hour-and-a-half sessions. Working with two children apiece, the mentors rotated their students through each subject, devoting half an hour to math, to spelling, and to oral language. Over the course of eight weeks, the program provided each child with twelve hours of tutoring, which paid off in increased performance according to tests administered before the tutoring started and after it ended.

The results were so promising that plans are now in the works to expand the pilot to the IBM Corporation through the Volunteer Center of Montgomery County, Maryland. Also, there are efforts to pull in other corporations nationwide through the Points of Light Foundation's Corporate Volunteer Council.

If your company doesn't have an employee volunteer program, contact the Points of Light Foundation to find out how to start one. The foundation can provide you with opportunities for training and organization, networking through a national conference, and potential national recognition through its annual Awards for Excellence in Workplace Volunteer Programs and the George Bush Corporate Leadership Award.

TIM CHENEY

✧ Look Close to Home

Chances are you don't have to look very far to find your Point of Light. You may have a light of personal experience glowing deep inside that gives you a special insight or connection to particular individuals or groups.

Take Tim Cheney. The retired entrepreneur, who hails from Maine and Florida, turned the tragedy of his own childhood into a plus by becoming a court-appointed guardian ad litem for troubled boys.

"God gave me a second chance in life," said Tim. "As a result, I have a lot of compassion for people who are in pain, particularly kids."

After a sledding accident as a child left him institutionalized for a year and a half, first in a hospital psychiatric ward and then in a group home for emotionally disturbed children, Tim went on a downward spiral of drinking and drugs.

"I felt abandoned and rejected by my family," he said. "I felt different and alone."

With his self-esteem at a low ebb, Tim turned to the streets, where he lived on his own at age fifteen and found comfort among a peer group of addicts and others in the underbelly of society. For the next fifteen years, he was in and out of jail, hospitals, and a variety of treatment programs. Somehow he managed to work his way through college while undergoing outpatient treatment in a methadone program. But at age thirty, his hard life finally caught up with him.

Lying near death on a gurney in Yale–New Haven Hospital—bleeding from a knife wound to the abdomen and riddled with acute hepatitis C, cirrhosis of the liver, and cellulitis—he had an epiphany: *This is it,* he said to himself. *This is my final curtain call. I want to live!*

Determined to turn his life around, he started attending Alcoholics Anonymous and Narcotics Anonymous and served as a VISTA volunteer, working with drug addicts and alcoholics in the New Haven jail. Along the way, he attended Yale Divinity School and found his niche in the business world, where he created a successful executive search and computer consulting company.

"I went from jail to Yale, and from sweeping floors to being financially secure," he likes to quip.

Now he's using those experiences to encourage kids who are in danger of falling through the cracks in the court system. After intensive training as a guardian ad litem, he mentors three teenagers who have been removed from their families for their own protection. One, a fifteen-year-old Hispanic with a family history of violence and crack addiction, lives in a youth shelter awaiting placement with a foster family.

"I had him removed from his home," said Tim, who feared for

the young man's life after being present at a nine-and-a-half-hour stand-off with the boy's parents on their front lawn. Tim visited the boy every couple of weeks and outfitted him for school with everything from T-shirts to pants to shoes. "He didn't have a thing."

But Tim's compassion is tempered by the reality he knows only too well. "I want these boys to know they have a choice in life. Their lives might be difficult, but they don't have to spend the rest of their days playing the role of victim. It's up to each one of them to take responsibility for his own future."

As for Tim, he summed up the impact of his volunteering this way: "Working with these boys makes me feel whole because it's unconditional giving. It's not about me."

❖ Be Ready to Respond

Opportunities to serve others can appear without warning, as they did with hurricanes Katrina and Rita. But when such crises hit, are you prepared to drop everything at a moment's notice and lend a helping hand?

Joe Huston is the kind of guy who immediately jumps in, as he did with Hurricane Katrina. As the volunteer search director for Texas EquuSearch, Joe led a team to Plaquemine Parrish in Louisiana, just weeks after returning from a thirty-nine-day stint in Aruba searching for missing teen Natalee Holloway.

An independent financial consultant who advises physicians and dentists, Joe can keep his business going almost anywhere in the world by fax and cell phone—anywhere, that is, except in the Gulf region after the hurricane.

In Louisiana, he found houses "pan-caked, lifted off their foundations, and stacked up like multiple car wrecks." For several days, his team forged through chest-high polluted water, walking

JOE HUSTON

house to house to check for the living and the dead—until the sheriff's department called a halt to the effort because of the fetid water.

Undaunted, Joe and his team turned to East New Orleans, where they worked side by side with the 148th Infantry Division, a National Guard unit out of Ohio. Because of his search-and-rescue expertise throughout the United States and in Sri Lanka after the tsunami, Joe found himself put in charge of two squads of National Guardsmen. Their task: to convince any remaining residents to evacuate. In a neighborhood partially engulfed in water, Joe and his team found three people still alive but determined to stay.

Two of the residents—a Vietnamese father and son—finally relented and were airlifted out, but Mary, a woman in her seventies, refused to budge. Forty-eight hours later, when the team made a last-ditch effort to rescue her, she was adamantly sticking to her guns.

"She didn't want to leave her cats or be a bother to her kids," said Joe, who estimated she had five days' worth of food and water on hand.

"I knew that if she didn't get out soon, she would die."

After Joe managed to wheedle out of Mary the name of her son-in-law and the state he lived in, he called the Texas Equu-Search office to track him down. Within days, the group's volunteer staff located the man, who arranged for Mary's rescue. She is now safe and sound, living with her daughter and son-in-law.

"It was a team effort," said Joe. "In Louisiana, we had thirteen people who gave up time from work or used vacation time to respond to Katrina. Among them were a paramedic, a teacher, and several business owners. None of us had ever worked together before, and yet we all had the same goal: to save as many lives as we could."

But for Joe, the payoff is even more personal. When he returned from Louisiana, his seventeen-year-old son gave him a hug and, with a tear in his eye, said, "Dad, I'm really proud of what you're doing."

✦ Play to Your Strengths

Sometimes the most effective way to use your talents for others is to do what you know best. For culinary expert and cookbook author Richard Grausman, that meant one thing: teaching kids—especially those in academic difficulty—how to cook for a living.

After a successful career teaching French cooking to adults across America for the Cordon Bleu school in Paris, Richard turned his energies to the New York public schools, where he hoped to influence the taste of a new generation of young people.

"I had been to a conference where the speaker had presented a grim forecast for the future of cooking in America," said

RICHARD GRAUSMAN

Richard. "After hearing a woman talk about cookless kitchens, microwaves in automobiles, and families eating on separate schedules, I came away depressed."

Then one day in the shower, he continued, a lightbulb went on in his head: *If there's anything I can do in the latter part of my life to change the cooking forecast, what would it be?*

The answer came quickly: *Get into the schools!*

It didn't take long before he proposed a series of free cooking classes for teachers to the New York City Board of Education. Although the board jumped at the chance to introduce Richard's new recipes and cooking techniques, there was only one hitch: There was no money to pay for ingredients and equipment.

A trip to a school in Brooklyn confirmed the dire situation. During a bread-baking class, Richard peeked in the classroom cabinets and drawers and discovered that the cupboards were, indeed, bare.

"I paid for the flour out of my own pocket," the teacher confided.

Rolling into action, Richard called his contacts in the kitchen equipment industry, and before long donations came pouring in. There were pots, pans, chocolate, flour, butter—everything a teacher would need to transform the palates of his students.

"It was like Christmas and Hanukkah all put together," the teachers told Richard. He inaugurated his first class for teachers in October 1989, and by the following February he had twelve schools lined up for his cooking program.

From there, Richard's vision exploded. "Speaking with the kids, I realized that the students in these classes were the ones the public schools had failed. They were D and F students, who had no preparation for a job or a future."

Richard immediately changed all that by finding restaurants where students from his classes could get entry-level jobs. Within months, he had launched a full-fledged nonprofit organization called Careers through Culinary Arts Program, or C-CAP, to serve as a vehicle for donations. Within five years, in addition to New York, he had programs up and running in Philadelphia, Washington, DC, Norfolk, Chicago, Phoenix, and Los Angeles. In 2005, he added Boston to the lineup.

Now in its sixteenth year, C-CAP works with ten thousand students annually in two hundred schools across the country, providing $2 million each year in scholarships. Since the program began, more than $15 million in scholarships has been awarded to up-and-coming chefs, who are working in such establishments as Bobby Flay's Mesa Grill, Charlie Palmer's Aureole, and the Four Seasons Hotels.

"We're affecting lives in a dramatic fashion," said Richard, who earned the President's Volunteer Service Award for his ef-

forts. "People say that you get so much more out of giving than receiving, but until you give in a way that's meaningful to you, you don't really get it.

"There are lots of successful people out there who could gain a lot of pleasure out of the latter period of their lives by passing the things they've learned on to others."

✧ Partner with Established Organizations

Some of us, including several of the people highlighted in this book, are take-charge types who have a vision for an innovative program and want to shepherd it through to completion. But before you take the plunge to create your own nonprofit organization, take a step back. Starting a nonprofit from scratch can be a bureaucratic nightmare, fraught with complicated accounting, fund-raising pressures, and organizational glitches.

Instead, why not explore working with a nonprofit group in your community that is well established? Youth groups, foundations, and even faith-based organizations might be potential partners. Working through such groups, you might have access to office space, volunteer leadership, grant-writing expertise, and community goodwill that could jump-start your program.

That's the route followed by two Florida women who initiated a program called the Teen Writers Workshop. Their idea was to introduce teenagers to professional writers through free half-day workshops on Saturdays throughout the year.

To get started, they linked up with the Laura Riding Jackson Foundation, a local group that promoted literary arts. Working through the foundation, which had a talented grant writer as executive director and a track record with the state of Florida's Division of Cultural Affairs, they were immediately able to start

getting grants and donations to keep the program afloat. The partnership even resulted in a $10,000 grant from the National Endowment for the Arts, one of only six in the state of Florida at the time.

With funding secure, they also enlisted the cooperation of the local Environmental Learning Center, which provided free space for the workshops, and they were up and running.

Since the program started in July 2000, the Teen Writers Workshop has reached more than eight hundred high school students in six counties through eighteen workshops—three of them in a prison for teen felons adjudicated as adults.

"Our partners provided a springboard to success," said one of the workshop's founders. "Without their network and expertise, we would never have been able to pull this off."

❖ Get Creative

Think out of the box for ways to merge your artistic or entrepreneurial talent with a worthy cause.

Take a kid named Kinkade. As a newspaper boy in Placerville, California, back in the 1960s, he took his first entrepreneurial steps to raise money for a blanket drive for starving children in Mexico. The budding artist designed a poster that looked just like a newspaper ad and inserted mimeographed copies in each copy of the *Sacramento Bee* on his paper route. The poster looked so real that his customers called immediately with donations.

In a more recent case, James Pangilinan, a student at Wesleyan University in Connecticut, combined his passion for helping the homeless with his instincts as a filmmaker to create his first feature film, *An American Childhood*. The ten-minute film, which he shot on location on the streets of LA, juxtaposed scenes of Rodeo Drive

JAMES PANGILINAN

and Beverly Hills with gritty street life among the homeless who came to his aunt's food outreach program, Mama D's Kitchen.

The result was a gripping look at poverty in America. A screening at James's affluent high school not only raised awareness but also brought in $300 for his aunt's program.

Not content to rest on his laurels, James has now set his sights on Africa, where he spent several weeks teaching English a few summers ago.

"No one is paying any attention to the crisis in Darfur," he lamented. "Children are dying by the thousands, and nobody cares."

Is there a new movie in the works, perhaps a universitywide fund-raising campaign in the offing?

James is keeping mum, but you can be sure that the creative wheels are turning.

Searchlight:

Have you ever taken time to meditate on what your Point of Light might be?

Your Point of Light:

Set aside an hour *today* to take the self-test, Discovering Your Point of Light, on page 158. You might be surprised at what you find out about your passion and how quickly you'll be ready to act on it.

You are the light of the world. . . . Let your light so shine before men, that they may see your good works and give glory to your Father who is in Heaven.

—MATTHEW 5:14–16 (REVISED STANDARD VERSION)

Letting Your Light Shine

Whatever your Point of Light may be, it's an expression of an expansive attitude toward life, a spirit of giving that wells up from a source deep within. This spirit celebrates selflessness over selfishness, compassion over vanity, and community over consumption. It recognizes the obligation each of us has to give something back, to make a vital connection to others that can strengthen and sustain our society and our world one person at a time.

Right now your Point of Light may be only a glimmer, a faint promise of something more. But if you start your day in a spirit of giving, you will begin to fan the flames of service and see every encounter in a new way, as an opportunity to share the light. After all, if light is love in action, then wherever you are—on the way to work, walking around the mall, or coming back from a movie— your antennae may pick up a signal from someone in crisis and send a message that goes straight to your heart: *Do something!*

When that happens, you're likely to act. Reflect back on that time, perhaps not so long ago, when the cashier at the grocery store had tears in her eyes as she rang up your charges. Did you fumble with your purse and pretend that you hadn't noticed? Or did you stop and ask her what was wrong?

Or consider that lunchtime at the restaurant counter, when a scruffy guy slid onto the stool next to you and asked you for a cup of coffee. Did you brush him off and keep reading your newspaper? Or did you buy him a sandwich to go with that cup of java?

You may also harbor a nagging memory of the blind man you saw trying to hail a cab in the pouring rain. Did you jump into the only cab in sight because you were late for an appointment? Or did you help him into that available taxi and then wait patiently until another one appeared?

Situations like these seem to arise at the most inconvenient times or places, but perhaps it's the very inconvenience that makes our response so meaningful. Take a lesson from Charlotte Terry, who is always in a hurry but never too rushed to let her special light shine.

A Wallet Full of Miracles

Charlotte was driving up Route A1A at eight o'clock one morning on her way to a volunteer "turtle patrol" meeting on the beach in Indian River Shores, Florida, when, out of the corner of her eye, she spotted a wallet in the middle of the road.

"I was late, as always, and I really didn't have time to stop, but something in me said, *Do it!*" Charlotte explained. "I knew the wallet was important to the person who had lost it. Because my husband had just lost one a few weeks earlier, I was especially sensitive to this situation. And so I stopped."

Charlotte picked up the wallet, identified the owner, and tried several times to reach her. "When I finally tracked her down, she was hysterical with joy—she was actually in tears," said Charlotte.

As it turned out, the elderly owner of the wallet had been displaced from her home by one of the hurricanes that had recently

CHARLOTTE TERRY

hit central Florida, and her emotions were unusually fragile. The recovery of her wallet meant more to her than merely reclaiming a possession; in the depths of her being, it represented a sign that her life would soon get back in order.

"I'm glad you have some peace," Charlotte told the woman when she handed over the wallet. "I was hoping that someone would do the same for my husband."

Charlotte's husband never did get his wallet back, but a few months later Charlotte got a special payback of her own. She was heading for the ticket booth at a rodeo, where she was treating two inner-city boys to an old-fashioned Florida experience. But when she reached in her pocket to pay the admission fee—you guessed it: Her wallet was missing.

"Has either of you seen my wallet?" she said to the boys. "I must have lost it, and if I don't find it I can't pay for the rodeo."

The boys scrambled into action, searching inside and outside

her red pickup truck, but with no luck. Finally, they ran to the rear of the vehicle, where one of them discovered the wallet lying precariously on the back bumper.

"This is a miracle!" Charlotte told the boys. "We've just driven an hour and a half on bumpy roads, and this wallet stayed on the bumper the whole time. Is God good, or what?"

The boys, wide-eyed, nodded in assent. Charlotte picked up the wallet, bought the rodeo tickets, and ushered the boys to their seats just in time to see the first bull rider bolt out of the gate.

Some might see this as a coincidence. Others might say, "A real piece of good luck!"

Charlotte doesn't see it that way.

"We're all interconnected," she said. "If you do something good for someone else, it will come back to you."

Many of us genuinely *want* to reach out to others, to go the extra mile for someone else, but something holds us back. Maybe you're like that, and you're waiting to be asked to lend a helping hand. If so, you're in good company: 70 percent of Americans who volunteer say they got involved simply because someone asked them.[8]

So why wait any longer? *Consider yourself asked.* Today, right now, this very minute, we're inviting you to take the next step: Embrace your Point of Light! If anyone questions why, say it's because George Bush, Bob Goodwin, and Thomas Kinkade asked you.

And then . . .

Let your light shine.

Share the Light

The Points of Light Foundation would like to hear from you.
Please send us your own amazing stories of service as you or
someone you know shares the light in a unique and interesting
way. As we like to say, "The difference between a good society
and a great one is the heart of service evident in its citizens."
—Robert Goodwin and Thomas Kinkade

Send stories to: info@pointsoflight.org

☆ ☆ ☆ ☆ ☆ ☆ ☆ ☆ ☆

The Extra Mile

Hollywood has its Walk of Fame, and now the nation's capital has "The Extra Mile," a pathway near the White House that celebrates the exploits of some of America's most illustrious volunteers. Highlighted in a series of bronze plaques embedded in the pavement, these luminaries, who embody the best of the American spirit of giving, include Helen Keller, Clara Barton, and Martin Luther King Jr.

For information about The Extra Mile, which was dedicated by former President George Bush and Barbara Bush on October 14, 2005, log on to the Points of Light Web site: www.pointsoflight.org. If you're in Washington, DC, simply go to the corner of Fifteenth Street and Pennsylvania Avenue, NW, where The Extra Mile begins.

As you're walking the pathway, keep in mind that the names in bronze are just ordinary people who had an intense passion, a Point of Light that shined intensely on the American landscape. Someday your name could be among them.

Searchlights

To gauge where you stand on the continuum of giving, review these Searchlights from the preceding chapters, and make a commitment over the next year to take action.

Looking for Your Light

Searchlight 1: Do you seek ways to affirm at least one person in your life every day?

Searchlight 2: At least once a week, do you hear yourself saying, "I want to do this because it's best for another person"?

Searchlight 3: Does your heart skip a beat when you hear on the news about a family or a child in trouble?

Searchlight 4: At least three times a year, do you step out of your comfort zone to show kindness to a total stranger?

Searchlight 5: Is there someone you need to forgive today?

Searchlight 6: Have you been a source of encouragement to at least one person today?

Searchlight 7: Have you persevered with a person in trouble or a program in need, even when the payoff wasn't obvious or immediate?

Searchlight 8: Have you taken time to mentor a needy child or teenager one-on-one?

Searchlight 9: By your words and actions, have you sought to instill confidence in a child, a friend, or a family member today?

Searchlight 10: Do you spend at least 10 percent of your available time in activities that benefit people other than your family?

Searchlight 11: Have you experienced the joy of helping a child or adult succeed?

Searchlight 12: Have you ever taken time to meditate on what your Point of Light might be?

Inside the Points of Light Foundation

The Points of Light Foundation was founded in 1990 to engage people and resources more effectively in volunteer service to help solve serious social problems.

Initiated by former President George Bush, the foundation works in partnership with the Volunteer Center National Network, a group of 350 independent Volunteer Centers throughout the country, to advocate and motivate volunteer action. The foundation's areas of responsibility include:

National awards programs, such as the Awards for Excellence in Workplace Volunteer Programs; the Daily Points of Light Awards; the President's Volunteer Service Awards; and the George Bush Corporate Leadership Awards.

Make A Difference Day, a national day of service organized by the foundation in cooperation with *USA Weekend* magazine.

The National Conference on Community Volunteering and National Service, which is held annually in partnership with the Corporation for National and Community Service to provide workshops and networking opportunities for corporations and nonprofits working with volunteers.

Corporate volunteer-development services, to help businesses build and run employee volunteer programs. Recognized nationally as *the*

resource for corporations interested in promoting volunteering in the workplace, the foundation provides hands-on training and consultation, as well as extensive publicity and national recognition for superior corporate efforts.

"We Are Family" Project, a re-recording of the pop song by more than a dozen artists—including BeBe Winans, Chris Brown, and Ciara—to raise funds to provide vital services to the estimated 200,000 families displaced by Hurricane Katrina. Distributed by Universal, the "We Are Family" CD and DVD are available at www.wearefamily2006.com, Wal-Mart, and other leading retailers.

The Extra Mile—Points of Light Volunteer Pathway, the nation's newest monument, which features a walkway near the White House in Washington, DC, emblazoned with bronze plaques commemorating Americans who have changed the world by going the extra mile for others.

<div align="center">

Points of Light Foundation
1400 I Street, NW, Suite 800
Washington, DC 20005-6526
Phone: 202-729-8000
Fax: 202-729-8255
www.pointsoflight.org

</div>

National Days of Service

The National Days of Service calendar is a portfolio of initiatives that provide opportunities for millions of people to volunteer their time and talents to service projects and activities throughout the year.

The Points of Light Foundation and the Volunteer Center National Network established the National Days of Service Calendar to mobilize volunteers through flexible, onetime volunteer opportunities throughout the year.

Martin Luther King Jr. Day
January, Third Monday of the Month—A Day On, Not a Day Off!

During his lifetime, Dr. Martin Luther King Jr. forged common ground on which people from all walks of life could join together as equals to address important community issues. Each year, the Corporation for National and Community Service, the Martin Luther King Jr. Center for Nonviolent Social Change, Inc., the Points of Light Foundation, and other national organizations work together to make service to others the common expectation of all Americans during this national holiday. For more information, contact: 202-729-8144; mlkday@cns.gov; www.mlkday.org.

National Youth Service Day (NYSD)

April—Youth as Community Assets, Resources, and Leaders

Over the past decade, National Youth Service Day has brought together more than thirteen million people in thousands of communities nationwide. National Youth Service Day has three primary goals: to mobilize youth to identify and address the needs of their communities through service; to recruit the next generation of volunteers; and to educate the public about the year-round contributions of young people as community leaders. NYSD is a program of Youth Service America in collaboration with the National Youth Leadership Council, *Parade* magazine, and sixty national partner organizations. For more information, contact: Youth Service America, 202-296-2992; info@ysa.org; www.ysa.org/nysd.

National Volunteer Week

April—Inspire by Example!

National Volunteer Week began in 1974 when President Richard Nixon signed an executive order establishing the week as an annual celebration of volunteering. Every president since has signed a proclamation promoting National Volunteer Week. Governors, mayors, and other elected officials also make public statements and sign proclamations in support of National Volunteer Week. Sponsored by the Points of Light Foundation and the Volunteer Center National Network, National Volunteer Week is the official time to recognize and celebrate the efforts of volunteers at the local, state, and national levels. For more information, contact: 202-729-8168; volunteerweek@pointsoflight.org; www.pointsoflight.org/nvw.

Join Hands Day

May—Youth and Adults Volunteering Together

As we fast become an age-segregated society, the goal of JOIN HANDS DAY is to begin making connections and friendships across generations that will continue long after the day is over. Developing these relationships is essential to creating healthy organizations, neighborhoods, and communities. JOIN HANDS DAY is sponsored by the National Fraternal

Congress of America in partnership with the Points of Light Foundation. For more information, contact: 877-OUR-1DAY; www.joinhandsday.org.

One Day's Pay
September 11

One Day's Pay, a nonprofit public benefit corporation, was founded in 2002 to honor the victims of the September 11 terrorist attacks on America. We pay tribute to them by working to establish September 11 as a national day of voluntary service, charity, and compassion, and by encouraging individuals, employers, and groups to permanently set aside time each September 11 to help others in need through service or other giving activities. The day is sponsored by One Day's Pay in partnership with Points of Light Foundation, Youth Service America, and Citizen Corps. For more information, contact: www.onedayspay.org; info@onedayspay.org.

Kids Care Week
October, Fourth Week of the Month—Celebrate Kids Making a Difference in Their Community

You're never too young to volunteer! Kids Care Week is dedicated to recognizing the power of kids to reach out and help others in their local and global community. During the week, young people focus their compassion on a specific social issue by participating in a national service project. Kids Care Week is celebrated during the fourth week of October, culminating on Make A Difference Day. For more information, contact: Kids Care Clubs, 203-656-8052; www.kidscare.org.

Make A Difference Day
October—A National Day to Help Others

Known as the "national day of doing good," Make A Difference Day is a national effort designed to mobilize citizens in communities across the country in volunteer service. As a result of the work of volunteers, the lives of millions of others are greatly improved. Make A Difference Day is co-sponsored by *USA Weekend* magazine and the Points of Light Foundation

with the support of Newman's Own. For more information, contact: 800-416-3824; diffday@usaweekend.com; www.makeadifferenceday.com.

National Family Volunteer Day

November, Saturday before Thanksgiving—Time Together—Time to Act

National Family Volunteer Day is designed to showcase the benefits of families working together, to introduce community service, and to encourage those who haven't yet made the commitment to volunteer as a family. National Family Volunteer Day is held the Saturday before Thanksgiving and kicks off National Family Week. For more information, contact: 800-VOLUNTEER; www.pointsoflight.org/programs/seasons/NFVD.

Key Contacts for Giving and Volunteering

Points of Light Foundation
1400 I Street, NW, Suite 800
Washington, DC 20005-6526
Phone: 202-729-8000
Fax: 202-729-8255
www.pointsoflight.org
Volunteer Center National Network
Points of Light Foundation
1-800-VOLUNTEER
www.1800volunteer.org

Chapter One: Timothy Miller
Texas EquuSearch Mounted Search and Recovery Team
PO Box 395
Dickinson, TX 77539
281-309-9500
www.texasequusearch.org

Chapter Two: Timothy Radcliff
The Seeing Eye, Inc.

PO Box 375
Morristown, NJ 07963-0375
973-539-4425
www.seeingeye.org

Chapter Three: Molly Banz
Molly's Angels
1700 Second Street, Suite 255
Napa, CA 94559
707-224-8971
www.mollysangels.com

Chapter Four: Merritt Kinkade, Robyn Strumpf
The Thomas Kinkade Company
900 Lightpost Way
Morgan Hill, CA 95037
www.thomaskinkade.com

Project Books and Blankies
Attn: Robyn Strumpf
www.booksandblankies.com
www.booksandblankies@aol.com

Chapter Five: Melanie Washington
Mentoring—A Touch From Above
3515 Linden Avenue
Long Beach, CA 90807
562-490-2402
www.matfa.org

Chapter Six: Fred Downs, Jim Mayer
Veterans Administration
www.va.gov/volunteer
Or call your local veterans hospital and ask for volunteer service.

Chapter Seven: Phil Stevens
Walking Shield American Indian Society
22622 Lambert Street
Lake Forest, CA 92630
949-639-0472
www.walkingshield.org

Chapter Eight: Lynn Price
Camp To Belong
9455 Sand Hill Place
Highland Ranch, CO 80126
303-791-0915
www.camptobelong.org

Chapter Nine: Judge Mary Terrell
The High Tea Society
PO Box 29024
Washington, DC 20017
202-806-7621
highteasociety@yahoo.com
www.highteasociety.org

Chapter Ten: John Sainsbury
Habitat for Humanity RV Care-A-Vanners
rvinfodesk@hfhi.org
www.habitat.org/rv

Indian River Habitat for Humanity
Andy Bowler, Executive Director
4568 North US Highway 1
Vero Beach, FL 32967
772-562-9860
www.irhfh.org

Habitat for Humanity International
121 Habitat Street
Americus, GA 31709-3498
229-924-6935
www.habitat.org

Chapter Eleven: Dr. Robert Springer
Project Catapult
SaddleBrooke Community Outreach
63675 SaddleBrooke Boulevard, Suite L
Tucson, AZ 85739
520-825-3302
www.community-outreach.org

Chapter Twelve: Discovering Your Point of Light
Volunteer Center of Bergen County
Attn: Janet Sharma
64 Passaic Street
Hackensack, NJ 07601
201-489-9454
www.bergenvolunteers.org

Partners in Education
Attn: Chris Toppe
Points of Light Foundation
1401 I Street, NW, Suite 800
Washington, DC 20005-6526
202-729-8000
www.pointsoflight.org

Guardians for New Futures, Inc.
Attn: Tim Cheney, President
PO Box 3211

Fort Pierce, FL 34948

tcheney@guardiansfornewfutures.org

www.guardiansfornewfutures.org

Or to volunteer as a guardian ad litem in your area:

www.nationalcasa.org

Careers through Culinary Arts Program

Attn: Richard Grausman

250 West Fifty-seventh Street, Suite 2015

New York, NY 10017

212-974-7117

www.ccapinc.org

Teen Writers Workshop

The Laura Riding Jackson Foundation

PO Box 3233

Vero Beach, FL 32964

772-569-6718

www.teenwritersworkshop.com

Conclusion: Letting Your Light Shine

Attn: Charlotte Terry

3507 Ocean Drive

Vero Beach, FL 32963

www.charlotteterry.com

Selected References

Bartlett, John. *Familiar Quotations.* Edited by Christopher Morley. Boston: Little, Brown and Company, 1951.

"Doing Well by Doing Good: The Trajectory of Corporate Citizenship in American Business," GolinHarris, September 17, 2004.

Harper Study Bible. Edited by Harold Lindsell. Grand Rapids, MI: Zondervan Bible Publishers, 1952, 1971.

Independent Sector. *Engaging Youth in Lifelong Service: Findings and Recommendations for Encouraging a Tradition of Voluntary Action Among America's Youth.* Waldorf, MD: Independent Sector Publications Center, 2002.

Independent Sector. *Giving and Volunteering in the United States: Findings from a National Survey* (Item No. P251). Waldorf, MD: Independent Sector Publications Center, November 2001.

Meacham, Jon. *Franklin and Winston: An Intimate Portrait of an Epic Friendship.* New York: Random House, 2003.

Price, Lynn. *Real Belonging.* Portland, OR: Inkwater Press, 2004.

Tocqueville, Alexis de. *Democracy in America.* Edited and abridged by Richard Heffner. New York: Signet, 2001.

US Department of Labor: Bureau of Labor Statistics. *Volunteering in the United States, 2004.* December 2004.

Endnotes

1. US Department of Labor: Bureau of Labor Statistics. *Volunteering in the United States, 2004.* December 2004.

2. Tocqueville, Alexis de. *Democracy in America.* Edited by Richard Heffner. New York: New American Library, 2001, p. 198.

3. Meacham, Jon. *Franklin and Winston: An Intimate Portrait of an Epic Friendship.* New York: Random House, 2003.

4. The following account, including the dialogue, is based both on interviews with Lynn Price and also on her book, *Real Belonging.* Portland, OR: Inkwater Press, 2004.

5. US Department of Labor: Bureau of Labor Statistics. *Volunteering in the United States, 2004.* December, 2004.

6. Independent Sector. *Engaging Youth in Lifelong Service: Findings and Recommendations for Encouraging a Tradition of Voluntary Action Among America's Youth.* Waldorf, MD: Independent Sector Publications Center, 2002.

7. "Doing Well by Doing Good: The Trajectory of Corporate Citizenship in American Business," GolinHarris, September 17, 2004.

8. Independent Sector. *Giving and Volunteering in the United States: Findings from a National Survey* (Item No. P251). Waldorf, MD: Independent Sector Publications Center, November 2001.

Photo Credits

Portraits throughout this book are based on photographs with the following credits:

President George Bush—*Alexander Rogers*

Robyn Strumpf—*Lifetouch Portrait Studios*

Melanie Washington—*The Boeing Company*

Phil Stevens—*Figges Photography*

Lynn Price—*Michael Ensminger*

Judge Mary Terrell—*E. Austin Dandridge*

Chris Toppe—*Veronica Akishev*

Richard Grausman—*Jerry Ruotolo*

James Pangilinan—*Michael Pangilinan*

THE
SABERDENE
VARIATIONS

THE SABERDENE VARIATIONS

THOMAS MAXWELL

THE MYSTERIOUS PRESS

New York • London

The Mysterious Press, 129 West 56th Street, New York, N.Y. 10019

Printed in the United States of America

First Printing: November 1987

10 9 8 7 6 5 4 3 2 1

Library of Congress Cataloging-in-Publication Data

Maxwell, Thomas.
 The Saberdene variations.

 I. Title.
PS3563.A926S33 1987 813'.54 87-42700
ISBN 0-89296-166-X

For Elizabeth

THE
SABERDENE
VARIATIONS

Prologue

ONE

Victor Saberdene used to say that everything always looked innocent at the beginning. But nothing ever turned out that way. The endings were never innocent.

He used to say that when you started looking closely the illusion of innocence began to disintegrate, scrutiny destroyed it, and the truth—which was almost always even worse than you'd imagined—was revealed. It wasn't a particularly appealing attitude but Victor was young then, full of youthful cynicism, a budding tough guy. And, too, you might say he was on the other side of the law in those days. By that I mean that he was a prosecutor, an assistant D.A. up in Massachusetts. Like everything else, the job was part of his plan.

Victor always had plans, of course. Growing old as an underpaid guardian of the public weal was not one of them. Prosecuting the bad guys was only the first step. He said it was just like learning to be a good tax man. You always wanted to hire a guy who'd worked for the IRS at the start of his career. Those were the guys with the two key qualifications. First, they

1

were killer sons of bitches or the Feds wouldn't have signed them on to begin with. Second, they'd been on the inside, they knew perfectly well how the IRS tried to fuck, maim, and murder every living soul it could get its hands on. Those guys, Victor would say, were absolutely even-handed: they'd torture and squash a little old lady who'd muddled her return with every bit of the merciless zeal they'd once brought to bear on Al Capone. They were equal-opportunity bastards. The thing was, you wanted one of those sociopaths on *your* side when the sky fell on you.

The same principle came into play in the law. Victor knew that the big rewards—money, fame, power, sexy women—lay in defending rich and powerful citizens against a variety of charges, most of which doubtless fit like elastic gloves. But no matter how villainous his clients might be, and occasionally they weren't villainous at all, Victor swore they were saints compared to the system that plucked them out of the hat and ticketed them for destruction.

Victor hated the system just the way he hated the IRS. "They're all criminal bastards out there but some of them have got the law on their side," he'd say. "The point is, Charlie, it really is a jungle. Civilization is a membrane stretched pretty thin, trying to hold in the pus, trying to keep the evil under control. And it's springing leaks. Everybody's a bad guy at heart. Some guys just never get the chance to prove it. The ones I hate are the guys who've got licenses to be bad."

Victor really did hate the system, so, naturally, he went to work for it as a prosecutor, finding out exactly how it worked so that later on, in the name of justice for all, he could blow it to pieces. He became a defense attorney, one of the very best, because he'd spent his time in hell being a prosecutor.

As it happened, I wasn't a cynic. Morally, I thought Victor was either a poseur or simply full of shit. On the other hand, if I were ever accused of murder—and more important if I were

2

ever *guilty* of murder—I'd want Victor setting fire to the system for me. Anyway, he thought I was naive and I thought he enjoyed playing the role of amoral cynic and it didn't make any difference to either of us. We were friends. We went way back together. I was glad to see his plan working for him. I really was.

TWO

There was something else Victor Saberdene was fond of saying which always stuck in my mind. I'm not sure what lay behind it but he was a great student of the patterns of the lives of his clients and their alleged victims. Maybe he was just offering me the result of his observations when he said: "Charlie, there is no immutable law of human behavior that you as a writer ought always to keep in mind. We all have only one life to live and the trouble is we have to keep living it again and again until the final variation kills us. Maybe you could call it fate. I call it Saberdene's Law." When I recorded that conversation in my diary I gave it a name of my own. Saberdene's Variations.

While it sounds like glib phrasemaking at first, I don't think it was. He meant what he said. He was not given to the sort of banter that a man uses to try out his passing ideas. When he said things, they'd passed well beyond the banter stage. In that sense, he was a serious man. And, really, wasn't he just saying that we all keep making the same mistakes throughout our lives, that we never seem to learn much from them?

I've always thought that my own mistakes had served the useful purpose of frightening me into a state of cowardice, but that's another story and runs contrary to the conventional wisdom—namely that mankind is in the regrettable habit of just never learning. Victor saw us all like nothing so much as the

3

Bourbon kings, forever struggling in the grip of history, condemned to repeat our follies until we repeated them once too often.

THREE

All these recollections came back to me in slapdash fashion while I was recovering from the wounds that just about did me in. It had taken a year for my memory to get itself in working order following the events up at the lake. The doctors had told me not to worry about all the blanks, that they would fill in sooner or later. One of these medicine men likened the remains of my memory, or rather the demolition of it, to a bad wound. The bullet had not only blown a hole in what had always been a perfectly serviceable head: it had also lacerated the bits of my brain that had contained large chunks of my memory bank. This was not irreversible damage, he had told me with a cheery smile, or at least not necessarily so. He said my memory had been badly bloodied and then grown a kind of thick scab. When it had recovered, rejuvenated itself, the scab would flake away and fall off. And there would be my memory perfectly healthy again. Probably.

Probably, I yelled at him. *Probably?* What kind of shit was that? Still, as it turned out, he knew what he was talking about. The scab analogy was a pretty good one. All my recollections of Victor Saberdene were, I suppose, equivalent to the itching you feel beneath the scab when the healing process reaches a certain point.

And when it started to return it came back with a rush, the memories tumbling over one another like drunks trying to get out of a burning flophouse. It took a while to sort them out, get them into the proper order. I had to make sure the turning points were all in place, those pivots on which the story turned so delicately. I thought about the shotgun at Purdey in London,

4

and poor Abe Braverman, and the man standing in the rain under the streetlight just across Seventy-third Street . . . and I remembered how important it had seemed that I wasn't an insomniac like Victor . . .

It's funny how most of the stories which make up our lives tend so often to hinge on little things. For instance, the whole lamentable saga of the Saberdenes might have turned out differently if I, like Victor, had been a chronic insomniac. But I sleep like the dead. Two minutes after my head's on the pillow, it's curtains. I was once married to an insomniac and even she couldn't keep me awake, which was little short of miraculous. She hated me for my easy repose. She impulsively tried to shoot me once while we were grouse hunting in Scotland. Victor saved my life by pushing me out of the way, knocking me down actually, as my wife, Lady Hilary, blazed away in my direction. She couldn't believe that I'd been in the slightest danger at all, an attitude not shared by a beater standing next to me who was dusted with passing buckshot. The way life works, seldom does anyone save your life. But Victor had saved mine. And that was one more bond between us that the mere passage of time could never lessen. . . . Anyway, the fact is I'm a sound sleeper and there might not be a story about the Saberdenes if I weren't. Though maybe that's wishful thinking on my part.

Why am I telling the story now?

Because I'm sure it's finally over. And I'd better tell it while I can.

But why tell it at all?

I suppose, for one thing, it's because I'm the only one left who can tell it. And for another, it's an interesting story. At least it is for anyone curious about women. And men, too, of course. And marriage. And anyone interested in passion and, let's face it, anyone interested in murder.

So why not pull up a chair, throw another log on the fire, fasten down that banging storm window, settle in for the long night. Top off your glass with the good twelve-year-old single

malt. Light up, if you've a mind to. Caution to the winds. Who wants to live forever?

My name's Charlie Nichols.

Let me tell you a story.

Let me tell you about the Saberdenes.

PART ONE

Chapter One

ONE

He came out of Lock like an advertisement
for the goods within, stood in the fresh damp glow of watery
sunshine adjusting a straw boater on his massive square head.
They must have had the very hell of a time fitting it to him,
perfect oval on that block of granite. But he settled it firmly
with the palms of his hands on the brim's edge, tilted it rakishly.
He'd chosen the green and purple band of Wimbledon. He was
wearing a pale tan linen suit, a purple-and-white-striped shirt,
tan reversed calf wingtips. I recognized the shirt because I'd
had Turnbull and Asser make up a couple for me years before
at the height of the sixties. He was tall as ever and had put on a
bit of bulk since I'd last seen him, gaining weight and fame
simultaneously. He stood there satisfied with his new hat,
lighting a thin cheroot while the traffic purred by in St. James's.
I didn't even consider passing him by: he was the closest friend
I'd ever had. I was heading upstream toward the Burlington
Arcade and the Royal Academy and pulled the absurd but

nonetheless magnificent little car over to the curb. The top was folded down and I gave him a wave above the windscreen.

"Victor," I called, shaking my head. "Stop posing. The jury has long since retired to its deliberations."

He smiled with the bottom part of his long, large-featured face. His eyes never smiled. He said it was simple heredity. "Coincidence is the mother of probity and providence, Charlie."

"What the hell does that mean?"

"Who cares?" He shrugged. He gave the XK-140 a long, quizzical look. "Jaguar never intended this sky-blue shade—"

"More of a robin's egg according to the man in Devon who did the paintwork—"

"Leave it to you to find a blind painter, Charlie. I weep." He opened the low padded door with its lip of fresh tan leather. "I'm too tall to fit—"

"Just put your legs in back—"

"Droll as ever," he said, squeezing his knees up against the polished walnut dashboard. "Drive on."

"Well, probity's mother aside, it is a hell of a coincidence running into you like this—"

"Not at all. I came to London to see you, Charlie."

We'd moved off into traffic. Summer rainclouds had scudded from out of nowhere, whispering across the sun.

"What for?"

"Need a hack to write my book for me. I'm too busy, of course, to do it myself. You're the man." He laughed immoderately. I hit a bump and mashed his knee against the dashboard. "You still drive like the revenuers are after you—"

"You live in a dream world, Victor. I don't do jobs like that—"

"Bullshit. It's always a question of money. Everything is."

"In that case you can buy me lunch while I turn you down."

"Ha! You haven't a prayer. You've already capitulated." I felt his huge hand descend on my shoulders. "Damn, it's good to see you, Charlie."

10

He was right. It was good. It had been too long. A soft rain began pattering on the long blue Jag bonnet. Drops puckered on the narrow strip of glass before me.

"Came to pick up a shotgun, too," he said. "Buy me a shotgun and hire Charlie Nichols." He laughed. The rain made little hollow reports when it struck his hard straw hat, like tiny criminals banging at his door in search of salvation.

TWO

It was early summer of 1978. We were both on the verge of forty and I hadn't seen Victor in over a year. We'd graduated from Harvard together at the beginning of the sixties, had met that first day of freshman year when we'd arrived at Matthews, the great dark red pile in the corner of the Yard, and found we were living next door to each other. I hadn't known a soul and he'd been surrounded by prep school friends who were always blond and wore garters but we'd hit it off anyway, who knows why? Maybe as the products of two contrasting backgrounds, we shared a certain curiosity about one another.

We played tennis together, got loaded on beer, and stayed up all night talking about girls and Adlai Stevenson and Eisenhower and Jack Kennedy and Chuck Berry. All deep, deep stuff, at least the way we treated it. We moved on to Eliot House as roommates but our social lives inevitably diverged dramatically as time passed. It was simple. He had money, I didn't. He was courted by Porcellian and wore a cute little pig, a gift from his mother, on his watch chain. I played football. I saw less and less of him and when I did catch a glimpse he always seemed to be in dinner clothes, like a dream of *Brideshead Revisited* which a lot of us were reading in those days. I picked up a hell of a concussion and a compressed vertebra in the goddamn Yale Bowl. I caught the ball, yes, sandwiched between two beetle-browed Yalies and the goalpost, scored the touchdown, yes, but

it was small comfort in the ambulance when I discovered I couldn't quite seem to move. I recovered quickly but that was it for football. Victor kept going to balls and cotillions and was always tottering off to Newport or New York or Philadelphia. I always assumed he was getting laid by the snappiest girls fluttering about the bright and shiny flames of Harvard clubland. I was a lowborn foot soldier who'd been carried off on his shield after beating Yale. I carried a green bookbag full of Hemingway and Faulkner and Fitzgerald. I had my share of Radcliffe girls, Cliffies, serious creatures in black sweaters with grubby nails and gray necks and tired eyes and perpetual-motion libidos. Victor always claimed that he hardly ever got laid, envied my weekends at the Kirkland Hotel Annex or the Bradford downtown across the street from, or at least nearby if memory serves, the Shubert.

Victor used to say that a gentleman never talked about his women unless, of course, he screwed them and then he was honor-bound to tell everyone he knew. He said his relative silence was proof that I was getting all the quail—look, it was a long time ago and that was how we talked—while he was doing all the dancing. He could, he pointed out, rumba. My back, thank God for silver linings, kept me from having to learn. Victor said it was a million-dollar wound. He hated dancing. But he was a game son of a gun. By the time we were seniors, he'd moved into an apartment and was hanging around with the Aga Khan and rich South Americans who used to sail long-playing records out of their windows onto passing pedestrians and motorists below. I mean these guys knew how to have fun. They would all go off skiing on winter weekends. Not up the road to Mad River Glen or Sugar Bush, of course. Gstaad and Klosters and St. Moritz. I got a job working the night shift toasting English muffins at the Hayes Bickford, now long gone from Harvard Square. I figured I was learning more about life than Victor Saberdene. Real life. The catch was that real life, on the whole, was for the birds.

12

Victor went on to Harvard Law. I went to work for a newspaper in Wheaton, Illinois, did a brief but educative stretch at *Playboy*, did six months with the Associated Press, and then landed at the *Tribune* covering crime. Chicago was a good place to cover crime. Next, standing in for a pal, I got momentarily famous when Mayor Daley's men in blue, on national television, kicked the shit out of me during the '68 Democratic convention. That led to reporting on the campaign that followed, which concluded with the election of the Nixxer himself. At about that time I discovered that the public was indeed an ass. Democracy had just flunked out. The idea of even a figurehead monarchy appealed to me with a new intensity. I went to England for the waters, working for the CBS-TV bureau, writing the stuff that the rich and famous correspondents said, thereby making them—not me—increasingly rich and famous. I wrote a book about the campaign of '68, a worm's-eye view, which some pals reviewed well. Then another book about the choice to leave my homeland behind—it was funny, not bitter, which stood it in good stead when it got to the serious stuff. Then I wrote *Abatoire*, the story of a serial killer who cut—I use the word advisedly since he favored a meat cleaver for his lonely hobby and was in fact a butcher—a considerable swath through the English midlands. Best-seller, magazine and newspaper serialization, Book-of-the-Month Club and Book Society, large paperback sale, la-di-da. *The Today Show*, Merv Griffin's shocked stamp of approval, movie deal, jokes from Carson. And finally the real thing—profiled in an airline in-flight magazine.

Victor did his time as a prosecutor, then got into defense work with a hotshot firm in Boston. In time New York called, a partnership, a highly visible career with the perqs he'd never doubted for an instant would be his. Regular table in the Pool Room at the Four Seasons, a couple of good clubs, a Turtle Bay brownstone. From his garden he could lift his glass to Kate Hepburn and she would nod to his dinner guests. He must

13

have gone through tuxedos like I went through socks. Jackie Onassis asked him to help her save old churches and things. Ah, happy the man . . .

I married the English woman, Lady Hilary, who lured me out among the grouse. Salmon fishing would not have served her purpose, presumably because it's easier to murder a husband with a shotgun than a fishhook, though drowning might have crossed her mind since my back won't allow me to swim. Victor, well aware professionally of just which gender is the deadlier of the species, remained a bachelor. His letters assured me, however, that his spare time—limited though it was—was far from barren of women. Like the true gentleman he was, he wrote a damn fine letter when it came to recounting his amours. Though true love, he happily confessed, he saved for the chap he saw in the mirror. He said it was his nature. And it was until later on, when he'd met the woman and moved on from Turtle Bay to Seventy-third.

So when he materialized outside Lock fondling his boater, we took up right where we had left off.

THREE

One moment the rain was dimpling the surface of the dirty river, the next it had stopped and the sunshine was nudging at the purple-rimmed clouds again. We were standing outside a Thamesside pub. The wooden slatted benches were drying in the summery breeze and the fringed awnings flapped lazily. Shepherd's pie, sausage rolls, mustard, heavy mugs of bitter. Waves lapped and sucked at the rotting pilings which dated from Shakespeare's boyhood.

Victor licked mustard from his fingertips and drank deeply. "The idea is this," he said, running his tongue around his teeth. "Four or five of my most important cases. All involving what we shall call, for lack of a better word, murder. Other things, too,

14

but murder—death, anyway, sudden and violent—at the core. Two of the perpetrators I got off completely, two drew considerably lighter sentences than they no doubt deserved, and a child molester—well, I say I saved him from being dragged into the street and strung up from a lamppost. But," he waved a finger at me, "it won't be a book about law. Or justice, whatever that is. People. It's a book about people. And mainly me, of course. And doing people is your strength, Charlie. The point is this. I want to do a book about the need for cynicism in dealing with an unfeeling, unfair, corrupt *system*. You following the bouncing ball, Charlie?" I nodded. "Then don't look so unhappy. We're talking about another best-seller, Charlie. The hero as a new kind of villain . . . the necessary villain our legal system requires. Make a good title, *Necessary Villain*. For instance, I had this fellow Hawthorne . . . civil disobedience—"

"What did he do?"

"Wasted an IRS man with a service revolver. It was like this." He tucked into some shepherd's pie, washed it down with more beer. "Hawthorne comes home from a day of looking for work, he sees an alarming sight in his suburban driveway. Two men with sledgehammers are demolishing his seven-year-old Honda . . . while his wife is inside cowering. It's scary as hell. Hawthorne ducks behind a hedge, sneaks in the back door, gets his old forty-five automatic, loads it, and comes out the front door. Unidentified men still beating hell out of his car. Wife having a nervous breakdown inside. Hawthorne tells these clowns to stop with the hammers. They tell him to fuck himself. One waves his hammer at Hawthorne. Hawthorne sends him off to join the Choir Invisible with one shot. The other guy drops his hammer and begs for mercy. Wife sobbing, tearing her hair, Hawthorne blows most of the guy's leg off to be on the safe side and calls the cops. Turns out they were IRS blackshirts trying to collect on thirty-two hundred dollars in back taxes. Which, it turned out, the guy didn't owe after all. The wife has

15

to be institutionalized for six months, loses the baby she's pregnant with . . . and the D.A. calls it murder. Do you love it, Charlie? I call Hawthorne a goddamned hero of the people. Jury agrees with me. Now we sue the shit out of the Feds. How could you keep from loving this story? And there'll be three or four more just like it. Guy murders his rich wife, poisoned her over about three years, patient guy . . . yeah, he did it, I suppose, but I found some holes in the case against him . . . and he's got all the money in the world as well as a young girlfriend—hell, he can afford me and he's got everything to live for. Tells me he only wants justice. I tell him justice is the last thing he wants—what he wants is to get off so he can live the rest of his life with this girl. You don't pay me for justice, I tell him, 'cause it's gone the way of the great bustard. It's barely a memory. You pay me to get you off—now we've got to figure out how much your freedom is worth to you. I got him off and he figured his freedom was worth about two million bucks on which he pays the taxes. Seems reasonable to me." He shrugged and munched on a sausage roll. "Make a hell of a book, Charlie. And it's a sweetheart deal—you get all the money. Because I got all the money I want . . . and I want my name on a book! I want my name on the best-seller list. Like Bailey. Like Nizer. That's why I'm making you an offer you just can't refuse."

Victor warmed to his subject throughout the remainder of lunch. I listened with an interest I couldn't deny. He was a compelling talker and since that was what the book would be it was bound to be compelling. The stories he told were colorful, pungent, driven by engines of real suspense and the spirit of voracious inquiry. As he talked, the question was always present: how would he find his way out of this situation, how would he work his magic? He spoke about a family murder for money, the killing of a small-time hood by a hit man hired by his abused wife's lover—a big-time hood, the mercy killing of a dying, cancer-ridden wife of fifty years by "the most entirely decent man" Victor had ever met. "Naturally the state wanted

16

to cram this man into a cell for the rest of his life," he sighed, indignant, "and let him rot away. I fixed that, by God. Fortunately he was rich. Made my job harder, of course, because I had to convince a jury that a rich man could also be a good man. I was equal to the task, I'm happy to report."

What his character came down to, simply, was that he instinctively sided with the underdog, preferably the rich underdog but, still, any underdog. And everyone filled that bill when the state was brought to bear on them. That was how he saw it. He liked to play it tough. He liked to claim he was the necessary villain. But it wasn't true. He was just a born defender. For all his bluster and bullshit, you had to love the guy. Anyway, I did.

"You're not half the scoundrel you claim to be," I said, smiling at him. "Softie."

"Keep a civil tongue in your head." He lit a cigarette and looked out across the river. "So how does it sound to you, Charlie?"

"Interesting. I'd have to come back to the States to work on it; I'd hate leaving London. I like my life here. I'm working on a book now, a Title poisons his wife, leaves her paralyzed, he's discovered to be having an affair with her sister . . . the wife dies . . . the Title and the sister just vanish from the face of the earth. And it's been four years. Good story, Victor."

"I got a dozen like that," he said dismissively. "Think about it. Boils down to interviewing me, getting me to open a vein and let it drip into your tape recorder. What it would be, laddie, is a damn good time for both of us." He turned to me with a crooked grin on his huge, beefy face. I wondered if he had a blood pressure problem. "Just think about it. Be fun having you around New York. We can catch some Yankee games, I keep season tickets—you could go every night . . ."

He was making it sound like a vacation and I knew it wouldn't be.

17

FOUR

The shotgun.

The shotgun had brought Victor Saberdene to London, had been commissioned by him long before he'd connected me to the idea of the book he wanted to bear his name. Before he'd dreamed of a book at all.

The shotgun was really where the story I'm telling you had its true beginning.

I pulled up and parked outside Audley House in Mayfair. The destination was of course Purdey, the gunmaker.

"Big moment for me, Charlie," he said as we stood ouside the door. "It's an over-and-under, fifteen grand, ordered it damn near three years ago." He nervously adjusted his boater like a boy presenting himself before his prom date. "Finest guns in the world. They build it to your specs, measure you like they were going to run up a suit or two. Center of your back to the point of your shoulder, shoulder to the crook of your elbow, elbow to your trigger finger, on and on. It's like being in the middle of a gavotte. They make the stock from seasoned walnut, from the Dordogne yet . . . When they get it all assembled, stock and barrel and action, the chairman and the managing director personally test it at the shooting ground in West London. Whatever you're shooting at—if you can't hit it with a Purdey, you just can't hit it. Each gun has a number, running consecutively since 1814. All told they've built about twenty-five thousand guns. Darwin took his on *Beagle*. Khrushchev had four. Bing Crosby. Edward VII was a Purdey fanatic. When he died in 1910, nine kings attended the funeral. Every one of them was a Purdey customer." He grinned, the great long solemn face transformed with the joy of acquisition. "Today Victor Saberdene takes delivery, Charlie."

We waited in the Long Room, which doubles as the board-room and the showroom. A deep baronial table dominated the room, eight chairs drawn up. The dark walls were decked out with portraits. Among them all the Royals. Victor led me to inspect one while we waited for the gun to be escorted in. "The nine kings," he said. "Haakon VII of Norway, Ferdinand of Bulgaria, Manuel II of Portugal, William II of Germany, George I of Greece, Albert of Belgium, Alfonso XIII of Spain, George V of England, Frederick VIII of Denmark." He winked at me. "Good company, Charlie."

The gun nestled in its case was brought in, revealed like a gigantic jewel beyond price. He hefted it gently, sighted, stroked the engraving. "Wonder how many murders have been committed by men and their Purdeys?" he mused.

The representative of the firm demurred, stroked his Guards mustache, wouldn't take the bait, said: "None, I should hope, sir. But back in the days when we built dueling pistols . . . well, who can say?"

When we left, Victor cradled the case as if he were playing a cello in the front seat of the little Jag. The sun sprayed like gold through the green crowns of the trees.

"Halcyon days," he said. "Salad days."

"We're lucky men," I said. "Things have gone right for us."

"I'm happier than I have ever been," Victor said. "But I'm afraid."

"What are you afraid of?"

"Afraid I'll never be this happy again."

That night we dined at the Ritz, then went for a stroll, found ourselves in Berkeley Square listening, I suppose, for the long-ago nightingale. Staring at the shadowy outline of the Chinese roof on the little pump house at the center of the garden.

"It's a night for romance," he said a trifle lugubriously. The breeze rustled the leaves in the darkness above us, a summer sound. Someone once told me they were the thirty finest

19

examples of the English plane tree. Planted on the very spot in 1789.

"You need a girl. A real girl. One to love and marry."

"Ha! You're a great advertisement. You know what the sage said—marriage is the death of happiness."

"I'm serious," I said. "You need to complete yourself. The animus requires the anima—"

"I think you've just struck Jung a glancing blow. I haven't the time for a wife—"

"Sure. And that's what we men say right up until we find the right girl—"

"Do you believe in love, Charlie?"

"Love and work, that's all there is to life—"

"Do you believe in love at first sight?"

"I think maybe it's the best, truest kind—"

"I've never been in love. I don't have enough faith in women."

"That usually means you haven't got enough faith in yourself, doesn't it? You've got to have some faith when it comes to love. You've got to have more faith than distrust—too much of what people call love is built on a fine frightened foundation of distrust. If you don't have faith, then there's little reason for going on with it—"

"Well, I have faith in my Purdey. It'll do as it's told."

"But," I said, "you've got to watch who's giving it orders."

"And I have faith in myself, Charlie. I have faith in you, if it comes to that."

"It's not enough," I said. We'd drunk a great deal of champagne. I sat down on the grass, leaned back against a tree, and wondered if it was one of those that had been there since 1789. "If you don't have faith in a woman, poof, nothing else really matters, life's in ashes . . ."

He sank down beside me, legs out before him on the grass, huge feet jutting up far away like gravestones. "I wonder if

you're right, Charlie. Women. Are they so goddamned important? Why are they so . . . so—"

"Why do we breathe air? Why is gravity? Why do little replicas of ourselves enter the world from between their legs? Why did I buy the Jag knowing it wouldn't start half the time?"

He laughed. "Listen, you're beginning to sound like a writer. All this life-is-ashes stuff—"

"Listen to me, Victor," I said. "I may never be so wise again. Mark my words. Tonight I am a prophet. *Cherchez la femme.*" I waggled a finger in his face. It was like Harvard again. We'd be talking about Chuck Berry anytime now. "And happiness will be yours. You will be complete."

He sighed. "Balls, Charlie."

FIVE

Victor spent the weekend with some shooting chums and his Purdey somewhere on Salisbury Plain but when he called Monday afternoon, instead of bragging about his marksmanship, he said he had to come round to my flat in Draycott Place that evening. He sounded harried and said it had to be then, couldn't be put off, because he'd been called back to the States unexpectedly and urgently. He was leaving first thing in the morning. I told him I'd be waiting.

The windows were open, a light rain was pattering in the courtyard, and I was listening to an old Bunny Berrigan recording from 1936 when Victor arrived. I'd spent the day working. The place was a maze of clipped manuscript pages, newspaper cuttings, notebooks, bulging file folders in different colors from Ryman's in the Kings Road, reference books, fountain pens, ink bottles, records and tapes. I was bleary-eyed, on my second gin and tonic, and Victor wanted one of his own right away. His suit was rumpled and rain-spotted. He sank his mighty bulk into an overstuffed, sway-bottomed chair, and

drained off half the gin and tonic in one long swallow. Once we were settled I asked him what the hell was up. He sank back in his chair, took off his glasses, heavy black ones with power frames as he once referred to them, and ground his knuckles into his deep-set, cavernous eye sockets.

"It's been a brutal weekend, Charlie, me boy, starting with you and your drunken philosophizing the other night. Screw the nightingale! You're the one who sang in Berkeley Square . . ." He grimaced, drank. "You really oughta keep your mouth shut when you're tight and in love with love. You hit a nerve, set me thinking. Ruined my whole damned shooting trip. I'm afraid I wasn't being quite frank with you. Like I didn't tell you about Samantha, did I? Going to marry old Samantha, that's the part I didn't tell you—"

"Tell me about her? You never mentioned her name. Look, Victor, what's got you so upset?"

"Doubt, Charlie, doubt. I'm drowning in doubt all of a sudden. Listening to you jabber on about love, life is ashes without it. All palpable bullshit undoubtedly . . . but just maybe you're right . . . and if you are, if love is actually important—well, then, why the hell am I marrying Samantha Frost? She's a model, a stewardess, an actress—what the hell difference does it make? Fact is, she *is* a model. Highly decorative woman. I never have any idea what she's talking about, let alone thinking. And now I'm supposed to be marrying her? Christ, this could be a big mistake . . . we're talking real *size* here, Charlie boy. It's insane. And even if it isn't insane it's sure not like what you were talking about . . . What if you know more about love than I do? Let's get serious—what do I know about love? I'm a busy man, for Christ's sake. You're a goddamn writer, you sit around on your can all day, plenty of time to think about love like some dim-witted sonneteer from out of the past . . . Charlie, can't you see I need another drink? Don't be cheap . . ." He kept talking while I clinked ice into his glass and followed it with gin, tonic, and a thick slice of

22

lime. "So I thought about Samantha and that great little fanny of hers and I wondered, does Samantha's fanny add up to love? God forbid, is Samantha my anima? I broke out in a cold sweat . . . I wanted to weep. Me! Weep! Would this Samantha person *complete* me? Complete my life? Seemed unlikely. Believe me, Charlie, Samantha's hard pressed to complete a sentence. All this going round in my head, I was a danger with that gun in my hand. Lord Harndean, the old fart, told me I looked peeky! Victor Saberdene—peeky! Oh, Charlie, Charlie, how can I marry this girl? No, no, I've got to dynamite this whole mad business. And it's not going to be easy . . . You don't know Samantha, she'll kill me—"

"I do have some experience with lethal women," I said.

"Oh, that. Lady Hilary was just a damn bad shot—"

"Ha! You saved my life—"

"She wasn't trying to hit you—"

"The truth remains for eternity between Hilary and her confessor—"

"Listen, we're supposed to be talking about Samantha and me—"

"Mmm. Forgive me."

"—and I'm telling you she'll kill me. She's the sort of woman who'd eat her young and complain about the calories—"

"But why did you ever tell her you'd marry her?"

"Tell her? Hell's bells, Charlie, I *begged* her. There I was, looking at middle age, no wife, no kids, nothing but my work, I got scared . . . then *you* get tight and start yapping at me . . . well, I guess I owe you a thank-you, but I'm not in much of a mood for it right now. Anyway, I'm getting out of it, this Samantha thing, and in coming to that decision I've kept myself half-stewed all weekend."

"And now," I said, "you're dashing back to New York in the morning to give her the bad news."

He exhaled a sigh that seemed to shake the room.

"Well, that's not quite the whole of it. No hurry about bagging

23

dear Samantha; she's not going anywhere, is she? No, that's not why I'm going back. You see, there I was at the Dorchester, festering and suppurating over Samantha, mourning my weekend, when I got this call. Bad news. From the closest thing I've ever had to a mentor, a hero, an idol. Andy Thorne, Professor Andrew Thorne up in Massachusetts. Retired out in the Berkshires. He really took me under his great flapping wing in law school. We just hit it off, he was a relaxed guy, seemed to have things in perspective, only guy at Harvard Law who did, so far as I could tell. Used to lecture wearing this beat-up old sweater and his fishing hat. Anyway, he called me first thing this morning, shook me out of the throes of my hangover . . ."

Victor's face, boulder-sized, normally pale, had taken on a grayness as he'd turned to the subject of Professor Thorne. His hand was shaking as he lit a cheroot. For a moment he stared out into the rain, lost in thought. "Terrible tragedy . . . young woman has been raped and murdered and they caught the son of a bitch who did it." He sighed, looked up at me through the smoke. "Thorne wants me to come back and help put this bastard away . . ."

"But you're a defense lawyer," I observed with my fine flair for grasping the obvious.

"Yeah, yeah, that's the point. He wants me to give the prosecutor the benefit of my expertise. He knows I'm better than anybody this bastard's going to have defending him. So I'll take the prosecution through the hoops and jumps . . . the trial should be a picnic after coping with me. Thorne wants this thing airtight. Well, who can blame him?"

"Well, I don't know. Sounds to me like he's going to a lot of trouble. It's awful, granted, but women do get raped and murdered from time to time—it's a fact—"

"True enough but this—"

"And the legal system sort of handles it without resorting to its greatest enemy—that's you—coming back from abroad to help them out—"

"The legal system!" he snorted. "Thorne needs me precisely because he hasn't got any more faith in the legal system than I do. Every time out it's a crapshoot. Juries, judges . . . would you want to let a judge or a jury decide what kind of car you're going to buy? What color tie you should wear? What to have for lunch? But we blithely entrust them with deciding our fates every goddamn day—it's insane. People who have never given much of anything a serious thought get to decide if you're guilty or innocent. With that kind of court, can you wonder at what I do for a living? I make my living getting the bastards off, planting the seeds of doubt in a juror's mind, nurturing that seed, watching it grow big goddamn roots so it cracks the wall of the System and brings it tumbling down." He finished his drink, and ash dribbled down the front of his suit. "Thorne needs me because he doesn't want to risk the wisdom of the legal system. He doesn't want the prosecution to fuck it up. He wants this guy inside for good. This one is very special—"

"Why? What's the big deal? You have to come back from London . . ."

"The woman who was killed, she makes it special. Anna Thorne. Andy Thorne's daughter . . ."

Chapter Two

ONE

Victor went back to the States and you know how things work out. I didn't see him again for several years, what with one thing and another. But he did have his secretary send me quite a lot of clippings relating to the trial of Anna Thorne's murderer. I suspected at the time that this was Victor's way of continuing to remind me of the book project, of what an interesting chapter this would make. He never wrote me about it, though, and my own work was keeping me pinned down like enemy fire in an open field. Once the last batch of clippings arrived Victor might have dropped off the edge for all I heard from him. In a way his silence was a relief. I didn't have the time to write his book, yet neither did I need the distraction of having to argue with his determination to have his own way.

The Anna Thorne murder made for good reading, particularly because one of the *Boston Globe* reporters who knew Victor from the old days had gotten wind of his involvement in preparing the prosecution's case. Hell, Victor probably told him. He certainly granted a lengthy interview in which he

discussed the curious position in which he found himself: working the other side of the legal street, giving his old mentor and friend a hand during a time of terrible tragedy. And, yes, he had met Anna during his law school days when he happened to be a guest at Professor Thorne's home. And, yes, it was a sad day, indeed, that brought him back to the village of Earl's Bridge in the Berkshires. Somehow, for a man who wasn't actually a participant in the trial, Victor had managed—at least for the duration of one widely read Sunday magazine piece—to make himself the center of attention. I loved it. Vintage stuff.

The case, as reported during the trial, was certainly replete with personal tragedies on all sides.

Anna Thorne, twenty-two years old, a recent graduate of Wellesley College, had been working as a stagehand at a summer theater, one of several scattered throughout the Berkshires. The Avon Playhouse was located just on the outskirts of Earl's Bridge, in view of the bridge itself, which must once have been famed for something or other. Her older sister, Caroline, was an actress and dancer who performed at the same theater. This sister was described in one article as the "willowy, winsome, always winning local favorite" but bad writing wasn't on trial, I guess. The third leading character in the real-life drama was a drifter by the name of Carl Varada, who seemed to get a uniformly bad—indeed, prejudicially bad—press.

The story itself seemed fairly straightforward. Maybe Victor was right: his participation probably was its most interesting facet. The rest of it was just sad.

Carl Varada had been seeing Anna Thorne. In fact he'd established very quickly a reputation as something of a chaser. He certainly caught Anna. He was described as a large, powerfully built young man, a onetime body builder with what appeared in the newspaper photographs to be long wavy blond hair, a long faintly aquiline nose, arrogant eyebrows arching over sleepy, heavy-lidded eyes. Every father's nightmare. He

27

was said to be in his late twenties, veteran of the Texas oil fields, onetime trucker, a carny barker through the hot dusty country towns of the Deep South, a gambler, a survivor of Vietnam. He'd apparently packed a lot of living into his three decades without ever finding his niche. The more I read about him the more the word "drifter" seemed an accurate summation of an alarming life. A kind of rampant, threatening ego, so attractive to certain—often rather sheltered—young women, was stamped on that face as if by a branding iron.

On the night in question, after the evening's performance, Anna hadn't returned to the Thorne home on the quiet elm-shaded Main Street of Earl's Bridge. The next morning her body, raped and strangled, was found in a thicket bordering a lovers' lane.

The investigation turned up the fact that Anna's sister, Caroline, had seen Varada and Anna arguing earlier that evening. Later, after the show, a couple backing their car from the parking lot had seen her going off toward the secluded path behind the scene shed with the large man's arm around her shoulders. When her corpse was examined, shreds of skin were found dried beneath her fingernails. Varada's scratched face was a match.

Varada's fate was sealed when a search of his past turned up a record of several assaults, two of which included accusations of rape and sodomy. He was obviously one very bad dude who said nothing more in his own defense than that he certainly never had to rape Anna Thorne because "the chick couldn't get enough of it. She begged me for more." He looked out from those blank hooded eyes and said he didn't kill her. "What good was she to me dead? Dead meat's not my thing."

Victor must have made a good devil's advocate. The prosecutor built an overwhelming case, hammering away on Varada's past sins, his life-style, and the testimony of Anna's sister.

The jury was out for four hours. Varada went inside for life. The final act of the tragedy came when the sister collapsed

upon hearing the verdict and was removed to a Boston hospital.

You'd have thought the story was over. It must have seemed that way.

TWO

A couple of years later I returned to London from a holiday in the south of France and began the ritual reading of the newspapers which had accumulated in my absence. Beating my way through the underbrush of IRA outrages and terrorist bombing atrocities, I was surprised and delighted to come upon Victor's name in both the social and literary columns.

He had been in London for an American Bar Association convention, during which time he had made the rounds plugging the English publication of his memoir *Necessary Villain*. There was no collaborator credited but I couldn't help wondering who it might have been. In any case, I was glad he'd done the book and wouldn't be showing up to bug me about it. Victor was my oldest friend but I didn't want him ever thinking he was my boss, however remote. I did go out and buy the book. Seemed okay, but naturally I figured I'd have done better with the material. Oddly, considering his unique role, there was no mention of the Anna Thorne murder.

More interesting than the book was one of the notes in the society pages. Mr. and Mrs. Victor Saberdene had hosted what sounded like a lavish cocktail publication party at the Dorchester for the lawyers, or at least a good many of them. I got the impression that there was a considerable contingent of English lawyers as well. But what mattered to me was the mention of *Mrs.* Saberdene.

So Victor had taken the plunge. A little late for a first marriage but he'd always done things his own way, according to his own timetable. I sat back trying to imagine the woman he'd

29

married. And I remembered the boozy conversation we'd had that night years before on the damp grass with the plane trees all around us. I still thought I'd given him good advice though I'd hardly expected it to shake him up the way it had at the time. Although her name was not given in the papers I knew damn well he'd gone home, thought things over, given her fanny further attention, and married Samantha just as he'd intended in the first place. He wouldn't have had time to find another girl. Hell, Victor was a very busy man.

THREE

It had been eight years since our chat in Berkeley Square and I felt as if a lifetime had passed since I'd returned to my own country. Of course, in a way it was a lifetime ago that I'd left, not really having a clue as to what the future held. As I'd said to Victor, the roll of the dice had been good to each of us. When I'd left for England I'd never have allowed myself to hope for what had in the ensuing years come to pass for me. But I'd just as surely hoped that I'd come back to New York someday, just as I found myself doing.

I'd come home to sign a lucrative new contract with my American publisher. I was also doing my media bit shilling my latest book, the true story of Con McElway, a celebrity cat burglar who had, much to his surprise, one day found himself blackmailed into working for the Russian intelligence services in London. Disconcerted, Con realized the Russians were now choosing his "clients" for him, as well as substituting sensitive documents for his normal swag—that is, jewels and the odd *objet d'art.* Con was an intensely engaging man who'd been quietly turned by the Brits and was now living, bored and antsy, in retirement on the Isle of Man surrounded by very touchy dogs and an armed guard. His was a funny, exciting, adventurous story and I was able to convey enough of it during TV interviews to keep people moderately amused.

It seemed to me I'd made a good day's work out of it and I was relaxing alone in the late afternoon in the Peacock Alley lounge in the lobby of the Waldorf. I'd taken a first sip of my dry Rob Roy when I heard my name, looked up, and saw Victor looming over me, all in gray, like a pillar. He'd seen me on *The Today Show* that morning and run me down with a few phone calls. He was grinning at me. "I knew you'd show up eventually," he rumbled at me, chuckling, "just in time for my second book. Of course, I can't offer you the same generous deal now that I've got a best-seller behind me—"

"Once a shyster, always a shyster," I said. When I stood up he gave me a bear hug that would have frightened a lesser man. I struggled free and we stood there grinning like a couple of schoolboys.

"Damn, it's good to see you." He sat down and ordered a martini. His hair was iron gray now. He was heavier but still solid, more massive and indestructible than ever. Those big feet looked like paving slabs. A thick wedding band was embedded in the meat of his ring finger.

"Crime still paying, I assume?"

He looked at me from beneath eyebrows which had grown furiously, like twisted, barbed vines, and said: "You should know. Without crime, you and I, old boy, would be exactly nowhere." He lifted his glass. "To crime."

I mentioned the wedding ring and he looked down, a massive parody of shyness, the vast face blushing slightly. "I'll bet it's Samantha," I said. "Your anima figure after all."

Victor snorted gruffly. "At least you're right about my finding my anima. I feel complete for the first time in my life." This was not the Victor I was used to: he'd kept his feelings masked, always assuming he had the feelings which connected the rest of us mortals to the outside world. At times I'd wondered. "Much as I hate to give you credit," he went on, grinning sourly, "I've got to admit you've been right occasionally. Never more so than that night in Berkeley Square. Though I seem to recall I

31

wasn't overjoyed at the time. You were complicating my life."
He paused with his martini, sipping, staring at the olive. "I've
never forgotten that talk, Charlie."

"Well, tell me about this anima of yours."

"First, after our meeting at your place, I went back to New
York on my way up to Massachusetts and got Samantha's
attention long enough to tell her it just wasn't going to work,
that I was a workaholic, that she needed a man who was better
at traipsing around nightclubs with her. I mean, can you
imagine me, leaving the courtroom, dressing up like an Italian
coke dealer, and lounging around the Palladium and Limelight
all night?"

"I've never heard of them—"

"Good grief, what a sheltered life you lead over there!
They're not your milieu, trust me. Dancing spots—"

"But dancing was always your sport—"

"Well, you'll be gratified to know I've hung up my dancing
shoes. I've done my last Monkey, whatever they call them now."

"Samantha was a dancer then."

"My God, yes, thrashing about all night long. But she's
nothing to do with me anymore. No, I married someone very
different."

"So who is this poor unfortunate?"

"Well, this is one of the reasons I was so determined to track
you down, Charlie. There's something going on at home. Pretty
upsetting . . . it has to do with my wife . . . and, well, you're
my oldest, best friend. It's best friend time, Charlie." He
frowned at me, jowls drooping like the cement of a statue, solid.
"Someone from the past has come back to haunt her. Melo-
dramatic. Damn strange. And she's a little, well, delicate.
Psychologically. It sounds corny but apparently she's been
getting these telephone calls—"

"Apparently?"

"Well, no, not just apparently. The first couple of times I
thought maybe she was exaggerating some of these weird

wrong numbers you get in New York. But then she taped one of his calls on the answering machine. It was all too real." He shifted his great bulk and lit a cigarette. A man had begun playing Cole Porter's gilt and white piano.

"Obscene?"

"Not dirty words. Just . . . well, the man's presence is an obscenity in itself. That he would call her, *her* . . . it's, it's—"

"Wait a minute, Victor. I'm completely in the dark about this."

"I know, I know. Forgive me. I'm very sensitive about this. I want you to meet her, get to know her. You'll like her, Charlie. And maybe you can help get her out of this depression. This fear . . . The thing is, she had a breakdown once, years ago, just when I met her. Listen, Charlie, I'm telling you the God's own truth, I couldn't resist her. She's so damn beautiful, so good, so vulnerable, so hurt—not damaged goods, but she's been pretty badly hurt . . . I was there waiting for her when she came out of the, ah, hospital, and that says it all. You know me, Charlie, I'm a goddamn busy man. But this girl, she'd been through such hell."

"Victor, what had she been through? You always do this, you forget I don't know what you're talking about—"

"I'm sorry." He shook the great head and squinted at me through the smoke. I'd never seen his face quite so worried, so furrowed with deep concern. I was looking into the core of his psyche. He was in love.

"My wife," he said softly. "Her name is Caro." He caressed the name as he spoke it, sighed. His deep-set eyes softened. Everything about his face changed. *Caro*. "She was Caroline Thorne. It was her sister, Anna, who was murdered. Caro's testimony sent Carl Varada to prison. Now—oh hell, Charlie! Now Varada's out and he's come back for Caro!"

33

Chapter Three

ONE

They all called her Caro.

I look back on that night, my first sight of Caro Saberdene, and I wonder still if I had an inkling of the fates out there conspiring on the heath. Beginning with the moment I stood in the foyer of the town house on Seventy-third Street and saw her come through the drawing room's double doorway, her face wearing a somewhat dutiful smile, her bare arm extended to shake my hand, to greet her husband's inevitable old friend, I knew I was slipping, robbed of my will in a strange, almost pleasurable way, into an entirely new existence which swirled like a natural force around the woman everyone called Caro. What did I guess in those moments? Did a voice speak to me, warn me, and was I heedless? I don't really think so. Not consciously so, anyway. But I felt something visceral. I could hear voices in the room behind her but we were alone in the foyer, with graceful dipping palms and the parquet floor and the paneled walls gleaming with polish.

"Hello," she said. "I'm Caro Saberdene. And you are abso-

lutely bound to be Charlie Nichols—I've read your books." She shook my hand and her smile broadened in the heart-shaped face. More teeth than the rest of us have. An olive complexion. Tawny, sun-streaked hair to her shoulders. She leaned forward and brushed her cheek against mine. She was wearing a black sleeveless dress. Victor had warned me and I'd worn my tuxedo, which had seen a lot in the ten years since I'd had it made for me at Huntsman in Savile Row. "I feel like I've known you as long as I've known Victor. I'm so glad you could come. But you are doomed to put up with a motley crew, I'm afraid. Some of the partners."

"Motley is my usual style."

"Then you'll be right at home." She took my arm, guided me toward the voices. "Let me get you a drink. Then I'll introduce you around." She squeezed my arm and smiled up at me quickly, no longer performing a wifely duty. "I'm so glad you're here." She sounded as if she knew I'd been clued in, as if she knew Victor had warned me of trouble brewing.

I may not have had any premonitions, but looking into that face, feeling her arm against me, I was sure I'd never reacted so quickly to any woman before. I remember wishing, in those moments before we went in to meet the others, that she were anything on this earth but Victor's wife.

TWO

It was six minutes past eleven when I noticed that the other end of the dining table had fallen silent. That meant that Victor had stopped being brilliant and fascinating for the moment and the listeners were taking the respite to mull over the received wisdom in grateful silence. Margo Norman seemed particularly mesmerized by Victor's observations. From what I'd heard he'd grown expansive on the subject of Gothic painting which he'd begun to collect "in a small way." But her fascination, I

35

suspected, would have been identical had Victor been re-capitulating Joe Namath's career as quarterback for the New York Jets. Margo was apparently Victor's protégée within the firm, the only woman Matz, MacReady, Stetson, and Saberdene had ever chosen to lead in criminal defense cases, surely with Victor casting the deciding—if not the only—vote. Clearly Margo Norman worshiped Victor Saberdene the man, as well as Victor Saberdene the career. All things considered, I was sure Victor felt that she had an utterly firm grasp on reality.

In the moment's stillness, Caro removed her hand from beneath the wrinkled paw of Judge Martin Edel, who had grown casually amorous as coffee and the hazelnut mousse had been served by the Filipino couple who took care of the Saberdenes. Mrs. Edel looked on, stifled a yawn. Muffy Stetson chain-smoked her way through the mousse while her husband across the way next to Laura Matz tried to express interest in Laura's racquetball tournament at the club. The Matzes lived in Darien. They seemed to derive a good deal of comfort from the fact.

Marc Foxx had felt earlier that there might be an audience for his views on Hitchcock's masterpiece *Vertigo*, but he had miscalculated. Foxx, it had turned out, was the writer who had transformed Victor's collected tapes into *Necessary Villain*. He seemed to be attached to Margo Norman, at least for the evening. And in the quiet it was Foxx who unceremoniously dropped the clanger. What Victor had in college called "the turd in the punch bowl."

"Say, Victor," Foxx observed, stirring several lumps of brown natural sugar into his coffee, "did you notice the other day, a month ago, maybe, your Carl Varada was set free?"

At the sound of the name Caro's hands clenched involuntarily, as if she'd been singed by an invisible flame. Little fists, a diamond and pearl ring catching the candlelight, ducked beneath the table into her lap. Her mouth was set in a fixed

smile and her eyes flickered, sought Victor's at the other end of the table.

Foxx, with his tight red curls and auburn eyebrows, small periwinkle blue eyes, appeared to be perfectly cast in the role of inquisitive, purposely insensitive reporter. "After eight years, the guy is suddenly free. Pardoned, given a cheap suit and a firm handshake . . . the money he'd earned making twine and license plates, whatever they do up there . . . and he's returned to society, to behave himself and make his way." He shook the red halo, the curls vibrating. "You sent the wrong man up the river, Victor." He smiled, like a Puck twisting a knife in a wound, as if collaborating with Victor had led to something other than friendship.

Judge Edel looked at Caro, a morsel of mousse clinging to his ripe, pendulous lower lip. He had the seamed face of an old man who'd played a lot of poker, scrutinized even more frightened witnesses and shifty criminals and crooked lawyers, and never fallen for a bluff unless he wanted to. He cleared his throat, a wet sandpapery sound.

"Really, Foxx," Tony Matz said, blandly disapproving.

Victor leaned back in his chair, slid a buttery leather case from the pocket of his dinner jacket, and extracted a long Punch Presidente. He leaned forward to light the cigar at the candle flame. He puffed slowly, a smile crossing his thin lips, as if he hadn't a care in the world, least of all the fact of Carl Varada's release from prison. Caro watched him. She seemed to be searching for a signal, an all's-well. I knew all of Victor's gestures: time hadn't altered them. When he looked his most composed, he was playing hardest for time. Getting his bearings, turning the tables in his mind. He was good at it. He made his living doing just that. He had made himself impervious to surprise and that had made him both rich and famous.

"Well, let's face facts," Foxx persisted. "The law miscarried."

Judge Edel said haw-haw and poured a tot of brandy from a bottle near the flower arrangement before him, among the

37

candles. "Not at all, not at all. The man was a soulless brute. Deserved to be put away, clapped in irons, dropped into a hole, and forgotten—which is precisely what would have happened in a wiser age. Damn sight better if he'd been hanged . . . no, Foxx, the law worked like a Swiss movement. Just got him for the wrong murder. A trifle, a detail. Now the man's free to kill again . . ."

Victor smiled through the haze. "You are indeed a hanging judge, Martin."

"I prefer to think of myself as a good judge of character." He rolled brandy on his tongue, satisfied. "You're the one I must always give the fish eye, the gimlet eye. In the normal run of things, you defend such men, scoundrels and brigands and considerably worse—"

"Not men like Varada," Victor said equably.

"It's a relief to know you draw the line somewhere."

"Victor is," Foxx said, "a victim of his image. A captive—"

"Oh, do put a sock in it," Muffy Stetson snapped, "there's a good boy."

"Indeed I do draw the line somewhere," Victor said. "Varada is a poor man. Which is customarily where I draw it."

Tony Matz muttered: "Speaking for the firm, let me say, Thank God."

I couldn't keep my eyes off Caro Saberdene during this exchange which struck me as uniquely cold-blooded. Even for lawyers. She turned toward me, sitting on my right at the foot of the table. She caught my eye and I tried to smile reassuringly but it died being born. She shook her head imperceptibly and I noticed her earrings swaying. Pearls. One black and one pale pink, almost white, and somewhere in my memory they struck a faint chord. The candlelight glowed in the pearls, as if Hitchcock had devised tiny bulbs to fit within them, trans-formed them into molten drops, flowing, suspended like cries of passion from her delicate lobes.

It's all right. She formed the words with her lips, didn't speak

them aloud, and her eyes shifted enough so that I knew she was referring to the talk of Varada. She reached across and patted my hand with her fingertips, said: "I do miss London. We haven't been there in so long . . . Tell me what's going on there . . ." Her smile seemed to invade me, enter me through my eyes, and I thought about what she'd been through: the murder of her sister, the trial of Varada, her testimony putting him away, her breakdown, now his release and return. And I watched the contrasting pearls catching the fire and I sensed the manner, the form she was showing by bearing up in the face of Marc Foxx's thoughtless observations. I felt her hand on mine and I began telling her about London, and the burble of conversation took its place in the background. She knew how to behave. Grace under pressure. Courage.

THREE

The clock on the mantelpiece had just struck midnight and I was the only remaining guest. We'd gone to the study, the three of us, and inevitably Victor had begun filling me in on the Varada situation. Caro and I were sitting at opposite ends of a wine-colored, tufted leather couch. She'd kicked off her shoes and sat with her legs curled under her bottom. She was wriggling her toes in her stockinged feet. She smoked a cigarette pensively, listening to her husband recount the facts of a story which had turned her life inside out. The bright side, if such a tragedy as murder could be said to have one, was that she'd found and enchanted Victor. Now she sat listening, slowly turning a huge Baroque pearl ring on the third finger of her right hand.

"So there was Varada, rotting in prison—watching television and reading up on the law, I have no doubt, and sodomizing any chap he could get his hands on—" Caro flinched a little at that, said nothing. Victor took a deep breath, scowling, his huge

hands flat on the arms of the massive leather wing-backed chair, clamped like steel over the brass-tacked ends. "When an insurance man from Boston put a bullet in his head in a motel down on the Cape. Fellow called Paul Bingham. And he left a long, specific note . . . about how he'd followed Anna Thorne down that deserted pathway, how he'd seen Varada leave her there after they'd argued, how he'd gone up to her, intending to comfort her, and had instead wound up raping her, then killing her to save himself and his family from disgrace, humiliation, et cetera. He wrote down every detail imaginable, stuff only the killer could have known. When he realized the police thought Varada had done it . . . well, he told himself Varada was scum anyway—he couldn't bring himself to step forward to save such a creep. But it had been eating at him all these years. His wife had left him because of his morose rages, he'd lost his job, and he blamed everything on the murder and his refusal to admit it—so he wanted to wipe the slate clean . . . and killing himself finished the job."

"And set Varada free," Caro said softly. "It seems like it may never end, doesn't it, Charlie?" She looked over at me, using my name. "It seems like it may just go on and on. Now two people are dead, Anna and this Bingham person, Varada has had all those years wasted—"

"He's a fucking monster," Victor interrupted.

"And you can't blame him if he's come back with revenge in his heart." She stabbed her cigarette into the heavy crystal ashtray.

"Don't waste any sympathy on him," Victor fumed.

"What exactly has Varada done to warn you?" I asked. "If he's going to make trouble, why would he put you on your guard?"

"That's the kind of man he is," she said. "He gloats over the discomfort he causes his victims. He likes to tease, torture—"

"But maybe that's all," I suggested. "Maybe he's just playing

40

brain games with you. Maybe he knows about your—well, you know—"

"My breakdown? Yes, maybe he does. But I'm hardly a head case, am I, Victor? I didn't go crazy or anything. I was exhausted, under a lot of strain, someone had murdered my sister and I was sure I'd seen the . . . the prelude to the murder. I felt it was my fault. I should have talked her out of ever seeing him again . . ." She shook her head, the earrings swinging again, and put her fingertips to her temple. "I do have a headache. I'll admit to that. But not to being crazy." She smiled tiredly.

"You really ought to turn in, darling," Victor said. "I'm going to persuade Charlie to stay with us awhile." He turned to me. "You can manage that, can't you?"

"Well, I don't know, I—"

"Of course you can. You said you'd finished your media shtick. We'll just move you in here from the Waldorf. Nothing simpler."

"Please, Charlie," she said. Her face was suddenly bright, like a child confronting a happy change of routine. I felt like Uncle Charlie arriving unexpectedly with a bag of tricks and candies. Looking at her I felt again the frisson of danger. I am not a particularly amusing man, though reasonably good-natured. But when it comes to women I'm occasionally given to excess. Caro was well under my skin already: I'm only recounting the true story, hiding nothing, as I saw it happen. I already understood exactly what Victor had meant when he said he couldn't resist her. She was just one of those women. Her hair just then was so shiny it might have been newly polished, like perfect teak. "Say you'll stay," she said. "You and Victor will figure out a way to fix this mess."

"Sure," I said, "I'll stay." Victor had saved my life once and there was Caro. Caro hadn't saved my life but maybe I could help save hers. I couldn't say no.

41

I jumped like a nervous cat when the phone rang with all the stark, loud clarity of a pistol shot.

Caro leaned over and picked it up, shrugging at whoever might be calling so late.

"It's sure to be Matz," Victor said, nodding wearily at me. "He always drags the party on by phone, always thinks of something he should have said . . . and he's always wrong." He snorted, yawned behind his huge paw.

Caro had said hello, nothing else, was listening. I glanced over at her: she'd gone dead pale, was staring at Victor, her eyes wide and pleading. He saw the change in her, said to me in a thick whisper, "It's him!" He jabbed immediately at a button on the answering machine. Then he went to stand beside his wife, stroking her hair, then resting his hand on her shoulder.

"What c-c-can I say?" she stammered softly into the mouth-piece. "What is it you want from me?" She listened, then glanced up at Victor. "Yes, he's here . . . look, please stop calling . . . I'm sorry for what you went through, I'm sorry, what do you want me to say? . . . Oh no, don't say that, oh God, please . . . do you want money? What? What can we do?"

Victor was massaging her shoulder. "That's enough, hang up on the bastard . . . I just want some recordings in case we need some voiceprints—" He reached out to take the phone away from her but she shook her head, stood up, her face intent, brows drawn together.

He stepped back and she brushed past him, went to the bay window looking out from the second floor to the street. Victor and I were both right behind her.

The street looked empty beneath the lights with their slightly roseate glow which made the scene look artificial, like a movie set which could be struck and carted away while we slept. The trees were translucent green in the artificial light. Caro stood staring out the window. I felt as if we'd all simultaneously stopped breathing.

Then, slowly, with a kind of arrogant nonchalance, he

42

stepped out of the shadows of one of the trees and I saw the telephone obscured behind the trunk, in the shadows. He was tall, something like six-four, Victor's size. He wore a seersucker jacket and chino slacks and a straw fedora with a brightly printed band. He stood still, looking up at us in the window, his face shaded by the brim. But I felt as if I'd have recognized him anywhere.

Deliberately, with a sense of theater, he raised a forefinger to his hat brim and flicked it toward us, a mocking salute.

Caro sucked in a sharp breath. The telephone clattered to the floor, smacking off the windowsill and, soundless, she folded up and slid to the carpet herself. Victor had pressed against the window, glaring in a massive rage, and hadn't even noticed that she'd fainted.

I knelt beside her. She was limp and helpless and I scooped her up and took her to the couch. Her face rolled toward my chest and I smelled her perfume. Felt her body rising against me as she breathed. She was awake, eyes fluttering open, as I laid her on the leather couch. She reached out, took my hand, squeezed it tight. Her eyes were huge and dark and soft. They devoured me.

Victor was staring down at us as I knelt beside her.

"That son of a bitch," he said, calm now, "is going to make me kill him . . ."

Chapter Four

ONE

Caro insisted that she was perfectly all right and we weren't to be silly and worry about her. She kissed Victor goodnight, came over to me, thanked me for being willing to put up with their problems, and brushed her cheek against mine. I felt one of the pearls bobbing at the corner of my mouth.

Victor rubbed his eyes. His bags were growing more empurpled as the night lengthened. "Well, let's listen to what the bastard had to say." He pushed the answering machine's playback button angrily as if it were responsible for the lousy news.

". . . lovely lady of the house herself?" Varada's voice was deep, tinted with some indeterminate southern drawl that bore mockery like the arrogance I'd seen in the newspaper photographs of his face. "Bless my soul, I do believe it is. How are you, lovely lady? Was it a nice party tonight? Did that horny old judge behave himself?"

Victor stopped the tape. "How the hell does he know stuff like this? It's like he's got us under a magnifying glass. Caro

leaves the house, he's nowhere in sight—but then he'll be looking at her through the window of a shop on Madison or she'll be having lunch at a sidewalk cafe and there he'll be, across the street, watching her. It's like he knows where she's going . . . Now he knows Edel is a philandering old fart. I don't get it."

"Maybe Edel's behavior is not exactly a secret," I suggested.

"So what? How does he even know Edel's coming to dinner?" He shook his head impatiently and started the tape again.

We heard Caro's voice. "What c-c-can I say? What is it you want from me?"

"Why, not a thing, I don't want nothin' from you, lovely lady. Unless you can give me back those eight years of my life—now come to think of it, that's what I want, yeah, that's it, by God, eight years. Maybe your hubby can help me out . . . by the way, you gettin' much these days, juicy lady? He worth anything at all in the sack? My, but I got me a lot of lovin' those eight years in the joint, no doubt about that . . . but I just don't think you'd like hearing about it very much. Things you ain't never dreamed of. Well, I do hope you're gettin' plenty, honey. I surely do. Is he there, that big old hubby of yours?"

"Yes, he's here . . . look, please stop calling . . . I'm sorry for what you went through, I'm sorry, what do you want me to say?"

"My, my, you gonna give your hubby some sweet pussy tonight? Nice and juicy. He like the way you taste? Maybe I should ask him in person . . . he could tell me all about the way you taste—"

"Oh no, don't say that, oh God, please . . . do you want money? What? What can we do?"

"Money? I don't want money, dear lady. There ain't enough money, not for what I went through. No. Maybe I'll take it out in trade, you'd like that, I know you would, just like your sister you'd beg for more . . . Say, why don't you come over to the window, let me say goodnight . . . you come over, then I'll be

45

on my way and you can go to bed with that lucky husband of yours . . ."

That was it.

Victor stared at me. "Christ, can you believe this guy? He's an argument for the death penalty." He paced to the window and looked out at the spot where Varada had stood so recently, taunting Caro. "You know," he said, his back to me, "he'd be delighted to know we haven't made love since he showed up."

"It's not surprising," I said. "So what are we going to do?"

He slowly turned toward me. He looked exhausted. "We might as well just go to bed." He smiled halfheartedly. "I'm glad you're here, sport. We'll think of something . . ."

"Is Caro all right?"

"I'm worried about her. Normally she's sound as a dollar, no bad effects from her bit of bother—hell, it was a long time ago. But with this kind of pressure—well, I worry. It's getting to her. She tries not to show it. I'm counting on you to perk her up, get her mind on other things. What did you think of her, Charlie?"

"She's beautiful and . . ."

"And?"

"And I liked her. There's something about her—"

"You're damn right there is. That's just it. There's something about Caro."

TWO

There was indeed something about Caro Saberdene.

But I was determined either to fight it or ignore it because she was Victor's wife. He wasn't making it easy for me. After all, the thought of my real reaction to her must never have crossed his mind. I was his friend. You had to trust your friends. And even if you couldn't always trust your friends, they sure as hell wouldn't betray you when you were down and needed their help. So he didn't make it easy for me. He kept thinking what a

46

good idea it was to throw us together with the aim, of course, of perking her up, as he put it. Why my company might serve to take her mind off being stalked through Manhattan by a man with all the charm and style of an axe murderer escaped me but I wasn't going to argue. Being with her, floating in a bubble of her beauty and vulnerability and fear, was a remarkable test of friendship. I was determined to pass the test.

In the morning, after a solitary breakfast in the garden served by the Filipino woman, who clucked knowingly at my feeble observations regarding the shopping habits of Mrs. Marcos, I looked over my copy of the *Times* and there she was coming out the French doors wearing a sleeveless white linen dress. In the early sunshine through the trees her skin tones seemed to have darkened perceptibly, to a soft buttery tan. She wore the same earrings, which, I was to learn, were seldom changed. She wore the very large Baroque pearl ring set in gold. She carried a soft bag that matched the color of her arms. "You know what they say," she said softly, her voice almost musical, lilting. "When the going gets tough, the tough go shopping. Have you been to Ralph Lauren's new shop at Seventy-second and Madison?" I shook my head. "It's the most beautiful store in New York. Get cracking, Charlie. There's money to be spent."

You won't believe this because another woman saying the same words would immediately strike one as crass and offensively materialistic. But it seemed to me just then that Caro Saberdene was being brave, almost brave enough to make my eyes tear up. Call me a foolish romantic.

She was right about Lauren's store. It lay within an old mansion, rooms cascading one after another, cluttered with countless antiques, a set dresser's hope of heaven, a uniquely clever backdrop for the clothing, the hats and shoes and shirts and ties and blankets and sheets and pillowcases which buttoned up around the pillows. The clerks all looked as if they'd posed for Polo ads. Caro was showing me the place, as if it were

47

a gallery or museum, and I bought a couple of ties, one green, one brown, with men playing cricket on them. On the third floor she saw a pair of spectator pumps which had caught my eye at once. Like Caro herself there was just something about them. The brown leather matched her bag and her arms, glowed with a supple sensuality. She put them on, modeled them for me, and was smiling as if she hadn't a care in the world when she wore them out of the shop.

"Perfect," she said. She put her arm through mine as we walked toward the park. Sitting on a bench in the shade, heat waves shimmering up from the toy boat pond, she insisted I put on one of my new ties. The green one. She said she thought I looked positively swell in my cricket-man tie.

Half an hour later she'd led the way to the Marlborough Galleries on the second floor at 40 West Fifty-seventh. There was a new show of Alex Katz's recent paintings, which I had never seen, recent or otherwise, except as color reproductions in magazines. In real life they were, of course, much larger. That was the only difference that mattered. Countless paintings of his wife, dark-haired, a prominent slightly beaky nose. Caro pondered one, taking in the flat, bright colors, shook her head. "Can you imagine having this terrible, irrefutable record of your youth going, middle age arriving? All carefully recorded by your husband and then trotted out for public display? I wonder if she ever wishes he would die . . . then maybe she'd stop growing older. He's like a clock ticking her life away." She cocked her head at me. "Yes, I'm sure there are times she'd like to kill him herself. Victor told me that you insist on believing a wife of yours once tried to shoot you—"

"That's right. I do and she did."

"Well," she laughed, "you like living right on the edge."

"Hardly. It wasn't my idea."

The paintings began to gang up on me. All the flat, empty faces, bereft of shadings like a vista of yuppie masks. Were there people inside those two-dimensional skulls? Occasionally I saw past the surface into the haunted eyes.

48

"You look unhappy," she said.

"No offense but these people remind me of your dinner party."

She giggled softly. She seemed only to make soft, sometimes slightly teasing sounds. "Didn't take you long to figure us out. I was thinking the same thing . . ."

"I look at the pictures and I begin to make up stories about the subjects' lives," I said. "And the stories aren't very happy."

"The writer's impulse," she said.

"Is there some writer chronicling their lives? Do these people have their own John Marquand or O'Hara? Or is Katz their man?"

"I don't know. Maybe in *The New Yorker*. Actually they seem to be covered pretty thoroughly in nonfiction terms. *New York* magazine, *Vanity Fair* . . . *Vanity Fair* is doing a piece on Victor. Should I commission Katz to do a portrait of Victor?"

"What a gruesome idea!"

"Then why are you smiling?"

"Just thinking I'd be a better subject. Victor has too much character in his face."

"Is that what you call it? I thought he just had those bags—steamer trunks, really—under his eyes. Strain. I'm not sure Victor has all that much character. He's such a pragmatist and pragmatism doesn't make for character—"

"Being pragmatic *is* a strain. Gives you character."

"Well, you must not be all that pragmatic then. Your face is unsullied by care and strain."

"That's what I meant. I never know what's good for me, I blunder into things and then can't figure out what's going on. This show," I swept it with my eyes, "is unsettling to a man with a Katz face. A face like mine. I always find myself sliding along the surface, not making commitments to anything other than my work and the occasional irresistible impulse—"

"The truth is, you have the face of an innocent."

"Like a kind of idiot, I suppose," I said and she grinned and walked away, looking at more of the paintings. I watched her

from across the large room, marveling at the aura of control she exuded. She was so taut, right down to the tapping of her snappy new shoes. Her face was so fine and regular that she might have posed successfully for Katz: he might have found the emptiness he seemed to love in the smooth planes of her face, in the direct gaze, but he'd have foundered when he tried to capture the feeling in her eyes. But maybe he wouldn't have seen it. I was the Katz man; but not Victor. I was the one who'd told Victor all about the importance of love, and Victor had paid attention. It was on me that my message seemed to have been lost. I had not found my own Caro, my own anima.

I found her standing before an atypical, darkly colored canvas called *Twilight*. It was large, an ominously dark night, a cityscape, black buildings outlined against the sky, windows yellow and empty, like eyes staring at the huge face of a WASPy pale girl whose face filled the foreground. She is almost on top of you and she is afraid, you can see it, the fear curdling, blotting what in another painting would have been the customary vacuous face. She is being pursued. By the night itself, by the eyes watching her. You can hear the footsteps on the pavement behind her, you can hear the raspy breathing of the danger, of the man she can't seem to escape.

She turned to me and the jauntiness of the morning was gone. Her lower lip was trembling and her eyes searched my face. The painting seemed to have gone through her like a spear, pinning her to the reality of her own situation. She was an actress and her performance that day had been first-rate but the performance was over now.

"Let's get out of here," she whispered.

She was asking me to get her out of the darkness of *Twilight* and back into the summer sunshine, back to safety.

50

THREE

It was just past two o'clock and the luncheon crowd at the Sea Grill in Rockefeller Center had begun to thin out. We got an umbrella table outdoors with the fountain splashing beneath Golden Boy. The sunshine and the bright colors and the music from the outdoor speakers and the relentless crowds all seemed to restore her spirits. She laughed and drank a funny drink with a paper hat on a stick in it and told me about New York. Her New York, which was of course largely a reflection of Victor's New York. Dinners for Victor's clients at Mortimer's, something that sounded like "lollipop condos" which apparently referred to a trendy inclination to build one condo building on top of another, all the skullduggery of insider trading on Wall Street which resulted in the indictment of one of Victor's brokers, a new singer at the Algonquin and a house they were thinking of buying on Shelter Island and all the new plays she made a point of seeing, usually by herself since Victor was so busy and didn't much care for the world of make-believe.

"Do you ever wish you'd stayed an actress?"

"Oh, I wasn't much of an actress. I sort of fell into it. It was something to do in college and then I was involved with a guy who was a director in Boston and we hung around with the theater crowd there. And the bunch who worked on *The Phoenix*, sort of Boston's *Village Voice* . . . I wasn't much of an actress. The boyfriend always said I saved my best performances for real life—"

"Like most people," I said.

She went on talking while we ate, then stopped when she saw my face freeze in a double take. "What's the matter? What did I say?"

I shook my head. "We've got a friend . . ."

Carl Varada was standing at the bar, in the shade, having a drink, watching us across the sea of tables with their flapping umbrellas. He was wearing a tan Haspel suit and a straw hat, a white shirt, a striped tie, dark glasses. He nodded to us, a kind of exaggerated gesture, lifting his glass. I heard Caro's small gasp, saw her stiffen. Varada slid away from the bar and was ambling toward us. He was holding his glass, and a cheroot was stuck in the corner of his mouth. He stood beside the table, looking down at her.

"And how are you today, dear lady? Enjoying your little outing? Lovely, sunny weather . . . and you, pal, who might you be?"

"Well, I might be almost anyone, Mr. Varada . . ."

"Let's say you're a friend of the family and leave it at that." He turned to Caro: "Did you enjoy those paintings, by the way? You know what they made me think of? I knew a guy in the joint, looked just like one of those Katz fellas, prep school boy, all the advantages, I got to know him pretty well." He put his drink down, leaned forward with both hands on our table, and paused, smoke curling from his cigar. "You think those Katz men look empty and wasted? Well, I put a look in this young fella's eyes, a look like you never seen in all your born days . . . a look he ain't never gonna get rid of, lovely lady. He won't soon forget Mr. Varada. He'll string himself up from a shower nozzle before he forgets me. I'll be the last thing he sees before his lights go out for good." He chuckled softly as if in wonderment at the effect he had on people. "I gotta tell you, folks, I love, just love puttin' that look in people's eyes . . . it's a kind of I'd-rather-be-dead look, you know what I'm sayin'—"

"Pack it up," I said. "Fuck off."

He looked at me, the hooded eyes barely open way below the arch of his eyebrows. "Well, well, the little man is heard. *Vox populi.*" He grinned or leered, did something with his mouth. "Voice of the people. You learn all sorts of useless things when you're inside. You look pretty useless yourself, sport."

52

"Leave us alone, please, just get away from us." Caro's face was bleached of color, her eyes peeled in terror or hatred. "My husband won't stand for this—"

"Oh no! But don't threaten me. I hate being threatened. Shrink in the joint said I have a tendency to go all unstable when I'm threatened . . . and you'd better believe me when I tell you we wouldn't want that." He smiled, looking down the long nose with the break in it.

I stood up, deciding there wasn't a hell of a lot he could do to me in the Sea Grill. "Shove off, Varada. You're looking for a kind of trouble you can't even begin to imagine—"

"You don't say! Well, now I am well and truly scared, little man. So I surely will shove off. Never been one to hang on where he wasn't wanted." He smiled as if we were all old friends. I'm six feet tall and I had a good view of his chin. He casually put his hands up, palms toward my chest, as if he were calming me down or fending me off in a joking manner. "I'll be seeing you, though. You can depend on that, lovely lady. My goodness, but you're such a pretty thing . . . I can take your clothes off with my eyes. I know what you smell like and taste like. Fella develops his imagination when he's inside—don't move a muscle, pardner," he said, looking at her, talking to me, "unless you want me to tear you another asshole." He smiled again. "Well, I'm on my way." He saluted from the brim of that damn straw hat. "Give my regards to your husband, dear lady. Tell him to keep an eye out for me. Just when you least expect me"—he snapped his fingers—"there I'll be."

I was shaking while I watched him walk away, past the bar, then slowly up the stairs to the street level, where the sun glared brightly.

Caro's mouth was compressed in a tight red line, and a tiny muscle was leaping along her jaw. I sat back down and tried to keep my knees still. "Jesus," I sighed after a while.

She sat absolutely still. She should have gotten an Oscar right on the spot. I put my hand over hers.

"I'm all right," she said. She lit a cigarette with a steady hand. It was like watching a little girl show off. She exhaled and looked at me. Her color was coming back. "He won't stop, you know."

"Then he'll have to be stopped."

"That scares me more than he does," she said.

Chapter Five

ONE

I was in the back end of the library with the bay window looking out over the garden. The fountain was splashing and squirrels were enjoying a cocktail hour of sorts in what must have been one of the tonier venues of squirreldom. The chair in which I sat was a blood-colored leather wing back and the paintings on the walls depicted old English hunting scenes, riders in their muddied pinks receiving stirrup cups from pretty serving wenches, foxhounds scampering anxiously around the horses' hooves. The Purdey rested in a rack over the fireplace as if it, and the other guns in the rack, took precedence among the room's artworks. Books, drinks tables, an elaborate brass-bound camp desk, a couple of decorative gout stools. I remembered one of Victor's triumphant moments in Harvard Square, running across me one bleak November day outside the Bick. "Well, I've done it!" he cried. "I've just come from the doctor and my heritage is confirmed—"

"I thought your dancing master had confirmed that long ago—"

"No! And none of your cheek, boy-o. This is serious business. I have now been shown to have an excessive amount of uric acid in my system!"

"Well, this *is* good news!"

"Do you understand what this means?"

"Actually . . . no."

"I'm a cinch to develop gout in my later years! The Curse of the Saberdenes! I'll inherit my father's collection of gout stools, just as he inherited his father's, and so on through the centuries. Really, Charlie, it's quite a family tradition."

It took me some time to convince him of how delighted I was for him, all in those long-ago days which seemed, in retrospect, so carefree and full of optimism. Now I rested my own foot on one of his gout stools and looked out the window at his wife. Caro had changed into ancient Levi's and a faded Harvard sweatshirt, was on her hands and knees in the garden messing in a flowerbed with a trowel. She was removing brightly colored blooms from pots and replanting them in earth. She was wearing mud-smeared white gardener's gloves. She was very intent on the job, blotting out the events of the afternoon. The garden was in shadow, the vine-covered brick wall and the treetops rising above her. But it was still hot, close to ninety.

I was watching her, wondering if she'd gardened as therapy when she was recovering from her breakdown, when I heard the Filipino houseman go to the front door and let someone in. There was some murmured conversation and a few moments latter Caro stood up and the maid came into view. Caro listened, nodded, made a face of surprise, dropped the trowel, and came quickly back toward the house smiling, blotting her moist forehead on the sweatshirted forearm.

It wasn't long before she came into the library with a smallish, trim, white-haired man. She was tugging the muddy gloves off, said: "Charlie Nichols, this is my father, Andrew Thorne. Who has just dropped in unannounced from the sky!"

"Professor Thorne," I said.

"Call me Andy. Nice to meet you, lad. Victor has spoken of you often and, I must say, interminably. And I've read your books, as well." He cocked his head at me: I could see Caro in him, the shape of his face, the level eyebrows, the thickness of his hair. For an uncomfortable instant, I felt as if I were meeting the father of a woman I loved, as if I were sizing him up in just that way. He had the same tautness in his carriage. When he shook my hand he might have been a retired general. "Yes, read 'em amd enjoyed 'em. You're a bloodthirsty lad, Nichols." He was ramrod straight but casual, familiar, easy-mannered. He wore an old safari jacket, a Brooks Brothers blue button-down, gray summer flannels that hadn't seen a press since the Cards beat Boston in the '46 Series. Victor had once told me Thorne was a baseball fan and the memory flashed across my mind. His white bucks were scuffed half to death. He carried a hard-sided Vuitton case that wouldn't see fifty again and I'd have bet he wouldn't let the houseman carry it.

"Well, judging from Victor's conversation about you I ex-pected you to be wearing your fly-tying hat when I first met you—"

"Ah, that goes back a few years. Victor always got an inordinate amount of pleasure out of my little eccentricities. The law school was actually rife with them, eccentric old farts everywhere. Why he settled on mine . . ." He shrugged. "But if we knew why the mind fixes on a given point, well, we'd know a great deal more than we do now. Fact is, I don't fish anymore."

"No longer a challenge?"

"Dad had a heart attack a few years ago—"

"Mark my words, young Nichols, you reach a certain age and a daughter thinks she has to answer questions for you, do your explaining for you. It's mystifying. My heart attack, if that's what it was—I've always suspected it was bad clams down on the Cape or a highly questionable burrito and tamale combination

57

plate the same day—in any case, what passes for my heart attack did not rob me of the power of speech—"

"Oh, Dad, don't get snippy—he's got a pacemaker and he's a very lucky man—"

"See how they manage to diminish a fellow?" He gave me a beseeching look, his grin the same as hers, hers a carbon copy of his. "Honest to God, she treats me like a child. Heart attack. Yes, well, have you ever heard someone insisting that fishing—*fishing*, for God's sake!—is too strenuous for your heart? What, pray tell, isn't? But so said my sawbones. Anyway, I'm in fine fettle, young Nichols—"

"Well, it's certainly a surprise to see you," Caro said.

"Is it? I thought Victor would have let you know I was coming. He called me this morning from the office, said he wanted me down here for a council of war. He wants to do something about Varada . . . thought I might have an idea or two."

"Do you?" I asked.

"Might have. We'll see."

Shortly thereafter Caro hustled him away to get him installed in his room. The brownstone seemed to have a limitless supply of bedrooms. I sank back into the chair, sat looking down into the garden. Not much later Caro reappeared, began systematically cleaning up after herself, hosing the wet earth from the flagstones, lining up the plants she hadn't transplanted from their pots. I thought about the mess we were in and faced the real reason I was hiding out in the library. I'd never been so frightened of another human being—just by his presence, the way he carried himself, the tone of his voice, the hooded lizard's eyes as if he were a giant Komodo dragon waiting for his prey—as I was of Carl Varada. And I didn't find much solace when I considered us. A harried, sedentary, albeit large, lawyer; a skittish woman who'd had a nervous breakdown precipitated in part by the man himself and who was probably feeling some guilt about having been instrumental in convicting

him; an old man with a bad heart; and one cowardly writer who hadn't faced death since a wife in his past had or hadn't taken a shot at him . . .

The fact was, Carl Varada outnumbered us.

I hoped Andy Thorne's idea was a good one.

TWO

I was on my way to the garden, passing through the dining room which opened into the flagstones, when I caught a flicker of movement in the corner of my eye. Victor and Caro were alone in the kitchen, clearly visible, and he had enveloped her in his long arms. He was still wearing a charcoal-gray pin-striped suit, straight from the office. One gigantic hand gently stroked her hair. She was resting her cheek against his lapel. I felt as if I were trespassing on the privacy of their lives, like an eavesdropper at the keyhole. I was frozen, not wanting to watch, unable to look away. Suddenly her eyes, like a doll's, clicked open. She saw me at once, standing there in the dim dining room like a thief, someone stealing a moment of her privacy.

Instinct told me she'd look away or close her eyes, allowing me to slip away, papering over the crack, but my instincts were exactly wrong. Instead, she locked her eyes to mine, an acknowledgment of a kind I couldn't name. The moment stretched interminably, his great pale hand caressing her hair, calming her, but she seemed so deathly calm on her own. Her eyes weren't challenging me. She was just staring at me. Finally I went away, went on into the garden with the cascading fountain and the shadows of the trees lengthening.

I sat down at a glass-topped table with the wisteria tendrils curling away from the wall, flicking curiously at the back of my neck like tongues of serpents. I saw the two faces before me. A candle had been lit in a hurricane lamp on the table. Victor's

face, tired, pained, fearing for his wife, remembering her breakdown, remembering the man he'd helped put away for a ghastly crime, but one he hadn't after all committed, however capable of murder he might be. And Caro's face, unlined, almost uninvolved, as he patted her hair, her face so remote for such a tender, loving moment. I remembered the Katz face with the footsteps behind her drawing ever closer . . .

But looking at her I saw no histrionics: Was she acting still? Was she acting unafraid, pushing herself to give the performance of her life?

THREE

Victor's hands wrenched one another, fingers intertwined, while he tried to stay calm otherwise. Caro was the performer in the family: Victor was an open book here in private, unlike his work in the courtroom. We were all sitting in the garden. Caro had asked me to tell Victor the story of our confrontation with Varada at Rock Center. When I wrapped it up, he stared at me, his hands working as if Varada's throat were in his grasp.

Finally he said: "You know what I hate most? Not the dirty-minded schoolboy mouthing off—that's offensive, I'm sure it's unnerving to you, honey," he touched Caro's knee, petting her, "but it's standard stuff from any crap artist. No. What bothers me is his ability to just invade our lives! At will! He seems to know every goddamn thing about us—"

"As if he's stealing our signs," Thorne said. Caro looked at him quizzically. "Baseball talk," he said.

"Exactly," Victor said. "Did you see him at the Katz show, Charlie? Caro? No. But he knew you'd been there. So how the hell did he know? He's like a ghost, right here with us, listening. Where does he pick you up on your excursions?" He threw up his hands and stared up through the trees at the heavy, humid night sky.

"Tell me," Thorne said, fumbling for a pipe in the pocket of the rumpled safari jacket, "did he make any specific threats? Did he say he was actually intending to do anything particular?"

Caro said: "No. Just his awful hints. Dragging Victor into the conversation . . . the way he looks at me, it's like being violated. When he talked about the look he put in that young man's eyes before he pictured him killing himself . . ." She swallowed hard. "It made me think about what he might do to me if he got me alone . . ." She couldn't go on with that and sipped iced tea to get a grip on her composure.

"Do you think he carries a weapon?" Thorne was pushing tobacco into the bowl of his pipe from a yellowing, cracked oilskin pouch.

"He *is* a weapon," I said.

Thorne nodded, lit his pipe with a wooden match from another of his pockets. He puffed reassuringly, calmly. "He's scaring us. He intrudes on us, he says offensive things to us, his presence is a threat. Somehow we've got to scare him off, threaten him. We've got to turn the tables on him. Take the play away from him. As I see it," he sucked the pipe contentedly, as if it were an aid to thought, "the problem is we're on the defensive—they're stealing on us, we can't throw anybody out. So we've got to go on the offensive ourselves. *We've* got to watch *him!* We've got to let him know if he's so much as one more step out of line, we'll be all over him. We've got him on the answering machine tapes . . . We've got to have our own people taking pictures of him following Caro and talking to her, our people shadowing him everywhere—bugging him until he gets tired of the aggravation and just goes away—"

"But how?" Caro said.

Victor sighed heavily. "Abe Braverman, I suppose."

FOUR

Abe Braverman was about fifty, balding, and had small restless eyes moving in the face of a prosperous, careworn partner in a good firm of accountants. He wore a gray suit in a 48 Portly, a good-sized diamond ring, and pointy black shoes. He stood about five-seven, looked like he was lugging around 230 pounds. The backs of his hands were covered with wiry black hair. He was a private detective and he'd conducted many investigations for Victor. Victor said he was the toughest, most ruthless, most relentless man he'd ever known. He also charged like a Park Avenue lawyer and that, Victor reasoned, was somehow reassuring.

"No problem with surveillance," Braverman said, his stubby legs crossed, ankle over knee. We'd adjourned to the study and it was past ten o'clock. Andy Thorne was looking tired. We were all worn out.

"But we don't know where he lives. How can we follow him?" Caro was leaning forward in her chair, casting an occasional anxious glance at the telephone, as if it might ring at any moment and drag her back into Varada's world. Andy Thorne had turned the television on while waiting for Braverman, and Baltimore was beating the Yankees, 7–0.

"No, Mrs. Saberdene, we go at it the other way round. I put a couple of my best operatives on you, don't you see? And we wait for Mr. Varada to come to us . . . or to you, so to speak. Then we've got him, don't you see? Then we stick to him like a bad debt. We'll find out where he lives, how he's conducting himself when he isn't following you."

"And then?" she said.

"Then we'll have a discussion with Mr. Varada. We'll suggest that he absent himself from your life. Maybe even our fair city.

He's making a nuisance of himself. We'll suggest he's had his fun and now he should run along. Most people in his position do exactly that."

"Not Varada," Victor said gloomily. "He's going to laugh at us. He's not breaking any laws. I thought about getting a restraining order but it's a joke, thinking it would stop him. It would just make him mad . . ."

"Then he'll require some coercion," Thorne said, looking away from the ball game. He looked at me and smiled thinly. "Look, the law is one thing and family is something else entirely. Victor's right. Varada's the kind of man who'll push this right to the end—his whole history says the same thing. He just doesn't care. We'll have to make him see the light."

"That can be arranged if need be," Braverman said.

"But then," Caro said, "we'll be no better than Varada—"

"At a certain level of human behavior," Braverman said, "we are all more or less prey to animal behavior. Animals tend to deal in necessities. You, Mrs. Saberdene, are in a fight which may well be a fight for your life, your own survival. In such a case, a great many means which we would normally find repellent are morally justifiable . . . and that hardly means you are no better than Mr. Varada. Indeed, he sounds like a genetic oddment of human refuse. A mistake." He belched softly behind his hand and fished a Rolaid from his pocket. "In brief, we'll do what we have to do."

"All right," she said, "you've made your point."

"Who are you going to use, Abe?" Victor yawned, shook his head to loosen the cobwebs.

"Al Potter and Horace Claverly."

Victor nodded. "A pair of imposing specimens—"

"I've always found it best to send a man to do a man's job." He crunched the digestive tablet. "Now, shall we make a plan for tomorrow?"

FIVE

I woke up in the middle of the night, light rain tapping on the vines outside my open window. It was one of those secret summer rains of which, next day, there is no hint but the effulgent greenery. I hadn't been dreaming of Varada but he sure as hell popped into my mind the minute I was awake. The act of thinking about the man made me literally sick to my stomach. I had the feeling that he could have closed his hand, as big as Victor's, around my skull and crushed it like a beer can. This line was not, I realized with customary acuity, the way to get back to sleep.

I got up, put on my robe, and looked out the window. My bedroom was on the top floor. I looked down into the street half-expecting the worst. But Carl Varada was not there, not keeping watch over us as we slept. Would Abe Braverman and his minions be able to convince him to leave the Saberdenes in peace? How far would they go to make their point? If Varada lived by the rule of the jungle, were Potter and Claverly sufficiently adept? Why didn't Varada just want some money? If the guilt of the Saberdenes coupled with their fear was sufficient, why not just take a hundred grand and get on with rebuilding your life? How much satisfaction could there be in terrorizing people? But, of course, terror-implied was only the prelude to whatever Varada presumably had in store for Victor and Caro later on . . .

I went downstairs in search of I-knew-not-what, poking through the darkness lit only by the glow from the streetlamps outside. Like most walkers in the night I was drawn toward the kitchen but stopped short when I saw a light.

For the second time in a matter of hours I was suddenly cast in the role of First Voyeur.

Andy Thorne and his daughter were sitting at the long trestle table around which the kitchen centered. They sat in a vast silence, like two strangers. She wore a navy-blue robe with white piping. He was in pajamas. They each stared into coffee cups. The rain dripped on the flagstones beyond the French doors. Two people who had nothing to say to one another.

The tragedy in their family seemed to be a physical presence, standing between them, crowding out anything else. I looked at them and I couldn't help thinking of them as characters in one of my investigations of a murder case. The tragedy had all been brought back to life, back from Anna's grave, by the discovery that Varada was innocent of her murder. Now the horror of the incorrect verdict was compounded by Varada's return . . . What was Andy Thorne thinking? What did he want to do with Varada? If I were writing the book, what thoughts would I attribute to this old man with only one daughter left?

I was frozen again, not wanting to draw attention to myself, not wanting to be noticed, not wanting to join them—and then something must have flickered at the edge of Thorne's consciousness. He looked up, saw me.

"Charlie, come on, join the party." His smile locked in place. "Pretty quiet party, I'm afraid. Thunder woke me up."

I went into the kitchen. Caro smiled distantly, picked up the remains of her father's tuna salad sandwich, and rinsed the plate. Thorne said something, I replied, Caro silently watched us, and finally Thorne said he was going back to bed.

When we were alone I said: "Everything all right? Did I interrupt any—"

She shook her head. "My father and I have little to say to one another. Anna was his favorite . . . and his attitude is sort of a resigned wouldn't-you-know-it-would-be-Anna-who'd-get-herself-murdered—"

"I'm sure he doesn't feel that way—"

"Charlie, you don't know a damned thing about it."

65

I felt myself flush, embarrassed, but she seemed to be stating a fact, nothing more.

"I'm worried about Victor," she said. "I'm afraid he has some plan of his own he's not telling us about. I'm afraid he might decide to go after Varada . . . and he's no match for a man like Varada . . . oh, damn it, Charlie . . ."

She took a step toward me. I saw she was crying. She wiped her sleeve across her cheek. She leaned against me, I heard her voice muffled against my chest. "Just hold me for a minute, okay?"

I knew I was standing exactly where Victor had stood earlier. Only now I was the one holding Caro while I stroked her hair just as he had done.

Chapter Six

ONE

I didn't sleep worth a damn.

If I wasn't thinking long guilty thoughts about having my arms around Victor's wife and wanting to keep them there, I was thinking about Varada. What in the name of God did he plan to do? Scaring hell out of everyone wasn't going to be enough for him. One look into those hooded eyes and you knew scaring people was just the opener, just something to set the mood. I'd written about enough sociopaths to know what seemed to them the only logical conclusion. People dying. That was the part that was eating me.

So when I came downstairs and saw Victor, the whole night coalesced, guilt about the way I was reacting to Caro and fear that Varada was going to kill them. Kill *us*, if it seemed convenient.

"You look like shit, old son," Victor said. "Cheer up, it's not the end of the world. Have a Pop Tart, have a cup of coffee. French Market, coffee with chicory. Opens your eyes right up. You'll love it." He beamed at me. He was huge and crisp, white

67

shirt, blue suit, bow tie, polished shoes, the *Times* on the table before him. "Conchita," he called to the kitchen, "a Pop Tart and coffee for Mr. Nichols."

"Conchita?" I said. "Is Conchita a Filipino name?"

"I don't know. She looks like a Conchita to me, she doesn't seem to mind, she's been with us six years, so let's not make a federal case out of it, okay?" She brought me coffee right away and I told her I'd forgo the Pop Tart and have some plain toast with butter and jam. Victor broke off a chunk of a second Pop Tart. "So, Charlie. Sleep well?"

"Like a baby. I woke up and cried every fifteen minutes."

"Well, I've got a handle on this thing now. Andy was right. I was on the defensive. No way to be. Ever. Gotta take control. I've been up since six, thinking things over. I was scared of this jerk! Jesus! That's all ass backward. I *make* people scared, I don't *get* scared." He licked blueberry filling from his thumb. "Well, the news from the front is that I'm me again. So you go through with our plan, as per last night. I've already been on the horn to Potter and Claverly. I've used these guys before. They may sound like a comedy team but, believe me, Charlie, they are not funny fellows. All you have to do is take Caro up to the Metropolitan. Somewhere along the way they'll just fall in discreetly and tag along. Tall black guy, that's Claverly, and Potter is about the size of a refrigerator. One will stay fairly close, the other will be farther away, they'll try to sandwich Varada. Braverman's given them his photo and the description you gave last night. All you've got to do, old son, is squire Caro. Look, Charlie, I sure as hell appreciate your baby-sitting like this, but don't worry about a thing. We're all going to come out of this okay." He fixed me with those deep-set eyes. "This is all going to be over and done with by tonight. Do you hear what I'm telling you?" I nodded. "Well, then, cheer up, for Christ's sake!"

He was full of himself that morning, sure he could see the future. He was fresh, well rested, ready to go. He was whistling

"Moon River." I knew this Victor. He figured he had the bull by the balls and was about to start squeezing.

Caro had been right last night. Victor had a plan of his own. I didn't know what was going on in that huge head but I was sure that even had I known I wouldn't have felt any better. I'd stood beside Varada, felt the weight of his gaze, seen the smirk and heard that too syrupy drawl, and I had felt myself coming unglued. I was afraid and so was Caro. Our fears were feeding off one another.

And Victor was thanking me for spending time with his wife.

I hoped he was right. I hoped it would be over by that night. Then I could get away from her. I could run for home.

TWO

"Behold," she said. "The Rubens Venus. I thought you'd find it particularly interesting."

We were standing in a cool, lonely gallery, before a large canvas. A fleshy Venus, her skin pink with the iridescence Rubens had made his trademark, her hair long and thick, was turning toward us, seductively, as she'd been doing through the centuries. There was a kind of modest brazenness in her eyes, the oxymoron which lay at the heart of every persuasive seduction. In her hand she held a mirror—*Venus at Her Glass*—from which she'd turned, as if she knew we'd be watching.

"It's fine," I said. "But why particularly interesting?"

"Look closely. At her face and at the reflections . . ."

"Well, I'll be damned—"

"You see? I thought you'd like it." A group of schoolchildren under guard whispered and pattered past us. Somewhere two men were watching us but I hadn't seen them. The Venus suddenly had me in its grip.

From one ear dangled a perfect pink white pearl, even more

69

glowing than her flesh. Reflected in the mirror, from her hidden ear, hung a black pearl.

"I've seen the way you watch me," she said. "Looking at my earrings. Right?"

"You are a very observant woman."

"I had an acting teacher once, he always told us to observe people closely. So I have been observing you. Closely."

"Observing me observing you—"

"My earrings. My father took me to see this painting once, in Europe, when I was a little girl. I never forgot those twin pearls . . . and when I graduated from high school he presented me with these. He used to say they cast a spell. Then he had me read *Zuleika Dobson* and I saw what he meant about the spell. What do you think, Charlie?"

"They're very pretty. But it's always the woman who casts the spell." *Zuleika Dobson.* That was what I'd nearly remembered when I first saw Caro's earrings. Zuleika and Caro, two of a kind. I remembered Beerbohm's novel, the Oxford undergrads throwing themselves into the river, a mass suicide in her honor, so smitten were they. I looked at Caro. Hell, it made sense to me.

"Well, I know what you've been thinking when you watched me."

"Am I so obvious?"

"You've been thinking, is she working herself up to another breakdown—isn't that about right? Victor's worried sick, keeps staring at me when he thinks I'm not looking. He half expects me to butter my hand and eat my napkin . . ."

"Well, no, that's not what I've been thinking—"

"The point is, I'm trying hard not to let all this get to me any more than absolutely necessary. Victor's worried, Dad's worried. It's awfully nice having you here, Charlie. Someone from outside the infernal circle of survivors. You remind me of innocence . . ." She smiled up at me, hesitant, almost pleading, but I didn't know for what.

"*Are* you worried about another breakdown?"

"What? Me worry? Sure, of course I'm worried. You think I'm crazy? I'd have to be crazy if I weren't worried, Charlie."

THREE

We were sitting ducks which, of course, was the way it was supposed to be. Heavy low clouds rolled across midtown Manhattan and the humidity took a quantum leap upward. The sun disappeared. Shadows went with it. We slowed down. My shirt was sticking to my back. When New York gets really hot and humid and the breeze dies, you quickly grow a kind of grimy scum. It starts on your forehead. It's a mess. I was a mess before we got to the Plaza. By some peculiar quirk of fate, the scum never seems to afflict beautiful women. Go figure.

"Do you see them?" she asked. She was wearing a beige linen dress. She looked like she'd never been cooler.

I stopped and pretended to look at books at the Strand's movable kiosks. It didn't take me long to spot the black guy, Claverly, who was standing about twenty feet away. He wore a tan wash-and-wear suit and had a camera slung around his neck like a diligent tourist. It was a Nikon. He looked prosperous. He grinned in my direction, a gold tooth flickered. I didn't see anyone matching Potter's description. I didn't see Varada. But I knew he was there, somewhere. Watching us, playing with us.

"Claverly's over there," I said, holding a book, pointing out something on the page.

"Book's upside down," she said solemnly.

"Doesn't surprise me at all. My eyes are full of sweat and I don't feel like reading." I put the book down. "Come on. We might as well push on."

We crossed Fifty-ninth Street, past the musicians whacking away on the steel drums by the fountain in front of the hotel, across Fifty-eighth Street, past Bergdorf's. Just out for a stroll. She stopped from time to time, inspecting shop windows. I kept

71

snatching little surreptitious glances behind us but Claverly was our only companion. The process was getting to me. I'd never been good at waiting. Never been good in the role of bait. I kept trying to remember that nothing bad was supposed to happen to us. I took out my handkerchief, wiped my face with it, and it came away damp and dirty. We passed Harry Winston, passed the big Doubleday on the west side of the street, passed Air France and Dunhill and ran into heavy crowds swarming out of Saks across the street, streaming toward the Rockefeller Center restaurants. Now I could no longer find even Claverly. But nothing bad was supposed to happen. All we were doing was drawing Varada into the open again so Claverly and Potter could follow him back to his hole, give him the word, scare him off.

So I kept sweating through my clothes while I tried to remember there really wasn't anything to spoil the calm. But I'm a smart guy and I wouldn't swallow that one. Varada was like a terrorist's bomb. He was just waiting to go off. You could see it in his eyes, in the exaggerated swagger, the slow forced drawl, as though if he let himself speed up he might ignite, go off, start shredding his way through masses of flesh. Jiggle him and *blam!*

So where the hell was he? Why hadn't he shown himself yet? How could he resist the enjoyment of tormenting us?

The bastard . . .

We crossed Forty-second Street and saw a crowd forming a semicircle in front of the library. From a tinny outdoor loudspeaker came "The Dance of the Flowers." We went closer, stood at the edge of the crowd which watched, awestruck, very rare in New York gatherings. The two lions *couchant* flanking the steps, Patience and Fortitude, were garlanded with thick ropes of ravishingly bright flowers. Between them two gigantic figures towered over the onlookers, dancing to the music. A man and a woman, elaborately costumed, her long dress

dropping all the way to the cement, pirouetted and kicked and twirled with exquisite grace, all on stilts. It was weirdly hypnotic, as if they were descended from another galaxy far away and were giving an exhibition of a new art form. They whirled, spinning on the stilts, his trousers concealing his, giving an impression of *Yellow Submarine* characters, their movements quick at the source but slowing, becoming almost languid by the time they reached the distant outposts at the ends of the stilts. They moved like vast, programmed robots, and you couldn't stop watching them. Caro stood with her mouth open, smiling in childish wonderment, her expression replicated throughout the crowd.

I saw from the corner of my eye a small black boy wandering away from his mother. He was wearing a navy-blue tee-shirt with the interlocking NY logo of the Yankees on his chest. A Yankee cap rested atop his ears. He'd apparently had his fill of the stilt dancers and was heading for the rope of flowers around one leonine neck. He must have been five years old. Standing on tiptoe he struggled to pluck one of the flowers but couldn't quite reach it. He looked around with his huge eyes, the whites like headlamps, as if expecting to be chastised. Seeing no one, no mother, no older sister to spoil the fun, he went back to his pursuit of a flower. I couldn't keep from smiling and wanted to give a small cheer when he was suddenly hoisted up by a pair of large hands. Quick to know a good thing, the little boy grabbed two flowers. As he turned, smiling hugely, he gave one of the two flowers to the man who'd helped him. As he reached toward the man's face he tipped the brim of the straw hat and the man laughed and pulled the bill of the Yankee cap down over the boy's eyes. Giggling, the boy ran, clutching the flower, to his mother while the man stuck the yellow flower into his lapel. I couldn't look away.

It was Varada.

He looked at me, as if he'd known I'd been watching him,

and grinned. He pulled the stem down through the buttonhole and sauntered away from the great stone lion, shouldering his way through the crowd. I whispered to Caro, she looked, nodded, and we held our ground.

Varada came to stand beside me. "Cute little jigaboo, wasn't he? I'm a sucker for kids." He leaned across me, tipped his straw hat to Caro. "Howdy do," he drawled. "Amazin' what they can do on those stilts, ain't it? Why, look at 'em, just twirling their little hearts out . . . all that control! Why, I'll bet they never fall down." He shook his head in amazement at the dancers' dexterity. My stomach was preparing to do a half-gainer. I looked around trying to find Claverly or Potter but I felt Varada's hand on my shoulder like a sack of cement.

"Say, you're lookin' nervous, pal. What's the matter? Relax. Gotta take time to smell the roses." A laugh like a gargle rattled around in his throat.

Caro stared at the dancers. I saw Claverly, who'd climbed up near the lion and was trying to look like he was shooting some tourist pictures. We were in them.

"Well, you two don't have much in the way of small talk. You're a great disappointment to a friendly old boy like me." He slapped me in a friendly way on the shoulder. "I've got some good news for you, though. I'm gettin' pretty tired of all this pussyfootin' around." He looked down the long nose, eyes still behind the low-slung lids. "I'm about ready to *do* somethin'. I jes' can't wait much longer . . . I got me some big surprises in store for you folks . . ." He laughed softly, began applauding as the music ended and the two dancers took bows from on high.

Then he was gone. Neither Caro nor I had said a word. When I tried to find Claverly he too had melted away. I never did see Potter.

Caro took my arm. "Come on, Charlie. We've done our part. Let's get a cab and go home."

In the cab she looked at me, in a very small voice said: "What

did he mean, Charlie? What's he going to do to us? Or is it Victor he's after?"

I told her I didn't know. I was remembering Victor at breakfast. Why had he been so sure it would all be over tonight?

FOUR

Caro and I told Victor and Thorne the story over dinner in the garden. The rainclouds hung so low they felt like cobwebs brushing your face. There were a couple of large oscillating fans set up on the flagstones, sweeping across the garden.

"Well, it worked," Victor said. He lit a cigar with some difficulty. The fans kept blowing the matches out. "All we have to do now is wait for word from Claverly and Potter. I think we've just about gotten clear of this mess."

Thorne said: "You surprise me. I'd have thought that Mr. Varada would be a tougher nut to crack—"

"We'll see." Victor was smiling to himself, satisfied. "I do believe Claverly and Potter may persuade him to see the light."

It turned into a long tense evening. After dinner we gave up on the *al fresco* side of things and sought the air-conditioning of the study. Thorne settled into one of the deep leather chairs to watch the Yankees and the Red Sox on a small color television. Caro put a cassette into the VCR and she and I watched Alan Ladd and Veronica Lake and Bill Bendix in *The Blue Dahlia*. I told her the stories surrounding the making of that long-ago masterpiece, Raymond Chandler staying drunk to write it as they shot it before Ladd was inducted into the army, the producer John Houseman providing a twenty-four-hour-a-day nurse for the writer so he wouldn't drink himself to death. She relaxed, losing herself in the movie. "I think the woman is the bad guy," she said. It turned out she was wrong about Veronica Lake but I told her if we'd been watching Bogart and Lizabeth Scott in *Dead Reckoning* she'd have been right. I drank iced tea

and Victor paced in and out of the room, putting away gin and tonic at a goodly pace. The telephone rang twice and he grabbed each one on the first ring but neither was Claverly. Thorne was pleased with the ball game. The Red Sox blew the Yankees out.

At eleven o'clock the doorbell rang.

Victor said: "Thank God!" He hugged Caro. "This is the good news, honey."

He and I went to the door together. Caro and Professor Thorne waited in the doorway to the foyer.

Victor flung the front door open, stopped, then staggered back, as if someone had hit him. I moved to the side to see past him.

Carl Varada was standing in the doorway.

His face was shaded by the brim of his Panama but there was no mistaking his stance, the slant of his broad shoulders, the slight tilt of his head. As Victor took a couple of steps backward Varada came forward, like nature, filling the vacuum.

"What the hell—" Victor swallowed the words, stood aside since he had no other rational choice. "You've no business here."

"Now, don't get your skirts in an uproar, Counselor," Varada said. "I think you may want to have a word with me after all. I've already had a discussion with your colored gentleman and his helper. They made it mighty clear to me, your wishes and whatnot, and I told them mine." He raised his hand as Victor started to say something. "Now, you hush up, Counselor. You had your boys do your talkin' for you. You set them on me but once we'd talked things over I jes' knew I ought to have a word or two with the Massa himself."

He came farther into the foyer, into the glow of the chandelier, and I saw his face. Caro, watching from the door to the study, gasped and shrunk against her father.

One side of Varada's face was scraped raw, eyebrow to the line of his jaw, as if it had been laid open with a paint scraper.

76

The finely shaped, full lower lip was deeply split in the middle. Blood had dried beneath his lip. More blood was caked beneath his nose. The front of his seersucker jacket was soiled with smears of blood. Victor's high spirits had stemmed from a plan that was now obvious in its stark simplicity. Looking at Varada, I had the feeling that he was lucky to be alive.

Once Victor got a look at him, his confidence began to return, replacing the shock. "I'm not sure I have anything to say to you. You've been given a warning. Leave us—and in particular my wife—alone! You're scum, Varada, you have to be treated like something I occasionally have the bad luck to step in. Now, why don't you just go away . . ."

Thorne and Caro had come into the foyer, like filings being drawn irresistibly to the magnet of Varada. Caro couldn't take her eyes from the wrecked face and the bloody jacket. Her eyes were as wide as a child's at a freak show, gaping at the bearded lady and the lizard man and the two-headed embryo in the bottle.

Victor and Varada faced each other like two eternal adversaries, both huge and threatening. No, that's not exactly true. Victor's hands were balled into massive fists hanging at his sides, clenching and unclenching, kneading his anger and frustration. Varada was, as always, relaxed, nonchalant. As if he already knew how it would finally turn out.

Varada turned toward Thorne and Caro. "Why, Professor, I haven't seen you since my trial, since I got a taste of your justice." He smiled broadly, winced, and touched his split lip. "I'll be honest with you, Professor. I sorta hoped your heart would of given out by now . . . but here you are, one tough old bird. We'll have to see what we can do about that." He smiled ingratiatingly. "But as long as you're here, and as an expert in the law, I'd like to consult you—for instance, what do you think of your son-in-law sending two thugs to beat on me tonight? Scare me off, that's what they were sent to do, and you can see they surely did get their licks in . . . yessir, I gotta give

77

'em that. But what kind of thing is that for the counselor here to do? And to an innocent man, entitled to the full protection of the law? You hear me, Professor? I didn't kill your daughter—I just did the time! I'm an innocent man! And he looses his dogs on me . . . now, how can he do that?"

Thorne's voice was dry. He tried to swallow and couldn't get the job done. "You've made a nuisance of yourself, Mr. Varada. You've threatened my daughter, you've waged a campaign intended to terrorize her and her husband . . . whatever Victor did, sending men to persuade you to leave them alone, that seems a reasonable response—"

"Reasonable? Sending these goons to kick me half to death? Why, you do surprise me, Professor! Where does the law come into all this? Or does it only apply on your side? Damn it, this is still a free country. I jes' find myself walkin' around, sometimes I bump into your daughter . . . why, hell, you're the only folks I know in this big cruel town." His voice had slid into the exaggerated mockery I'd heard before. It felt like a razor blade under my fingernails.

"You'd better leave us alone," Victor said, "or what you got tonight will be only a pleasant memory—"

"Counselor, I'm gonna do just as I goddamn please," Varada said. "I always do just as I goddamn please." The mockery was gone, replaced by the sudden chill, a hammer of violence in his voice. "You should have told your boys to kill me 'cause that's the only way you'll be rid of me. I just don't scare. And I got me some mighty big plans for you and the little missus here—"

Victor made a lunge at him and suddenly Victor was on the floor gagging, choking, gasping for breath. Caro stifled a scream and ran to him, kneeling beside him, looking up at Varada as he stepped back, drawing his fist to his side. He'd buried it in Victor's guts. Nothing to it. Victor got up on hands and knees, head hanging down. Caro had her arm around his back, trying to help him.

Varada shook his head, chuckling. "You got real trouble on

78

your hands now, folks. You send men to take care of me. Then the champ here attacks me when I come to chat. You know what you should do? I think you should talk to your boys, see what they've got to say about our little meeting . . . here, I got a number for you to call." He took a scrap of paper from his pocket and handed it to me. "You give 'em a call, you hear their side of things . . ." He went slowly back to the front door. "I can let myself out. And don't you jes' know I'll be seeing you real soon . . ."

Victor vomited on the parquet floor. Andy Thorne was pale and shaky. Caro looked up at me as if I had the answer.

FIVE

The telephone number proved to be the emergency room at Bellevue. There was a good deal of noise in the background, screams and sirens and shouting and swearing and sobbing. Three or four people talked to me, put me down, picked me up again. Finally I got someone who said he was an orderly. I asked him about Claverly and Potter.

"Oh shit!" he exclaimed. "Them dudes been through the wringer, man. Hey, you know them dudes? You better call next a kin, man. They in surgery now, y'know. Lemme tell ya, they lookin' like somebody dumped 'em in a cement mixer and turned it on high, my man. On high! We got your knife wounds, your cracked skulls, your broken cheekbones and collarbones and armbones, we got your abdominal bleeding, broken ribs, we got your eyeball hangin' down on your cheek— they tryin' to put all the pieces back in the right places now but it's gonna take all night. Man, you know what happened to them dudes?"

"Yes," I said, "I do."

79

Chapter Seven

ONE

Abe Braverman leaned back in the leather swivel chair and made it squeak. He puffed his Dunhill pipe. In his office he looked more than ever like a successful accountant. He wore a gray suit with a gray-and-cream-striped tie and an off-white shirt with French cuffs. He was scowling behind the smoke. He was doodling on a pad of pink paper shaped like a dinosaur. The gold pencil was tracing and retracing the block letters forming the word *paralyzed*.

"Paralyzed, Victor," he said for the eighth or ninth time. Behind him through the open venetian blinds the Empire State Building was shimmering like an illusion in the midday heat. "Mr. Varada broke Horace Claverly's neck and now he's paralyzed from the neck down. I'd have bet there wasn't a man alive who could put Claverly down like that . . . And Potter." The thought of what had befallen his two operatives seemed to overwhelm him for the moment. The air conditioner was making my sinuses angry. "Potter's lost an eye. Skull's fractured. Honest to God, Victor, this guy is one fucking brute." He spoke quietly, in an oddly reverential tone.

Victor stood up and began pacing the width of the office. The door was closed, the typist beyond swatting away at her word processor. I watched her through the window. "Abe, what can I say? I got you into this mess—I'm sorry as hell. I blame myself—"

"I don't," Braverman said abruptly. "I blame Mr. Varada."

"I know, I know," Victor began, his face sagging, but Braverman cut him off.

"Look, they were big boys, they could handle themselves, they were armed. Now Mr. Varada must have their guns. Christ, he's a nightmare waiting to happen—he happened to these men last night. I just can't imagine how he did it. Victor, from a purely professional standpoint, it must have been something to see."

"If I were you, I'd be crazy, I'd—"

"Oh, I'm going to redress the balance," Braverman said. "Mr. Varada is all through. I promise you."

"What are you going to do?"

"Don't bother yourself about it, Victor."

"He keeps telling us about these big plans he has for us. *Us*, Abe. I'm afraid for Caro. She's right on the edge. I think about—you know, rape, murder, this man's capable of any goddamn thing—"

"Like I say, put it out of your mind." He got up and walked us to the door. Before opening it he said: "If I wind up needing a lawyer after this is over . . ."

"You've got one, Abe. You've got the best in the world."

TWO

In the subdued gleam of cutlery and crystal and white linen we lunched at the Harvard Club. The crowd had thinned and we sat in a corner. I didn't have much appetite but Victor, looking gray and weary again after his single ebullient day

81

which had ended so badly, was wolfing down well-done roast beef. Disconcertingly, he was the same color as his lunch. We were the same age but I knew I looked a decade younger. Maybe writing kept you young. Or maybe the courtroom piled on the years.

I put my knife and fork down and sipped some iced tea and figured I had better speak up or forever hold my peace. "Victor, just what the hell do you think you're doing? You decide all by yourself to have two guys get tough with Varada, not—repeat not—just talk to him, threaten him a little . . . but beat hell out of him—not exactly cricket, you'll agree—"

"Fuck cricket. This is not the playing field at Winchester—"

"And it all blows up in your face. Varada practically kills both of them. So what's Braverman supposed to do that Claverly and Potter didn't do? Get a posse?"

"Abe knows what he's getting into. They didn't."

"Jesus, Victor! Wouldn't you say this is getting way the hell out of hand? Like, whatever happened about going to the police?"

Victor fixed me with a baleful stare from the eyes sunk so deep beneath the overhang of his brow. He swirled claret around his glass, took a mouthful, and swallowed it carefully, savoring it. "I urge you," he said at last, "to put away childish things, ideals, for example, grow up, and join the real world. It's about time, Charlie. You're looking at everything backward. In the first place, Varada's the injured party here. Oh sure, he's bugged us on the phone, been a nuisance, but for Christ's sake, anybody's gonna look at us and say he's been wrongfully imprisoned for all these years and my wife and I teamed up to do it to him . . . and if that's not bad enough I send a couple of guys to work him over, two against one and the one is this innocent guy—but whattaya know, this innocent guy gets lucky, fighting for his life, and whips the two mercenaries . . . and if this comes out the very least that happens to me is I get disbarred. You with me so far, Charlie? All right, then, in the

82

second place it will be one very cold day in hell before the police look kindly on any requests for favors from Victor Saberdene. I have spent my career making a great deal of money seeing to it that the bad guys get away with it—that's what it comes down to, Charlie." He leaned back, pushing his empty plate away, and finished his wine. "Take away the cases of legitimate injustice which I do for my own reasons, God knows not for the money—why is it always the poor who are innocent?—take them away and what has my life added up to? Representing clients who, for the most part, are guilty as sin . . . that's what a criminal lawyer does. I'm good at it. Well, that makes it a little tough for me to go to the cops and ask them to bend the rules, protect me and my wife."

"You paint a bleak picture," I said.

"Sometimes it's a bleak world. Sometimes you get caught in a situation for which society hasn't given you a convenient answer. I've got to take care of this my own way. It's me against Varada and the deck's stacked in his favor. So I have to get an edge. Claverly and Potter, they were an edge. Not a big enough edge as it turned out. I've got a lot at stake here, Charlie. My wife's terrified, working her way through a lifetime supply of Valium, she could come unglued at any moment . . . it's me against him now . . ."

"You and Abe Braverman," I said.

"Abe's the only edge I've got. And Abe's not a good guy to get pissed off. And he's mad about what happened to his men last night . . ."

THREE

Victor and Andy Thorne were sitting in the garden with gin and tonics and the oscillating fans blowing. The six o'clock heat was the highest of the day. The radio in the bathroom where I was taking a cool shower said it was ninety-two in Central Park.

83

The heat and the tension running through the brownstone made you want to stay in the shower and hide from everything until it was over. I finally got out and dried off and shaved for the second time that day. I was halfway down the hallway to my room, wrapped in my old seersucker robe from Brooks, when I heard her crying.

The door to their bedroom was open. Caro sat in a small chintz-covered chair by the window, in shorts and blouse, her bare legs tucked underneath her. She was gnawing a thumbnail and sobbing, her body shaking. I was frozen in place again, caught watching her in a private moment. This time she looked up, shook her head at me, waved me away. I nodded, wondering what I might have done to help, and went on toward my room. Then I heard her voice behind me.

"Charlie," she sniffled, "I'm okay. Just giving in to things for a moment." She hiccuped and a faint smile played across her beautiful face. She wiped tears away with her fingertips. "Once I started, like an idiot I couldn't seem to stop." She leaned against her doorway, curling her bare toes into the carpet. Her legs were straight and tan like the girls at summer camp a long time ago.

"I wish I could help—"

"Look, Charlie, you're the only volunteer in our little band. You could get out of it . . . maybe you're a sucker if you don't. I don't know."

"Well, Victor's got his ace in the hole," I said. "It'll be all right."

"Braverman." She shrugged. "What can he do? That's what gets to me, that's why I was crying. I just don't see what anyone can do . . . maybe if Victor just talked to him without all the anger—oh hell, I'm babbling. Thank God for Valium." She dredged up another faint smile. "We'd better get dressed. Victor wants a night out." I turned and she spoke again. "Sometimes I long for . . . for a good clean feeling. Some

84

kind of triumph. Virtue as its own reward." She closed her eyes. "That good clean feeling when you're young. I guess that's it."

That night must have required all of Caro's acting ability. It wasn't just the Valium that pulled her through. It was something else, a strength she called on in the clutch, like a great pitcher reaching back for a little extra with the bases loading and the game on the line. When I next saw her, she was wearing a sleek black silk dress that seemed to ripple in the slightest air currents. We were gathered downstairs and Andy Thorne was begging off the evening out.

"Anyway," he said to Victor, "I'll be here to take any messages. Better than any machine yet devised, laddie."

FOUR

The Oak Room at the Algonquin was dim and shiny and the crowd was glittery with their rings and necklaces and New York money. The level of conversation was low and well mannered with the tinkly laughter in which beautiful women seemed to trade so heavily. We steadfastly avoided the subject that filled our minds so completely. I suppose we drank too much and God knows we ate too much. Victor downed a chocolate sundae and then ordered brandy for all of us with the coffee.

When Michael Feinstein sat down at the piano and the lights dimmed further, Caro touched my arm, told me how wonderful he was. She applauded enthusiastically. Her eyes and smile had the kind of feverish, dangerous quality Jennifer Jones used to project on the screen. When I was a young man and first saw those movies, I'd been drawn to that quality, and watching Caro react to the clear, resolute voice of Feinstein singing the Gershwin songs, I realized that nothing had changed. I was older now and I'd been over the jumps with my share of women, but that dangerous thing they do, dancing along that emotional high wire, still entranced me. Such women were

frightening and the fear you felt made them somehow—disastrously, more often than not—appealing. If we'd all been in one of those long-ago movies, Jennifer Jones would have been right on the money.

Victor, having eaten furiously, proceeded to drink two brandies with equal determination, applauded like a madman, and grew steadily grayer. In the heightened atmosphere created by Feinstein's performance the excitement of the audience provided an adrenaline rush for all of us. In those moments I saw Caro and Victor in new roles, unlike what I'd seen before. Suddenly they seemed almost strangers, caught and held tight in their own little cells, linked, oddly enough, by me. They looked at me rather than at one another, as if a gulf I'd never noticed before separated them. It was an impression, nothing more, though later I had reason to remember it.

When Feinstein had done his final encore and the lights had come back up, Victor excused himself and left the table. We watched him go, a massive figure, shoulders hunched slightly, his great square head above the crowd. A couple of people waved to him and he nodded in recognition, then suddenly stopped at one of the banquettes, leaned down to talk with a couple including a strikingly elegant woman who tilted her head and delivered one of the markedly tinkly laughs just before brushing her lips against his cheek. Caro watched with a slow smile, which came and went almost without having been there at all.

"She's exquisite, isn't she, Charlie? Ravishing, wouldn't you say?"

I looked at the woman and her husband exchanging small talk. "Very pretty, I suppose."

"But?"

"A little glacial for me."

"And what is your type, Charlie?"

"Oh, I don't think you really want to go into this—"

"Of course I do."

"All right," I said. "I've had plenty to drink, too damn much. I've been listening to the most romantic music in the world in one of the most romantic places . . . and this whole mess we're all in seems to create a new set of rules—doesn't it, somehow?"

"As if nothing we say can be taken down and used in evidence against us."

"So long as that's all understood." The woman Victor was bending toward threw back her head, and a diamond necklace twinkled below her wide, red smile. "You, Caro," I said, feeling peculiarly light-headed, images of Jennifer Jones and God knows what else flitting across my mind. "You are my type. If I'd met you before Victor he'd never have gotten a chance at you."

"Well, Charlie! What a flatterer you are!" She looked past the brandy snifter at me.

"Nothing but the plain truth, I'm afraid. And I've said way too much—"

"Well, what type am I, then, Charlie?"

"You're the type I can sit and look at for a long time and I never stop smiling. And I like your eyes, the sadness in them, the sorrow and the recognition of your fate and the vulner-ability—"

"My fate," she mused. "And men get so wrapped up in female vulnerability!"

"Right now you're about the most vulnerable female I've ever seen. But what do you like, then, a man who treats his women rough?"

"Depends on my mood. Sometimes it's, well, it's exciting to be afraid—"

"Female vulnerability again. Like always picking the wrong men—"

"But maybe it's all an act, maybe I'm not afraid at all—"

"I think you're acting, all right. But you're putting on a show

87

of bravery. Every time you turn around, I see the truth in your eyes . . . you're looking for Varada."

"I'm trying to be brave for Victor, Charlie. He's so worried about me. It's funny. I'm not even his type—"

"What are you talking about? That's silly—"

"I'm quite serious." She nodded toward Victor and I looked. He had moved on, was just having a word with the *maitre d'*, then he disappeared into the lobby. "I'm not his type but she is. The woman he was talking to. Sammy Barber. She used to be a model. Samantha Frost she was then, before she married Thaddeus Barber. Victor nearly married her." Her eyes were too bright and vivacious. I nodded, remembering that conversation with Victor in London so long ago. Victor had decided against Miss Frost and was on his way back to help Andy Thorne and now everything was very different. Victor had been very successful at helping Andy Thorne. He'd sent Varada to prison and married Caro Thorne but nothing had turned out quite the way it was supposed to.

Caro had said something more while my mind had been sorting through the ironies of the past. "What did you say?" Surely I had misunderstood.

"Victor's having an affair with her. Don't look so shocked, Charlie. Such things do happen, you know."

"I find it very hard to believe, Caro. I really do."

"That's because you are a very loyal friend. But it's been going on for years. It's all right, really. Don't worry, it doesn't make your old pal a bad guy. He loves me, I know that. He dotes on me. But I'm a *case*, don't you see? A head case, a nut case . . . he can't get that out of the back of his mind. I'm someone he has to take care of—and he's very good at caring for me. But the fact is the excitement has gone out of it for him . . . went out of it years ago. The sexual excitement, to call a spade a spade. He pitied me when we were involved with Anna's death and the trial of Varada. To return to your point,

88

Victor was powerless to resist my vulnerability, which would seem to prove your theory."

"It's not my theory. Just an idea I applied to myself. And I doubt very much that Victor's having an affair with that woman—"

"And you should know, being such an expert on our marriage." She was laughing at me.

"Maybe not, but I know something about Victor—"

"But you know almost nothing about me. You see, Victor liked me in bed. It took him a while to realize that I'm almost completely frigid." She looked up brightly, her gaze fixed on something past me. "Ever since Anna's death . . . the way she died. But it took Victor a long time to realize the truth— because I'm such a wonderful little actress!" She changed the tone of her voice completely. "Darling, what's the matter?" All the playfulness was gone and her face was suddenly tight and afraid.

Victor was standing over us, put his hand on my shoulder. My first reaction was relief that I wouldn't have to respond to Caro's accumulated confessions.

"We've got to go," he said. "I just called the house and there was no answer." There was an uncharacteristic tremor in his voice. "I'm worried about Andy and that goddamn pacemaker of his. All this stress—Christ, I never should have asked him to come to New York. Come on, let's go home."

Chapter Eight

ONE

From the street outside the brownstone you could see that something was all wrong. It hit me right away and by the time I was halfway up the stairs Victor had the same impression. He was right behind me when we went inside.

The front door stood open, as did the second door into the foyer. The light shone through to the street.

Coming through the second door was, it seemed to me at the time, the final step into the nightmare. I was wrong. The nightmare had just begun.

First I saw the blood spreading away on the black and white parquetry. On his side, having tried to crawl somewhere before his strength gave out and the blood stopped pumping, was Abe Braverman. The smell of the slaughterhouse was everywhere. His head seemed oddly hinged, bent back in the rictus of violent death. His throat had been cut. His hands were covered with blood as if he'd tried to hold his jowls together and failed.

Victor stood staring at the body, then turned to me with a questioning expression on his vast flat face. He took a step

backward, slipped in the blood, and grabbed my arm to steady himself.

I looked away from the blood-soaked corpse, sprawled in its dark crimson slick, and saw what Victor had missed.

A hand, white and clenched, in the doorway leading to the room where Caro had first led me when I'd arrived for dinner.

I pushed the heavy sliding door all the way back.

Andy Thorne lay facedown on the carpet and he was very still.

TWO

The next half hour was a blur.

It was obvious that Abe Braverman was dead.

Andy Thorne was still breathing. Shallow and raspy but he was still alive.

Victor started working over him. He seemed to know what to do. Caro got on the telephone and calmly got hold of the Emergency Medical Service, told them an elderly man with a pacemaker had suffered a serious heart attack. When she hung up she was white-faced and biting her lip to keep hold of herself and went to kneel at her father's side. She'd told me her father would have preferred her dead to Anna but she was his daughter and nothing counted more than that.

The EMS ambulance was there within ten minutes. Operating with a kind of uninvolved superefficiency, they whisked Andy Thorne out on a stretcher. In the meantime Victor called the police. Caro went with her father, and Victor spoke with one of the team members before he came back inside. He stood looking down at Braverman, then looked at me.

"So much for my edge," he said softly. "I gotta get a drink or I'm gonna puke. I've already thrown up on this floor once this week . . . Jesus, Charlie." He sighed. "Abe. The son of a bitch killed Abe . . . what I'd give to know how he managed it—"

91

"From behind," I said. "Out of the shadows somewhere, got that big goddamn arm around his throat, one slice, and Abe got this far . . ." I shrugged. "Varada must have been watching the house."

We went to the study and I stood with my back to the air conditioner, feeling it chill my clammy shirt and stick it to my back. He handed me a tall gin and tonic. I'd never wanted a drink more in all my life. This was all so different from writing about a murder. This had nothing to do with research. He told me that the EMS guys hadn't offered any predictions about Andy Thorne. "I have to do something, Charlie. This shit has got to stop." He was whispering, thinking aloud.

"It must have happened very near here," I said. "Varada just hangs around, like smoke over a burning house. Braverman couldn't have gotten far with a wound like that."

"It's my fucking house that's on fire. Mine!" Victor exploded, kicked an embroidered gout stool all the way across the room where it bounced against a bookcase. "We're going to find a bloody trail leading to my doorway . . . poor Abe!" His fists were clenched, veins bulging at his temples.

"We're looking right into hell, Victor. You must see that. We've got to leave this to the cops—"

"Sure, sure," he said. "Up to a point."

While we waited for the police to arrive he told me to leave the talking to him. I was just a friend who happened to be on hand for the festivities. I didn't know a damned thing.

I figured it was his hand. He could play it any way he wanted.

THREE

I gave the cops a very brief statement, stayed out of the rest of it. I wasn't even in the room when they spoke with Victor. It took a couple of hours before the remains were taken away and Victor and I were left alone again.

"Well, thanks, old son," he said with a weary, wry smile. We were slouched in the study. "Thanks for keeping the old trap shut. I can't let them get any idea Varada's involved—"

"So how did you explain Braverman's expiring in your foyer?"

"I told them I knew him, had worked with him. My theory is that he was on some unknown errand in the neighborhood, got mugged, fought back, and paid the price. Realized he was near my house and tried to get to me for help . . . Andy buzzed him in and had a heart attack when he saw the shape Abe was in. Hell, Charlie, Andy may have been trying to answer my call when it hit him."

"Did they buy it?"

"So far. Why not? Let's just hope Abe didn't leave a lot of notes for the cops to find. About Varada, I mean. We'll see. If he did, I'll have to come clean and that's no problem. All I'll have been trying to do is protect my wife . . . anyway, you're out of it. Cop-wise, anyway."

"How about Varada-wise?"

"I'm working on that. We're getting down to the short strokes, old son. The keen legal eagle had better think of something. Pronto." He yawned, looked at his watch. "Look, I'm going to the hospital. Andy'll either pull through or not. The one I'm worried about is Caro. I know her, she won't come home until Andy's in the clear or dead." He stood up. He wasn't looking very spiffy anymore. All the starch was pretty well taken out of him. A starchectomy.

At the door I stopped him. "One last thing," I said. "Maybe I'm dense, but what's the point in keeping Varada out of it now? Maybe they could nail him for Braverman's murder—"

"No, he's too smart for that. Believe me, Charlie. First they'd have to find him. Then they'd have to break his alibi and he'd have one, Charlie, bet on it. Probably some woman he's got scared half to death. Or a bartender and some winos who'll swear to God he was with them all night. On and on and on. I

know what I'm doing. Varada is gonna be clean on this. At St. Pat's praying with Cardinal O'Connor. No, I've got to keep Varada out of their thinking for now. Or it's all gonna come out, Caro will maybe crack up, I'll be disbarred, Varada will sue my ass. There's no other way."

"Victor . . . what are you saying to your old pal Charlie?"

"I'm telling you there is only one way out of this now. I'm going to kill him." He smiled abruptly and looked twenty years younger. "Don't look so surprised. You know enough about this sort of thing. You've written books about these guys, the sociopaths, the psycho killers who exist to kill. Think about it, how many people has Varada killed? Does he even remember? I'd say some girl he picked up at a carnival, a girl who thought he was quite a hunk, a quick naughty thrill . . . and they found her in the high weeds a couple days later. Maybe a guy with a car at a highway diner at just the time Varada needed a car . . . and they found him wedged behind a rock under a one-lane back-road bridge somewhere." He looked back at me from the stoop. "He's not going to kill me and he's not going to kill Caro. But he is going to die trying. I promise you. Believe it, old son."

Alone in the house I found it all but impossible to close my eyes, let alone sleep. Me, the guy who was usually gone by the time his head hit the pillow. Adrenaline, I suppose. Aftershock. I went upstairs to my room and got into pajamas and lay down but it was pointless. So I took a shower and got to thinking about Varada. He was out there somewhere. He'd killed one man, left another paralyzed. Taken another's eye and almost as directly put Andy Thorne into an intensive-care unit. And he hadn't even reached Caro and Victor.

I was prowling the hallways when I came to Thorne's room. The door was open and I went in. It was spare and neat, like the man. His silver-backed hairbrushes were set precisely squared on the night table, next to a framed photograph. His late wife, I thought, picking it up to get a look at her. Then I

94

saw that it was Caro. I held it to the dim light, peering into her eyes.

But it wasn't Caro, either.

It had to be Anna. The daughter who shouldn't have died.

FOUR

Morning came and Victor returned from the hospital with a plan and the news that the word on Andy Thorne was "guarded." He'd spent the night keeping Caro company and quietly figuring things out. When he explained it all to me it sounded like one gigantic mess waiting to land on all of us. On the other hand, Victor was a master of planning.

He said he had to bring Varada out in the open. The way to do it was to make Varada curious by hiding Caro. If our pattern of behavior was broken, if he couldn't find her, Victor reasoned, then Varada would come after her. To the brownstone. Because it was Caro he'd chosen to terrorize. And because he was insane.

"Once I can get him into the house," Victor said with the utter calm of the truly desperate, "I'll kill him as an intruder. I'll worry about the consequences when I come to them—they won't be as bad as Varada alive."

"Look," I said, "this plan is made up primarily of holes stuck together with occasional possibilities. What if he won't play the game, just goes away? What if he—hey, wait a minute, where will Caro actually be? You're not thinking of keeping her here to lure him in? That would make all three of you insane—"

"Of course not, Charlie. That's where you come in. Caro has begun to look upon you as something like her knight in armor, protecting her, keeping her company. You've been a hell of a sport—and she has complete faith in you . . . which is why I'd like you to be her keeper for just a while longer. Until I can

95

finish this thing. I want you to take her away. Secretly. Nobody will know but the three of us."

He had a country place up in Westchester, deep in the hills, off a narrow private road, unmarked, not a clue as to ownership. It was about as anonymous as it could be, a secure hideaway. There was simply no way that Varada could know about its existence, let alone how to find it. It was there that I would take Caro until the Varada thing was over.

"There's something wrong with this," I said. "Taking matters into your own hands, I don't like it, Victor. We live in a civilized society, there are ways to handle things like this—"

"Charlie, the social compact was scrapped a long time ago. We pay our taxes and when you turn the handle water comes out of the faucet. The garbage usually gets picked up. And that's it. The rest of the time we're just victims awaiting our turns. It can come in the subway or in the park or while you're walking your dog or trying to find a cab or leaving Yankee Stadium. Wham, it's your turn, you're left dead or bleeding and nobody much gives a shit. So much for the social compact. The miracle in this town is that a Bernie Goetz doesn't turn up every day having had absolutely enough: enough fear and enough thuggery and enough terror. Where are the frustrated people blazing away at the punks and hoods and practiced killers who've taken one look at this brave new world of ours and decided it's their very own? I don't know but I'm damned sure I feel no obligation to be a victim . . . so let's not talk about how we'd take care of this in a civilized society because that's just not where we happen to be. We are in the deep dark woods, my friend, and sometimes we get the bear . . . and sometimes the bear gets us. This time I'm going to get the fucking bear and make him an ex-fucking-bear." He'd kept talking while he led the way into the study. "If you have a better plan, then now is the time to trot it out."

I didn't. He nodded at my silence and went to the wall rack and took the Purdey down from its resting place. "Best gun I've

ever had. And I've had a few. I thought about this gun during the night, Charlie, remembered the day we went round to Audley Street in that fancy little car of yours and picked it up. Damn, they were happy days, sport. Y'know what I was thinking about that gun, Charlie?"

"No, I don't suppose I do."

"I was thinking about whether I wanted to kill Varada with it or . . . or if I wanted you to guard Caro with it—"

"Guard her from what, for God's sake? Nobody knows where we're going, there's no way to identify it as your house, and now I'm guarding her with a shotgun? I'm no good with a shotgun. Anyway, what's the point?"

"The point is, I'll feel better. And she is my wife. And you're my pal. Just do it, okay?"

FIVE

We worked on the assumption that Varada was somehow still watching the brownstone. I packed a bag. Victor filled another with some of Caro's things. Victor carried them down the steps to the street. I carried the Purdey in its leather case. We stood at the curb while the taxi waited. Like a couple of very bad actors we played a farewell scene, handshakes, pats on the back, and I got into the backseat. He stood on the sidewalk waving as I pulled away obviously heading for the airport. A few blocks away I told the cabbie to forget Kennedy and go to the hospital. He couldn't have cared less.

Caro was dozing in one of the visitors' waiting rooms, half a cup of cold coffee nearby. She came to, fully alert, as soon as I sat down next to her. Andy Thorne was more or less out of danger, stabilized, the doctors said, vital signs all right, but he was still in intensive care. Caro's face was pale and drawn, showed the wear and tear not only of the night but of the whole

Varada campaign. She stared at me while I told her Victor's plan. She sipped at the cold coffee.

"I don't like it," she said. "As a plan, let's face it, it's dog food."

"Well, I'm not the guy to argue with you. But I didn't have a better one. And you know Victor—"

"Oh yes, Victor's very determined. I can see him, sitting at the desk in the study, shotgun across his knees, waiting for Varada . . . while Varada calmly sets fire to the house . . . but there's no arguing with him. He'll have his way." She smiled tiredly. "Can you face guarding the troublesome damsel in distress? It's a very nice place, actually. You'll like it. And in a couple of days, when nothing happens and Victor gets bored, we'll come home . . . Is the front hall cleaned up? All that blood—I've been thinking about Father all night, now it just hit me, oh Christ, Charlie, poor Braverman's dead . . ."

I didn't have anything to say. Finally she smiled sort of sadly at me, patted my hand. "Charlie, my poor Charlie. What next?" I didn't have an answer to that one either.

Mainly I was thinking about her. I was going to be alone with her while Victor waited to kill a man. The gears were grinding us very small, indeed. The thing was, looking at her, tired and with circles under her eyes and worry etched across her face, I wanted her.

And now it seemed I'd have her to myself. She'd said she was frigid, an oddly antiquated term. I wondered if she was telling me the truth.

The longer I looked at her the more ashamed of myself I was.

Chapter Nine

ONE

The house was much as advertised, tucked well off that narrow country road, about a mile from an apple orchard, surrounded at a great distance by hedges thick enough to stop a panzer division. The driveway wound past and through a stand of beeches. There was a pool with a changing house, yellow-and-green-striped awnings and sunning chairs that matched. There was a tennis court behind a high fence with wisteria clinging to it. There was nothing to show who owned it.

I carried our gear inside and she went upstairs to change clothes. I turned on the air conditioners, took off the seersucker jacket with the sweat-soaked back, and made myself a gin and tonic with Boodles and lots of ice. I pulled open the heavy sliding glass doors leading from the huge living room onto a patio looking out across the lawn, the pool, the court. It all seemed so peaceful in the late afternoon, one of the playgrounds of the rich and powerful, so very far from Carl Varada and Abe Braverman's corpse in its ocean of blood. I was

thinking about the lawn parties, the beautiful women in big hats or tiny swimsuits, the ghosts of all those who had lived there before and seasoned the place and got it ready for the Saberdenes, when I heard her coming down the stairway from the balcony that circled the room.

We'd driven up from the city in nervous, self-conscious silence. I wasn't quite sure if we were worrying about Varada and the way he had of maiming and killing people, or if it was just the fact that we were going to be alone together with no one to remind us to mind our manners. Maybe she was worried about one thing and I was getting bent out of shape by the other.

She was wearing madras Bermuda shorts and a white blouse, a duplicate of the slim, straight-legged, tanned girls of my youth. She'd brushed her long hair back. She wore a gold bracelet. It slid up and down her arm while she poured herself a glass of white wine. She showed me the house and took a couple of steaks from the freezer and then we had another drink while she walked me around the grounds. It was hot and humid. The birds in the beeches and the elms just sat there muttering. It was too hot to fly. We had skipped lunch so I lit the gas barbecue grill. She tossed a salad and I grilled the steaks. The perfect suburban couple. I couldn't pay any attention to whatever we were saying. It was like watching a silent movie.

She was, under the circumstances, a good hostess. She was trying hard. She did all the talking and I did all the watching. She wasn't saying anything important: she was just filling the space. I watched her face, the curve of her mouth, the delicacy of her long lashes. I watched her legs, the way she stood leaning against a tree with her hands behind her, the way she walked, the way she kind of loped barefoot back to the house to fetch ice and lime for the gin and tonic. I had the same sensation again, that of feeling young, like a Harvard man in pursuit of the perfect Wellesley girl from *Mademoiselle*'s college issue

100

twenty years ago. If I'd had my way time would have been frozen somewhere back then and now she seemed like the spirit of that past I'd longed for but never really had, Victor's past of evening clothes and dancing pumps and holidays at some shore with girls like Caro.

Tasting the gin and feeling the sweat trickling down my back and watching her tan thighs and the pull of the madras across her hips and hearing the soft thunder behind the purple clouds creeping toward us from the west, I knew how completely I'd fallen under her spell. And how envious I actually was of Victor's life and his woman. I couldn't ignore the promise of the heat and the way she blotted her forehead with a napkin and the big house we had to ourselves.

Finally she fell silent. We sat at the white wrought-iron table with candles flickering in the moist breeze and the leaves rustling in the trees. I felt like Nick Carraway messing around with Daisy Buchanan on Gatsby's time. All I needed was a dock and a blinking light. I'd watched her long enough and downed enough gin not to be ashamed of myself anymore. Everybody was having lots of trouble and I was trying to take advantage of the bad nerves that were going around. There'd be time for sermons and soda water in the morning.

We'd finished eating and the sun had slipped down below the forested ridge. The first drops of summer rain were beginning to patter in the swimming pool. I couldn't wait any longer.

I got up and went around the table. She stood up and I grabbed her and held her against me. She looked up at me, eyes wide, and I kissed her. Her mouth opened and I kissed her harder, feeling her body straining against me. I held her for a long time, until she knew I was getting serious, and then she took a step backward. I let her go. I put my hand out to steady myself against the tabletop. There was a sudden heavy clatter on the flagstones. In the candlelight's flickering shadow, I saw the Purdey. I'd knocked it over.

We both stood there looking at it. The noise and the reality of

101

the gun's presence had effectively shattered the scene we'd been building. I'd broken the mirror. Instead of Caro and me starting up something that would have its own life right away, I looked through the mirror and saw Victor sitting with his gun across his knees, waiting for Varada. My passion was wilting, a casualty.

"I understand that murder, danger, the threat of violence—all that stuff excites people sexually." She knelt and picked up the shotgun, handed it to me. "And we've taken such care not to talk about it . . . only made it worse—"

"Maybe that's it," I said. "Just a psychological phenomenon, doesn't have anything to do with us—"

"Don't laugh at me," she said softly.

"Don't be so funny, then."

"Look, this is all too crazy. We're not ourselves. Damn it, Charlie, you know everything about me. I've told you things I've never told anyone before. Maybe it was because I like you, Charlie . . . or maybe it was because of what we're going through. Maybe because you were a stranger with a sympathetic manner. But now I've told you things and that makes you something else. Not a stranger. Everything's changed. But not quite *everything*, understand? I'm still married, Victor's still my husband. I've still got the life I had before you turned up and sort of stirred things up—"

"I know, Caro. I've taken advantage of this crazy situation, taken advantage of you when you've been at your most vulnerable. I'm not overwhelmingly proud of myself . . . for wanting you, for betraying my old friend. So maybe we should just pretend none of this happened—"

"Oh, Charlie my boy! We can't do that . . . we've almost got our cards on the table. It did happen. It happened to both of us. These last few days have changed everything. You aren't the only one who feels things . . . but let's wait until this mess is over and then—well, let's not worry about it now—"

"We'll wait and then everything goes back the way it was."
"Oh no, forget that. It's never going to be the same again."
It was raining harder by then. We were both all wet.

TWO

Caro went to bed. Early and by herself, thank God. I like to
tell myself that I wouldn't have slept with her even if she'd
wanted to. A harmless lie on my part, right?

I sat up watching the Yankees game on television while the
humidity built up in the air-conditioned room and ran down
those vast glass doors, as if it were raining indoors, too. I didn't
know the score or what inning it was or who they were playing.
My mind wasn't on baseball. My mind was upstairs in her
bedroom, which was a hell of a place for it.

What the devil was I doing out in the middle of nowhere, a
place Varada couldn't possibly find, a place where Caro was
completely insulated and safe, when I should have been back in
New York with Victor laying a trap for Varada? Or better yet,
talking him into letting the police handle the whole thing?

About ten-thirty I couldn't sit still any longer.

I picked up the Purdey, making sure it was loaded, and slid
the glass doors open. The rain was drumming on the patio, but
the hell with it, I decided to make a tour of the grounds. That's
what the guard does. Maybe I thought Varada was lurking
behind a hedge. It was ridiculous. It was something to do. The
hair was standing up and waving its tiny hands on the back of
my neck. I wasn't scared: there was nothing to be scared of, if
you didn't count the girl upstairs. But I was as tight as the fat
lady's girdle. A night patrol, a stroll in the gentle rain, was in
order.

I bisected the lawn, which was about the size of a square
football field. The wind had come up harder and the rain
falling into the pool was dancing along the crests of little waves.

The underwater lights made an aqua glow, cast peculiar shadows. Puddles were forming on the tennis courts. Rain was whispering in the stand of beeches. Through the rain the house looked cozy and comforting, the windows turned to shining yellow invitations. A dog was howling in the distance. A bird, maybe an owl—how the hell would I know? I wasn't nature boy—said something behind me and I damn near levitated. I swung around with the shotgun, came within a twitch of blowing holes in a few trees. It was crazy. Finally I made a circumference of the lawn, rain streaming into my eyes, and was panting by the time I got back to the house.

I went to bed about midnight. I was exhausted. Sleep overtook me even more quickly than was normal. The rain on the roof and against the window made a steady white noise, enveloping me. At the far end of the bedroom the air conditioner was humming smoothly. My sleep was deep and dark.

Lousy dream. I was back in the foyer twenty-four hours ago. Braverman was on the floor again but the blood was pumping exaggeratedly, leaping like a geyser, and the parquet floor was ankle-deep in it. His throat gaped like a screaming mouth. I couldn't tear my eyes away and I wanted to throw up but I couldn't. Then I saw a huge clock suspended over me, ticking so loudly I couldn't think. Caro was standing in midair, beside the clock, moving the hands this way and that, as if she might push time backward and Braverman wouldn't be dead anymore . . .

I came awake soaked with sweat, dying of thirst, and lay still for a moment trying to get my bearings, struggling up out of the dream. I halfway thought I'd heard something that had awakened me but it was fuzzy and maybe there hadn't been anything after all. It seemed to take a long time to wake up.

And by then I couldn't hear anything out of the ordinary. Just the rain and the steady hum. Still, something told me to get

104

up. It was raining harder, thunder cracking like heavy fire-
works.

I sighed to myself, went out to the balcony, and looked down
into the living room. I'd left a table lamp turned on low. It still
cast a dim glow. Everything was as I'd left it.

Then without warning the glass doors were thrown open and
the wind blew the curtain wildly and the rain swept into the
room.

What happened next couldn't have taken more than five
seconds, possibly ten at the outside. I've replayed it in my mind
a thousand times. But no matter what I do, I can't change what
happened, can't make it better.

A huge figure materialized in the doorway, caught in the
rain, caught in the swirling curtains, arms windmilling like the
thing your mother used to call the bogeyman.

The gun, the Purdey! I'd left it propped on a chair by the
bedroom door. I dashed back to get it, thinking I had to stop
him from getting to Caro . . . Shit, how did he find us, how
the hell did he know?

And the gun was gone.

I tripped over the chair, felt everywhere for the damned
thing, couldn't find it or the light switch.

Confused, afraid, operating on the reptile brain within each
of us, I ran back to the balcony, made for the stairs. Did I think
I was going to attack Varada with my bare hands?

The shape had freed itself from the curtains, had staggered
to one side.

The explosion shook the house, rattled my bones.

The shape cried out, wobbled backward, ripped the curtain
from its moorings, leaned for an instant against the glass.

The second explosion smashed him back, the glass door
exploded into the night, and the shape fell through the hole,
collapsed on the patio.

The next thing I knew I was down the stairway, standing in
the living room. To my right, silhouetted in the dim light was

Caro in her nightgown, holding the Purdey. She stood like a statue. The wind ruffled the nightgown, pressed it to her body. She didn't make a sound.

I turned left and went out onto the patio, cutting my bare feet in the broken glass but not knowing it. I was flashing back on all the horror movies I'd ever seen, where the dead guy isn't dead after all and reaches up and grabs your leg. He lay sprawled, one arm thrown up across his face as if he hadn't wanted to see his fate rushing at him.

He wasn't moving. He wasn't breathing.

Finally I bent down beside him. Caro had come to stand in the doorway. I pulled the lifeless arm away from the face.

I was looking into the dead staring eyes of Victor Saberdene.

PART TWO

PART TWO

Chapter Ten

ONE

Sometimes you wonder how much tragedy one person can withstand. I watched Caro, knowing that this was one of those awful times. The murder of her sister, the horror of the trial, her own breakdown, the reappearance of Varada and the torment he brought with him, her father stricken . . . all was prelude to the final obscenity, the huge figure coming from out of the night, the shotgun . . . and her husband dead by her own hand. How much sorrow, how much despair? She may not have asked those questions, but I couldn't ignore them. Why had the fates singled her out? What could she have done, how offended them, to be so cruelly punished?

But of course my tendency was always to ask such questions, frequently rhetorical questions, as if I were writing the opening sentences of one of my books. Caro didn't think that way because there seemed to be no self-pity in her nature. She was the leading performer in what seemed to be a kind of Greek tragedy. What she reminded me of was, in her own way, Jackie Kennedy living on through the dark tunnel of the sixties, beset

by a sort of cruelty you could go mad trying to explain or understand. I said nothing of the kind: she would only have been embarrassed by it.

Caro wasn't having any of that sympathy stuff, not even in the immediate aftermath of Victor's death. Was she still giving a performance? If so, she somehow managed to convince herself as well as make things easy for all those around her.

There was at least a practical explanation of what had happened. In the newspaper it was treated as an accident. None of the details of the Saberdenes' private lives was revealed. The fact was that there had been several break-ins in the vicinity of the country house as well as a case of rape. That alone provided an explanation for the shotgun, the jumpiness on our part, and my presence in the house—the old friend of the family accompanying her, with her husband expected to come up for the weekend. Somewhere a tongue or two may have wagged and clucked, a theory proposed about the family friend's being on hand, but we never heard it.

What really happened?

It was recorded on Victor's answering machine.

Varada had called Victor at home.

Well, Counselor, I know where you've tucked her away. And, wouldn't you know, I'm feeling mighty sexy tonight . . . There was that long, mocking whiskey chuckle, smothering you with its arrogance. *I may just have to go knock me off a juicy little piece of her pussy tonight, what do you think of that, Counselor? Honest to God, I don't really think she'd mind . . .* More moist, rumbling laughter.

Victor's shock had registered on the tape. *How could you know*—he'd bitten off the last word as the chuckle bubbled toward him.

You don't really think that fella with her can stop me, do you, Counselor? Get serious! Give her a call, why don't you? Warn her . . . the line's out, Counselor . . . no way you gonna warn the lady in time, Counselor . . .

Then he hung up. And Victor must have desperately called

110

the Westchester number. To no avail. The telephone didn't ring that night. We didn't know until I tried to call the police that it was cut.

Victor must have been going crazy. I've seen his panic and frustration again and again in my mind. The frantic drive northward from the city. Why hadn't he called the state police or the local law up there? I don't know, except he was dead set on keeping the law enforcement agencies out of it. Victor was Victor; he did things his way.

He must have seen the light I left burning. He must have thought it was better not to come in the front door, must have believed some stealth and possibly surprise would come from another means of entrance. Who knows?

And naturally Caro, having heard the odd noise at the doors, or before that from somewhere in the night, a noise that shouldn't have been there, had failed in a try to wake me quickly, had taken the gun, had seen the terrifying figure in the doorway, had been thinking Varada, Varada, Varada, had fired in sheer terror . . .

There was one aspect of the night's events which bothered me because it alone made no sense.

That severed telephone line.

Yet Varada, who must have been there on the grounds to cut it, never put in an appearance. He left it to Caro to do his killing for him. It was like driving a single stake through both their hearts. And God only knew how he'd located the house in the first place. The bottom line was simple. We'd had a visitor from hell.

TWO

Victor's death was ruled an accident. There was never any question of bringing charges against Caro. Her doctor kept her on mild sedatives for a week and, considering her past and the

111

particular pressure of the tragic events, a private nurse moved into one of the spare bedrooms for several days. But the fact was simply that Caro came through it with remarkable calm.

One evening her doctor, a thickset man with wiry blond hair and a pink face, accepted a gin and tonic and sat with me in the back garden after seeing that she was safely sound asleep. I observed that she was holding up remarkably well.

"So it would seem," he said, working his tie loose and undoing his collar button. "On the one hand, I'm very relieved that it should be so. On the other, we have to hope she's not bottling up all the pain and frustration and anger. The problem is there's really no way to tell. We just have to wait and see. So few people ever go through things on the order of what she has, it's hard to judge what may be going on inside her head." He swirled the ice in his glass with a stubby forefinger.

"She has incredible self-control," I said, wondering what he'd say if he knew the Varada dimension.

He nodded. "In a curious way, her father's condition is good for her. She must be strong to help him. Therefore, she will be strong. And, if I may say so, it's very good that you happen to be here. She needs to keep her chin up for you and—also very important—she can share her memories and sorrow with you. If you can, stick around for a while. It'll do her a world of good . . . she's never made friends easily. You're something of a godsend." When he got up to leave he said: "She's quite a specimen, Mr. Nichols. She's had far more than the normal complement of nasty shocks in her life. Maybe it's true what they say. What doesn't kill us makes us stronger."

The police asked us more questions about the death of Abe Braverman but even they seemed rather daunted by the enormity of the tragedy that had beset the household. Whatever theories they might have had they didn't share with us. They must have poked around in his cases to see if someone might have wanted to kill him, if it hadn't been a mugger gone berserk. They never mentioned Varada to us: Abe must have

kept this one in his head. I never did find out if they tied Abe's death to Claverly and Potter and the mangling they endured. The truth was, I think the summer horrors New York was breeding somehow took our business out of the spotlight more quickly than I'd imagined probable. After all, I was used to the slower pace of London.

There was a slasher loose in the subway system, striking at random, his brain fried on the griddle of madness, hatred, whatever. Somebody else was stealing human heads from morgues and mortuaries, a peculiar kind of nonlethal pilferage. Good for lots of headlines. Crack was being purveyed from Wall Street to Harlem: some of the more colorful dealers announced their presence by loudly cracking bullwhips on Forty-second Street. There was an epidemic of babies toppling from high windows. The government of the city was rotting from within, almost disappearing under an avalanche of indictments. A guy with a saber carved up a bunch of tourists on the Staten Island ferry. Cops were being arrested for shaking down cocaine dealers and going into business for themselves. Six movies were being shot on the streets of Manhattan and if the swarms of tourists weren't looking around to see if the slasher might be creeping up on them they were trying to catch a glimpse of Dustin Hoffman or Warren Beatty. It was also hot as hell and humid as your goldfish bowl. So, all things considered, the Saberdene tragedy had to fight for newspaper and television coverage. Then half of a new building fell down on a platoon of pedestrians and somebody threw a spring-loaded dagger at a ballplayer from California up at Yankee Stadium and Caro Saberdene found herself consigned to ancient history within a week of her husband's death.

THREE

The funeral was very small, guarded by a security organization from the city. It was held without any church service up in Westchester. A few of Victor's law partners spoke briefly. They were all very proper, very controlled individuals: it would have taken a good deal more than a partner's death to produce a tear, though I'm sure they were preoccupied by strategies to retain the kind of fees Victor attracted. There were people who prided themselves on knowing how to behave. Caro, although she was not personally close to them, was in many ways one of them. She knew how to behave and she was grace itself when it came to dealing with them. I think maybe I was the only one in attendance who shed a tear and I felt oddly ashamed, as if my breeding were being revealed as not quite up to snuff. But I tried to be discreet, moved off by myself, wiped away the tears with my bare hand so no one would see the white flag of handkerchief.

Forty-eight hours later we were sitting in one of the partners' offices down on Wall Street listening to a longtime friend of Victor's inform Caro that she had come into an estate valued at just this side of eleven million dollars. Never has such a sum received so little reaction. Finally I paid it my personal respects by breathing a heartfelt *Jesus*. Caro's mouth flickered at the corner, a tiny involuntary smile, when she heard me. The partner, a man of great gray pin-striped gravity, went on reading the list of assets.

If Caro was holding up superbly, I was having some difficulties. She and I really didn't have much chance to talk through that first week or ten days following Victor's death, what with the doctor wanting her to take her pills, the nurse bustling about making sure she got plenty of rest and quiet, the

114

Filipino couple being as solicitous as humanly possible, and a few of the partners and their wives dropping by on sympathy calls. I tried to stay out of the way. I tried not to worry about defining my role but inevitably I contemplated the future, which consisted of pondering Varada, Caro, and myself—what we were all going to do.

She did make clear to me, though, that she wanted to continue Victor's policy regarding Mr. Varada. That is, our lips would stay buttoned. It seemed to us then that the death of Victor marked the end, that Varada would be content. We wanted it over, done with.

I don't want to place myself onto center stage at this point. For that matter not even Caro was dominating events just then. Rather it was a period when the process of coping with Victor's passing took hold of us, directed our behavior. My own reactions were private, but for the sake of clarity let me quickly describe what was going on in my mind while I played the family friend, good old Charlie, for anyone who took the time to notice me.

I felt a deepening sense of guilt about having fallen in love with Caro at all and, even worse, about not having just shut up about it. I had gone behind Victor's back, which was wicked: I had drawn Caro into my passion. I felt guilty about having slept too soundly that night: if I had been on the ball I'd have been the one with the shotgun and maybe I wouldn't have fired, maybe I'd have waited just long enough to see that it was Victor . . . Maybe. Maybe it would all have turned out differently. Maybe I would never have had Caro to myself. And I felt like hell even thinking along those lines. But I was stuck with the reality of it: she was the one who heard the noise, who came and got the gun assuming it was probably nothing, not wanting to try too hard to wake me but taking the gun to be on the safe side, and it was she who pulled the trigger. Sometimes I came awake in the night that first week, terrified, having dreamed

115

that it was I who had heard the noise in the night and gone downstairs and shot my old friend.

Love. How can I explain that it wasn't common lust? The more I watched her that week, the more I saw her composure under nearly unspeakable pressure, the more I knew that I loved her, that I was spellbound by her.

Bad timing. Sure, sure. You're telling *me* it was bad timing! She was freshly widowed. She was suddenly enormously wealthy. Both emotion and propriety made my feelings tasteless at the very least. But there they were. What she felt now—not what she'd felt before, when the ending we'd foreseen was something else entirely—I couldn't be sure. I'd have to find out.

And finally let it be noted that I was still afraid.

It was Victor who had died. Varada was still out there somewhere.

FOUR

I didn't know how to restore the intimacy Caro and I had established in those tense days leading up to Victor's death. We now seemed never to be alone and on the rare occasions when we were, there seemed to be a subtle barrier between us, as if she knew I was waiting and it was up to her to set the agenda. I couldn't force the issue of our relationship: it would have been too crass, a kind of insult to her courage. But the wait was driving me crazy. I didn't know if we even had a relationship anymore. Maybe it had died with Victor. If I'd been a gentleman maybe I'd have assumed it had, maybe I'd have been preparing to pack my bags and go home to London. But I couldn't just let go. Hell, I was no gentleman and I knew a real lady when I saw one. And I knew Varada might still be watching.

How long would I have waited before doing something, probably something preposterous and overt? We'll never know

because, just about when I'd come to the end of my tether, two weeks after Victor's death, she came into the study carrying a tray of coffee things. She'd had dinner in her room and I'd eaten alone in the garden, come inside to sit before the air conditioner and try to pay attention to a ball game on the tube. The humidity permeated everything. The leather furniture was sticky with a patina of moisture. The pages of a book on my lap were wilted and rippled.

"Charlie," she said, then paused. Watching her, I felt shy, as if our memories of one another might somehow differ in crucial ways. "Charlie, I know what you're thinking."

"Really? I wonder—"

"I always know what you're thinking."

"Ahh. What do you expect me to say? But then you already know—"

"You're thinking about packing up and going back to London. And I want you to tell me you'll stay."

My heart took a little leap. "But what's the point? You need some time to yourself. You've got to sort things out and get on with your life. You could hire a private security firm to deal with Varada . . . Isn't all this obvious?"

"No, it's not obvious at all, Charlie. Maybe you're talking about yourself . . . maybe you're the one who needs a little time to yourself. It's your life that's been on hold, ever since Victor dragged you into our melodrama." She had put the cup down and was staring at me, her eyes huge, the two pearls hanging absolutely still. "I've already done some thinking and I want you to stay and be patient with me. Do you have to leave me, Charlie? Do you want to?"

"I can't just stay here forever like a permanent houseguest. For one thing, aren't you concerned about what people will say?"

She solemnly shook her head. "I couldn't care less, Charlie. Why should I? My life is my own now. The real question is just this, can you be patient with me? This is important . . . you

117

know what I've been doing? I've been reading your books, right from the first one about the political campaign of 1968. I've been trying to get to know you—"

"You know me," I said. "You even know what I think—"

"That's not the same. You *know* me. No one has ever gotten to know me so quickly. But you're still a mystery to me. Please stay."

"Look, do you understand what was going on between us before—you know?"

"Of course I do. But I wanted to get through this *thing*. And then we could figure out what it all meant, means. But everything ended so strangely, so badly, so sadly. It threw the timetable out the window." She sighed heavily, curling her toes into the carpet. "We were falling in love, weren't we?"

"I was. I'm not sure what you were doing. You had a couple of things on your mind. Like trying to stay alive. That sort of pressure could turn all your emotions inside out."

"Odd as it may seem, I'm used to it . . . pressure. I seem to have an infinite capacity for attracting it. Like a lightning rod. I'm not incapacitated by it. But if you can only give me a bit of room on the love issue—do I sound like Victor? Like a lawyer?"

"Not in the least."

She slowly poured more coffee into my cup. "Well, can you? Give me just a little time?"

"Sure. Time. Some room. But wouldn't it be easier on you if I gave you some real time, more than a bit of room? I could go back to London, give you six months, come for a visit at Christmas if you still wanted me . . . we could have a fresh start."

"No." She shook her head, the pearls swinging. "I don't want to risk it. I'd miss you, Charlie. I wouldn't have anyone. Not Dad, not you . . ." Her voice had lost its customary extreme certainty. It was trembling in her chest. She stood up abruptly, went to the window overlooking the garden where I'd once

118

seen her puttering in the wet earth. "I need you to help me through this, Charlie. I don't want to be alone."

I got up and went to her, put my arms around her. She was stiff, the tension you don't see with the naked eye. But she leaned her sleek head back against my cheek. I kissed her shining hair, smelled her.

"For one thing, this isn't over yet. I'm still afraid."

"I know." I felt her begin to relax in my arms. "I'll stay." There was no point in telling her that I, too, was afraid.

Chapter Eleven

ONE

The next morning after Caro had left for the hospital I was having a cup of coffee with the morning's sports pages when Conchita came bustling across the patio with a pot of fresh coffee in one hand and the cordless telephone in the other. "For you, meester," she said. I was always *meester*. I thanked her, she refilled my mug, and I took the phone.

"Nichols here," I said.

"Mr. Nichols, we haven't met but I've heard a good deal about you. Years ago, from Victor." It was a woman's voice, almost melodious, just audibly breathless, as if she were nervous. A laugh stuck in her throat. "He used to say you were quite an expert on the subject of love, his mentor when it came to romance . . . anyway, my name is Samantha Barber. He may have mentioned me a long time ago as Samantha Frost."

"Of course he did. But all that mentor stuff is pretty unnerving. I plead not guilty, it's just not true—"

"True or not, you changed Victor's life with some advice you once gave him. And you certainly changed mine—"

"I doubt that," I said. "But if I did, it was for the better, I hope."

"No, that's not quite the way it turned out but that, thankfully, is not why I'm calling you . . . well, it's about Victor, actually . . ."

"Yes," I said when I heard her taking a deep breath. I thought I heard ice cubes sloshing in a glass, clinking against crystal.

"I want to see you, Mr. Nichols. The sooner the better."

"All right. May I ask what's on your mind?"

"Look, this really isn't easy and it's only going to get harder. But I've got something to tell you. I know Victor would want me to do this. Otherwise I'd say the hell with it . . . but I keep thinking about Victor." She coughed. I heard the sibilant sound of her sipping, swallowing. "I can't say any more now but you must believe me. It's important."

"Fine. I'll be glad to listen. When?"

"Tomorrow. I really can't sit on this any longer. I've got to get it off my chest, Mr. Nichols, and damn the metaphors. Then . . . well." She took another sip. "It's got to be just you tomorrow. You alone."

"Fine. Caro goes to see her father at the hospital in the morning, stays all day. You name it."

"The bar at the St. Regis. Three o'clock. It'll be empty. We'll have it to ourselves and, Mr. Nichols, you're going to need a drink."

"I usually do," I said.

TWO

I made the mistake of walking to the hospital to see Andy Thorne. It was hot again, and the humidity made it feel like a higher being had dropped a heavy, dirty net over the city. I took off my seersucker jacket. There were blotches of sweat showing

on it like Rorschach tests. I carried it from a forefinger, dangled back over my shoulder. The trees were so green it seemed they would burst with their ripeness.

I should have grabbed a cab and stuck my head out the window to catch the breeze, tongue lolling like an old dog, but Samantha Barber's comments had left me unsettled. I needed the time a stroll would give me, to think or, more accurately, to worry. I kept thinking about the night we'd gone to the Algonquin, the three of us to hear Michael Feinstein and seek some respite from Varada, that very long night that found Abe Braverman dead and Andy Thorne nearly so. But what was lodged in my mind was the sight of Victor inclined over the pretty blond woman with the laugh I recalled—or was it just another melodic laugh in a crowded room?—and Caro's voice telling me that Victor was having an affair with the blonde because she, Caro, was frigid . . . It had sounded sad, a sad story, but not at all melodramatic because Caro didn't strike me as a dealer in cheap effects. But Samantha Barber was something else altogether. She seemed the very stuff of self-dramatization. The model was apparently as much of an actress as the actress.

However, thinking about Samantha didn't get me any closer to the reason why Victor would want her to talk to me, no closer to why I'd be needing a drink.

The funny thing was, I believed her.

THREE

Andy Thorne was pale, his skin papery and clinging for dear life to his cheekbones, as if he were somehow imploding. He'd become an old man, frail, trembling. He was balancing on that taut wire, suspended above the grave, and you couldn't know just yet if he'd regain his strength and his footing or just slip away. But the tubes were gone from his nostrils and he was

sitting up and the remains of a good-sized lunch were left on the rolling tray he'd pushed aside. The air conditioner was on and the television was murmuring, Bogart still believing that Lizabeth Scott was one of the good guys.

"You're looking great, Professor," I said. "It's absolutely amazing—"

"What's amazing, Nichols," he croaked, "is how shameless a liar a perfectly normal, decent fellow can become when faced with an old crock like me about to push off into the great void . . . my body has betrayed me, young Nichols. A traitor to my brain, which remains in reasonable working order. Tragedies seem to pile up quite literally on the doorstep and still one survives. Braverman dies, my son-in-law dies, and I pedal onward, still searching out my reward. How can such things be?"

"Beats me," I said. "And while you look like hell you do look a lot better than you did. Okay?"

"As always, everything's relative. I'm glad you came. It's about time Caro took some time off for herself. Sometimes the girl is too strong for her own good." He sighed and gestured at a chair. "Sit down. You look like a dishrag. Have a drink of that ice water." He looked up at the television screen. "She thinks of everything. Video recorder, stacks of movies . . ."

I sank into the chair and mopped my face and felt the cold air across my wet back. "So, how do you feel?"

"I'm coming along. Going home in another week or two. I'll need some busybody nurse for a while, or so they tell me. I'm not prepared to debate the point. I'm an old wheezer, as my granddad used to say, and old wheezers apparently need keepers. Funny, you never think it'll come to you and sure as the very dickens, it does. It's a betrayal, Nichols, or did I say that already? You'll know all about it one day." He lifted a glass to his lips and wet them. "Victor, he's been spared the final indignity."

"Caro's handling it well," I said. "Her resilience amazes me. I guess she's made of the right stuff. I wonder, though, how

123

much is she hurting inside? You know her best, now that Victor's gone . . ."

He slowly pushed himself up against the pillows, staring into the flowers on the tables all around him. Then he took a deep breath and nodded as if he were answering some unspoken question. "Oh," he said at last, "she can handle it. You may have noticed, she's different from the rest of us . . . it's in the chromosomes, I understand."

Among the vases of flowers on the bedside table was the framed photograph of Anna. I picked it up and looked at it, saw again the close resemblance to Caro. "I've wondered, why isn't there a picture of Caro, too? None of my business, of course."

"You're right, it's none of your business. Or is it?" He gave me a wintry, bleak grin. "I could say it's because she isn't dead yet, so I don't need a photograph to remind me of her. Or I could tell you it's because she's had an almost pathological fear of having her picture taken since she was little. I remember how she'd heard or read somewhere that there were savages, in New Guinea maybe, some godforsaken place, who believed that the camera stole their souls. Caro used to hide and cry when the camera came out at Fourth of July picnics or on Christmas morning. I could tell you any damn thing and you'd be none the wiser. But none of that would be quite accurate.

"No, life never seems to be that simple, does it? The real reason is that there has always been a barrier between us. It's not easy to explain, it's almost as if we came from different cultures. We don't seem to possess the same coordinates, we're not on the same map. Similar, but not the same. There's been a distance there that I could never travel. So we've never been close. Now with Anna," his mouth made a faint smile, "I was close. Truly close."

Listening to him talk about his daughters I kept hearing what I'd heard one of them say.

He wishes I'd been the one who died . . .

124

"There's a kind of scorn in her, Charlie," he said, his eyes moving from Bogart and Lizabeth Scott and Morris Carnovsky to the flowers to the face of his dead daughter, back to me. "But there's a mystery to it. Who's it all for, this scorn? For men? Or for herself, maybe? Maybe it's just for everybody, the human condition. Damned if I know. I've tried, I've bent over backward to make up for the distance I've felt between us. She's my daughter and I love her. I honestly think she'd do just about anything on this earth for me . . . and I for her. But she seems to have come here from that other place where they order things differently."

"Well, I can't say I know what you're talking about," I said. "She's so giving, she works so hard at making life—well, good, *nice* . . . for the people around her. For Victor, for you. Even for me. She tries so damned hard—"

"I know what you mean. How to put it? She never seems able to relax. It's as if she's always waiting for something bad to happen . . . *bad*. Even as a little girl she was always walking on eggshells. Maybe it was because she was so pretty and solemn as a child. She had a way, Charlie, of sort of being in the room with you and then—this sounds strange but it was strange, used to give her mother and me gooseflesh—her body remained there with you but you knew that *she* somehow wasn't there anymore. Just gone, like the past. A memory." He sighed and folded his papery arms, thin and bony, sticking from the sleeves of the hospital gown. His face wore a look of concerned satisfaction, as if he were back at Harvard Law laying out a curious, somewhat enigmatic case. "No one wanted to face that moment when she withdrew into herself. Sometimes she seemed so old, so serious, so sad . . . so fearless and distant . . ."

Andy Thorne had finally grown weary from the thinking and the talking and I watched him slip into a doze, his breath steady and a little raspy. On the chest of drawers there was a stack of novels Caro had brought, which she read aloud to him. There was a chess set she'd bought and she played with him. She'd

125

brought the VCR and the videocassettes stacked beside the books; *Patton* and *Dead Reckoning* and *The Band Wagon* and *Cape Fear* and *Bringing Up Baby* were at the top of the pile. Yet he called her distant and scornful and remote. What in the world, I wondered, did he want from his daughter? She struck me as someone else altogether, someone I'd never have recognized from Thorne's description.

I kept thinking about how she'd been an actress. I wished I'd asked Thorne about her acting, what kind of parts she'd played, had she been any good . . .

Was she acting with me? Was she trying on a new role?

I wondered about her charges of Victor's infidelities and I wondered about her own life, the part played by men. Had there been anyone before me during her marriage? Had she ever been unfaithful to him?

What had their life together been like beneath the surface? I began to realize that all I knew about their marriage was what they'd told me. And they'd given me conflicting versions. Now Andy Thorne had provided me with a third view.

It was all confusing. Except for one thing. I knew you never knew what was really going on until it was happening to you.

Chapter Twelve

ONE

The next morning Caro was up and off to the hospital as usual, though I could tell she'd had one of her bad nights. She was trying too hard to smile when she saw me in the garden. Her cup rattled in the saucer. There were dark ridges underlining her eyes, and her mouth was tugged down a fraction at the corners, as if she were clenching her teeth with determination not to let it show, not to worry me. I took one look at her, slid all the *New York Times* but the sports pages across the table toward her, and kept conversation to a minimum. She missed Victor's presence, the routine, the reassurance, all the trappings of a loving husband. But she missed him all the time. The bad nights, they were something else. After the nightmare she looked drawn and red-eyed and a little shaky. She'd told me about the nightmare just once. I hadn't required a second telling. In the nightmare she was back in the Westchester house, she was firing the gun at the figure in the rainy, windy doorway, firing again and again and again as if it were a shotgun with a hundred barrels, and Victor's face was

revealed, she knew him, he was smiling at her, but she couldn't stop shooting and it kept on happening until the face was gone. The nightmare. No, I didn't need to hear it all again. I didn't need to ask. I knew.

I sat in the garden reading a John le Carré novel and wondering what had gone wrong, why I no longer enjoyed his novels as I once had, until I was struck by my first urge to write something about the past few weeks. We seemed to have come to a rest stop, an oasis, allowing time to gather my thoughts. I seemed to have lived through one of my own books and now it was time to sit down and take some notes. When it's time, it's time, and there's no denying the need to write something down.

Victor's study was dim and cool and orderly. I found a cassette of Lester Young playing with Teddy Wilson and Oscar Peterson in the fifties and popped it into his Tandberg deck. "Stardust" and "Indiana" and "These Foolish Things." Conchita had just left with her spray gun, and drops of water were beaded on the leaves of the rubber plants and the wandering Jew and the date palms.

It felt presumptuous, looking at Victor's desk and the leather swivel chair as if it had passed to me, along with his wife. But that was ridiculous. It was a desk. I needed a desk.

It was when I slid the drawer out, looking for a pen and a pad of paper, that I took one step too many into Victor's world.

There were date books, notepads, desk diaries, checkbooks, envelopes, stamps, paper clips, stick-on pads, all the junk everyone collects. But this was Victor's junk and like an inquisitive jerk, prying into a dead man's secrets, I began to flip through the bits and pieces.

Varada's name was jotted down, beside the words *Release date 21 April*. This on the page of a desk agenda dated 1 March. Which meant that Victor had known seven weeks before the time Varada was actually coming out.

The name *Alec Maguire* was written on a separate sheet of lined notepaper with a telephone number. The area code was

128

for Boston. Following Maguire's name was an arrow drawn to *Varada* which had been circled again and again until the paper was worn through.

Later on in the diary, on the day before he had found me in the Waldorf lobby, he had written: *Nichols = Stalking Horse. Escort Caro. Bait the Hook.* I didn't like the implications of any of that. It didn't take much insight to see that Victor had planned our meeting rather more carefully than he said. My immediate assumption was that he'd used me to give Caro the appearance of a safety net while using her as bait to draw Varada into the open. Victor had apparently expected trouble from the start. My guilt at betraying him with his wife was not quite so imposing as it had been a quarter of an hour before.

In the checkbook which was Victor's alone there was a record of four checks totaling $5,600 made out to this Alec Maguire. The first was dated one week previous to Varada's release date.

I dialed the Boston number.

"Maguire Agency. May I help you?"

"Sure. I was given a number to call in Boston but I may have transposed a digit or two. Are you the shop which has made the dried apple a gourmet's delight?"

"Oh, I'm afraid not. What you're looking for is probably down at the Quincy Market. Dried apples, sure, Quincy Market."

"No kidding. Well, my mistake. What do you do? Maybe I need you more than I need dried apples—"

"You never know," she giggled. "Mr. Maguire is a very well regarded private investigator. *Boston* magazine said he was Boston's answer to Sam Spade!"

"A private eye," I said.

"True story. A shamus." She sounded very proud.

"Well, does Mr. Maguire happen to be in? My need for a shamus far surpasses a need for those dried apples."

"Gosh, I'm sorry. He's in New York City today. Working on a case. Could I have him call you when he gets back?"

"I'm in New York myself. Do you know who he's seeing down here? I could call—"

"Oh, I'm sorry, that's confidential. But I could have him give you a call when he picks up his messages—"

"It's okay. I'll get back to you."

Victor seemed to have had a detective for every occasion.

TWO

Samantha Barber was waiting for me at the St. Regis. She was sitting at one of the little tables off to the right, surrounded by the sepulchral calm of such places at midafternoon. She was wearing a sleeveless linen dress in pale lime green. Her lipstick was pale, too, and her tan was like pink gold. Her hair was the color of champagne. Watching her was making me pale. She looked almost entirely artificial but the parts had been assembled by someone who loved the work.

"Mrs. Barber, I presume. I'm Charlie Nichols."

"Have a chair." She looked at my face. "Hot, isn't it?"

"Keeps getting worse."

"It's just that we're weakening instead of getting used to it." She inclined her elegant jaw and the waiter went away to get us more gin, more tonic. She was wearing a gold pin and earrings, all barely there. Her nails were peachy, matched her mouth. Watching, waiting, I remembered how her mouth had been a red slash at the Algonquin that night and her laughter had carried across the crowd. She wasn't for me but I could imagine what Victor must have seen in her. But it made no particular sense to me. She was hard in every way that Caro was soft, brittle where Caro was supple. She looked as if she needed a daily buffing to maintain the shine. New York is full of them, I suppose. Carefully tended New York women, whatever that may actually mean. Her looks were Samantha's stock-in-trade, her capital, and she'd obviously conserved it, though not

without a breathtaking expenditure of her effort and men's money.

"Do you mind if I smoke?" she said. Inevitably she produced a gold case and a gold lighter, inquired down the length of her nose, inquired with a voice that had taken on a whiskey crack over the years. Sexy voice.

"I don't care if you burn," I said. "Sorry, sometimes I can't help myself."

"You should try, Mr. Nichols."

"There are always so many other thing that seem more important. Like being summoned to rendezvous with snappy blondes who have heavy things to tell me." I watched the flame dancing at the tip of the Merit 100. She didn't inhale much. It might have undone some of that work. "Let's get to it. I'm a busy man."

She burst into that ravishing, tinkly laugh. Up close I got the disappointing impression that it was the result of a lot of practice. "Oh, don't be so tough."

"We're not on a date, Mrs. Barber. And I'm curious about what's so important that I'll need to take it with a drink. What's the story?"

All of a sudden the veneer started to peel. The hardness went out of her voice and it fell to a sort of breathy whisper. I'd interviewed people about murders and when they came to the absolute cream of the jest, the bloodletting, their voices dropped the same way. It was fear. But what could this specimen be afraid of except the onrush of time?

"Look, Victor Saberdene was very special to me, a very old friend. When he was killed I did some long hard thinking about my life, what I owed him. We had some good times and some not so good times but for years we'd been dear friends again . . . I could just keep my mouth shut now or I could do him one last favor." The drinks arrived and she plucked the lime from hers and bit into it, sucked the bitterness. "I decided

131

to do the last favor. I'm afraid. Do you understand that? There's someone I'm afraid of . . . but I owe Victor."

"Fine. But what could any of this have to do with me?"

"Quite a lot."

"Well, why not get it off your chest? Who are you afraid of?"

"I'm afraid of Caro Saberdene. That's what I thought Victor would want me to tell you."

"Mrs. Barber, are you serious? What's the point? If you have some vendetta you're pursuing against Victor's wife—widow, I should say—then take it up with her. Just leave me out of it—"

"You must listen to me . . . please. It won't cost you a thing and it means a good deal to me. There's no one else I can tell. You must be aware of Caro's past. She's known to be mentally unbalanced. I mean, she has a history of it. Let's face facts. It's not just me saying that she's got problems, believe me. Victor has talked about it many times, how worried he's been about her state of mind, how she's even turned her irrational anger on him—"

"Oh, please!" I smiled at her. "You can really save your breath, Mrs. Barber—"

"She tried to kill me, you idiot!"

She turned away after saying it, her face suddenly flushed.

"That's quite an accusation. I'd be careful where I said it, if I were you."

"Just listen. Give me some credit. I'm not the one who's crazy. She came to my home . . . she came after me. We have a co-op on Park Avenue, she came into my own home, in a cold rage, and accused me of having an affair with her husband. You should have seen her eyes—I've never seen anything so . . . so empty. There was nothing human in them. It was like she wasn't actually there at all . . . I was terrified. I knew her history of mental illness—"

"That's absolute rot," I said, trying not to respond in her own distraught manner. "You should know better. Under a hell of a lot of pressure, nearly a decade ago, she had a crack-up. She

came out of it and went on with her life. Which happened to include falling in love with Victor Saberdene and marrying him."

She shook her head. "No. You weren't there, she hit me, I bled. She'd have killed me—"

"So why didn't she?"

"Because Victor had followed her, burst in, and pulled her off me . . ." She took a long drink and ran her tongue along her lips. "Victor saved my life. I only wish I could have returned the favor."

"What's that supposed to mean?"

"What does it sound like, Mr. Nichols? It means that I believe Caro Saberdene killed him."

"Of course she killed him, it's common knowledge—"

"*Meant* to kill him. *Murdered him,* okay? Is that clear enough for you?"

I let her accusation hang there between us like an obscenity. She looked away again, across the room, nervously dug another cigarette from her case and lit it, exhaling the smoke vehemently, a mixture of anger and impatience. I knew she was operating in a kind of vacuum, obviously unaware of Varada's return to torment the Saberdenes. Although I was far from an expert on feminine psychology, you didn't need to be an authority to know that Samantha Barber's observations about another woman would have to be taken with more than a grain of salt. She must have held a grudge against Victor, whatever their subsequent relationship, from the time he unceremoniously dumped her. Shortly thereafter he had married Caro. One look at Samantha Barber and you knew that she would be a bad loser in the sexual skirmishes which were bound to be her customary context. The anger she'd felt for Victor would surely have been easily enlarged to include Caro. And, of course, there was still that one joker lurking in the pack. I decided to play it.

"Caro was upset because she believed you were sleeping with her husband. Right?"

"Yes."

"Well?"

"Well what?" she snapped, continuing to avoid my eyes.

"Were you?"

"Look, *I* haven't killed anyone. We're not talking about me—"

"But, for the record, were you?"

"Victor said his wife was frigid—"

"So, were you having an affair with Victor? Sleeping with him?"

"What of it? What if I was? She wouldn't—"

"So, one woman confronts another about having an affair with her husband. Somebody gets slapped. Big deal. No way in the world that's evidence of having a homicidal streak. In fact, I'd say that you got off lightly. And if I were you I wouldn't drag Caro's name through New York's fashionable watering holes, as they say . . . I wouldn't want to see any of this in Liz Smith's column."

She was pulling herself together for rebuttal. She leaned back and regarded me with a faint smile through the drifting smoke. "Why," she said softly, "am I putting myself through this conversation? What do you imagine I have to gain from telling you this? If you can answer that one, let me know because it's escaped me. Think about it, Mr. Nichols."

"I honestly don't know," I said.

"I'm telling you this because Caro murdered Victor and Victor meant a great deal to me. And because he always spoke of you with great affection. I guess I'm trying to warn you about Caro, whatever your relationship with her is or may come to be."

"You don't need to warn me about her. Shall we leave it at that?"

"She didn't just slap me and storm off in a huff. She did hit me, bloodied my nose. Then she grabbed a poker from the

134

fireplace set and was coming after me . . . when Victor came into the room and got it away from her. I'm telling you, she would have murdered me on the spot. Victor kept that from happening . . . but she didn't fail when she shot Victor. He didn't have anyone to save him from her. Victor believed, he *knew* she was unstable and dangerous." She was finally looking at me straight on, her eyes narrow and unfaltering. "You'd do well to believe me, Mr. Nichols. Or are you too far gone to hear what I'm saying . . . yes, I suppose you are. In that case I'm truly sorry for you. You have a very dark way to go . . ."

"Victor loved his wife very deeply," I said.

"And she killed him—"

"He told me that he loved her and his every action proved it to me. He was far from perfect—I'm an authority on being imperfect—and their marriage was probably just as troubled as most. But let me be frank, Mrs. Barber—the story you've told me rings with spite and cruelty. As you've pointed out, your motive escapes me. Except that you couldn't possibly have said such things were Victor still alive. And for your own information let me assure you that you don't know anything like the whole story—try to believe that. And let me suggest again that you keep your accusations to yourself."

"You needn't worry about that. Whatever you may believe, I am not a gossip. You are the only person in the world who needs my advice about Caro Saberdene." She sighed, dropped her gold lighter into her bag, and put on sunglasses. "Since you're not about to take it, I can only wish you the very best of luck. I've done what I can and my conscience is," she smiled almost sadly, "well, fundamentally clear. I've done what Victor would have wanted me to do. Please, don't get up. I'm already running late. Finish your drink." She stood looking down at me. "Victor loved you, Mr. Nichols. He'd want you to take care of yourself."

Chapter Thirteen

It was a relief, when I checked the messages on the machine back at the house, to hear Caro telling me that she'd be spending the evening at the hospital with her father. She'd get a sandwich in the coffee shop. Then she and Andy were planning to watch *Casablanca* and *The Maltese Falcon*. She laughed and said they had a chair for me if I felt like attending. "If you come," she said, "bring the popcorn."

I stood by the desk smiling at the sound of her voice, half-thinking I might join them. But no, Samantha Barber had put me in a rotten mood and I was relieved that I didn't have to inflict it on Caro. She was very sensitive to my moods. She would have asked me what was wrong and the last thing I wanted to do was haul out the specter of Victor's old girlfriend. Whatever had happened between them, if indeed Caro had ever gone to the Barber place at all, it was bound to bring up unpleasant and unnecessary associations.

Samantha Barber's motivation continued to elude me. The more I thought about it the more the woman's performance

tended to splinter. If I hadn't known Caro I might have believed the story. Which only went to show you the value of the objective outsider's opinion: it could be so easily pushed and pulled into an unwarranted monstrosity. Thank God I did know her, could protect her from a character assassin.

In the latter part of the evening I needed to get out of the house. It had begun to rain and the heat had eased into the midseventies. The rain was coming down hard, bouncing in a blur off the pavement, reflecting the headlights of the cars sending up furls of water from the paving. I stood at the top of the steps feeling the first cooling breeze in a long time. I opened Victor's umbrella with its ash handle, had a momentary flashback, to Victor standing in the rain in Harvard Square more than twenty years before, felt the twinge that came when I realized I would never see him again, that now the times we had shared were truly fading into oblivion where they would finally disappear as if they had never happened, as if Victor and I had never existed.

I pulled myself out of that, looked across the street to where I'd once seen Varada from a window in Victor's study. Varada, Varada . . .

Where the hell was he? What was he doing now? Had he left New York, left our lives? And how would we know whether he had or not? How long would he linger in our minds, threatening us? How desperately insignificant Samantha Barber seemed when you had even the memory of Varada. I thought how many heart-stopping memories of him I had gathered in so short a time. And the gallery of those snapshots of time Caro must have stored inside her . . .

I was still contemplating Carl Varada when I crossed the FDR Drive with the traffic swishing along the wet, shiny highway below and reached the sidewalk running along the East River. The fog riding above the water and rain muffled the sounds of the city. The moon had long ago called it quits. The lampposts

loomed up before me like tall skinny stalks topped by furry blurred blooms. A garden of the night and the river and the occasional foghorns moaning from ships you could no longer see.

The idea of ships you couldn't see dovetailed a little too neatly with my thoughts of Varada. Every instinct I had was telling me that he was still there, still watching and waiting, preparing to leap and strike when we least expected it.

I didn't know how far I'd walked but I was working up a sweat under my jacket, and the umbrella seemed to have sprung a leak. I stopped and leaned against the fence, looked out across the river to Queens and Brooklyn blinking and glowing behind the fog. It was only then that I fully registered the steady clicking of footsteps that had been trailing along behind me for maybe ten minutes. I cocked my head like a poorly trained mime, tried to pierce the fog for a glimpse of my companion, when the clicking stopped.

A large shape became faintly visible along the fence, leaning on it as I was, unmoving. When I moved away along the walkway the clicking began again. When I turned a corner I stopped, moving off the path to stand beside a steel buttress anchoring another overpass across the FDR. I don't know what exactly I thought I was doing but the bottom line was that I had the feeling deep in my gut that the clicking was Varada. He'd come for me. He was stalking me.

My legs were a little rubbery. And even if I'd felt like running I didn't know where the path went, where the next overpass was, and I didn't want him to know I'd spotted him. I just wanted to become slightly invisible and get a look at him.

The shape materialized out of the fog, its face hidden beneath a broad umbrella, like a doorman's. He couldn't see me and I couldn't identify him. But he stopped opposite my hiding place, turned slowly. He was big and he was looking for me.

Then he spoke.

138

"Mr. Nichols? Is it you, Mr. Nichols?"

The voice wasn't the same. It wasn't Varada.

I stepped out from behind the support. "I'm right here."

Slowly he shifted and turned toward me, the umbrella still in my line of vision. "I've been following you, Mr. Nichols."

"So I noticed," I said.

He came toward me.

"Lift the fucking umbrella," I said.

He lifted it slowly. Everything he did, he did slowly.

"You may not remember me, Mr. Nichols. My name is Martin Edel. We met at dinner at the Saberdenes'." I remembered the heavy, drooping lower lip and the way Caro's delicate hand had escaped his wrinkled paw on the tablecloth. Judge Edel. He turned his heavy jowled old poker face on me and waited.

"Someone called you a hanging judge," I said.

"Victor. Victor always found that an amusing riposte. Why I cannot imagine but then I never spent much time trying to plumb the depths of Victor's idea of wit. He was my friend, always my friend, and I never analyzed him. I might have been better off had I done so, the way things have turned out." He tweezed the lower lip between thumb and forefinger, tilted his head back fractionally so that he looked rather like a pig regarding a truffle beyond price, said: "Walk with me a moment, Mr. Nichols." We fell into step. "You noticed I was following you. Very alert. Who did you think I was, pray tell?"

"Varada."

"Of course. I daresay you were delighted when my identity was revealed."

"I daresay. Why were you following me, Judge?"

"I've been thinking about you for the past few days, debating a point. I went out to take a long walk in the rain, found myself heading for the Saberdenes' with the idea that we should have a chat. Then I saw you ahead of me. An omen, I told myself. So I followed you and here we are. I have something to discuss with you."

139

"About what?"

"About the Saberdenes. Come see me, Mr. Nichols. At my home. Sixty-second and Fifth. Tomorrow evening? Could you arrange that?"

"Why? What has it to do with me?"

"I'm unsure as to how to answer either question. After you see what I have to show you, you may be able to tell me yourself. But I am not in any way a frivolous man. I have no intention of wasting your time. Let's say nine o'clock. Does that suit you?"

"All right. I'll take you at your word, Judge. It's strange, if you don't mind my saying so, the way your face gives away not one damn thing."

"I'm a judge. That's exactly the way it's supposed to be. Keeps everyone in suspense, I find. I love suspense." He made a small smile above his jowls. "Don't you love suspense? Plenty of it in your books."

"Suspense is just grand," I said.

We stopped at the next overpass. "This is my stop," he said. He looked down at me when he'd gone halfway up the stairs. "By the way, I'll have a chap on hand to meet you. He has quite a story to tell. You'll find it interesting, I'm sure. And Nichols . . ."

"Yes?"

"Be sure you come alone. That above all. Alone." He flapped a huge hand at me. "Goodnight, young fellow."

He'd used the same words that Samantha Barber had used, urging me to come alone. Meaning no Caro. Obviously it was just a coincidence. The judge might just have been thinking of her tender feelings at this time. Maybe he had something to tell me about Victor, something not fit for a widow's ears.

TWO

The next day my publisher, Neal Davidson, had me to lunch in the Pool Room at the Four Seasons. He always had a corner table and he lived in fear of two things: that the tax laws would be changed to alter his expense deductions and that either of his two former wives would be seated nearby and thereby ruin his lunch. Beyond those dangers, he seemed to lead a life of cheerful and profitable mischief making. After a couple of gin gimlets and desultory reports on reviews of my new book which were beginning to trickle in from the outback, he fixed me with, yes, a gimlet stare and got to the real point of the exercise.

"You've had rather an exciting visit to the old homelands," he said. "I mean, the synchronicity of it . . . or is it serendipity? I can never get those two straight—"

"Let's try it in context," I said. "What's on your mind?"

"Just that you, one of the world's—yes, Charles, one of the *world's*—foremost writers of true crime books, you come to New York and not only stay at the home of your oldest friend, who happens to be one of the world's leading criminal defense lawyers, but then by a miracle of chance the lawyer's wife murders the lawyer . . . well, Charles, the old publisher's mouth fairly waters at the prospect of such a story—indeed, the prospect of such a book. Egad, Charles, a golden apple has plummeted from out the sky and into our laps . . . ah, here are your shrimps. At seven dollars per shrimp, I do hope you enjoy them." He grinned first at the shrimps, then at me. "Synchronicity? Serendipity?"

"Try coincidence," I said, "and of course you've got it all screwed up. Particularly the crucial point—"

"Well, unscrew me, do!"

"There was no murder."

141

"No? The chap's dead, Charles."

"It was a tragic accident. Period."

"Are you quite sure of that? I mean to say, I've heard the odd rumor that there's a past involved. You know, a *Past*, as in 'woman with a past.' Somerset Maugham country. You're right on the scene, I realize. I thought you might have the lowdown, so to speak." He maneuvered a bit of cold salmon with *sauce verte* onto a fork and eased it into his mouth, savoring it. "Eat, eat. *Mangia!*"

I snuggled up to the shrimp in mustard sauce and ate one, seven dollars' worth, hardly noticing it. "Who's dealing with rumors about the Saberdenes?"

"Who knows? One hears so much drivel. I might have heard something from Marc Foxx at a party a while back. He worked on Victor's book, you know. He may have said that he'd found Mrs. Saberdene something of a mystery." He shrugged and nudged my arm with his elbow. "I naturally have an obligation to discuss the book aspects . . . after all, you're virtually a part of the story, wouldn't you agree?" He smiled blandly. "You're the man to write the book, Charles, or someone else will. I understand there was a murder, a trial, the woman in the case sending the killer to prison with her testimony . . . then cracking up . . . then marrying the famous lawyer. And now she kills the lawyer. Goodness gracious, Charles. It's a ready-made saga . . . and the poor fellow who went to prison turns out to be innocent! I mean, what does one want for one's nickel?"

"You seem to know a hell of a lot, Neal."

"One hears this and that. Lifeblood of publishing." He looked up and gasped sharply, then slumped back in the banquette.

"Are you all right?"

"Oh, never better. For just an instant I thought Marian had come in. Christ. A reprieve."

142

"Neal, listen to me. I will not write a book about the agonies of the Saberdenes."

"Nobody would ever have you stay with them again, is that what you're saying? Blackballed in the houses of your friends?"

"Neal, you live in another world. Victor's death was a ghastly accident and using it to sell books is one bloody hell of an awful idea. Clear on that, are we?"

"All right, you must be guided by your own lights. I realize that. You've always been a gent, I've always said that. However, I think you should know that I've already had two agents onto me with proposals for books on this ghastly accident. And they don't know a tenth of what you do, nor would they have the slightest interest in sparing Mrs. Saberdene. And Marc Foxx's agent has a call into me this morning and you just know what it's about . . . so, maybe you ought to at least think it over, Charles."

"It's simply impossible."

"Do I detect a personal component in your reasoning?"

"Indeed," I said.

"How personal, Charles? You might as well tell me, I'm so damned insistent." He pushed his plate a few inches away. "I only eat half of any meal these days. Got to drop a fast twenty. I'm a paragon of will." He winked at me, smiling, happy with his leaven of malice. "You know, you really can trust my discretion, Charles. What's going on with you and the Widder Saberdene?"

I figured what the hell. He'd been my publisher in the States for a long time and I'd gone through his divorces with him and we knew where each other's bodies were buried. And it would do me some kind of psychological good to tell someone.

"All right, Neal. I'm in love with her. Don't press me beyond that."

He stared at me, making a soft whistling sound through pursed lips. He crooked a finger at a waiter and said nothing until the coffee arrived. He emptied a packet of artificial sweetener into the cup and stirred.

143

"Well, my goodness, good luck to you, Charles. And you're a braver man than I am, Gunga Din."

"What the hell is that supposed to mean?"

"Merely that from all I've heard Caro Saberdene is something of a handful. But that's none of my business, is it?"

"You can say that again."

"Don't be testy. All I hear is mere gossip of the Rialto. And, incidentally, wasn't she an actress or something?"

"Oh, dry up, Neal."

"No sooner said than done, Charles."

Later that night I found myself wondering about her skills as an actress. Later that night I felt a chill that touched my soul.

THREE

The judge's library was cluttered with memorabilia, a museum devoted to himself, everything from an ancient puffy football with the score of a game enscribed in flaking white paint to the model of a World War II B-17 Flying Fortress to photographs featuring the mature Judge Edel with dear friends of his who happened to be mayors of New York, governors, and presidents of the United States. The draperies at the windows hung from bronze spears. Thick-leaved rubber plants and Boston ferns fought for purchases on heavy-legged tables with fringed throws. The wallpaper, where the walls weren't covered by glass-fronted bookcases, was dark green with a print of tiny rosebuds, twining vines, and nearly black leaves. The room was lit by several table lamps of equally complex design, each with a yellowing shade. The effect was not unlike that of various rooms in crumbling English mansions where old Victoriana had gone to die.

Judge Edel stood with his back to the window which overlooked Central Park and Fifth Avenue. He was smoking a cigar, the smoke hanging in the gloom of the twelve-foot

ceilings. The smell of the room was less of cigar smoke than of a peculiar, faint mustiness, the smell of the past refusing to let go and become only a memory. The judge seemed integral to the past, still in his suit and tie with the heavy jowls obscuring the collar, like Charles Laughton's in an old movie.

"Mr. Nichols," he rumbled, waving his cigar in my direction, and then letting it drift to include the man standing across the room from me, "Mr. Alec Maguire. He's come all the way down from Boston at my request, Charlie. He has a story and something I want you to see."

"How are you, Mr. Nichols?" He came across and shook my hand. He wore a large class ring, gold with an immense red stone. He wore dark-framed glasses and a blue blazer. His receding hair was dark, curly, and lay close to his skull. A long face with a long narrow nose was bracketed by tiny ears, no bigger than a boy's. "I'm a private investigator working out of Boston. Got my own agency up there."

"Boston's answer to Sam Spade," I said.

"Well, think of that! My fame precedes me. Let me say that I've read your books with a professional interest, you might say. Fine work."

"I'm delighted to hear it," I said. "But I'm at a loss as to what's going on here tonight—"

Judge Edel spoke up through a cloud of smoke. "Alec has done a variety of jobs over the years for Victor Saberdene. The first time was the business of Anna Thorne's murder. Checking on Varada's background. Then checking the facts regarding the man who recently confessed to the murder of Anna Thorne. And finally—well, Alec, why don't you take it from here."

"The last job I did for Victor," Maguire said, "began once I'd verified the man's confession through my police contacts. It was right on the money which meant there was no doubt about Varada—he was innocent, he'd spent eight years in prison for a crime he didn't commit. Victor figured that he might well have revenge on his mind . . . particularly in light of the kind of

145

sociopath he'd always been. I mean to tell you, Nichols, this Varada's got a history to curl your hair." He rubbed his palm across his own kinky hair and grinned. "This guy came direct from the Black Lagoon. He was the guiltiest son of a gun who was ever innocent of a murder charge.

"So Victor was a little concerned about the mood Varada might be in. He asked me to tail him from the moment he left prison. Which I did. Now, here was a guy who was entirely alone. If he were in one of your books you'd have called him an archetype of the existential antihero. With bells on. He stayed in a rooming house in Boston for a while, got himself a couple of women, worked off a little steam with them but no harm done. Then, darned if the son of a gun didn't give me the slip. At Fenway Park, a Red Sox game, he was there one minute, gone the next . . ." Maguire shrugged. "I blew it. But it was a one-man tail at that point and there's nothing much harder to do than that, if I do say so in my own defense.

"You'll never guess where I found him. Heck, I was just playing a hunch. Never did find out if he'd spotted me. Anyway, I played the only card I had—gave myself twenty-four hours, then I'd have let Victor know and he could have hired somebody in New York to bodyguard Mrs. Saberdene at that end. That was Victor's concern, of course, thinking of how her testimony had sunk Varada. But I did find him . . . back in Earl's Bridge!

"Darned if he didn't, eight years later, return to the scene of the crime. I'd lucked out. He was staying in a run-down motel about ten miles away, he'd rented this beat-up old car, and I just saw him on the street in Earl's Bridge. So help me, never been so lucky on a case. Anyway, he went back to the same theater. Bright sunny day. He walked down that same path where Mrs. Saberdene had seen him go with Anna . . . it was so weird! Because *he* hadn't killed her. Sort of the wrong man returning to the scene of somebody else's crime. Weird!

"Then he took a long walk through town, right past Thorne's

house, then, honest to God, he walked all the way out to the cemetery . . . I kid you not . . . he took a little buck-and-a-half bunch of daisies and put them on Anna's grave!"

Maguire stopped to take a sip from the brandy the judge had poured for us and I said: "I'm at a loss. I just don't get it. This is not the Varada I've come to know and love. The man you're describing sounds too much like a human being—"

The judge rumbled again and a lock of gray hair drooped across his seamed forehead. "Prepare yourself, Mr. Nichols. In the vernacular, you ain't heard nothin' yet." His chest and belly shook as he leaned back in the deep old morris chair. He folded his hands across his vest with its gold chain. "Now, back to the cemetery at Earl's Bridge . . ."

"Well, sir," Maguire said in his deliberate, precise manner, "I was standing under a tree near the iron fence watching him, so darned hot I thought I'd drop in my tracks, and then he finally left the cemetery. Walked right past me, wearing this Panama hat, a safari jacket, didn't even seem to notice me. Next day he left the car where he'd rented it and caught a bus to New York City. I followed the bus but one of the hoses went out on me, my car overheated and seized up, and naturally I lost him. So I called Victor and he told me to come down to New York and keep an eye on Mrs. Saberdene just in case Varada decided the time had come to bother her.

"So I watched her without her knowing it for ten days. Victor didn't want to worry her, told me she was—what was his word?" He snapped his fingers, the red stone in the class ring flashing. "Delicate. Said she was delicate and he didn't want to frighten her. Well, nothing for ten days and he'd just about decided to call it off with a sigh of relief when I followed her to the Market Diner at Forty-fourth and Eleventh Avenue. Over by the big Greyhound package station—not the sort of place she usually went. She went in, sat at a booth by the window. I had a perfect view . . . and pretty soon—"

Judge Edel interrupted. "Now, this is the meat of it, Nichols.

This is what Victor brought to me about a week before you entered the picture. Go on, Alec."

Nichols. The old stalking horse. I saw the notation as if it were still in front of me. Good old Charlie. Oh, Victor, Victor, you bastard . . ."

Before Maguire could get under way the judge took a large manila envelope from the table beside his chair and with his huge meaty hands slid out a stack of photographic enlargements. "These are the pictures Alec took. Have a look at them."

I took one look at the top picture, then the second, and the third, then I came out of my chair like the champ at the bell for round one.

"This flat fucking cannot be! What the hell do you guys think you're doing? You listen to me, you, you . . . Caro Saberdene is scared to death of this man. Whatever these pictures mean . . . if they're, they're doctored to make things, uh, well, look bad . . . I mean, this is complete nonsense, you've gotta see that . . ." I blustered myself out and Maguire bent down and picked up the stack of pictures, squaring the corners in the awkward silence that followed.

"Stop sounding like Jimmy Stewart getting all het up." The judge's hand fell like a sash weight on my shoulder, casually pushing me back into my chair. "Those pictures are the real goods. Might as well accept them for what they are."

He spread them out on a long low table, moving a couple of potted ferns and some *National Geographic*s.

The first glossy black-and-white showed Caro sitting at the table in the window at the Market Diner. Across from her stirring a spoon in his coffee cup was Carl Varada. His Panama hat lay on the table obscuring his left hand. Caro was looking directly into his face. He was, droopy-eyed, looking down at his coffee.

Through the next dozen pictures Caro was sipping coffee, looking impassively at Varada while he talked, Caro speaking, her face solemn, Caro wiping at her eyes as if she were on the

verge of crying. There was no way to tell what might have been
said. There was no real emotion in the pictures. Just my own
shock at seeing them for the first time.

"Now, a second set," Maguire said. "I shot them at a place
called Peter's Bar and Grill up on Columbus. I followed her in
and Varada was already sitting at the bar. Middle of the
afternoon, pretty empty. I sat at the end of the bar and stuck
my head in the *Daily News* and snapped off another roll of
pictures."

Varada taking hard-boiled eggs from a rack in front of him,
breaking them on a napkin, peeling the shells away, munching
on them while he talked to Caro. Once again she sat passively,
either looking across the bar into the mirror or staring at
Varada. She seemed never to speak, in an almost catatonic state.
Then Varada's face became more animated, the eyes almost
flashed below those high, arched, arrogant brows. Then he
looked disgusted, frowning, lips curling in a mocking smile that
was in fact a frown. Taking his straw hat from the bar, putting it
on, then ambling away from her toward the sunny glow coming
from the doorway. Caro still sitting frozen, her thumbnail on
her lower lip.

"I took these shots down to Victor at his office," Maguire said.
"As you might imagine he was shocked at first, then he was
confused. Not angry. Just confused. Like what he was saying
was, What do they mean? I can't give an explanation, either,
and I told him so. Mrs. Saberdene seems just to be listening to
Varada. She doesn't seem to want to be there but on the other
hand she could just have gotten up and left at any time. Varada
never seemed more than irritated. He wasn't threatening, he
wasn't angry." Maguire shook his head, perplexed. "But what
they might have been saying—well, I didn't use a mike. Who
knows what they were talking about?" He shrugged. "I guess
there's only one way to find out."

"And what might that be?" I was holding my temper,
ignoring the gremlins drilling at my psyche.

149

Maguire shrugged. "Ask her," he said softly.

"Now," Judge Edel rumbled, "here's where I came in. Victor brought the pictures to me as an old friend. He was naturally distracted by them, he asked me for my interpretation. Well, hell's bells, what could I say? Caro met him at least twice, why remains a mystery. I have no intention of asking Caro. Was Varada threatening her? He certainly seemed to be threatening her later on—shortly after these meetings took place the phone calls began." He took forever lighting another cigar. "Caro said nothing to Victor about the meetings, not even after the harassment began."

I said: "Did Victor ever confront her with them?"

"No. He told me he would not even consider such a course. He felt that she was under enormous pressure, that she was too near the edge—psychologically speaking—and he didn't want to run the risk of having her slip off. He said he thought that Varada was trying to get at him through her, maybe blackmail, money, you name it. When she didn't want to play that game Varada decided to step up the attack."

Maguire said: "I told Victor that I had a prior commitment in Boston. I told him I felt that Varada had played his hand and come up empty. I told him I thought Varada would fold and clear out because Caro hadn't cracked like one of those eggshells. It turned out that I was wrong."

"Victor told me about the telephone calls," Judge Edel said. "Then, my God, he told me about Potter and Claverly and Abe Braverman. As far as I was concerned Victor was the one who'd gone over the edge. I didn't know if he needed a keeper or a psychiatrist and I told him so. I told him he had to go to the police and if he got caught in some fallout he'd have to face up to it. But Victor told me I wasn't getting the point, he was going to do it his way. Now, Nichols, since I knew you'd been caught up in this thing, sort of an innocent, I thought maybe you should be told about these remarkably puzzling pictures. Of course, Varada hasn't been seen or heard from since the death

of Victor . . . Well, Charlie—do you mind if I call you Charlie?—I've probably complicated things for you. But I think Victor had a great deal of faith in you. I think he'd have wanted you to know about these pictures. I don't know what they mean but they worry me. I guess there are only two people on earth who know. And apparently they aren't talking."

"What is it that worries you so much?" I wasn't sure I wanted to know but it was one of the questions God wants you to ask.

"I'll tell you, Charlie." The judge turned his back on us, opened the heavy draperies, and looked out at the glowing night sky above Central Park. "The thing I don't understand is . . . I look at these pictures and, God damn it, it looks to me like they *know* each other. That just sticks in this old craw."

Chapter Fourteen

ONE

Caro was in bed by the time I had gone for a walk to mull over the judge and Maguire and those damned photographs, then made my way back home—or to the Saberdene brownstone, which I'd come to think of as home. At least I'd thought of it as home until I'd seen the photos and the judge had finished with me.

I began feeling like a world-class sap: Victor had used me for a stalking horse and Caro had somehow played me for a fool . . . and she had, indeed, been giving a performance. A brilliant performance, convincing me of what I wanted to believe. Or had she? Was she completely innocent of the implications the photographs made so starkly? It was all impenetrable because there was no answer to the only question that mattered anymore. *Why?*

In my experience, such as it is, confusion and frustration and depression are the three primary components of cosmic drunks, which is what I proceeded to accomplish over the next three hours. I drank my way through a virgin bottle of Bell's

scotch while I sat in Victor's study and had a replay of a Mets game on Sports Channel racketing along before me and who the hell cared how the game turned out. I woke up at four o'clock on the floor, halfway between the big leather chair where I'd been sitting and the liquor cabinet. I can only assume that God intervened and dropped me in my tracks before I could get to another bottle. He probably wanted to keep me around for more punishment because I hear He is at times a vengeful God.

I've also heard that some hangovers can kill. It is a view to which I now subscribe.

Things didn't look a damn bit better in the morning sunshine. Worse, if anything. I kept seeing those photographs. They almost came to life in my mind, like movies, but they had no sound track. It was the sound track I needed, the only hope I had of explaining what Caro might have been doing during her secret meetings with the villain of the piece. No sound track. No explanation. Of course not.

I was tiptoeing along my own worst doubts about her and I got the last thing in the world I expected when I finished negotiating the stairway. Absolutely the last thing, which had become just about par for the course.

She was more beautiful, more radiant, than I had ever seen her. I saw her in the garden, in a sundress, her tawny hair shining in the light filtering through the trees. She saw me, her smile lit up the face which had so often been a solemn mask since I'd known her, and she came toward me grinning broadly, laughing softly.

"You," she said, "look like Judge Edel took advantage of your virginity after he got you drunk. He's tried often enough with me." She took my arm and led me to the table. "You need intravenous coffee. Did you have a nice time?"

I groaned, wished I hadn't told her I was going visiting at all. When I'd slumped in the wrought-iron chair, she leaned down, tilted my chin up, and kissed me softly but firmly. There was a sparkle in her eye, new to me. Why now, of all mornings?

She poured coffee and buttered a toasted bagel and put it before me. There was a clean fresh breeze. There was still hope that the heat wouldn't get out of control. Faint, like all my hopes that morning, but still a hope.

I'd laboriously gnawed my way through most of the bagel when she came and knelt beside my chair, put her hand on my knee, and took my hand.

"Charlie, I know how awful everything has been. It seems like forever, these past few weeks. But I woke up this morning and everything seemed to have changed . . ."

"I know exactly what you mean, Caro. I felt the same way last night—"

"Oh, I'm so glad! I'm so very glad, Charlie." A tear escaped and she wiped it away, never taking her eyes from me. "The world is getting back to normal now. I can feel it. In my heart."

I might have blurted out my questions about the photographs right then. But I couldn't. I couldn't bring her down, couldn't inflict the hurt. She was so happy. She was coming out of the woods. And I understood what Andy Thorne had meant. I didn't want her to be hurt. I didn't want her to withdraw into her own quietness, I didn't want her to leave me, to cut me adrift. Somehow, I really wasn't sure how it had happened and maybe no one ever quite does, but she'd become that important to me. And with the perversity of human nature, she was even more important now that I'd seen the photographs and my faith in her was crumbling all around me. I looked at her face, felt her squeeze my hand. She could feel that the world was getting back to normal and it showed in her face.

"I woke this morning and it was like coming out of a terrible dark tunnel full of death and pain. I've been trying so desperately to come to grips with Victor's death, the part I played in it . . . and I've thought about how I've kept telling myself for years that our marriage was a good one. How I never really wanted to admit it was just a shell with the two of us

154

rattling around inside, hardly ever touching—well, you, with your kindness more than anything, have allowed me to admit the truth to myself . . . remember that night at the Algonquin? I'd never said those things to another soul, Charlie, but I said them to you. Because I trusted you . . . because I knew I was falling in love with you . . ." The sunlight was crossing her face. I couldn't look away. But in the shadows of my mind I kept seeing her across the table from Varada.

. . . *God damn it, it looks to me like they* know *each other. That just sticks in this old craw* . . .

"Now it looks like Dad's going to be all right," she said. "And Varada hasn't shown up since Victor's death. Charlie, I'm almost afraid to think it but . . . but it's like the slate has been wiped clean and I can go on from here, I can build a new life . . . Oh, Charlie, I've spent so much time alone since Victor's death, I've thought so much about him and you and us—I'm in love with you, Charlie, you've been brave for me and you've believed me and stood up for me and you wouldn't have had to do any of it. And you've made me feel like a schoolgirl with a crush that has turned into something else, something wonderful and serious. All the things Victor told me about you are true. He said you probably didn't know it but you were the best friend he'd ever had . . . I can see why, Charlie . . ."

I felt totally paralyzed, a captive of confusion. Everywhere I looked I got an entirely different view of what was essentially the same subject. Victor had been so in love with her: he'd convinced me of that beyond any doubt. Yet Caro said it was a frigid marriage based on his belief in her weakness, his need to take care of her. And Samantha Barber, corroborating what Caro herself had told me, admitted she was having an affair with Victor. Samantha also contended that Caro, who knelt beside me now with the look of love in her eyes, was unbalanced and had attacked her, would have killed her . . .

Victor had Caro followed by a private detective but he pulled me into it, too, wanting my help as a stalking horse—

155

presumably to draw fire. But he had neglected to tell me the one terribly anomalous truth: that he had photos of Caro meeting with Varada—who was supposed to be terrorizing them, who in fact *was* terrorizing them and was about to start scaring the shit out of me.

And now Caro was telling me she loved me, telling me that everything was getting back to normal. Until last night—she was telling me what I wanted to hear above all else. But now I knew about those photographs.

As she watched me, Caro's face darkened with concern.

"Are you all right, Charlie? What's the matter? You look like someone's walking on your grave . . ." She stood up, touched my shoulder. "Is your head that bad? You haven't heard a word I've been saying." She bent down and kissed my forehead. "I should give the judge a stern talking to."

"I heard every word. But I admit no earthling has ever drunk quite so much—"

"You're such an innocent earthling, Charlie. And I've run you down with all my problems. I'm so sorry."

I looked up at her and tried to smile. It wasn't much of a smile but she blamed Judge Edel. In a way she was right, I guess.

"Such an innocent," she said again.

"That's me," I said.

TWO

Later on I gulped a handful of Advil and told her that I wanted to take her shift with Andy at the hospital. It would give her a chance to just relax and putter around the house. She nodded happily, acknowledging her need for a break.

She followed me to the front door, hugged me, held me tight. "God," she whispered, "I'm so glad you're here. I feel as if my life has been pulled back from the edge. By you, Charlie. You

came to save me and you have actually done it. I didn't know real life could ever work out that way. Bravo, Charlie!" She brushed my cheek with her lips and stood in the doorway watching me head down the street.

The steps she had been taking all day completed a kind of crazy circle. I had begun by betraying Victor's belief in me only to discover that he was using me as bait in a fairly dangerous game. And neither had he revealed his hole card, the photographs. Now I had come to doubt Caro's role in the affair, just as she decided she really could let down her guard and show me her emotional vulnerability. I felt as if I were watching a creature madly devouring its tail until there was no head, no tail, just a mad and blinded creature. We'd all been betraying one another in terribly civil ways. But when it came to the photographs—well, someone should have told me. There'd been too many secrets.

And of course I was keeping my knowledge of them secret, which proved, I suppose, that duplicity was one very contagious disease.

Andy Thorne looked less well now than he had the last time I'd seen him but he adamantly insisted that he was feeling stronger every day. He said he'd be going home soon, possibly within a week, according to his doctor. "It'll be a relief," he said, "to get back among my own things, my books, my doodads. I still tie flies . . . hobbies and habits, they die hard. I can't fish but I still pride myself on the flies. Maybe I should take one last fishing trip, fish one last stream . . . and if I keel over, well, we owe God a death and if I give Him mine in that stream, then I'm quits for the next, or words to that effect. Oh, damn this bed!" He struggled with two pillows until he had them straight, then sank back winded. "A heart attack is a bitch," he said. "Or stroke. Damn thing! And I'm lucky; my sawbones never tire of dithering at me." He grinned slowly, then narrowed his eyes, the lids crinkling like parchment, as if he were actually noticing me for the first time since I'd arrived. "I must say, laddie, you look more than a little hollow-eyed. Anything special?"

157

"Yes, Professor, I'm afraid there are some things that are very special. I wouldn't be laying this on you if there were anyone else I could talk to. But there just isn't. You're it, Andy."

I slowly and calmly took him through my encounters with Samantha Barber and Judge Edel. It took some time and he listened, eyes closed, seldom interrupting. Much to my surprise my head didn't fly off and buzz around the room deflating. When I'd finished the recitation, Thorne's eyes opened slowly and he licked his dry lips. "The thing is," I said, "I just don't know what to do."

"Do? Do about what, Charlie? Frankly, I'm surprised you haven't gone back to London by now—"

"What I should do about your daughter."

"I don't understand. Why do you have to do anything about her? She's not your problem."

"I'm in love with her."

"Little sudden, isn't it?"

"We've been in a pressure cooker together. That can speed up the process." I shrugged. "Sometimes it just works that way."

"Yes, you're right." Thorne nodded slowly, remembering. "That's the way Victor fell in love with her, too. In a pressure cooker." He had begun to mumble, his voice lowering to a whisper, slurring the words.

"Are you okay, Andy? Would you like me to call a nurse?"

"No, no, I'm fine." He brushed my concern away with a flick of his hand. It dropped limply to his chest. "I'm just tired. Well, if you've fallen in love with Caro, then it's up to you—looking after her. You're the one who's got to take care of her now."

"I'm sure she's quite capable of taking care of herself," I said.

"So you'll be taking Victor's place," he said haltingly, feeling for the words.

"Victor didn't trust her," I said. "How can I trust her after seeing those pictures?"

"Now, that's one way of looking at it, Charlie. But it's not what your Boston detective said, is it?" He sighed. "He said Victor

158

hired him to protect her . . . and you could say that, couldn't you? And Victor . . . didn't think the photographs . . . important enough to tell you about them."

"But there are so many questions, Andy. Why did Varada go back to Earl's Bridge? What was the point? Andy . . . why did he take flowers to Anna's grave?"

"Ah, Charlie. That's a mystery, isn't it?" He coughed and turned his head away from me.

"Why did Caro meet with Varada? The judge said he couldn't fathom it . . . they seemed to know each other."

"You can always just ask her—"

"Yes, and she'll withdraw, do her disappearing act—"

"You may have to risk it." He coughed again. "I don't feel so good, Charlie. Can you get me that glass of water?"

I held the plastic cup of ice water out to him. Suddenly he grabbed my wrist, his fingers tightening in a spasm of pain. The cup fell from my hand, water soaking his chest and the sheets. His eyes rolled back, the whites seeming to bulge. He sounded like he was choking.

I began yelling for a nurse.

Chapter Fifteen

ONE

Andy Thorne had suffered another heart attack. Nobody seems to call them heart attacks anymore and maybe that wasn't what it was but that's the sense I made of it. The next day a team of surgeons performed a lengthy triple bypass somewhat against the normal odds. During the night before the surgery Caro remained at the hospital and was more or less constantly on the scene for several days after it.

"He's all that remains of my past, Charlie," she told me during a brief rest stop at the brownstone. "With him gone I'd feel as if I'd never been there at all. No one to validate my memories, as they say. He just can't die, Charlie, I'm not ready for that yet." She'd smiled tiredly and momentarily rested her head on my shoulder. "You may be my future," she whispered, "but my dad is all that's left of what went before. I can't lose him. Maybe if I stay with him he'll draw strength from me . . . Maybe there really is some kind of psychic energy, something I can give him. A lifeline to pull him through."

I had plenty of time to think about her, to worry about her,

and I kept seeing her standing over Samantha Barber with the poker in her hand, Victor bursting into the apartment and stopping her from committing a murder. I kept seeing all those photographs spread out on the table and the judge saying *they know each other*. I had plenty of time to wonder just what I should do. And then she'd come home from the hospital, eyes bleary and red from worry and lack of sleep, and I'd ask myself how I could doubt her decency, honesty, sanity. Well, I'd seen the photographs. For starters.

But, but . . .

I was overwhelmed by her courage and the strength of her will. She simply would not let her father die. She insisted that he live, she damn well demanded it. "There's been too much death in my life," she said. "Enough is enough, Charlie."

Her morale would not crack. Nor would her composure. You looked at her and you knew she'd never heard of a crack-up, a nervous breakdown. That had all happened to another person in another time because this woman was impervious. Death was overmatched when he came looking for Andy Thorne.

It almost broke my heart, her courage. She'd been through so much of what was unspeakable, she'd thought she was out of it, and then the forest of sorrow, like something predicted in *Macbeth*, had come after her, had closed around her again. But she refused to capitulate.

Eventually Andy Thorne's condition stabilized. The doctors assured her that he was out of danger and that if she didn't go home and get some rest they'd be treating her for exhaustion. She came home and slept for fifteen hours.

While she slept I decided that I simply couldn't confront her with Samantha Barber and the judge and Alec Maguire. Whatever had been going on was over. I also decided that I would have to leave New York. Varada had apparently given up his campaign of terror, so I *could* leave. It was all too complicated. I couldn't seem to make any sense out of it. Neither could I be the cause of her being hurt anymore. I'd go

161

back to London and maybe later, when the heat had been turned down for both of us, we could see one another again. What would happen would happen. Not much on the nobility scale but good intentions, anyway.

The next day, rested and smiling and beautiful, in linen with pearls swinging from her delicate ears, she came to me in the garden where I was planning my farewell address. She settled on the bench beside me. Her scent was subtle flowery for the high summer afternoon. Two cardinals which had taken up residence in the garden flickered brilliantly among all the green, all the shadows. She touched my arm.

"How are you holding up, Charlie?"

"Me? It's you, Caro, you're the one. You look wonderful. So beautiful you make me buzz—" She cocked her head. "What are you doing?"

"Shhh. I'm listening for the buzz."

"It's a metaphorical buzz," I said. "Just looking at you makes me happy." This was not how I had planned the farewell address.

"Well, for a happy man, sonny, you're looking pretty down in the dumps. I know how neglectful I've been but I think I'm back from the far side again. Neglect is now a thing of the past. Give the girl a kiss, Charlie."

She kissed me and I tried to make it warm and loving. There was no way to get that particular slow curve past a power hitter. I didn't want to be yet another burden for her. But I couldn't fool her. And I owed her something, too. Honesty.

"Charlie, listen to me. You've seen me through the very worst time of my life. This has all been so much more horrible than what happened eight years ago. A hundred times worse. I'm not the same person I was then. I'm stronger. You've helped me prove myself. To myself most of all. I haven't cracked up. I haven't come to pieces the way Victor always thought I would. You've helped me there, too. Now, Charlie my boy, you've got something on your mind. Something bad. And I'm going to

help you. It's time for me to return the favor. Let me. Please, Charlie." She stood up and took my hand. "Come on. Let's go for a walk in the park."

TWO

Central Park lay exhausted in the midday heat. Humidity hung like nets in the trees. The kids in the fields and the joggers and the strollers moved slowly, like creatures struggling to get free from prehistoric ooze and losing the battle. Toy sailboats bobbed gently on the pond without a breeze to catch. Little children watched in surprise as their ice cream cones melted in their hands and nursemaids screamed at them. Stray dogs lay on their sides in scraps of shade, tongues drooping disconsolately on the grass. I sensed one hell of a kinship.

Caro swung along beside me looking composed and oblivious to the heat. She wouldn't let me off the hook. She had to know what was bothering me. So I told her.

"Samantha Barber called me," I said. "She had a story to tell me."

"Okay. What kind of story, Charlie?"

"A story about you." I gave it to her, the whole business. She didn't try to laugh it off. She nodded solemnly at one point, shook her head, bemused. None of it shook her and when I came to a halt she took my hand and swung it between us as we kept walking.

"Oh, I'm sorry you had to hear all that. It must have made you wonder which end was up!" She grinned at me, her face full of trust. "There's a lot of truth in what she says. Would you like to hear my commentary?"

I nodded.

She brushed a stray wisp of honey-brown hair from her forehead, pursed her lips for a moment. "Samantha has never gotten over the way she lost Victor. She just thinks that way—

163

she sees it as losing Victor to me and of course that's absurd. Their relationship ending had nothing whatever to do with me. That's just a fact, whatever she thinks. I'm not apologizing for Victor—he may have been his usual brusque self, shy, aloof, when he broke it off with her. He may have seemed uncaring, even brutal. I can understand that. Then he married me and it was more convenient for her to blame her frustration on me. But she never forgot him, obviously. He's not the kind of man a woman can just forget . . . he *wasn't*. Samantha probably kept current on whatever gossip she could pick up about us. She knew her man, I guess, because when she let Victor know that she was still sexually available to him, well, Victor was fairly quick off the mark. She hadn't married Barber yet and deep down I expect she thought she could get Victor back—if she played her cards right.

"I didn't know about their affair until Samantha called me and asked me to come around for tea. I'd noticed some vaguely unusual behavior on Victor's part but he often went through periods of depression or withdrawal whatever the cause. I got used to his moods. And when his old flame called, well, I began to get the idea. This was about three years ago, if anyone's counting.

"Tea turned into a major combat zone. Never experienced anything like it. The real problem was that Samantha had been drinking something other than tea before I got there— apparently working up her courage to face me. She really didn't pull any punches, either. She told me all about her sexual relationship with Victor in precise detail. I couldn't believe some of the stuff she included. I must have said something like 'enough already' but she was just getting up a full head of steam. She was at great pains to inform me that Victor was tired of my nuttiness—her word—and would leave me in an instant if he weren't so worried about my going mad and killing myself. She just went on and on and I kept telling myself that I would not allow myself to break down in front of this creature.

164

"I sat on the couch, she was standing, and she kept pacing around the room and I finally looked up at her and she was poised over me, her fists clenched, her face all screwed up with frustration and hatred and rage . . . as much at Victor for refusing to leave me . . . she was just screaming at me, her face was all red and puffy . . . I admit it, Charlie, I kind of snapped at that point, I stood up and slapped her as hard as I could . . . and she was so drunk and unsteady she fell down, I remember seeing the red blotch on her cheek and along the line of her jaw, so help me I thought maybe I'd broken her jaw . . . I hoped I had!

"Anyway, she was on the floor near the fireplace and I turned around and was walking out when I heard a noise and I looked back and she had the poker from the brass fireplace set in her hand and she was starting toward me. I made a very hasty retreat, slammed the door behind me. I could hear her sort of howling and screaming behind the closed door while I waited for the elevator. And that was it, Charlie.

"Her story about Victor showing up and *my* having the poker and wanting to murder her—well, she's made sure no one could set the record straight but Victor and he's dead. Believe me, Charlie, Victor never knew anything about my seeing Samantha . . . at least I never mentioned any of it to him and if she told him he never let on to me.

"And how could I be angry with Victor for having an affair with her? Really angry? I was a failure in the marriage bed and I knew it, so what could I say, Charlie?"

THREE

She must have thought the inquisition was over because she beckoned me to come sit beside her on a bench in the shade. A willow drooped over one of the pretty little humpbacked bridges behind us, joggers trying not to expire on the track

beyond and below the boulder nearby us. The sounds of Central Park West barely reached us. Caro sat quietly, half-turned toward me. "Does that make sense to you?" she asked. "Does that put your mind at ease, Charlie? I can't answer for what's going on in Samantha's head, but that's exactly what happened."

"That's fine," I said. "But there's something else—Caro, I don't even know how to bring it up—"

"Just do it, then. We've got to get everything straightened out between us, Charlie. Don't worry about me. What is it?" She took her sunglasses off, dangled them, and watched me. She was absolutely still, like an animal poised to face a challenge, only the glasses slowly swinging. Her face gave nothing away.

"Judge Edel," I said. "He had something he thought I should know about. He said Victor would want him to talk to me . . ."

I told her everything about the photographs, everything about the eerie night I spent with the judge and Maguire. When she realized that Victor had had her followed, the color left her face, her lips tightened, but she said nothing else. She waited and when I'd finally finished she looked away, back at the bridge on the footpath as if it might lead to a better, safer place. Finally she sighed, stood up. She walked to the top of the bridge, looked out across the running path toward the thick stand of trees, a disk of blue lake shimmering beyond.

"Naturally you're upset," she said, measuring each word. "You'd be nuts if you weren't. But this spying is all a surprise to me, too. And I find all this simply unforgivable behavior on the judge's part. And worse, much worse, on Victor's. How very much like the judge, how reptilian! Why in the world didn't he just ask me what was going on when he saw the pictures? He didn't have to worry about my tender feelings—but instead he goes to you! He knows nothing of our relationship . . ."

"He came to me because he knew Victor and I were close . . ."

"Which is absurd on the face of it since Victor, being his usual

166

cowardly self, didn't let you in on the big secret while he was alive. Victor's not asking me—when he saw those pictures and must have been stunned by them—is utterly despicable. There's just no other way to say it." She shook her head, her eyes moist with anger and frustration. "You're the only one who just came to me and asked me, Charlie, as if I were a sane person who would have an explanation . . ."

"I'm sure Victor didn't want to upset you—"

"Oh, you're such a blind, loyal friend! Too good a friend, better than Victor deserved, I'm afraid. And Edel—my God, the mind reels! Why does his mind work that way? What is the enchantment of conspiracy, of going to you behind my back? Maybe I'll never understand. Maybe it doesn't make any difference now."

I didn't say anything and finally she leaned away from the bridge railing and smiled at me. "Now, those photographs—okay, here's what happened." She took a deep breath. "I got a telephone call from Varada one day and I guess if you look at it from his point of view it wasn't such a crazy idea, calling me, I mean. After all, he hadn't killed Anna . . . and I can only tell you that he wasn't at all threatening. He just said he'd appreciate it if I'd meet him. In a completely public place, in case I didn't feel safe. He wanted to talk to me. He asked me, he pleaded with me, not to tell Victor. He wanted no part of Victor. Frankly, Charlie, I felt so guilty about my testimony helping send him to prison, I thought I owed him something. What harm could it do to go talk to the guy? I know it's hard to believe now, but he wasn't the same man you've seen . . . I may not have been thinking too clearly, I'm willing to admit that, but I was so overcome with guilt at the whole tragic mess—well, I told him I'd meet him.

"So I went to that diner way over on the West Side. And there he was, coming to the table, after all those years, and I was afraid. Just plain afraid . . . but he sat down like anybody would and he only wanted to talk. While Victor's little man was

snapping his pictures. He talked about how he endured prison, how he'd prayed that someday the real killer would be found— and then he told me how it had felt when his prayers had been answered. Then he said he felt we owed him something, Victor and I, for all the horror we'd caused him, all the lost years.

"But then he began to talk a little wildly, he said my sister had loved him, he said he thought that maybe if I tried I could be in love with him, too . . . he said he wanted me to meet him at a hotel and go to bed with him, that I should take Anna's place . . ." Her voice was trembling and she didn't say anything for a few moments. Then she forged ahead. "I tried to stay calm and speak reasonably with him, which was stupid, I suppose, but any peaceful alternative to what he had in mind seemed worth going for. Well, finally he went away after he told me to think it over.

"Then a few days later he called again, told me he wanted to talk to me again. He said if I didn't come, or if I told Victor, he'd make sure that both Victor and I were very, very sorry. He was very sincere. So, okay. Since he wanted to meet in another public place, that bar over on Columbus, I decided I'd meet him one more time and try to convince him that he was making a big mistake if he thought Victor wouldn't strike back at him. Well, that was the wrong thing to say. He got sort of quietly angry, said he hated to be threatened. Then he gave me a little demonstration. He took two hard-boiled eggs and cracked them on the bar. He said it would be just as easy to crack Victor and me—then he leaned over and whispered to me what he wanted to do to me, said if I let him he wouldn't bother Victor . . . but I just couldn't, Charlie, I couldn't go with him, not even to spare Victor." Tears were streaking her face. Her teeth chattered while she tried to control herself. She wiped the tears away with my handkerchief.

"And then you came into it. You know the rest." She gulped back a sob. "Maybe I should have let him do what he wanted

with me. Sooner or later he'd have gotten tired of me and gone away and Victor wouldn't be dead—"

"And we might have gone to your funeral, not Victor's," I said. "Why didn't you tell Victor?"

"I don't know anymore. Except I thought I might still bargain with Varada, my body for Victor's life or something . . . I don't know, Charlie. It's just one of those things, you lose either way."

I put my arm around her, pulled her to me, felt her shaking. "I call Victor a coward," she whispered, her face moist against my chest, "and I'm the biggest coward of all. Oh, Charlie, Charlie, it's all too late for me, isn't it?"

I held her, stroking her long tan hair, telling her that the bad times were all over. Later she said: "Don't let me think you believed whatever the judge was implying about me . . . please don't, Charlie. I couldn't live with that, I just couldn't bear it."

An hour later we were out on the lake with the towers of Manhattan rising over us beyond the thick greenery of the summer trees. I stopped rowing and let the rowboat sit, slowly drifting, barely moving. Clouds had piled up over the city, pale gray and rich purple. Caro was dozing on a pillow, her eyelids fluttering, one hand tight in a tiny fist.

Suddenly it was raining, big soft drops at first, and lightning cracked to the south over midtown. I began rowing us back to the boathouse. I felt drained and simultaneously relieved beyond my wildest dreams. There was nothing wrong. I could hardly believe it. We were getting wet and she was still half-dozing, smiling at the rain touching her face.

We were outside the boathouse and it was raining harder and people were scurrying around giggling and screeching and laughing. We were huddled under a tree, soaked to the skin, our mutual relief so powerful we could hardly handle it.

We decided to just say the hell with it and walk home in the downpour. For some reason I looked behind us—maybe I was

169

checking the sky, or looking for the little trolley car, I don't know—but I shouldn't have.

My eyes swept along past the boathouse, past the low rambling restaurant, and came to rest on a huge boulder, bald and gray and rain-blown, overlooking the lake.

Carl Varada was standing on the boulder. He was wearing the same Panama hat, the safari jacket slung over his shoulder, the bush shirt plastered to his immense chest.

He was watching us. Not moving. Just watching.

Caro didn't see him. I didn't look back at him. We walked all the way home and the shower ended on the way. Caro walked close beside me, holding my hand.

But I was thinking about Varada. I thought about all that he represented in our lives, all the fear and evil and the distrust I'd felt toward Caro. I thought about Victor dying because of Varada. I thought about my almost leaving Caro because of Varada's forcing his way back into her life. I thought about Varada whispering filth into her ear . . .

And I just wanted the chance to kill him.

Chapter Sixteen

ONE

The sight of Carl Varada standing on that rock, the rain pelting down on him with the purple clouds rolling up behind him, made me figure the special effects couldn't be far away. I didn't want to put up with Varada and, more important, I did not intend to put up with Caro having to deal with him anymore. I wanted to kill the son of a bitch but, of course, I'm just a guy and just guys don't actually want to kill people. They want them dead, mind you. They just don't want to have to do it themselves.

Alternatively they want to get the hell out, which is what I decided we had to do. Fortunately I had just the place, a place which had nothing to do with the Saberdenes, a place Varada could not possibly find. A place where we could be alone.

It was a ramshackle old house up north—or down east, if you prefer—on the Maine coast, an easy drive from Boston but far enough away to free you from urban life. The name of the town was Hackett. At one time it was a busy fishing community but I had the impression that a couple of small industries had

been added along with a resort quality, and the fishing was now less crucial to the local economy. This information was derived entirely from letters I'd had from Cousin Helen. A great-uncle of mine had once lived in the place. He died ten years ago, leaving the house to his only daughter, who had in turn left it to her daughter Helen, who got married and moved to Atlanta. I heard she was trying to unload the old place so I wrote to her. She sent me snapshots since I'd never seen the house and wrote glowingly of its virtues. I had made some money by then and decided to buy it. Still sight unseen I arranged from London to have it rented out in summer as a vacation home, primarily to Bostonians. Although it was possible to live in year round, if you were good with fireplaces and storm windows, it had no basement and no central heating plant. Helen did tell me that if I were ever to use it in summer myself I should have plenty of firewood on hand because July can be a long cold month on the coast of Maine.

Knowing I was visiting America that summer I'd told the real estate agent in Hackett to take it off the market and spruce it up for me. However, all that had overtaken us in New York pushed the house and the thought of using it completely out of my mind. Now it was back. Now it seemed the perfect hideaway, as well as a secluded and romantic setting for us to get to know one another. It sounded like something from an old movie and that was fine by me. Caro loved the idea. She said she'd never heard of a better idea. Nothing on earth could have made me happier.

I knew everything was going to get better now. The clouds Samantha Barber and Judge Edel had hung on Caro were gone. Varada wouldn't be able to find us. Andy Thorne was making good progress. And Caro was fresh and new and shiny. "I feel positively dewy," she said.

We took the shuttle to Boston, rented a car at Logan, and drove up the coast to Hackett.

It felt like going home. It almost felt like a honeymoon.

TWO

The house sat out on a wedge of land half a mile from the edge of town. It faced the water with a wide strip of our own beach falling away on two sides of the triangle. The third side was a road leading down to the two-lane highway which was becoming the main street of Hackett. There were oaks and elms and a thick stand of spruce which formed a windbreak between the house and the beach. The wind was steady and salty. It had weathered the shingles to a dark, blasted brown, permanently dampened and caked with salt. A porch wrapped around the seaward side. The paintwork was mainly a memory. Seabirds swooped and called over the surf rolling along the sand. I couldn't quite believe I owned the place but we settled in so quickly on the first day that, by nightfall, with the breeze turned to a steady cold blow, with a fire crackling in the big living room, we were already used to it. It creaked and moaned and the fog moving in actually tasted salty, as if we were at sea and drifting on a benevolent trade wind.

That room, where we sat and warmed ourselves and watched the sparks pop in little flurries onto the brick hearth, had won Caro's heart. There was a mixture of ancient rattan pieces with faded flowered cushions and even older Adirondack chairs with the upholstery tied to the wide flat slats with strings. An enormous rag rug that had never seen the inside of a carpet warehouse; a vague, comforting musty smell that the scent of burning logs was dispelling. The lamps were made of twisted, aged wrought iron that looked like roots. The shades were crisp yellow parchment from the twenties with borders depicting scenes of Indian lore looking handpainted. The paneled walls were spotted with knots and framed reproductions of Maine coastal scenes cut from magazines and newspapers that had

173

long ago gone out of business. It was old and solid and the fact that it had all been there so long told you that it was going to be there a lot longer.

We sat on the floor before the fire sipping brandy from old chipped cups. "Charlie," she said, "it's perfect. It's a dream."

"No," I said, "it's reality. The bad dream has just ended."

She put her cup down on the hearth and rested her head on my shoulder. "This is the first time we've ever really been alone. Everything else seems so far away. In time as well as space. Do you feel that, Charlie? It isn't just that we're miles from New York and everything that happened there . . . I feel like we've been moving forward in time, too. I suppose it's some kind of fancy defense mechanism, but Victor and Varada and Braverman, they all seem to belong to another world where bad things happened, a long time ago . . . they're fading in my memory, Charlie. I'm happy now."

"It's about time you were happy," I said. "I want to make you happy from now on, Caro. If it's within my power." I touched her cheek, her lips with my fingertips, tracing her features, claiming them.

Suddenly she was flushed, breathing hard. "I guess this is the time, isn't it? We've waited and now it's time. Kiss me, Charlie."

I kissed her for a long time and she said: "Don't stop, please don't stop now . . ."

It was like a dam bursting. She swept me away with her passion. It was as if she'd been waiting all her life to feel secure and safe and happy and now she let go, let her emotions take over. It was the most erotic experience of my life yet it had nothing to do with the sexual acts themselves, which, I'm sure, were restrained by many people's standards these days. If we were not entirely conventional lovers, neither were we acrobats, nor were we testing one another's strength. We were simply making love for the first time because we were in love. The power of her emotional concentration was so visible, her intensity, her need so great: her need to love, to give herself

174

while taking me, was the purest experience I'd ever known. I felt enfolded within her, completed by her, fulfilled because of her. It made me remember a conversation I'd once had with Victor. Anima, that was it, looking for the anima figure. I'd thought that Victor had found his anima in Caro but I'd been wrong. I was the one.

Later on, when the fire had burned down but the glow of warmth was still all around us, casting our shadows to the corners of the room, she nuzzled my ear, whispered: "Was that all right? Was I too . . . cold?"

"Nothing that a whole lot of practice won't make perfect. Everyone knows that." I stroked her hair. "You know how wonderful you were, my darling."

Her solemn face lit up in the embers' glow. "Maybe we should start practicing right away. If you're up to it . . ."

I kissed her and we got back to practicing. We practiced all night long.

We spent the days fitting ourselves into the life and rhythms of the town. We stocked up on food. We bought a grill at the hardware store and charcoal at the market and took it down to our beach at twilight. We bundled up in sweaters and jeans and cooked burgers and steaks and lobsters over the coals with the wind whipping the smoke to shreds. We found an old net and racquets in the garage and played badminton and walked barefoot in the icy surf. We sat on the rocks watching the Atlantic sky go dark with the sun setting red and orange behind us. We would walk into town to get the newspapers and sit in the grassy square and read them and check out the towns-people, who were so different from New Yorkers, so much slower, so much calmer. Teenagers looked like survivors of another age altogether: they seemed quieter, more at ease with the world around them, with the result that they reminded you of a time when kids were just like real people. Never once did I hear kids screaming the simple word *Fuck!* at one another, at the world in general, while they hung around downtown killing

time. We might as well have landed on Mars. Or maybe it was New York that was Mars.

It was quiet in Hackett. It was beyond mere quiet at the house. It was still. There was just the surf, the birds, the wind in the trees and nibbling at the chinks in the old walls. At night we would sit and feel the fire's warmth and read and listen to the Red Sox games on the radio, Ken Coleman's reassuring voice from Fenway Park and points west.

And we would make love, hour upon hour, and fall asleep, Caro in the crook of my arm, breathing softly against my chest, her hair against my cheek. One night she woke, shivered, clung to me. "I never had any idea it could be like this. It's like . . . childhood, only I never felt like this. It's like I never had a childhood, Charlie. It's like I never was . . . innocent, somehow. Now I feel innocent, Charlie. And happy. Life is just beginning, isn't it, Charlie?"

But she also had dark times, too, as if she were slipping back into that other life where everything kept ending.

THREE

One night when I came up to the house after making sure the fire was out and our bits and pieces gathered together in the canvas carryall, I couldn't find her for a few minutes, then came upon her, feet curled under her, clasping her knees, in a dilapidated old rocking chair on the porch. I heard the squeaking of the rocker first and that led me to her. She was rocking quietly, staring out across the surf, which lay like a white ruffle in the moonlight.

"You okay?" I went to stand at the spindly railing, turned to lean against it and face her. The wind brought gooseflesh to the back of my neck.

"Not exactly," she said.

"Want to have an old-fashioned chin-wag?"

"You do sound odd when you dredge up the spare English-ism."

"I always think it's strangely amusing and seductive, doncha know. Fact is 'chin-wag' is sort of a John Cleese-ism from *Fawlty Towers*. It was funny when he said it. On the other hand, 'Henry Kissinger' was funny when he said it."

"Because it has a 'K' in it, I presume."

"So why aren't you okay? Tiring of bucolic peace and quiet?"

"I'd never tire of bucolic peace and quiet. There's not enough of it to last my lifetime. No, it's not that . . ."

"Come on then, my princess. What's the problem?"

She gnawed on a knuckle, spoke softly into the wind, and I strained to hear.

"Sometimes I get into a dark mood, Charlie. It's like a dark version of me emerging from the shadows, crooking a finger at me to come along, come along. And this enticer from the shadows is sort of oddly irresistible, like a man with a sack of sweets trying to get a litle girl into his shiny car . . . I don't want to go but I want those sweets. Silly little girl, giving into one temptation too many . . ."

"My beautiful Caro, where is the enticer leading you? Or us, I should say, because I won't let you go alone—"

"Oh no, you mustn't come. You must keep me from going, that's the trick."

"Where is he taking you?"

"Oh God, I don't know! I'm being a precious, self-indulgent nitwit! It's just that I'm afraid of the enticer . . . Charlie, I'm so afraid that none of this can last, all this . . ." She gestured, flinging one hand in an arch to take in the house, the beach, the ocean, me. "All this that is so perfect, so much a part of me all of a sudden."

"Sounds like a mild case of depression which the Maine night can bring on, or the New York summer, or a summer cold—it is perfect and it needn't end, Caro. Just because the nice things have ended in the past, that doesn't mean this will. Life doesn't necessarily work that way—"

"Oh yes, it does! You're an optimist so you don't know the truth, that's all. It always turns out that way, no matter which path you take. We pessimists accept the sort of general filthiness of things . . . but it's too bad that it has to smudge the best parts, too. For instance, all this we have now, I'm afraid it's not going to last—"

"Why not, for God's sake?"

"Because I don't deserve to have such happiness, Charlie."

"Don't be silly, my love. No one could possibly deserve the good times more than you. Now, come on, let's crawl off to bed and you can enjoy general ravishment."

And she went along, holding my hand.

But in the night something woke me and I was alone in the old double bed with the noisy springs and the mattress which wobbled with age. I lay there blinking, wondering what had wakened me, and then I turned in the damp, salty darkness to see if Caro was awake and found that I was alone.

There was a shock in the discovery, the way it ran through me in my sleep daze. I threw my legs over the edge of the bed and sat there listening for something that would tell me why I awoke or where she had gone. But all that came was a memory . . .

I sat there, heard rain lashing the house, realized I was damp with rain spraying in the window, then I heard thunder cracking but muffled, maybe it was coming from the ocean, and it all came back to me, waking in another strange bedroom, wondering why, then standing on the balcony looking into the living room, seeing Caro with the gun, the huge man thrashing at the curtains as rain spewed out of the night . . . It was like being a return passenger, headed back into that other nightmare, and I had to force my way out of it.

I left the bedroom, padded along the hallway, and went down the stairway, into the living room. Lightning flashed and the room was revealed in that stark half-white light and she wasn't there.

178

"Caro," I called and the word was lost in a thunderclap.

My breath was jammed in my chest, as if I'd swallowed a coin.

The door onto the porch stood open, rain spattering the floor and the throw rug. The gingerbread porch eaves dripped steadily. The wind blew the rain in my face as I stood in the doorway. It was like bathing in ice water.

I went outside, stood shielding my eyes from the rain.

She was standing at the point of the porch, like a figure in the prow of a storm-bound ship, rain all around her, wind whipping her robe, looking out into the darkness where the enticer must have waited.

"Caro," I yelled against the storm.

She swung around toward me and I was deep in the nightmare again. Only I was playing Victor's role.

She was holding the old shotgun that had been propped in the shadows by the fireplace. The barrels reached out toward me like terrible accusations, lit silver by the lightning. The loud crack followed and I shook my head.

"No, Caro," I called to her. "No, it's me, Charlie."

I felt as if the twin muzzles were swallowing me.

"No, Caro!"

Slowly she lowered it, stood still, staring at me.

I ran toward her, slipping and sliding, and threw the gun down and closed her in my arms. I squeezed her to me, whispering to her. She was cold and wet and limp.

"Oh God! Charlie, I thought I heard him . . . it was happening all over again . . . another one of Victor's damned variations, I was going to make the same mistake again . . . Victor was always saying we keep living the same life over and over again—"

"Don't worry, it's okay, it's all right now, I'm here . . . I love you, Caro, it's okay now . . ."

She sobbed, shivered, dug her fingers into me as if something, someone, the enticer, were trying to tear her away.

"Oh, Charlie, Charlie . . . I don't want to kill you, too . . ."

179

Chapter Seventeen

ONE

But nothing like that happened again. That was the worst she got. And by the time we'd been summer residents for three weeks our daily schedule had become a part of the town's life. In our own way we fit in and they got to know us at the drugstore and the grocery store and the meat market and the fish market and the big flower stall across from the post office.

We would usually walk down to the dock with the sun shining off all the bright white paint and we'd watch the small craft negotiating the harbor and we'd hook our fingers together and smile at each other a lot. Then we'd go to the Sea View Cafe with the big picture windows looking out at pretty much that same perfect view. Kids on bicycles, dogs running around chasing Frisbees, the station wagons and pickup trucks, the gift shops, the band shell in the park. We'd have breakfast, cranberry muffins and eggs and bacon and coffee, and we'd look at the papers from Boston with the baseball scores.

Then we'd dawdle back along the main drag, all the way back

to the house, and sometimes we'd only see one or two cars once we got past the last of the little town. Lots of birds, the wind in the long grass and the constant rustling of the trees and the never-ending salt smell of the ocean. Maybe we'd make love for lunch and go play with the gardening tools and dig some weeds out of the flowerbeds, then get on down to the beach in our sweaters and build a little fire in a sandpit and have dinner as night fell behind us and the summer chill rode in on the Atlantic tide and fog.

We had a life there for a while and it let me dream of how life might continue with her, how we might build it together.

Then it was the Fourth of July. Rodgers and Hammerstein could have written a musical about this Fourth of July. O'Neill's *Ah, Wilderness!* could have been born in Hackett this Fourth of July. This day was a perfect illustration of our embryonic life, this newly born existence of ours.

We walked into town in time to get a prime spot for the little parade. A VFW drum and bugle corps and a high school marching band and a bunch of kids decked out like Revolutionary War soldiers and there was a contest for dressing up like the Statue of Liberty. There was a sea of green foam-rubber headpieces and orange Styrofoam torches and old sheets for robes and the littlest girl won first prize and everybody else got a prize, too.

There was a softball game over at the high school field and I got roped into pinch-hitting and damn near killed myself beating out a slow roller to third. Then I had to slide into second and got forced anyway and tore my pants. The crowd found this vastly amusing and cheered when I hobbled out to play left field and thank God, by some miracle, nobody hit one in my direction. I only had to play one inning. It was a lifetime.

When I came out, Caro had a hot dog waiting for me. She had mustard on her upper lip. She said I was nothing less than heroic but she had to laugh. We went to a lemonade stand where the stuff was made from honest-to-God lemons and

181

there were big chunks of freshly picked ice floating in the tub. Dogs were playing in the outfield while the guys chased the ball down. It was perfect. Just like a television commercial.

In the evening the churches all pooled resources for a big picnic in the town square, back in the middle of town, everything centering on a large statue of an old-time fisherman who was frozen in time leaning into the gale with his sou'wester blown back, furling around him, a Maine man for all seasons. The kids dressed like the Statue of Liberty wouldn't dream of taking off their pointed crowns so they carried on shrieking and jumping the way kids do and some glutton for punishment organized a three-legged race that petered out under the weight of its own sappy nostalgia. A barbershop quartet held forth from the back of a flatbed truck while a good part of the crowd got into the mood and sung along.

Caro smiled brightly up at me. "Frank Capra is alive and well and living in Hackett, Maine. It's almost eerie, isn't it, Charlie?"

"Like one of those old *Twilight Zone*s. 'Caro and Charlie have left the terror of the city behind and stumbled upon a nineteenth-century Fourth of July in a Maine village. Are they a uniquely lucky pair? Or have they just possibly entered the twilight zone?'"

"Stop. You're giving me shivers." She moved closer to me, squeezing my arm.

There was a big American flag hung from a rope stretched tight between a couple of old oaks and the stiff evening breeze straightened the other flag atop a pole next to the post office steps. Red, white, and blue lights were strung from the trees and drooped around the gingerbread roof of the bandstand. I'd lived a long time abroad and I was used to Guy Fawkes Day in London. I'd forgotten how the blood could stir for the Fourth of July.

When the fireworks started I was all gooseflesh, cheering and oohing and ahhing with all the little kids at each starburst of orange and white and blue and red. Caro beamed and clapped

182

and talked animatedly with some of the kids clustered on the grass in front of us. I slid my arm around her, drew her to me while the explosions went on overhead. She looked up at me with shining eyes. I kissed her hair. And when it was finally all over we took our time walking home.

TWO

I was caught up in, hypnotized by, the exhilaration of the day. I didn't want it to end. I suggested a walk along the shore in the bright moonlight. Caro was all for it.

We stood in the long grass at the edge of the sand. The wind was picking up. We could still see the occasional flare of a firework over the harbor. I could still smell the acrid smokiness that had hung over the square.

Caro said she needed a windbreaker to go over her sweater and ran up to the house. I watched her go, bare legs flashing in the moonlight, a dream of my own.

I sat down on one of the damp rocks and lit a pipe, shielding the match against the wind. I smoked and thought about Caro and the day itself and the world it symbolized. Why not live here, I wondered. I could have the house outfitted and made truly habitable for the entire year. I could write my books. I could be a member of the community. I could easily enough go to Boston and New York for research and entertainment. And I thought that maybe Caro would like the idea of sharing the life. If she didn't like the house we could certainly afford to build another one. We could travel. We could have children of our own and buy them Statue of Liberty outfits . . .

The night fog was rolling in, gray and clinging and damp. I must have lost track of time, hypnotized by the sight of the approaching fog, so soft yet so relentless, thick enough to cover all of one's sins. Finally it was all around me and I was alone, encapsulated, and I couldn't have found her in the fog if she

had come back. And she hadn't. I checked my watch. She'd been gone nearly half an hour.

I knocked the pipe's ashes onto the sand, smudged them around with my shoe, and climbed up off the beach to the slippery grass. Slowly, moving carefully so as not to trip over a rake or fall into a flowerbed, I went back to the house.

I came across the porch, past the hanging pots of sturdy vines Caro had hung, let the screen door bang loudly behind me as I always did when I came home, and called her name.

The word bounced around, the way it would in an empty house.

The feel and smell of the fog had invaded the house, giving me a clammy feeling. I'd have to get a fire going.

"Caro?" I called again. "Honey? Where are you?"

I went toward the kitchen where the lights shone brightly through the doorway. It looked like an Edward Hopper, the cream-colored cabinets with glass knobs and glass-paned fronts, dishes gleaming behind them. A wedge of countertop. The old-time linoleum on the floor. One very still life.

I went to the kitchen doorway. Stopped.

She was standing by the sink, half-turned, staring back at me, her face smudged as if she'd been crying. Her mouth was open slightly as if she were trying to speak but couldn't quite get the words out.

My first thought was that she had taken another dive into her own private pool of despair and depression. She'd been able to avoid it for weeks but now—maybe the simple, unfettered happiness of the day's celebration had brought it on, the sorrow and unworthiness she felt in her guts. I didn't know where it came from. Maybe she'd been born with it.

"Hey," I said, "what's going on? I almost fell asleep out there . . ." I was trying to keep it light. I'm no shrink.

She shook her head at me, almost imperceptibly, stared at me almost as if she couldn't blink, had forgotten how.

"Oh, Caro," I said, "are you okay? Everything's going to be all right . . ."

I went through the doorway, slipped on something, looked down. Buttons . . . I looked back at her, not getting the point, then realized she'd clasped her arms across her breasts to hold her blouse together. The windbreaker and sweater lay on the kitchen table. Suddenly she sobbed.

And then, too fast to react against it, I was in a powerful vise. I felt like someone was snapping me in half.

An arm like a crowbar came around my neck from behind, jerked me tight against the hard barrel of a man's chest, and I was hit by the overwhelming smell of cheap men's cologne mingled with sweat and liquor and cigar smoke, and my windpipe was closing, and I couldn't swallow and I was being dragged backward, downward, my legs buckling.

A Panama straw hat tipped forward, came forward over my own head and rolled toward the table, then onto the floor with an awful, endless slowness.

Somehow he'd found us.

My vision was blurring so quickly I was afraid I wouldn't last long enough for Caro to get away. She hadn't moved, hadn't wanted to leave me to him, stood staring at us as he throttled me. She was frozen like a rabbit in the headlights' glare.

I struggled to wave to her, urged her to run, but she didn't seem to see me. I twisted my head to the side, loosened his grip, making him grunt and exhale a cloud of liquor, heard my own voice croaking at her, *run, run, get out* . . .

He angrily yanked me harder. The blood supply to my brain was being cut off and quite abruptly my legs went rubbery and limp and I collapsed backward against him.

His breathing roared like a storm at sea in my ear. I heard a muffled blur of sounds, my own heart pounding, the blood pulsing in my head, a chair clattering to the linoleum, her feet running, the screen door banging . . .

I smelled his bay rum, I felt the hair on his arms scraping my

throat, I couldn't breathe anymore, I felt myself being twisted and thrown, felt the floor flying up to hit my face, felt my nose collapse and blood fill my mouth and his knee driving into my back and then things began to crack inside me, bones or my lungs exploding like blown-up paper bags, whatever, it was some very deep shit, like cracking a chicken open . . . and then I knew I was going to die . . .

PART THREE

Chapter Eighteen

ONE

They found me curled in a ball under the kitchen table.

I don't remember how I got there. I don't remember the beating beyond the point when the chair went over and I heard Caro running, the slam of the screen door . . . I don't remember when he stopped and disappeared into the night.

I remember the final damage assessment because I had to live with it for a while. I had three broken ribs with the boot lacerations to match. One of my eardrums was broken: he must have done a Buddy Rich solo on my head but I don't remember that. My nose was broken and I sure as hell remember that. Christ. A close encounter of the linoleum kind. I had a severe concussion but, miraculously, no skull fracture. Something bad happened to my throat and windpipe and I could barely whisper for a couple of days. A few blood vessels had burst in my eyes which was mainly unpleasant for people who had to look at me. My kidneys had been punted into the middle of next week and I pissed blood for a week.

But I'm getting ahead of myself. I didn't know anything about what was left of me after Varada had finished when Caro got back with the on-duty cop. She'd run all the way to town and come back in the patrol car with the only ambulance in the vicinity coming along right behind. The doctor arrived in his own car. Quite a little parade. I'm sorry I missed it. And it was nothing compared to the spectacle of the ambulance ride to Boston, red light flashing and driving like a bat out of hell. I was awake for much of that part of the night and I remember hearing the Hackett doctor in his down-east nasal twang saying that he didn't see the point in keeping me there with God only knew what internal injuries and possible cranial "irregularities." Well, that was sure as hell reassuring. I fainted. When I woke up I was in the ambulance, looking up into the eyes of Caro Saberdene.

I remember the odd quality of light in the ambulance, thinking it was like being a battlefield casualty in *M*A*S*H*. There was a nurse the doctor had presumably routed out of bed and Caro and, following the ambulance, the doctor who wanted to deliver me and get a signed receipt.

Caro held my hand, bent over me to kiss my cheek and tell me I was a hero even if I did get the living daylights kicked out of me. I was alert enough and coherent enough to want to know just what had happened. It took some high-powered babbling to get it out of her but I finally said that if I was going to die I had the right to know the story. I didn't realized then how hard the story was for her to tell: I was too wrapped up in my own pain to worry about hers. It turned out to be as ugly a tale as you could imagine.

Varada had been waiting for us when she went back to get her sweater. She had no idea how he'd found us but he'd been awfully pleased with himself. He amused himself by slapping her around, knocked her down, then held her there while he explained some of the realities of her situation. If she didn't

190

give him the best time of his life right then and there he was going to rearrange everything about her in the slowest way known to man and then he was going to kill me while she lay there unable to do anything but watch. He forced her to stretch out on the kitchen table. Then he'd had her and while she whispered the story to me her voice remained rock hard and steady, the tears running down her face and dripping onto mine.

"He didn't give me a chance," she said. "He'd have killed you for sure, probably me, too. And if you'd come back while he was doing it to me he'd have killed you then . . . I got it over as soon as I could, then I begged him to leave. But he said he wasn't through with me . . . he told me he was going to stay near town, he'd call on me regularly and I'd better make him happy or he'd kill you, Charlie . . . then you came in, I'd gotten my clothing straightened as best I could, I'm stinking of him now, he wasn't drunk but he'd had a lot to drink, and he was telling me what else he was going to do to me . . . then you came in and I didn't know what to do, I tried to yell at you but I knew you wouldn't have run away . . . oh, Charlie, I didn't know what to do, he was so brutal, so cruel, everything about him is cruel . . . and I thought he was going to kill you, then you told me to run and I realized . . . that if I did run away he might think twice about staying there too long, he might stop working on you in case I found someone right away . . . and I guess that's what did happen . . . there wasn't a trace of him when we got back to the house . . . Oh, Charlie, he's not quite human, I told the cops he was a stranger, I said it was dark and, oh, I don't know, I kept remembering how Victor didn't want to identify him and I thought that if I told about him now, then everything would be opened up again and I didn't know what all would happen, so I lied . . . oh, Charlie, when will it come to an end?"

And she squeezed my hand and sat on the floor of the

ambulance with her face next to mine, brushing her lips against my cheek, not wanting to hurt me. In her own awful agony she didn't forget mine.

TWO

The doctor from Hackett was an old Harvard Medical School man with plenty of connections at Peter Bent Brigham Hospital, which was, in some way that I never quite straightened out, allied with Harvard. Anyway that was where I wound up that first night and where I remained for almost three weeks, doubtless as a perfect teaching example of one hell of a whipping.

Eventually my eyes got resynchronized and the headache receded to the bearable and the broken ribs didn't puncture the lung and only hurt when I tried to do something drastic like breathing. It would have been unendurable if it hadn't been for Caro, who came every day and tried to pretend that she wasn't being torn to pieces by fear and worry. She was falling back on her acting background: I could see it this time. She didn't have the resources of determination that had gotten her through Varada stalking her in New York and the shooting of Victor. She'd overdrawn that account. At first I thought it had to be the rape. But I was underestimating her. She had the kind of steely, sinewy resolve, the hardheadedness that made her see the violation of her person as a vicious crime of violence, not the destruction of her soul. Not something that had soiled her inner self. But something that could and did happen to unfortunate women every day, everywhere. No, it wasn't the rape.

What cut the heart out of Caro was the destruction of our dream. She no longer saw herself as a survivor and, while I don't want to sound any sappier than I normally do, I swear I saw what I can only describe as the light—it *was* a light, a

positive glow—go out of her eyes. Her fears that she didn't deserve happiness, didn't deserve the fulfillment we'd found in each other up in Maine. Night after night, once she'd left my bedside, the thoughts that ganged up on me as I tried to fall asleep were not of the encounter with Varada that had put me in the hospital. They weren't even of finding her on the rain-beaten porch with the shotgun, which I'd subsequently dreamed she was going to use on herself, not on me. No . . . what I couldn't get out of my mind was the night she told me it wouldn't last, that she didn't deserve to be happy. It made no sense to me. But she believed it and that was what mattered.

After a week of staying near the hospital in a motel, she took to spending the nights back in Earl's Bridge with her father and his nurse. In her fragile state of mind I had doubts about that particular venue as a source for bucking her up but I wasn't really consulted. She felt her place was as much with her father as with me. Who could blame her for that?

Her father was still weak but daily exercise and therapy was at the core of his recovery and as he put it, he didn't seem to have anything better to do. She said he looked rather hellish and walked with a cane but, thank God, he was alive.

She sat beside my bed and put down the John O'Hara novel, *Ourselves to Know*, she'd been reading to me, and stared out the window at the steaming streets beyond. "He's just waiting, you know," she said at last. "He's just waiting to die. He doesn't see his friends anymore. All the people he loved are dead . . . so he's got his nurse and me, that's all. And he sits there tying flies he'll never use, nobody will ever use . . . and he waits. Sometimes he and I sit there for two hours and we never say a word, Charlie. It makes me feel like I'm waiting to die, too." She shook her head, flicking the honey-brown mane, clearing the troublesome thought away. "He'll die soon. And then I'll be alone. God, how I hate that idea . . ."

"You'll never be alone," I said, "as long as I'm alive. I love you, Caro, and nothing can change that. Nothing. Not ever."

She bit her lip, sat still. "It's not going to work, Charlie. I'm such a mess, such a nightmare. I try to fix it but it never lasts. I think it's getting better but—it never does. There's always the nightmare at the end. Maybe—I don't know, maybe there are women who are just like that." She smiled at me. There was something like pity—or was it resignation?—in her eyes. "You may not see it yet, Charlie, but I'm used to it, I can see it beginning in the way you look at me. I've seen it in my father's eyes, and in Victor's, and now I can see it beginning in you . . . you're beginning to see that I'm that sad, sorry burden that kept Victor from leaving me—"

"Are you sure you're not seeing just a reflection of what you fear the most? You're no burden, Caro—"

"Oh, that's a good try, Charlie. But you're ignoring all the facts of your life. Love makes people blind . . . but if I'm blind to the truth I'm going to get you killed. There's no way to protect me, no way to put a twenty-four-hour-a-day bodyguard on me for the rest of my life . . . Look, you must run for your life, that's what you've got to do. Your life was just fine until you got mixed up with me. But when I came into your life you betrayed your friend by falling in love with his wife, you found yourself in the middle of all this grisly horror with Varada, I killed Victor, and the happiness we found afterward ended with your almost getting killed . . . It's as if somebody's playing a record way too fast, life is speeding by too quickly to get hold of it, it's speeding past and death is waiting at the end and we're being robbed of what's supposed to come first . . .

"I drew you into this and it just won't stop. He found us in Maine, he'll find us anywhere . . ." She sighed and looked back at me. Through it all I'd never seen her resigned before. "Maybe Victor knew I meant death, yet he knew fate had singled him out to protect me from things, from the effect I seem to have, from myself, from what goes on in my head . . . from what happened to people who came close to me . . . Anna, Dad, Victor, you, that Abe fellow, the two bodyguards

194

who were supposed to protect us . . . even Varada himself, look what happened to him when he crossed my path . . . it's a bad, bad joke, Charlie."

"Caro, you've got every right and reason in the world to feel down and whipped but you can't go on this way, you've got to realize there's a way out . . . We're going to find it. Just give us the time."

"You don't really believe that," she said softly. "You're trying awfully hard to believe it but you can't quite do it. I can see it in your eyes, Charlie. Now you're looking at me in that same pitying way Victor did . . . the way the doctors did when I was in the hospital years ago, I heard them say in the hallway outside my room, 'It's too bad, she's such a pretty girl,' and my God, how that's haunted me through the years, wondering what did they mean . . . why was it *too bad*? . . . Well, maybe I've known all along, maybe I just didn't want to admit that there's something about me . . ."

I tried to talk her out of it but she was inconsolable, not in a weepy way, but as if she'd seen the truth and there was no longer any point in pretending it wasn't true. I told her that time might make her see things differently. How empty that looks to me now as I write it and how hopeless it must have sounded to her when I said it.

She grinned at me ruefully. "But what can we do about Varada? He's just one more psychotic out there, the woods are full of them, and there's no way to stop him. I've thought about the police but then it would all come alive again, Anna and the trial and my breakdown and on and on—they could try to find him, maybe they would find him but they'd never be able to prove he killed Braverman and beat up Claverly and Potter. My God, Victor's the one who sent them to mug him! So even if he had no alibi, all he was doing was defending himself against my husband's thugs . . . and if I said he raped me and tried to kill you, he'd have been somewhere else and he'd say what has this crazy broad got against me? First she pins a false murder rap on

me, now she's having another shot—you thought she was crazy then, you should hear her now! Well, Charlie, that's just about where it stands, isn't it?"

"I don't know," I said. "How can he be so impregnable?" My head was throbbing. I couldn't think.

"There's nothing we can do," she said. "Except wait for him to come again. Then . . ." She shrugged. "You've had enough of me for a while. I'm going out and help take care of Dad for a few weeks. God help him." She smiled, turning the corners of her mouth down. Then she kissed me and left.

THREE

The next day I had Alec Maguire stop by the hospital. He came in, did a double take when he saw me, and asked what in the world had happened to me. I said one word: *Varada*. Then he gave me a sideways look, made an O with his mouth, and slipped his heavy spectacles off. He plucked the crimson square from his blazer pocket and began polishing the lenses. I gave him the whole story. His gentle smile drifted away and was replaced with a look of grim distaste. He put his glasses back on, the large red stone in the class ring twinkling in the morning sunlight flowing through the window behind him.

"Well, I will definitely be a monkey's uncle," he said when I'd finished. "This is the same guy I saw putting flowers on the girl's grave . . . y'know something, Nichols, the more I learn about my fellow bipeds the more I realize that the human psyche is one very unpredictable, very treacherous swamp. Talk to me about this guy. Victor never really told me much about him. So far as I know, he's a rapist, he's capable of vicious assault, and he's not a killer. And I've seen him chatting with Caro Saberdene in a couple of restaurants . . . now, what's the rest of the story?"

I told him the whole thing. "In the first place, be warned, my

196

friend," I said, "he *is* a murderer." It took a while to run through the Varada dossier.

"I've got a job for you," I said. "And you need the whole story before you take it on. Now you've got it."

"And now you'd better tell me what you've got for me to do."

"I'm very worried about Caro."

"I'm with you so far." He was looking out the window. His shoulders were beefier than I'd realized and he must have had an eighteen-inch neck.

"I'm afraid Varada will appear out of nowhere. That seems to be his M.O. I realize there's only so much you can do but whatever that is, I want you to do it. Stay close to her. She's going to be staying with her father but I don't know for how long."

"Back to that pretty little town," Maguire mused, stroking his tight curly hair as if to check that it was still there.

"Protect her from Varada," I said.

"I think we'd better go into a few of the particulars," he said. He sounded worried, which was just how I wanted him to sound. He had to realize what he was getting into.

197

Chapter Nineteen

ONE

Without Caro coming to spend hours at my bedside every day the waiting for my injuries to heal seemed endless. I watched some Red Sox games on television, did some cursory reading, and shot the breeze with the doctors and nurses. It was impossible: I was helpless, waiting for Varada to lash out at us again. At her. I could walk around and the pain was a little less agonizing as the days passed. I was still short of breath, the one ear was pretty well shot to hell, they kept X-raying my kidneys and my spinal column, which had been slightly rearranged by Varada's knee and boot. It was up to me, the doctors told me, if I wanted an operation on a disk. I said I'd wait to see if it got better on its own. They nodded sagely but said it was more likely to get worse. But I could always have the surgery later. They consulted me about the ear. It went on forever.

Caro called me most days. She didn't sound like herself. She didn't seem to have much to say and none of it was about the future, about us. Her voice was uncharacteristically lifeless, no

matter how hard she seemed to try. She sounded as if she had been magically trapped in a state of suspended animation. More than anything else she sounded like someone stranded in a waiting room with no place to go, no means of getting there. I heard it all in her voice and I recognized it because I heard it in my own.

There were also daily calls from Alec Maguire. Everything he said confirmed the impression I was getting from her. Nothing was happening. She sunned in a lawn chair, she took walks around the lawn with her father, she would walk the shady streets to do errands, she visited the cemetery once, a couple of times she went to the picturesque Earl's Bridge Inn for lunch by herself. One night she went to a movie. She didn't go near the theater where she'd once acted, where everything bad had begun to happen. It was a very reserved Massachusetts village, in the heart of the Berkshires, and no one paid much attention to her coming home. People tended to mind their own business.

"You're running up a pretty good-sized tab," Maguire said. "And I'm not doing anything brave, y'know?"

"Don't worry about that," I said.

"I'm not worried. I just hate to see you wasting money. I'm a frugal New Englander."

"If Varada shows up, you'll earn a whole lot real quick," I said. "You'll think you're the most underpaid man in the world."

"I hear you. Well, the son of a gun hasn't shown up yet. I find myself hoping like hell he doesn't."

"You're armed to the teeth? I hope—"

"Everything but heat-seeking missiles."

"Stay in touch," I said.

"Never fear."

About a week after Maguire must have been thinking I'd decided to support him for life, things began to happen.

He called me from Logan Airport in Boston.

199

"Well, Charlie, she's making a move. I'm out at the airport. She's picked up a ticket, one way to Los Angeles. First class. What now?"

"Any Varada sightings?"

"Nary a one. The man seems to be a bad memory."

"Let's hope so. I want you to go to Los Angeles."

"Can do."

"Alec, I figure it this way. If you can keep track of her, Varada can keep track of her. Don't lose her."

"Rest easy. I'll report in when she comes to rest somewhere. How are you feeling?"

"Better."

"Remember, each deep breath is a guinea in the bank of health."

"I'm coming out any day now."

"I'll call you tonight, Charlie. She's got to sleep somewhere."

"Let vigilance be your watchword."

He laughed at my feeling the need to say so and hung up chortling over my popping for the first-class fare.

TWO

The letter from Caro came in the next day's mail.

I picked it up, didn't open it for a moment. Just stood by the window of the hospital room, ready to leave at last, hefted the letter as if I could divine the contents. Her father's notepaper. Heavy, creamy paper.

I already knew what it had to tell me. I like to think I'm no male chauvinist. I like to think I'm a great respecter of women. I am, in fact. But each sex has its own idiosyncrasies and I'd been expecting the letter for some time.

It was simply inevitable.

So I finally went through the formality of opening it.

200

My darling Charlie,

As I write this I miss you so, more than I can possibly explain. You cannot imagine how daunting it is, writing to a writer. And already it seems that I'm starting out all in a muddle, as my grandmother used to say. She would tell me I was the most muddled girl she'd ever seen. How pleased she'd be to know that she was so right and that I at last realize it. Oh God—how did I get started on my grandmother?

Look, Charlie, this is the point. I'm leaving. For good, I mean.

I didn't know if I could write that but now I have and my hand is shaking. What a mess I am!

It comes down to this and don't argue with me, even if I'm not there.

If I stay with you, Charlie, you must know that he will surely kill you. You are innocent and brave and foolish. And in love. Can I say that? I think I can. You fell in love with me out of goodness and kindness, without knowing what I seem to bear within me like some horrible virus—the virus of sorrow and depression and loss. I try to hide it, sometimes I even convince myself that everything is all right, that I've made it to the sunny uplands. But until I met you I never actually climbed that last shadowy ridge and found myself safe on that sunny, happy place. For a month this summer between two unspeakably awful events, I found more happiness than I'd ever known. It ended with something too close to another death. Yours.

Victor used to talk about the variations people's lives went through, each life repeating again and again variations on a single theme borne almost genetically within them. My theme seems to be death and sorrow, things so awful I can't bear to describe them tho' I am willing you to understand them. My sister, my husband, very nearly you . . . and what I did to that man in the courtroom so long ago was akin to a murder of his soul, was it not?

201

Now I know I can save you by leaving you. I beg you to put
me out of your mind. Go back to London. Don't completely
forget our love but please, I beg you, forget

Caro Saberdene

THREE

It was one of those letters of renunciation that women so
often seem to think somehow provides an answer and simulta-
neously ennobles them. I'm not knocking women, just observ-
ing them, something I've done quite a lot. And I was moved by
her letter, too. She wrote a pretty fine letter. But I couldn't see
her plan as a solution to anything. Even if I packed my bags and
went home to London, to cry in my warm beer and turn our
story into one of those sad, violent, thoughtful novels—even if I
bailed out, how was that going to solve her problems? I wasn't
going to take Varada with me, was I? So what was she supposed
to do when he came charging out of the night with a gleam in
his eye? It didn't look to me as if she'd addressed that little
problem. But, then, I've never claimed to know what really goes
on in a woman's mind; if I'd known right then what she was
thinking, nothing on earth could have made me believe it.

Of course I wasn't setting any records as a planner myself.
Until the time she left for Los Angeles and I got her letter, I
can't see that I had any plan at all. I just kept punting and
hoping somebody would fumble; I just kept thinking that the
situation would somehow cure itself. I wonder now what the
hell was the matter with me, but the answer is an obvious one:
I'd never been caught in the middle of a psychopath's deter-
mined attempts to dismantle the lives of a bunch of people.
Who would know what to do? Victor had thought he knew and
had wound up all over a flagstone patio. Abe Braverman
thought he knew. Claverly and Potter didn't have a doubt. Me?
I'd just wanted to hide and at least nobody actually got killed.

202

Now Caro looked as if she'd decided on damage control: reduce the size of the target and make herself a human sacrifice while I ran to safety. Her plan was foolproof, I suppose. I'd be safe. She'd get raped until Varada was tired of the sport and then he'd kill her. Not a great plan.

My plan was pretty embryonic but I had a goal. An abstraction.

I was going to put an end to the Saberdene variations. That would put PAID to all of it. Alec Maguire was the first part of the plan.

He called from Los Angeles. Caro had checked into the Beverly Wilshire Hotel. He got a room, too, by calling on the good offices of the hotel security chief, who was an old pal from Vietnam days. She had rented a car at Alamo, driven directly to the hotel, checked in, ordered dinner from room service, and stayed inside ever since. Maguire figured she was just plain exhausted.

"Just remember one thing," I said. "You're protecting her from Varada. More than anything else, keep an eye out for him. Don't let him get near her. Alec?"

"Yes, massa?"

"No matter what."

"I grasped that point long ago, Charlie."

The next time my telephone rang it was Andy Thorne. He wanted me to come see him in Earl's Bridge as soon as I could get out of the hospital. He sounded weakish but very insistent.

I told him I'd be there the next day.

Chapter Twenty

By the time I'd finished the paperwork of the hospital discharge and rented a car, it was past noon and as hot as high August was bound to be in Boston. I was a little shaky on my feet once I was outdoors and the sun and heat came down on me like a very heavy hammer on a tenpenny nail. The air-conditioning in the Chrysler eased my queasiness, dried the sweat lathering my face. I told myself I was just getting my sea legs back. I drove west as the sun passed its zenith, heading into the velvety greenery of the rolling Berkshires, glimpsing the occasional white steeple of a church like a beacon, the soul of New England, a finger pointing the way to heaven.

I got to Earl's Bridge, a few miles to the south off the Mass Turnpike with its pilgrim-hat road signs, about three o'clock. They could have used the town as an archetypal symbol, close to Tanglewood, within striking distance of Jacob's Pillow and the Norman Rockwell Museum and all the perfect little summer theaters. I thought of Caro there as a girl, what a wonderful world in which to grow up.

It was all sun-dappled lawns and sugar maples and elms and oaks and willows with uneven narrow sidewalks and white

picket fences and bright flowerbeds and sprinklers wafting trails of water across the rich, almost edible-looking lawns, dogs barking at kids on bikes, summer tourists in seersucker jackets and bow ties, busy gift shops, the big lazy white hotel with a porch running its length with swings hung on chains and potted palms and Adirondack chairs with dowagers in them.

Thorne's house was a two-story job with white siding and green shutters and rosebushes and begonias and daisies and violets and a sidewalk made of stone islands wavering from the sidewalk to the front door, deep in the grass. The lawn was neatly mowed and carefully clipped. The standard-issue sprinkler wetted down the shady greenness. The trees looked a thousand years old. Andy Hardy or Ozzie and Harriet or Ward, June, Wally, and the Beaver would have felt right at home. It was a house where it was always good-humored inside and maybe it had truly been that way once, a long time ago in another world altogether, and maybe it would be again when there were no more Thornes, when the house had passed on, as houses do, to someone else, another family with kids and dogs and bikes on the lawn and a hopeful future. You could bet things wouldn't turn out quite right for them either, because things never do, but there was always that hopeful future. A future was what the household lacked now. A future and maybe that happy past that never was.

The woman who acted as Thorne's nurse/companion/therapist came to the door expecting me and led me through the quiet dark, immaculate house and out the back door to the lawn where Andy Thorne sat in one of the ubiquitous white slatted Adirondack chairs. He was in the shade with a pitcher of lemonade and a couple of glasses on a table beside the chair. He looked thin and wasted. His bare arms were skeletal. His skin was pale and the Foster Grants with the extra-dark lenses were too big for his face. His hair was thinner, still snow white, like moss clinging to the skull showing beneath the slightly stretched skin like a death's head. His eyes were bright and

205

alert, still. They moved quickly, taking me in, and one of the thin arms rose in greeting. In person he sounded stronger than he looked. Maybe he just needed to get some weight back. I hoped so.

"I know, I know," he said sharply, "I look like what you find when you unwrap the mummy, but the amazing thing is I'm not represented by a fistful of wilted daisies and a headstone. And what else is amazing, laddie, is that I can talk, I know my own name and I seem continually to amaze one and all, including the moronic sawbones, by telling them, yes, yes, I know who is president of these United States. Warren Gamaliel Harding of Ohio. Come, get out of the sun. Take off your jacket. Have a lemonade. Tell me how you're feeling. I've been led to believe that you got off easier than most who duke it out with our chum Varada."

"We didn't actually duke it out, Andy," I said. I draped my coat over the back of one of the chairs, sat down, heard myself sighing with the twinges I was going to have for a long time. "He did all the duking, you might say. He was well along the road to killing me when Caro ran for help, at which time he decided he couldn't take the time to finish the job. Caro saved my life . . . he'd been pretty rough with her." I didn't see the point of going into it. Maybe she'd spared him the details.

"So she told me." In the quiet of the backyard the sounds of a perplexed bird and a dog barking down the street seemed strangely mechanical. There was the constant hum of busy insects. "But—and you may not have learned this yet, laddie—you can't always be absolutely sure about what Caro tells you."

"Now, Professor—"

"Just hear me out, I merely want to have a word with you before I clutch my chest and topple off the parapet. I'm not looking for an argument." He smiled at me as if asking me to humor him. "Doctors tell me I'm not supposed to get worked up. Nursie will come out and break you in half if either of us misbehaves."

206

"She wouldn't find me much of a challenge," I said.

"All I'm saying about Caro is that . . . let's say she gets confused sometimes."

"I've never noticed that," I said.

"Tell me, did you ever ask her about the accusations that Barber woman made? And those pictures of Caro with Varada? Seems to me that that was about the time I had my little collapse in the hospital." He nodded toward the table. "Will you top up my lemonade, laddie?"

I ran through Caro's explanations for him while we worked on the lemonade and he listened quietly, nodding from time to time during the recitation. When I was done we sat slowly sweating, smelling the summer, hearing the bees. The grass had been mown lately, releasing the essential scent.

"Do you recall my telling you that we were never very close, Caro and me?"

I nodded.

"Well, if you wouldn't mind listening to an old man who is suddenly wondering how much time—in days and weeks, mind you—how much time he has left, I'd appreciate your letting me go on unburdening myself a bit. Now, let's see . . . you love my daughter, is that still an operative assumption?"

I nodded again.

"She told me you two had a wonderful, idyllic time up there in Maine. I'm glad you gave her that. Caro hasn't had many wonderful times in her life. Things never seemed to work out the way she hoped. She was never carefree, poor Caro . . . not like other girls. Not like her sister, Anna, for instance. And since you love Caro, I thought I ought to talk with you again, and that, I'm afraid, brings us back to Carl Varada."

I watched the flowers bend under the weight of the occasional bee. The summer afternoon was going slowly bad, like fruit left to rot in the tall grass.

"You see, Charlie, there's something only I know. I've never

207

told a living soul, not even Caro, because it seemed to me that there was no need. Well, I was kidding myself then and I've been kidding myself ever since. Why? Because I love Caro, too, whatever she does or is, whatever she may think. But I'm near the end now and Varada's back and you have wandered into the picture . . . and I'm tired of hoarding my little secret. One burden I really don't want to carry into the sweet hereafter. It's a load of mischief, Charlie. You're the only person I can tell. Are you a willing listener?"

"I'll listen," I said. Willingness didn't really enter into it.

"It goes back to the time of the trial, even before the trial, really. Varada's trial, I mean, of course. Seems like yesterday and it seems a thousand years ago. You see at the heart of the case against Varada, the first cause, was the assumption, the *fact*, that Varada had been having an affair with my daughter Anna. There was only one real problem with that—it just wasn't true. Varada was not having an affair with Anna."

"Wait a minute," I said. "If he wasn't . . . I mean, Andy, you're entitled to defend your daughter's honor, I don't blame you—but, well, hell . . ."

"Just listen to me, laddie. I'm telling you a story. Pretend you're researching one of your books. Hear me out." He wet his lips with lemonade, lowered the glass with a trembling hand. Then he dropped his hand back into his lap. "Varada did indeed *know* Anna. He worked around the theater and she appealed to him. You might say that he had what we used to call a crush on her. She was a bright, pretty girl and whatever you might think about Varada he's a bright fella.

"But what never came out in the trial was the simple fact that Varada was in love with somebody else! Aha, the plot thickens, Charlie. He was having one high-powered affair with another woman who was keeping him hopping. Somebody else altogether . . . but oddly enough there was a joker in the deck—God forgive me the cliché of a man of great antiquity.

208

And the joker confused the whole business . . . this other woman bore a certain superficial resemblance to Anna. As fate would have it.

"Now, this other woman and Varada did quite a bit of sneaking around because he wasn't someone she was exactly proud of. He didn't quite fit in with her view of herself, her family—this was not a guy to bring home to Daddy. His appeal was not something she could easily explain. So they saw each other in the dark of night, in out-of-the-way places, in lovers' lanes, in the park, even in the cemetery, which once had quite a reputation along these lines. If anyone ever saw them together, in a dark bar or in a car going by . . . well, it was Anna who was killed and Varada had unquestionably been seen making up to her with considerable enthusiasm and then been seen setting off down that lonely path with her and then she was found murdered with his skin under her fingernails—well, it was perfectly obvious that he'd killed her. It was like reading a road map, that was Victor's expression at the time.

"Please let me finish this, laddie. While everyone was thinking the killing was the violent conclusion to a lovers' quarrel, the truth lay elsewhere. It was Anna who led Varada down that path that night because she wanted to talk to him about the other woman, the one he was really having an affair with. You see, Anna knew this woman and she believed that Varada was ruining this woman's life, had created in this woman a sexual obsession the woman couldn't break away from . . . in the event, I can only assume Varada decided to make a pass at Anna and she scratched his face and he figured oh hell, this is more damn trouble than it's worth, and left . . . and the poor fool who killed her had followed them, probably for a voyeuristic thrill which got off the rails when he found her alone . . ."
He stopped, exhausted, brushed his hand across his forehead, and slowly lifted the glass to his lips once more.

"All right, that works for me," I said, not quite seeing the

209

point. "The trial turned to a large extent on the fact that Caro saw Anna go down the path with Varada. Given the evidence, the scratches on his face and the skin under her fingernails, anyone—including the jury—drew the conclusion that he'd killed her while they struggled. Caro could hardly have done otherwise. It all made perfect sense—"

"Not exactly," Thorne said softly. "Caro knew about this other woman, too, the woman Varada was really in love with, the woman who simply couldn't resist him. And Caro knew that this woman was perfectly well aware that Varada was a tremendous, terrible mistake . . . but this woman simply didn't know how to get away from him, she was addicted. And then Anna went down that path with Varada . . . and never came back . . . that was the way to get free of the hold he had on her—"

"You mean this other woman saw him take her down that path? Or Caro saw a way to help this other woman get free of Varada? Just what the hell are you trying to say? What's the punch line?"

"Oh, Charlie, watch my lips. Caro . . . was . . . the other woman." Listening to him I felt like my head was being held down on the block by a hooded figure with a big axe. "Caro was the one Varada loved, the one who couldn't break free . . ."

"How could you know that? Caro told you?" My voice was coming to me from far away.

"Anna told me. It was tearing her apart, she told me on the last day of her life. But that wasn't all I knew—just hearsay. No. I'll never forget that day. Anna told me about Caro and Varada, told me that she was going to tell Varada to leave Caro alone or she'd—well, what she intended to threaten him with I cannot imagine. Anna was perhaps the gentlest creature I have ever known. As their father I was baffled and worried . . . so I did that evening what I have done so often in my life. I went to the cemetery to seek the wise counsel of my late wife." He cleared his throat. "Ah, let me see. Anna told me what she was going to

210

do. And then she was killed and there was Caro all of a sudden—and she'd seen them go off together. Caro knew Varada, she knew the kind of man he was and she knew she couldn't resist the hold he had on her. Some women have that weakness, Charlie, just the way men do. I'm sure she hated him, was disgusted by herself, but she was powerless . . . then fate thrust into her hands the means to rid herself of him. Her sister was murdered and, by God, Varada looked like the murderer—"

"I don't feel so good, Andy. I don't like thinking about this stuff."

"No, I don't suppose you do," he said.

"But why is Varada stalking her like this? What's the point? She was wrong but my God hers wasn't the only evidence against him. Those scratches, other people saw them together—" I just let it trail off there.

"True, there was other evidence. But the most important evidence was suppressed. The last time I saw them together, Caro and Varada, was that night in the cemetery. I was talking to Mary, my late wife, and of course I had no idea that Anna already lay dead. I was standing in the cover of a huge willow near Mary's grave . . . I heard someone coming, two people talking, and I saw them, Caro and Varada, and he was telling her that her sister Anna was a little firecracker but he thought he could really get to like her—he was teasing Caro and she was saying that he'd better stay away from her if he knew what was good for him—look, Charlie, he hadn't just killed anyone, I knew that at the time of the trial and Caro knew it . . . but, when the time came to testify, Caro knew she could have told the truth and very probably have saved him . . . but instead she did all she could to put him away forever. And I said nothing. You know, Charlie, I think he loved her too much to bring her into his defense at the trial—maybe he's just that kind of crazy, arrogant son of a bitch, I don't know. But he didn't say a word. So he went to prison and that was that."

211

I said: "*Folie à deux*. That's all there is to say."

"I've always thought that Caro's breakdown after the trial had more to do with knowing she'd sent him, an innocent man, to prison when she could have saved him—more that than the fact of Anna's murder. But she wanted to free herself of him and didn't care how she did it. So the guilt that's been eating at her ever since came to a head when he was released from prison. And Varada, you can pretty well imagine what he figured she owed him . . . and now he'd come back to collect. Say he truly loved her. Let's say he still loves her. Wants her, have it any way you want it. So he comes back to collect. Only the lady didn't wait for him—is that the thanks he gets for keeping her out of their mess? She's married. Then suddenly the husband is dead. But does he get her then? No! She seems to have found herself a new boyfriend! You, laddie, Charlie Nichols. And now our Mr. Varada is very, very angry . . . and what are you going to do about it, Charlie? How are you going to save her now that Victor's gone?"

We sat silently watching the shadows of the tall poplars creep across the lawn toward us. The nurse, a large square woman with gray braids, started toward us from the house. Andy noticed her, came to life, and waved her away. She stopped, made a show of looking at her watch, and retreated. "My own opinion," he observed, "is that she missed her real opportunity when concentration camps went out of style after Hitler's war." He shook his head, watching her go back into the house. He cocked an eye at me. "Sorry if I've upset you, Charlie. But I couldn't leave it unsaid. It was about time, wasn't it? I've disgraced myself enough by sitting on it too long. I don't even ask you to understand. I simply don't care anymore. The guilt if I'd gone against Caro, if I'd helped free this man who was consuming her—well, that would have been worse."

"Look," I said, trying to keep myself pulled together, "everything you say could possibly be true. It certainly is true

212

for you, the way you see it. As you can imagine, I'm not exactly overjoyed at the idea of the woman I love being the subject—I hate it. I hate all of it. I hate the thought of her with that subhuman. I hate the thought that she ever enjoyed being with him. I hate it if she knowingly sent a innocent man to prison—if you can call him innocent by any possible stretch of the imagination. But it isn't really a question of how I'm going to save her. She's the one last seen saving me. And now she's gone away without telling me where for precisely that reason—to get me the hell out of harm's way. She's not the villain, Andy—"

"Oh, I never said she was," he said softly, sadly. "I know better than anyone else, Charlie. She's the victim in the end, as if it's written in the stars. Her role . . . it's locked inside her, always has been, and there's never been anyone with the key to the lock."

"Me," I said. "Never been anyone 'til me."

"You love her but—"

"I love her, period. No buts—"

"But . . . I wonder, do you love her as much as Varada does?"

"Do you mean, would I run the risk of dying for her?"

"Oh no, Charlie. You're already doing that."

"Well, what then?"

"I was thinking, would you be willing to kill for her? That seems to be the acid test. Victor was. Varada is . . . she seems to affect men that way, my daughter does."

"Maybe I'll be able to answer that question once I've found her."

"You're going in search of her?"

"What a question," I said.

"Let her go, Charlie. Leave her to come back in her own good time. Or just leave her to heaven. But you've got to save yourself . . . The *folie à deux* doesn't include you."

"She's alone. She's running for her life. She needs me.

213

Whether she wants me with her or not. And we've established the only fact that matters. Caro and I love each other. We'll come through it all right. I'm going to save your daughter. Bank on it, Andy."

Chapter Twenty-one

ONE

Andy Thorne insisted I stay the night but the exertion of our long conversation had put him to bed right after an early dinner. By the time I left, my brains felt pretty well scrambled. However he had felt by dinnertime, I'm sure I couldn't have taken another session.

I went for a walk at sunset, moving slowly through the quiet residential streets, noticing my surroundings on one level but not really paying any attention. I passed that cemetery which kept popping up in Caro's story, then I stopped and went back, went through the low open gates. It was a plain, tranquil, exquisitely restful place and I strolled among the headstones, tried to imagine Caro keeping a rendezvous with Varada in such a place the night Anna was killed. I tried but it had happened almost a decade ago and I couldn't do it. If Andy had seen her there with Varada, then he had. Then she must have been an entirely different person, someone I would never know. I'd never know what I'd have made of her back then: maybe she wouldn't have appealed to me in the least.

But that was a long time ago and people kept changing on you. My wife at the time—the woman who took that shot at me with the mistaken assumption, apparently, that I was a uniquely peculiar grouse—would quite possibly find little in the Charlie Nichols of today to remind her of that unsatisfactory spouse. Victor had changed a good deal over the years. Caro must have. And from the sound of Andy Thorne's story, Varada had changed as well. For the worse.

Which, I wondered, was the real Caro? Or was that an idiotic, irrelevant question? In describing his daughter, Thorne had never once remarked on any change in her—but would he have? He always spoke of her in the absolute: this is what she does, that is the way she behaves . . . But, of course, why not? It's the way people talk. I was thinking in circles, going nowhere.

My legs were giving out. I'd gone too far from the house. I was standing in front of the long veranda of the stately Earl's Bridge Inn so I climbed the steps and came to rest in the tavern. I sat at the bar and drank a mammoth Rob Roy, nursing it along slowly.

What had really been going on with Caro, Anna, and Varada?

If I were writing a book about the case I'd have talked to everybody in town. But now, dealing with my whole damn life, I couldn't take the time to do the research. Hell of a note.

It was quiet in the bar. Everyone had emptied out from both the dining room and the tavern. The barkeep, a white-haired party with the pink cheery face of an Irish priest, came my way drying a glass with a fresh white towel. How many times in the course of research had I played this scene?

"You're a summer people, am I right?" His blue eyes, pale as an arctic sky, twinkled at me.

"Not even that," I said. "Just here for the day."

"Business? Salesman, am I right?"

"Not quite."

216

He pondered that while he went on polishing. It was going to be a mighty dry glass.

"Quiet," I said, surveying the room.

"Keeps me sane. Everybody piles into the theater about now. Shakespeare fella must have had somethin'. Draws 'em like flies to a chop on the sill. And Tanglewood. Must be somethin' well-nigh magical about sittin' on the grass, half-eaten-alive by mosquitoes, listenin' to 'em sawing away. Never been there myself."

"Neither have I. Nope. I'm here visiting a friend."

"Is it a secret?" He snapped a quick pink smile at me.

"Andy Thorne," I said.

"Andy," he mused, nodding. "Fine man, the professor. I hear he's been taken badly of late. The stroke, that's what I hear."

I nodded. "He's coming along, though. Slow but sure. You know how it is."

"Andy and I used to fish together sometimes. Long time ago. Ten and twenty years ago. Then he stopped fishin'. About the time there was all that trouble. I always figured he just didn't want to talk about it and he knew we'd all be curious, thinkin' about it." He set the glass down on the bar like a trophy. "You know him a long time?"

"Not that long," I said. "You're talking about Anna, the murder—that trouble?"

"Bad business."

"I never knew Anna," I said. "I know the other daughter, though."

"Caro," he said.

"Right."

"Funny thing, you'd never have thought they were sisters at all. Nothing as funny as the way families turn out. Maybe that's why God never favored me and the missus with offspring. Sparin' us, He was. Andy used to tell me how much I was missin', used to say maybe I wasn't tryin' often enough. Good-natured. I wonder what he thinks about it now."

217

"I thought the girls resembled one another rather closely," I said.

"Physically, there I'd have to agree with you." He leaned forward on the shining bar. "Mind if I smoke?" He shook a Marlboro out of the pack and lit it, enjoying the taste. "But that was where the resemblance ended. Two very different kinds of girls."

"How?"

"Well, it was like this. Caro had this fancy streak, like what they used to call 'puttin' on airs.' That mean anything to you?"

"Sure."

"Goes with Caro being an actress, hangin' around in Boston, am I right? It's been my experience that your actress is your horse of another color, you follow me? I see 'em in here all summer long, drivin' the boys crazy and lovin' every minute of it. Caro Thorne was like that, damn fine-lookin', no doubt about that, but she was what they call hot . . . boys were on that girl's tail. I never had any particulars, none of my business, am I right?"

"And Anna?"

"Just the opposite." He tapped the ash into a white ceramic ashtray. "Never saw her in here in my life. Real quiet girl, serious, worked backstage over at the theater, used to be a Girl Scout, too . . . I wonder, do they still have Girl Scout cookies? The missus and I always bought those cookies from little Anna. Caro, she wasn't your cookie type, even as a little thing."

"I'd always heard that Caro was a solemn little girl, sort of withdrawn—"

"Just the type that starts feelin' her oats when she grows up, am I right? It's just human nature."

"Well, you may be right," I said. I finished my drink.

"That's what made it all so strange, I guess."

I looked up at him. "How's that?"

"Well, everybody said at the time that Varada character killed

218

Anna, that it wouldn't have been half so surprisin' if Caro'd been the one he killed. Just based on human nature, you follow me?"

I slid off the stool and felt the weariness swarm back, all over me. "Varada didn't kill her."

"You don't say," he said. "I thought sure as the devil—"

"Jury found him guilty."

"Now, that's what I thought—"

"But he didn't do it. Insurance man from Boston blew his brains out last spring. Left a confession."

"Damn! You don't say!"

"True story," I said.

"Pretty tough on Varada, am I right?"

"I guess so," I said. "Tough on everybody."

I wrestled with all the troublesome questions through a night that didn't have enough sleep in it.

What had really been going on with Varada, Caro, and Anna? I had that unmistakable feeling, familiar from every crime I'd ever researched and reconstructed. I was getting my first glimpse of the truth but it only hinted at its final dimensions.

Was Andy Thorne sure of what he'd seen and heard that night in the cemetery? And why hadn't he come forward if he'd believed an innocent man was going to prison? How good was his justification for keeping silent?

Or was Caro right about her father's lack of feeling for her? Did it run deeper than Thorne was willing to admit?

Had Caro really known that Varada was innocent of her sister's murder? Had Caro loved him or hated him? Or feared him? Or all of the above?

Had Caro been so utterly under Varada's spell?

I felt as if I were chained to a carousel. I couldn't stop it, I couldn't fight the cacophony, I couldn't think anymore. And I couldn't get the hell off.

219

TWO

Alec Maguire called me that night at Thorne's.

He was calling me from a place I'd never heard of, up in the mountains a couple of hours from Los Angeles. It was called Half Moon Lake.

Caro had driven there that day, gone directly to a comfortable lodge on the side of a pine-covered mountain overlooking the lake.

"My guess," he said, "is that it belongs to a friend of hers who's not using it at the moment. Or maybe she rented it by phone when she was in L.A. Anyway it's nice and quiet and peaceful. Gorgeous country, Charlie."

He said Caro was perfectly safe and quite alone. No sign of Varada. Maguire said he had checked into a motor lodge called the Bay View. He was planning to keep an eye on her, keep the lodge under as much surveillance as one man could manage.

I told him I was going back to the house in New York. Caro's house.

He said he'd check in with me there.

THREE

My God, it was strange being back in the brownstone, all by myself, in the house where it had all begun. The Filipino couple were off on holiday. The furniture had become a zoo of crouching figures hiding under drop cloths. Specks of fine dust in the sunlight when I pulled the drapes back. It was hot and stuffy. I got the air conditioners whirring and tried to settle in. But it was like landing on a verdant island, crawling off your raft, then discovering it was uninhabited. I rattled around,

bouncing off the ghosts, wondering when Caro would finally come home, wondering how long I'd wait. It was weird.

I couldn't even get involved in reading. Physically I was still in quite a lot of discomfort and my stamina was utterly shot. I kept falling asleep in Victor's big chair while a ball game was on television and waking up with no memory of the game.

All I could think about was Caro. And Varada.

Every day Maguire called with the same report.

Caro was leading a quiet, uncomplicated existence.

So where was Varada?

What was he waiting for?

I thought about Braverman and Claverly and Potter and I wondered about the morality of Victor's decision never to confide in the police. And I questioned Caro's decision to go along with it . . . and my own willingness to do it her way once she'd talked to me in the ambulance on the way to Boston.

The whole saga of Caro Thorne Saberdene was full of moral ambiguity. What ought she to have done when she'd become involved with Varada years ago? How could she have been so drawn to him in the first place? If, indeed, Andy had it right. Had Varada appealed to her because she feared she was sexually frigid? Was he a punishment she inflicted on herself? Why? From what neurotic source could so much self-loathing have come?

Should she have tried to clear Varada by telling the court she'd been with him after he left Anna that night? But maybe she knew how cold-blooded he could be, maybe she believed he had murdered Anna and was still able to keep his date with her later . . . Maybe she knew the kind of man he was and knew she had to put him away and maybe she also knew it was the only way to get free of him, to break her addiction, whether or not he'd killed her sister . . .

Had she lived for all these years with the knowledge that she'd sent him to prison simply to rid herself of the obsession? But what about Varada, what must have made him tick? Never

mentioning her in his own defense: why had he been willing to go to prison rather than reveal their relationship? It just wouldn't hang together for me. The story was leaking. If it were one of my books, so carefully organized and well thought out, I'd have to find the plug to fill that leak. But when I was writing a book, the story was over. The outcome was known and the explanation could be discovered. This story wasn't over yet. That was the problem.

What must it have meant to her when she learned he was coming out of prison? She must have reckoned the chances of his coming back to see her, must have known he'd come. They both knew he'd saved her from the ugliness he could have created by telling of their relationship: had she known why? And she must have known that there'd be some kind of due bill when he found himself a free man . . .

Any of this, all of it, would surely have made her afraid of him, try as she might to *act* brave, which she certainly had done. God knew, she was obviously repelled by him, in some kind of inverse ratio to the love she said she felt for me . . .

I spent a good deal of time reliving in my mind those days—in retrospect so exciting, so oddly enthralling because I was falling in love with her knowing I shouldn't, knowing I was doing it anyway, knowing I was betraying Victor—when we were being stalked by Varada. It was a kind of "love by terror" and I remembered the earrings on the Venus at the Metropolitan and the blank faces of the Katz men and women and the huge face of the frightened woman who could, I imagined, hear the footsteps behind her . . .

I remembered how fascinated I had been by her own black and pink pearls and what she'd told me about Zuleika Dobson. I remembered the giant dancers on stilts pirouetting before the massive lions and Varada coming from nowhere to play with the little black kid . . . and I remembered how the horror had begun then in earnest . . .

I knew all that but I couldn't quite imagine where it was leading. And in the end what finally did happen was quite literally beyond my powers of imagination, beyond anyone's. I'm sure of that.

FOUR

I was jumpy as a cat.

Where was it leading? When would it end?

And where was the son of a bitch?

My strength was slower coming back than I'd expected. And, I admit, I was scared to death that Varada would say the hell with Caro, and come to finish me off. At least, I might be easier to find.

I dined with my publisher, who was suitably impressed with what had befallen me since we'd last spoken. He mourned the fact that I wasn't interested in spilling out the story for $19.95 a copy.

Frequently when I went for a walk my paranoia would accompany me, blossoming obscenely in my buttonhole. I would become absolutely certain that Varada was following me, determined to put some blood in the scuppers. But when I had the courage to look behind me it was never Varada. I began to believe that maybe I was going a little crazy.

One night I walked home from a quiet solitary dinner at one of the little sidewalk tables at La Gouloue. It wasn't a long walk but it didn't take me long in those days to work myself into quite a state. This time I was sure it was Varada behind me. I'd gotten one look and there he'd been, the same kind of rolling John Wayne gait, the safari jacket, the mass of him in the shadows.

He stayed behind me all the way to the house. I went up the steps like a man with the hounds of hell baying at his heels, bolted the door, stood gasping like someone from a tale by Poe.

Half-dreading the result, I went to the far end of Victor's

study to the window overlooking the street. I concealed myself behind the drapes, peeking like a fool at the street, looking for Nemesis. But he was gone. I slumped, sweating, into Victor's leather wing-backed chair. When, when would he come after me?

And then the telephone rang.

My heart leaped, began smashing itself against my ribs.

It had to be Varada. But I had to answer it.

Wrong again.

It was Alec Maguire. He was out of breath, panting, calling as usual from Half Moon Lake. But that was all that was usual.

"Charlie, you sitting down? If you're not, grab a chair." He stopped to suck air into his lungs. "Okay, here's the drill. As usual I'm following the daily schedule. I staked out the lodge today from up the mountain road, using my binocs, she putters around in the yard, sunbathes on the deck—same as every other day. Come evening I follow her along to the Bay Club. Like every other night she has dinner there by herself. Coupla drinks, dinner, coffee, maybe a brandy, the slow walk along the lakefront, then home. Tonight's the same as ever. She got home, piddled around for an hour or so, then there's a light on in her bedroom for half an hour, then it's sleepy time. Same thing every day.

"So I came back here to the Bay Club for a nightcap. And guess who was sitting at the bar, Charlie?"

Instantaneously I felt the urge to vomit. He didn't have to say it but he did.

"None other than our friend Carl Varada! He was sitting at the other end of the bar, considerably bigger than life . . . but no need to tell you how big he is. Panama hat, safari jacket—"

"—I swear to God he must get a discount—"

"—chino slacks, not your tremendously varied wardrobe."

"So what happened?" I was fighting down the bile in my throat.

"He just had two drinks, smoking this skinny cheroot, didn't

224

have much to say to the bartender or anyone else. Just sat there with a very calm, quiet look on his face. He made eye contact with me once, we were the only two guys at the bar at that point, he gave me that look from those funny eyes, down that long nose, lifted his glass, and very quietly said *your health*, just one of those casual gestures between two guys at a bar."

"You're sure he didn't recognize you in some way?"

"Not a chance. Just one of those things that happen at a bar. Eventually he got up and left. I didn't want to be obvious, particularly since he'd noticed me, so I gave him a minute or so, then I got up and sauntered out to the parking lot . . . the son of a gun was nowhere in sight. Just evaporated. Beats me where he could have gone—"

"Where are you now?"

"Back at the Bay Club."

"For God's sake," I shouted, "get back to the lodge!"

"That's where I've just come from, keep your shirt on. I spent an hour keeping watch, not a sound, no lights, everything dead to the world. So I came back here to call you. Next I'm going back to the lodge and keep an eye on things through the night—"

"That's good. He's going to go for her, you know that, Alec. He didn't come to Half Moon Lake for the waters—"

"I know, I know. But let us reason together, Charlie. I'm eventually going to have to get some sleep. Contrary to popular belief, I am human. So, do you want me to engage an L.A. firm? They could have somebody up here to take a shift by tomorrow—"

"No, no, you don't have to do that. I'll catch a morning flight. Hang on until I get there."

"Then I'd better tell you how to go about it, Charlie."

When I hung up it was well past midnight, yet I doubted my ability to get to sleep. So I got quite a lot of Victor's twelve-year-old Inchgower inside me and went out and sat in the garden, letting the daze overtake me.

How the hell had Varada found her?

Had he been watching the whole time after the attack in Maine, followed us, then chosen to follow her because old Charlie surely wasn't going anywhere? Had he watched her go to Earl's Bridge, watched the house, had he gone to the cemetery again?

Had he then followed her to Los Angeles? But if he had, why the wait? Why hadn't he shown up until now?

About four o'clock in the morning I went back into the empty, echoing house and began to rummage around in Victor's collection of handguns.

Chapter Twenty-two

The brown bubble of Los Angeles enveloped me like one of those pretty tropical flowers that dissolve bees and spiders in their spare time. I was out of LAX and into my rented car heading toward San Bernardino and my eyes were already on fire. It was the brown haze invading me and my impulse was to get to the mountains, outrun it.

The highway was doing a belly dance in the heat waves. Maguire's directions lay on the seat beside me. My gut was empty. I was afraid I couldn't keep anything down. It was all because of Varada.

And yet I had to try to stop him. For my own sake, sure, but also for Caro. She was the reason that mattered; she was all that mattered. I didn't give a damn anymore about what she might once have been, what she might once have done. There was one, only one, Caro Saberdene in my life and she had never been anything but what I wanted. Nothing else mattered. I had to do what I could. Maybe I could slay the dragon and rescue the maiden in the tower. And maybe I'd die trying. But watching the heat shimmer off that boiling highway I knew I didn't have any choice.

The road climbed five or six thousand feet in a handful of miles. The heat fell away like snakes' skins, another couple of thousand feet and there was a sharp cool tang in the air. I stopped at a place called Bubbling Springs and checked my directions with a kid manning a gas pump. He was wearing a big hoop earring but he made sure I knew the difference between the road to Puma Lake and Little Fawn Lake and Half Moon Lake. About all that had changed since Marlowe made this trip forty years before was that earring.

Then I was back in the car with the yellow pines all around me and a slice of blue lake to my left with motorboats and water skiers and I felt as if I'd been in such a place before and I probably had been—a very long time ago. I felt as if I were headed into the past and of course it was all a trick of the mind. I paid attention to my directions, threaded my way along the narrow road with huge boulders protruding through the skin of the mountain, poised above me, as if ready to fall. Meadows full of yellow and purple and white flowers were slung like hammocks between the rocks and pine rises. And when Puma Lake came into view it could have been a vacationland of my childhood beckoning to me.

I saw a sign that pointed off toward Little Fawn Lake and I kept on, wheeling around Puma Lake until I saw another white arrow on a stake aiming at Half Moon Lake. The road swung into a pass trying to go unnoticed between two unfriendly granite towers which acted as a gateway to a rolling landscape of oaks and more bright flowers and a pretty little waterfall. Then another lake lay like a flat blue-gray plate below me with the town clustered around it and pine forests rising sharply on all sides.

Half Moon Lake.

Somewhere Varada waited. I was near him and he didn't know I was coming.

I pulled off the road onto a soft shoulder carpeted with pine needles. I turned off the engine. From far away, down there on

228

the lake, I heard the angry insect whine of an outboard motor. Blue jays flickered in the pines and the aroma of the trees was almost overwhelming. They shut out the bright sunlight and a man could think if he wanted to. If he weren't afraid to. I tried hard not to, just sat and got my bearings and saw the various lodges tucked away on the forested slopes. Across the lake the sun reflected on windows which blinked like semaphore lights at sea. *Go back . . . go back . . .* Well, the hell with 'em. I was wasting time. I turned the key and headed down the mountainside.

The Bay View Motor Lodge looked like a two-story Swiss chalet. An ornate cuckoo clock, telephone-booth size, sat in the middle of the roof and was presumably decorative rather than functional. There was a sundial on the lawn which informed the observer that it had been put in place during the summer of 1936. The fellow behind the desk had probably supervised the ceremony. His eyes were as blue and as clear as the lake. And he told me that Alec Maguire hadn't slept in his bed last night, according to the maid who'd done his room.

We made sure Maguire wasn't back in the room and I breathed a sigh of relief. He was still on the job waiting for me. I got back into my car, got my bearings straight again, and drove along the main street, hooked off toward the end of it, and swung past the lodge, 18 Bella Vista Drive, which was set well back from the street, twenty yards up a slope which looked to be an inch deep in brown pine needles. The house was weathered cedar with a screened-in porch angling away, providing a clear view over the water. The foundation was built of large gray stones. There wasn't a sound but the chattering and skittering of squirrels and the conversation of birds hidden in the darkness of the trees. As far as I could see, there was nobody home. I sat in the car for ten minutes. I wasn't accomplishing a damn thing.

I circled up the steep mountain road behind 18 Bella Vista and parked above it. It sat a hundred yards below me,

229

silhouetted against the lake in the afternoon sunshine. I spent an hour considering the various locations from which Maguire might have kept an eye on things but he wasn't at any of them. So far as I could see, Maguire was AWOL. Unless he was in the house. But no, he wouldn't have done that, not knowing I was on my way. He'd have waited for me. Maybe he'd gone for a bite of lunch . . . maybe I'd passed him on my way to the lodge.

Looking down the slope, through the pines, I felt suddenly uncomfortable, as if I had no business being there, as if I was poking around in somebody else's business. For just a moment I felt foolish, as if people hadn't been dying, as if I weren't in love with Caro . . .

And then I realized it was all for Caro, that Caro was the point. Varada had found her and I wasn't poking around in anyone else's business. I was going to save her, damn it.

There hadn't been a sign of life from the house all afternoon. I drove back down to Bella Vista and pulled up across from number 18. I had Victor's old forty-five in my waistband. If that didn't get me up to even with Varada nothing would, so I took a deep breath, and did a remarkably stupid thing. I got out of the car, walked across the street, up the carpet of pine needles, and knocked on the door. I counted to thirty, tried the door, and thanked God it was locked. Nobody home. My knees were shaking when I got back to the car and slid in behind the wheel.

Where the devil was everybody?

Somehow I'd managed to lose them all, as if the jet I'd boarded at Kennedy had been a time machine that had zapped me right past where I'd wanted to go.

Maguire had been watching Caro. I could only assume that Varada had been watching her, too. And now they were all gone.

I went back through town and parked at the Bay View Motor Lodge. I went to Maguire's room again but he hadn't come

back. I went back to the check-in desk and the old chap shook his head. We checked the parking lot for the car. It wasn't there.

Stymied. I went back to the street and wondered what an honest-to-God detective would have done. I didn't have a clue. So I took a walk, but the local color wasn't impressing me. It was a pretty place and all but as I prowled the streets I was checking out the faces, moving on, looking, hunting. There should have been some nervous sound-track music as the sun slid on down behind the mountain and the lake faded slowly to black.

I couldn't afford to think about where Caro was, what might be happening if Varada had found her.

Down near the water I dropped in at the Bay Club. The bar was half-full with deeply tanned vacationers quietly warming up for a long evening's revelry. I sat at a table looking out across the pristine docks where motorboats and sailboats bobbed at the ends of their tethers. Kids wandered up and down across my view, teenagers, lean and young and not very bright, as if their physical superiority had blotted out the power of their minds. Looking at the girls in bikinis, if that was what they still called them, made you wonder if brains were all they were cracked up to be. Caro's body had resisted time. I stared at the faces. Hers would have improved every one of those lean, tight bodies. But no, she wasn't there.

I ordered a club sandwich and a cup of coffee and stared, my mind unbelievably blank. I might as well have been on Mars for all the good I was doing anyone.

Somewhere around the curl of the lake, back in the direction of Bella Vista Drive, a truck with a flashing light on top was kicking up a fuss. It looked like a tow truck. Some of the kids on the dock had spotted it and were pointing, shouting things I couldn't hear. Another car with a light twirling like a sparkler went hell-bent in the same direction. A crowd on foot was heading that way. Watching the commotion I began to feel a rush.

I put a ten on the table.

Something interesting was going on. It was the first thing that had caught my attention since I'd arrived at Half Moon Lake. I knew I'd better have a look.

Chapter Twenty-three

ONE

The dock was crowded with teenagers looking down at the wooden pilings and the beach below. The tow truck had driven down from the road, across the dry sand to the wet, harder packed surface under the dock where the water sloshed back and forth. Three men in coveralls were doing the Three Stooges while a cop in a blue windbreaker was talking to the truck driver. A cable had been thrown into the water and a man in hip waders had attached it to the back end of a large squarish object which was in the process of being reeled in like Moby Dick. Water spewed off it, there was a muddy sucking sound, the rear wheels of the tow truck dug into the wet sand, the front end bouncing dangerously.

Slowly, like my memory of the end of *Psycho*, the trunk and rear bumper and back window of a nondescript sand-colored car struggled into view with the lake lapping around it. As the winch ground slowly, noisily, drawing the cable in upon itself, water cascaded from the undercarriage. The Three Stooges were trying to guide it to a safe berth as the roof emerged, then

the hood, until the front wheels were making contact on the firm sand. The winch squealed and the truck strained forward until the cop signaled to the driver to stop.

Conversation, punctuated by the kids' loud laughter, buzzed through the crowd on the dock. I couldn't see much, so I went back to the parking area, climbed down a flight of rickety wooden stairs through the beach grass, and stood on the sand watching the operation. Water was still dripping from the door closures.

Two of the stooges were preparing to open the door on the driver's side. "Stand back!" one of them yelled as he struggled with the handle. With a violent pull he opened it and more water sluiced out around and across his feet. "Jesus Christ, Harry," he shouted to the cop who had been coaching the driver to set the car down gently. "There's somebody in there!"

The cop hurried over and peered into the murky interior. He shook his head, spoke quietly to one of the men who poked his head into the car, then came back out. In a little while two more men came down from the street carrying a rolled-up stretcher. There were now half a dozen guys milling about the derelict car. The gathering on the dock had turned into a party. Someone turned on a radio. Billy Joel was singing.

A man had come to stand beside me. "Kids probably drove some poor bastard's car into the lake last night." He was wearing a Los Angeles Dodgers cap. "I saw it there, thought it was mine for one horrible moment. Kids." He looked up at the dock. "Happens about twice a summer."

They were pulling and tugging at the body inside. My mind was working so slowly it wasn't until precisely that moment that the thought came swirling out of my private cache of fears. I remembered Caro, and my stomach began to burn and twist. They had gotten the waterlogged body out of the car and onto the stretcher but my view was blocked.

From up on the dock, a girl looked down, said: "Oh, gross!" She turned away.

234

"Looks like they went too far this time," the man beside me said. "I knew this would happen sooner or later." He sniffed. "Now they killed some poor bastard."

They had thrown a canvas sheet across the body.

I couldn't wait any longer.

I pushed down toward them, slipping in the sand. The cop saw me coming and stepped forward toward me. "Just a minute, sir. You'll have to get back. We've got police business here."

"No, I just wanted to see her—"

"Not right now, sir. If you're missing someone—you recognize the car?"

"No, no. I just wanted to see the—"

They had lifted the stretcher and were beginning to move across the sand. I felt his hand on my arm, holding me tightly. "You don't want to see this, sir—"

"What happened?"

"I don't know yet. Either a drowning or a broken neck, goddamn belt around the neck, hooked through the steering wheel—it's a mess—"

"But is it a woman?"

He'd turned away pushing me with his back as the stretcher passed. "What?"

"Nothing," I said. "Nothing."

As the stretcher passed I saw that an arm dangled over the side dragging in the sand.

The hand caught my eye, bouncing along on the sand.

The hand was gray and rubbery from being in the water.

A huge class ring, a bright red stone.

"What?" the cop said, turning back to me. "No, it's not a woman, pal. Don't worry. Just some guy."

Maguire had found Varada.

TWO

It was dark by the time I got back to the car and checked the forty-five to make sure I hadn't shot my leg off without noticing it. I had to get the situation clear in what remained of my mind. I started by realizing that I didn't know if Caro was alive: it wasn't registering properly, the idea of her corpse, but seeing Maguire—well, seeing Maguire had in a peculiar way been more awful than seeing any of the others . . . Hell, I'd known him a little and I'd liked him, he'd hung in there until the end . . .

So, okay, I didn't know about Caro: but as far as I knew, she was still alive.

Varada had found Maguire, probably spotted him watching the house, and killed him. I didn't want to think about the belt around his neck, then looped through the steering wheel. He'd driven the car down to the municipal parking lot, waited until the dead of night and, with the lights out, eased it down onto the beach and under the dock, rolled it into the water with the windows open so it would sink quickly, not giving a damn who found it. I'd have bet the farm that there wasn't a single piece of ID on him except for the class ring, gold with the red stone . . . I saw the black hairs on the backs of his knuckles . . . and he thought he'd been overpaid . . . broken neck, drowning, what difference did it make, except to Maguire at the end . . . broken neck, that would be preferable, I supposed . . . now he had Caro and maybe the bastard felt safe, after all, maybe his guard was down . . . unless he'd seen me during the afternoon I might be able to take him by surprise. If I could *find* him. I had to find him. He couldn't find me. I'd find him and now I had a big goddamn gun of my own—if I had a chance, *any* chance, I'd kill him and ask questions later . . . If

236

he'd done anything to Caro—but no, he wouldn't have, not yet, he'd just hit town the night before, according to Maguire. He wouldn't have had the chance to use her, really use her the way he wanted to . . . so I had to believe she was still alive . . . and if Varada felt safe why wouldn't he go ahead and use the lodge on Bella Vista? He would, he'd use the lodge . . .

The shadows on the mountain road were a deep velvety blue, the pine forests black. The moon was silver behind the passing filigree of cloud. I found a secluded place to pull in with the heavy pine branches resting on the roof. I picked my way carefully down the hillside, tripping over stones and scraping my hands on bark. Deep in the trees it was too dark to see. I was feeling my way.

The lodge sat quiet and serene in the moonlight. No lights showing. By the time I reached the treeline at one side of the lawn it was so quiet I could hear the splashing from the lake where the fish were jumping. A bird made a mournful noise somewhere behind me.

The gun was heavy in my right hand. I bent low, scuttling along in the moonshade cast by the pines. Out of breath I crouched and waited. Nothing happened. No one had seen me. I could just make out the sounds from a little carnival at the other end of the town. Across the bay the red lights of the Ferris wheel flickered, reflected in the water.

I crossed the lawn and stood panting under the eaves, then worked my way to the side doors. I turned the knob and the door swung open. I went inside.

Right away I picked up the scent of her perfume, something she'd once told me was called Krizia. It was all around me. It was almost as if she were there on the landing with me . . . but if she were there, then Varada would be there, too.

The kitchen was empty. I went into the long rough-hewn living room, navigating by moonlight. The smell of stale cigar smoke mingled with the perfume. I had the sense that the house was empty: it was so quiet you could almost hear the dust

settling. A clock ticked. The distant calliope sounds of the carnival drifted across the lake, through the open windows. The cigar smoke was strong, as if it were his spoor. He'd been here. Recently. He'd killed Maguire last night and he'd come back here to take Caro by surprise. But that was old news. Where was he now? Where had he taken her?

I climbed the stairs to the second floor. I wanted some evidence of her. Some sign that she'd been here and would be coming back. The perfume's scent was stronger as I went slowly down the corridor. I looked into room after room until I found her bedroom.

Moonlight flooded through the windows facing the lake. I saw where she had been.

The bedclothes were scattered across the bottom of the bed, hung off onto the floor. I went closer, smelling her. The pillows were smeared with what I thought at first was blood but what turned out to be lipstick, as if her face had been held down on the pillows while she struggled. The picture was clear in my mind.

The sheets were still damp with sweat.

From the frame of the headboard a pair of handcuffs dangled like Varada's amulet, his trademark.

Tears of sheer simple rage burned behind my eyes.

Kill him, I had to kill him, and I kept looking at the handcuffs and smelling the sweat . . .

My hands were shaking. Cold sweat was running down my face. Kill him . . . I had to get out of there or I was going to start shooting hell out of an empty house . . .

I went back to the car, climbing carefully to avoid the loose stones and roots and tangled underbrush. Wherever they were, they were bound to come back. Her clothes were still in the closets, her suitcases stacked by the dresser.

I was out of breath and dripping wet by the time I got back to the car. I climbed in behind the wheel and settled in to watch the house below.

I must have dozed for a while. When I awoke I saw a light on in one of the windows. Upstairs. I looked at my watch. Three-fifteen. I checked the gun yet again, got out of the car.

I stood at the top of the slope, gathering nerve. You need all the nerve you can get when you are going to kill a man.

"Don't move a muscle, Charlie, or I'll blow your head all the way into the lake."

I knew the voice coming from behind me.

I felt the gun pushing firmly at the back of my head.

Chapter Twenty-four

"Well, Charlie, old fella," he said in that soft drawl I'd come to dread. "You're just about the luckiest man in the world." His hand on my shoulder felt like a load of bricks dropped from a very great height. "Sit down here and let us reason together." He was pushing me down. There was something in his remark that reminded me of Maguire. Let us reason together. "Now level with me, Charlie—you got a gun?" He was running his hands lightly under my arms. I grunted and opened my jacket. He slid the forty-five from my waistband. "Damn. That's kind of a dangerous way to carry. Do yourself a powerful lot of harm should it go off . . . yep, you are one lucky fellow." He sat down beside me, pointing the gun at me. "I'd hate to kill you. I'd never hear the end of it." He laughed softly. "Gotta keep you alive."

"Why? Why should I be any different?" I was gasping from fear. My breathing wasn't right and I didn't want to be humiliated.

"You've got connections, Charlie. She don't want me to kill you."

"Where is she? What have you done to her?" I was whispering. I couldn't seem to speak aloud.

"I'm not going to kill you, Charlie. You hear me? All you have to do is go away. That's it. Go away. Leave Caro and me alone. She tells me you'll behave yourself if we let you go. I believe her. Just get back into your car there and never look back . . . she says she told you that once before but you didn't get the idea. I told her I had my doubts about you gettin' it the second time around but she says you'll understand this time. Is she right, Charlie? Does Caro know you as well as she says she does?"

"She's not saying these things. You are. I don't believe she wants me gone—except maybe to save myself—"

"Hey now, wait a minute, old son. Think, Charlie. Why would I tell you to hit the road? Wouldn't I just blow you away? Are you forgettin' that I'm Carl Varada, the homicidal maniac? Why else would I give you this chance to save your life . . . except that it's what she wants me to do?" He sighed, looked down his long nose at me. "You're not nuts, are you, Charlie? You know a good thing when you see it?"

"For all I know you've already killed her."

"Oh, now, come on, Charlie! That just don't make any sense. You just beatin' your gums now, my man. You just wastin' my time 'cause you just don't get it, do you?" He slowly shook his head and scraped a lock of pompadour from his forehead.

"I get enough of it. You've got Caro and you killed Maguire. You've been killing people all summer. You're not going to let me walk away—"

"But that's the point, isn't it? That's what I'm gonna do. I trust you . . . because if you make any trouble for me you just know I'll kill Caro before I do another thing. You surely wouldn't want that to happen. So just leave us, Charlie. Think about it . . . she and I, we're alike, we're exactly the same, take my word for it. Now, just get in the car, old fella."

"And just forget Maguire? And Braverman? And Victor, for

Christ's sake? Let you do whatever you want to Caro? Live with that shit the rest of my life?" I saw the handcuffs, the pillows . . .

"Better than dyin' right now."

"You'd probably think so. I'm not so sure."

"Look, let me tell you the story. We got plenty of time; it's a nice night here in the piney woods." He punched my arm softly, like an old friend. "Cheer up, Charlie. It could be a whole lot worse—"

"It was a lot worse for Maguire."

"Oh, man! That is an understatement!" He fished a cheroot from his jacket pocket, lit it with a Zippo that caught a stray shaft of moonlight. "Now, this Maguire character. Lots of guts, a little short in the brains department. He came poking around last night, he actually came into the house, private property . . . breaking and entering or something damn illegal. He had a cannon on him, he was up to no good. So, I jumped him in the dark, snapped him, and you know the rest. I seen you there where they fished the car out of the water . . . I was hopin' you'd take the hint and get the hell out. Caro saw you and cried, she wishes you hadn't come—"

"I'll bet she cried." I started to stand up.

"Charlie." He drew the single word to abnormal length, pointing the gun at me. "Down, boy."

I sank back down. "Where's Caro? What have you done—"

"Oh hell! This was supposed to be so easy." He quelled his impatience, as if he were dealing with a recalcitrant child. "Boy, you gotta get with it. Look, Charlie, listen very closely. I haven't done a damn thing to Caro . . . that she didn't want me to do." A leer made its way into his voice. A challenge to my weakness. "You got to get that straight. Caro *likes* me, the way I treat her . . . she knows she *deserves* me, boy."

"How about the handcuffs? She like that?"

"Why, Charlie!" He flicked his gun hand and I felt the barrel rake across my face, splitting the skin stretched over my

cheekbone. "You should stay out of other people's houses 'less you got an invite! Shame on you . . . and you must know she likes it a little rough. Handcuffs were her idea! You should know as well as anyone what she likes, the way you been enjoyin' the lady's favors." He smiled at me. My nose was bleeding. The cheekbone was a white-hot flame.

"Come on, pal," he said. "I'm givin' you back your life. And I admit it isn't just because she wants it that way. I got kind of a soft spot for you myself. You got yourself some guts somewhere along the line . . . hell, I was bein' a pretty scary guy this summer . . ." He dropped the cheroot ash on the dry pine needles and carefully ground it out. "You really care about her, I give you credit for that. You've taken some risks, I respect that . . . but, Charlie, now's the time to take a hard look at it and bail out . . . Do something smart for a change, Charlie. You been a hero long enough."

"Let's make a deal," I said. He'd mashed my cheek against my teeth and there was bloody pulp in my mouth, getting in the way of the words.

"Oh, Charlie." He shook his head.

"Let *me* give *you* back your life," I said. "You must have gotten enough satisfaction by now. Saberdene is dead. You've made Caro's life a nightmare. You've had quite a summer. So let me take Caro. We've kept you out of this so far. Your name has never been mentioned. As far as I'm concerned, you stay away from us and we'll do what we can for you—"

"Old son," he interrupted me gently, "you keep insistin' on missin' the point. Caro *wants* to be with me. She don't want to see you, Charlie. Not ever again. Whatever happens is goin' to happen to Caro and me together—"

"That won't fly," I said, chewing the bloody pulp. "You don't seriously expect me to believe that." I wanted to keep him talking, the old hostage principle. Once they knew you it was harder for them to kill you. I didn't think it was going to make it harder for me to kill him. Oh yeah, I was going to kill him. I'd

get the chance somehow and I'd do it. I'd suffered a lot because of Carl Varada and I was beginning to forget I was doing this for Caro. I was thinking pretty hard about doing it for myself.

"Caro and me, we're a pair. You're gonna have to get used to that, Charlie."

"Bullshit, Carl old sock."

"Well, I suppose if it fooled everyone else there was no reason why it shouldn't of fooled a sport like you, not with Caro playin' the lead role—"

"What fooled me? Not Caro—"

"Killing Victor. We pretty well fooled everybody. I told her it was all too clever, I told her they'd suspect her right away . . . but oh no, not Caro, she had it all figured out. And she never doubted she could act the part. She told me that things like shooting Victor happened all the time." He shrugged. "She knew what she was talking about, the way it turned out. Damn it, she always seems to know—"

"This is ridiculous," I said.

"You still think that was an accident, what happened to Victor that night? Aw, come on, Charlie. It was the plan, a damn well perfect plan—not original, I guess, a little out of my league. It was Caro had the idea. I called her as soon as I got out of the slammer, she told me to meet her in New York, she set up places we could see each other . . . y'know, she felt pretty bad about me goin' to prison, she could of helped me but, hell, I didn't want her to get tied up in it . . . I mean, hell, I felt like one prize asshole myself. There was Caro, I'd gotten her pregnant and what was I doin'? Trying to screw her sister! My future was never farther away than the length of my dick . . . Anyway, she said we'd have all the money and she'd be rid of Saberdene." He lit another cheroot. "Whattaya think so far, Charlie?"

"I think you're going to a lot of trouble to cook up this story. I'm trying to figure out why." In my mind I was back in Judge Edel's study looking at the photos Maguire had taken of them

244

together. But I heard Caro explaining all that. I remembered the happiness we'd known, the love in her eyes and the pain.

"The trick was to get Saberdene up to that country house in the middle of the night. You were a complication, Charlie, but she said she could handle you. Turned out she was right. I called the poor bastard, got him up there on schedule, and she blew him away as planned. The way I figured it a whole lot of things could of gone wrong but none of 'em did. Bang, bang, she gets him with both barrels and I just went to ground.

"I knew everything that was going on all the time. I was always Johnny-on-the-spot. How the hell else do you think I could of found you up in Maine? You think I'm psychic? She told me, she told me! Think, Charlie, think! She cut the phone wire . . . She figured it out! How else?

"And now Victor's out of the way. Caro's got the money. And you and I are all alone in the middle of the night. Tomorrow, one way or the other, it'll just be me and Caro." He laughed quietly from behind the smoke. "Y'know how it is, Charlie. She'll get tired of me someday and try to kill me . . . but what the hell? Maybe I'll kill her first." That struck him as fairly amusing. "The way I see it, it don't really make no difference."

"I simply don't believe you," I said. "That's all there is to it."

"Well, old buddy, I really don't give a shit. I just want you to get lost and leave us to get to hell in our own way."

"I say you've already murdered her—"

"Damn it, Charlie!" he shouted. "You are the most contrary bastard I ever did see! How 'bout I take you down there and you can see for yourself. Honest to God, she'll kill you herself if she has to. Listen . . . you're everything she knows she should want . . . but me, I'm what she really wants. Down in her guts she wants me, Charlie. She says it's a sickness, she can't help herself. She didn't know there for a while, all that lovey-dovey crap going on up in Maine there . . . She fell in love with you, I guess, as much in love as a woman like that can be, anyway. And I was gettin' pretty antsy. Wasn't the way the plan was

245

supposed to work. I got to thinkin', what if she married you and left me holdin' the fuckin' bag again? Where the hell would I of been? Sure, I could kill both of you . . . but I'd sure as hell never get my hands on all that money. Get it? Was she double-crossing me or what? How was I to know?

"So I went on up there to Maine. Fourth of July, I went to the house. She didn't know I was comin'—she just thought I was waitin' to get word from her, see. She came back to the house by herself, piece of luck, and I told her I was a little, y'know, disgruntled, pissed off, you might say. I think she was a little scared of me so she did what she always does when she's scared . . . she said she wanted me, she said I should kill you when you came looking for her . . . she said a funny thing, Charlie, she said you were closing in on her and she'd tried but she figured you'd realize the truth about her sooner or later so I might as well finish you off . . . she was screwing me and she looked up and said you'd eventually realize she was crazy, she said she'd already seen it in your eyes . . . but then you came in and I guess she couldn't take it, watching me work you over, and she ran . . . well, I was about to crack you in two, and I got to thinking . . . You were just a dumb bastard who wandered into the whole mess innocent as a fresh-laid egg, you fell in love with the wrong dame. That ain't a crime in my book. I done it a thousand times myself. Why kill you? I kill guys who are after me, dangerous guys, people I need to kill. But you? You were harmless, why squash you? Like steppin' on a bug. No offense, Charlie. Listen, our plan was to kill Victor, then meet six months later in Rio, that was what she'd always talked about, the beach in Rio, Ipanema and Copacabana . . . Rio, like it was the other side of the moon, like she always thought she'd be safe there and could start all over. I'd tell her, you can never hide from yourself, your fate catches up with you wherever you go. My dad told me that when he was dyin' and I never forgot it . . . ah, Charlie, Caro and me, we were really crazy for each other that summer . . . then her sister, that

Anna, started digging around, found out about all the screwing we were doing . . . she tried to scare me off and like a damn fool I took a fancy to her . . . that night we walked down the lane there and I grabbed her and kissed her and tried to screw her and she scratched my face, she was so scared . . . I probably should have screwed her, she'd be alive still, I'd have stayed a free man, a whole lot of people would still be alive . . . Aw shit, Charlie, it's a fuckin' mess, ain't it? Somewhere along the line I got all turned inside out. 'Cause right now there's no doubt that I'm the psychopath they said I was at my trial . . . then she lost the baby while she was having her breakdown. She tells me she did it on purpose and maybe she did. She said two people who were mad shouldn't produce off-spring—a monster, she said it would be . . ." He laughed bitterly at the idea. "Tell you the truth, Charlie, I never thought her testimony could have saved me and my ass, anyway. If the truth about us had come out, hell, nobody would have believed I was with her when Anna got herself killed." He looked up at me, sucked on his cheroot. "That's the thing about Caro. People are always gettin' killed around her. But I ask myself, Charlie, why should you be one of them?" He smiled at me. The gun was drooping across his knees. He ground the cigar out under his boot heel.

He wasn't watching me. I think he actually liked me at that moment.

That was when I hit him with the stone I'd gripped by my thigh while he was telling me his story. I don't suppose I had to hit him so many times. But I was new at this game and I wanted to make sure.

Then I set off down the hill to the lodge.

I was soaked with his blood.

Chapter Twenty-five

I stood outside the side door again, catching my breath, wiping my blood-spattered face on my sleeve, grabbing at the twinges of pain in a freshly twisted ankle.

Then I went inside. I wasn't thinking. I was operating solely on shock and fear. Just then I was afraid of what I'd find in the house. I was afraid that he'd already killed Caro.

The downstairs was as empty as before. The house was still as a grave.

I climbed the stairs slowly; my ankle felt like a cracked china plate. I couldn't keep my nose from bleeding. The stair creaked in the stillness and the dark.

The light from her bedroom spilled out into the hallway. "Caro?"

I thought I heard a sound. A whimper or a sob.

She was crouched on the bed. One eye was puffy and discolored, yellow and purple. Her hair was sweaty, clung wetly to her forehead. The pink and black pearls hung motionless from her ears. She wore nothing but panties. On her left breast there were teeth marks.

She stared at me as if she'd never seen me before. Her arms

were twisted back. She was handcuffed to the headboard. There was nothing at all in her eyes.

"Caro, my God, you're alive!" I went to the bed. Her eyes tracked me. She shrank away when I bent toward her. I kissed her hair. She turned her head away. "I know, I know," I whispered, "I'm not such a pretty sight myself."

She said something so softly I couldn't understand.

I saw that the handcuffs were locked, her wrists rubbed raw. "The key, the key . . ." I was thinking aloud. But she was all right, she was scared and hurt but she was all right.

I found the key on the chest of drawers.

I bent over her wrists and fit the key to the lock, turned it.

"No, no," she whispered.

Then her hands were free. She still knelt rigidly, hugging one of the pillows to her chest.

"It's going to be all right," I said.

The door to the room banged back, slammed off the chest of drawers. Caro's eyes flicked toward the noise. She didn't make a sound.

"I don't think it's going to be all right, Charlie."

Varada stood in the doorway. He looked like what he was. Back from the dead. His hair was matted with blood and dirt and pine needles. His ear was smashed to a pink lump. Blood had run down his face and soaked into his shirt and the front of his safari jacket. He leaned in the doorway, dark blood running from his mouth. He held a gun that was pointing toward the floor.

"Tell him, Caro," he said, "tell him the truth. Tell him about us . . ." He spit a bloody tooth from his mouth. "Tell him it's the way you want it to be . . ."

He brought the gun up and staggered across the room. I'd left Victor's forty-five back on the hillside. He was going to kill us. Lost in his madness, he was going to kill us.

He stood over her, then slapped her hard with a full swing of the back of his hand. Her head slammed into the wall and when

she turned back to me her eyes had cleared, were focusing on me. He grabbed her shoulder and shook her. "Tell him the truth about us! Tell him about our baby you killed! Tell him how we planned to kill Victor for the money! Tell him!" He threw her back against the wall. She clung to the headboard. "God damn it! Tell him . . . then let him go! Or let me kill him . . . I don't much care . . ." He spit some pulp and it stuck in her hair like a rotten blossom. "Tell him the truth, bitch!"

He was shrieking at her, spitting blood, his eyes bulging at her, oblivious to me.

I made a dive across the blood-spattered bed. The gun came out of his hand so easily, as if he had no strength left. He turned toward me slowly, a look of surprise on what the stone I'd used had left of his face.

I shot him twice in the chest.

The slugs seemed to blow him open, or apart, all in a split second, lifting him back off the bed where he'd been kneeling and dropping him on the floor.

I crawled across the bed, threw the gun down as if it might somehow turn on me, looked down at him. He was clutching at his chest, the fingers sinking into the wounds as blood oozed between them.

"You . . . gonna be real sorry . . . about this . . ."

He was trying to laugh but died in the middle of it.

I sank down on the floor beside him. We were leaning against the wall, side by side. I couldn't think. I couldn't even feel anymore. Once I began to think and feel again, I knew I'd want to die, too.

She made a sound of some kind deep in her throat, not a word, something else.

I looked up at her.

She was kneeling on the bed. She'd turned to look at me. Her nipples were dark and erect, like tiny weapons. She was crying.

She was pointing the gun at my head.

"So, he was right. It's been you all along. Saberdene's goddamn variations." I licked my lips but it didn't do any good. Too dry. All I could taste was salty blood. "Living the same damn story over and over again . . . three of us loved you, Varada and Victor and then me, the latecomer . . . and now you've killed all three of us . . ."

Caro couldn't stop sobbing. "I did love you, Charlie, all of you . . . each one of you differently . . . but I loved me more, can't you understand that? I loved and hated me, everything you saw in me . . . I have to be free of all of you because each one of you *knows* me, sees inside me . . . I told you to forget me, Charlie, I told you to go away and never give me another thought . . . I wanted to save you, Charlie . . . why didn't you do it, why did you have to come after me? My God, how I warned you, how I begged you to forget me . . . why didn't you listen to me?"

I said: "I love you, it's that simple. It's my fate."

I leaned forward, tried to stand up. I reached out for her. I wanted to touch her for the last time.

Then I think I heard the roar, saw the flash of light, felt the fire enveloping me . . .

·

Epilogue

ONE

At the beginning of all this I told you I had a story to tell. Well, you've heard most of it by now, but not quite all. No, not quite all. You haven't heard the story of what someone who was about to die called the Nichols Variation. A last little joke before sleeping.

I also mentioned that it took me a while to recover from what happened up there at the lake. It was a very long process, a lonely, scary trip through uncharted territory. My memory of the events was agonizingly slow coming around, much slower than my physical recovery, which was pretty well completed within six months or so.

I was blinded for a while and that was a bitch. You want claustrophobia and panic in a very small place, like inside your head? Try being blind for a while.

One eye finally came back, functioning almost as well as ever. The explosion, the flash I thought I saw, the burn—they all played their own kinds of havoc with me but the one eye came back. I lost the other eye, on the side where the slug hit me. I've

got a little thing like a marble in there now. Nobody can tell there's anything wrong and I've grown used to it. I lost my hearing in that ear, too. The side of my head needed a lot of reconstructive surgery. The brain—that is, *my* brain—was exposed. A good deal of bone was blown away but the surgeons knew what they were doing. Part of my head is now something a lot like fiberglass or some damn thing. I'm squeamish about all that. I used to tune out when they started explaining. They've assured me my head won't rust or anything and what more can a fellow ask for? There's some metal in there, too, because like the guy in the old joke I occasionally pick up the news-on-the-hour inside my head.

I don't look much different, or should I say much worse? I do look different. I have a bit more hair now due to some artful and incredibly expensive reweaving which covers the worst of the cranial scarring. And I've grown a beard, maybe a little ritualistically, beginning a new life since I had sure as hell used up my previous one.

From time to time I get a dull, throbbing headache but a handful of Advil fixes that. Science marches on.

Memory was a mess. My recollections ended with the beating Varada had given me in Maine. When I came out of surgery for the gunshot wound I figured I was up there in Hackett, glad to be alive. Over the months of my convalescence bits and pieces of what happened came back to me. Once the new year had passed, Andy Thorne insisted that I come to stay with him. That was where I went through the period of nightmares, reliving events right on up through the moment I was shot. Together, piecing through it from beginning to end, Andy and I reconstructed the whole story. It was quite a story and, of course, very different from the one that came out during the official inquiry into the shootings at Half Moon Lake.

Officially, the tale of Varada's stalking Victor Saberdene's widow and the friend of the family, Charlie Nichols, seemed shocking and horrible, but not altogether unreasonable or

unlikely. In the end Caro had shot Carl Varada to save our lives and I had had the misfortune to get caught between them.

Well, that's the way it could have been. And I was in no condition to set the record straight. Whether or not I would have, I suppose I'll never know. But when I'd recovered and my memory of the truth had returned I certainly wasn't inclined to drag it all out again.

By the time I arrived in Earl's Bridge, Caro was gone. She spent the holidays that year with friends of hers and Victor's in the south of France, at a villa above Nice. I had no inclination to see her then. I was living in those days in a kind of bubble, stretched to the bursting point. I remembered loving her, all of that seemed like yesterday, but I didn't understand what had happened out there in California.

Andy Thorne helped me like no one had ever helped me before. He saved me in the most fundamental sense. He said that at bottom what he really wanted was what was best for Caro. I came to feel the same way. And for some inexplicable reason I didn't want to see her again. Perhaps my subconscious was protecting me, remembering beneath the surface what I had not yet been willing to face. Who the devil knows what really goes on in your head?

But as summer came and slowly turned to fall, Andy and I watched the Red Sox on television and went for walks and had dinners out at the inn and read and talked. As my memory of the events of a year ago returned to me, Andy was there to talk about Caro and Varada and Anna and Victor and me. He helped me to see the wellsprings of human folly and violence which had colored all of our lives. He led me by the hand, carefully, through the terrible agonies of his life and mine. He showed me the true face of love. We all had loved Caro. The survivors still loved her.

Caro.

She was recovering from what had happened to her life. No one seemed to know when or, indeed, if she would ever return

to New York. In one segment of the press she was considered something of a tragic heroine. My publisher let me know that there was a big book in the works on "the curse of the Saberdenes." As I write this I understand that it will be published next year. But I've refused to cooperate at any level and, believe me, I'm now the only person who knows the whole story.

Andy Thorne's heart went bad for the last time in November. He knew he wasn't going to make it this time. He insisted on staying at home, surrounded by nurses and paraphernalia but by all the familiar things as well.

The last time we spoke, about three hours before he died, he held a photograph of Caro and tapped it weakly with his forefinger. "Last words, Charlie," he whispered and his chest quaked with a small laugh. "Promise me this . . . you'll take care of her. Promise?" I promised him I would. He squeezed my hand and I told him to get some sleep. He did. He didn't wake up again. I think he understood. I think he was at rest.

Caro was in Rome at the time. Her attorneys reached her with the news I'd provided them of her father's death. She didn't come home. She sent a large floral remembrance, which is exactly what the funeral director in Earl's Bridge called it. Her attorneys also provided me with the sketchy information that she planned to spend the Christmas season in South America. No, they didn't have any greater detail. They weren't knocking themselves out being helpful but it didn't make any difference. I knew where she'd gone.

Once Andy Thorne had been consigned to the earth, beside his wife and daughter, I decided to take my finally complete memory and go home. To London, to my career, to the projects my agent had ready for me to consider.

But first I flew to Rio de Janeiro.

I owed her that much.

I owed Andy.

TWO

It didn't take me long to find her. She was staying at one of the extravagantly grand hotels that looked across the shining sands of Copacabana beach like something from an old RKO Fred Astaire vehicle. She looked like a refugee from the same dream factory. She was golden tan with the artful streaks in her hair. She lay on the beach, her body oiled and supple. Not a bruise, not the raw wrists of the handcuffed woman who had crouched on the bed and told me the truth at last and tried to kill me. Now she was perfect again. She'd never looked better and that pleased me. It was better this way. A better memory for me to carry with me for the rest of my life.

I watched her for a couple days. I wasn't afraid of her recognizing me. I had the beard and the slightly rearranged features and I'd lost a fair amount of weight. I checked into the hotel next door and was a part of the crowd on the beach, someone she'd never notice. She was traveling alone but it hadn't been long, I reckoned, before she'd found a man. I watched her with a sense of detachment, an almost academic attitude, and yet there was a part of me still loving her. I surely didn't hate her. No. I loved her because I had the memory. Looking at her I saw the same lovely woman, I saw the memory.

The man she'd taken on was a medium-tall bloke, reddish hair going gray, the leathery face of a man who'd spent a good deal of his life outdoors. His name was Brian Cruickshank. Sheep ranches, mineral deposits, shipbuilding. Australian. Multimillionaire. That much cost me twenty bucks and a chat with one of the desk assistants. He lived in Sydney. He was a long way from home and his bill showed he was running up a hell of a telephone bill calling home.

It's amazing how much and how easily you can find out stuff

like that. It was like writing one of my books. I even got the numbers he was calling back in Sydney. I spoke to his office and his home, where his wife answered. After a few days I knew he was rich, married, and wasn't expected home until the middle of January. And it didn't take me long to see that he couldn't get enough of Caro.

It didn't bother me to see her with another man. Does that make sense? I still loved her in that funny way that wasn't really rational but it was somehow impersonal. I was never going to make love with her again, never hear her whispering to me that she loved me, all that was as dead as Victor and Varada and Maguire and anyone else she might have led to an early grave since I'd last seen her.

She wasn't *my* Caro. My Caro had died when she looked into my eyes and I had told her I loved her and she pulled the trigger on me. So I was looking at her differently now. A gun going off in your face is bound to change your perspective. The irony was that I was now doing the one thing she hated more than anything else: I was looking at her like a case. A head case. And I remembered Andy Thorne wanting only what was best for her, asking me to take care of her.

Christmas passed. We were in New Year's week. I'd seen enough. God only knows what I was trying to prove to myself. But it was time to do something. I'd soaked up enough sun, taken enough drives along the ocean, done enough thinking. I wasn't going to change my mind. I had to see Caro one last time, alone, just the two of us so I could touch her, make her understand. Then I could go home in peace.

Brian Cruickshank was sitting in the fancy onyx and chrome and glass bar with the fans slowly beating the air and shoving the palm fronds around. The lights on the ocean seemed to point at us like fingers. The brilliantly lit cruise ships looked like floating decorations on the flat dark sea. Cruickshank was wearing dinner clothes. He looked the essence of health and prosperity with his deep Copacabana tan but he also looked

257

tired, with frustrated circles under his eyes that told me he was a man about to tie one on. I'd seen Caro go up to her room. I went up to the shiny black bar and sat on the stool beside him.

"You don't know me, Mr. Cruickshank, but you're in luck. My name's Sinclair, out from London. I know a good deal about you."

"Damn good for you," he said, watching my face in the mirror behind the bar rather than turning his head. He was smoking a Camel in a short ebonite holder and carried it off all right. "But I'm not in a chatty mood this evening. Perhaps you could wait until tomorrow, mate—"

"Sorry. It's today that's your lucky day, not tomorrow. You see, I know even more about Mrs. Saberdene than I do about you." I smiled reassuringly. My head was throbbing slightly in a way that only a partly artificial skull can. A soft thumping like someone inside a garbage can tapping with a padded mallet. "If you can spare me a moment I can spare you a god-awful lot of trouble."

"You don't say."

"Oh, I do say."

He sighed, tapping the ash into a chrome ashtray. "Well, I don't seem to have anything better to do, Sinclair. What the hell are you talking about? You coming at this from behind a bush?"

"On the contrary. I always believe in being absolutely straightforward with a chap I'm about to threaten." He turned his head at that.

"I don't threaten easily," he said. "In fact I don't think I can be threatened at all." He took a drink of a large martini. "So be careful. I am a comparatively hard man."

"Not so hard tonight, I think. I've come a long way to find Mrs. Saberdene. I'm not about to be stymied now. But as I said, you're in luck. Why should you want to needlessly complicate your very comfortable life? Mrs. Saberdene's husband wants her back. Quite simple."

"Her husband's dead, old man. Point to me."

"Her first husband, Victor Saberdene, is certainly dead. She killed him."

"Come, come—"

"Maybe it didn't make the Sydney papers. Or maybe you were out visiting one of your sheep ranches. She blew him away with a shotgun about eighteen months ago. Mistaken identity, of course."

"Of course. Often is, isn't it?"

"But it's her second husband who wants her back. Sir Hugo Wolff. He's a busy man. Arms dealer, actually. I'm one of his advance men, in a manner of speaking. In this case, I merely want to save you a gruesome consequence of your relationship with the lady—"

"Gruesome consequences? You do have my attention, I grant."

"Here comes the threat, then. If Sir Hugo learns that you've been chasing about Rio with his wife he just might include bits and pieces of you in his next shipment to Khaddafi. As I say, I have no wish to see you run through the old Cuisinart, but I am an intensely loyal employee. Better you than me in the Cuisinart."

"Fascinating."

"Now, if Sir Hugo is a bit of an abstraction, difficult for you to grapple with in flesh-and-blood terms, turn your mind to your wonderful wife, Jennifer, and little Brian and Mary Alice. Let's save them any . . . inconvenience."

"You are absolutely serious, aren't you?"

"Sir Hugo is not known for any sense of playfulness. If I were you, the contemplation of Sir Hugo's vast displeasure would render me most responsive to his—my—suggestions."

"And what would actually happen if I were not sufficiently responsive?"

"We don't want to talk about that, surely. Not in any specific sense. You would eventually deeply regret ever having been born."

He extracted the cigarette butt from the holder and slipped the shiny black object into his pocket like a conjurer. "All right, Sinclair. I've always prided myself on my instincts. You want what you want more than I want what I want. I know when I'm overmatched."

"Well done," I said. "One small favor. New Year's Eve."

"Yes?"

"Arrange two tickets for the cruise embarking that night on the good ship *Allemagne*. Inform Mrs. Saberdene, or more accurately Mrs. Wolff. Give her her ticket. Then go away, telling her you'll meet her on board that evening. Plead the press of business."

"And give you my ticket?"

"Right the first time. Tell me, Mr. Cruickshank, does she mean anything to you?"

"Sheep mean something to me. The mining operations mean something to me. The America's Cup means something to me. My family means something to me. Nothing else, Mr. Sinclair, means a goddamn thing to me."

"Well, you've done yourself a good turn tonight," I said.

He slid off the stool and patted my arm. "Happy days," he said.

THREE

This is the part of the story I must keep short. I simply don't have it in me to dive beneath the surface of the events. I myself am not a deep enough man.

I saw her standing alone at the rear of the ship on the lowest deck. She was leaning on the railing staring out at the sea. It was five minutes to midnight.

There were huge, lavish parties going on on the decks piled above us. Bands, screaming and laughter, movies, drinks, everything I'd counted on to give us privacy.

She seemed to be waiting. She didn't move. I hadn't been close to her since . . . well, for a long time. We'd never had a word about what happened that night at Half Moon Lake.

I went to her, stood behind her. Reached out to touch her shoulder. She wasn't surprised or startled and she didn't look back.

"I knew it would be you, Charlie. I knew you'd find me sooner or later. I've waited. I counted on it. Another of Saberdene's Variations. How are you, Charlie?"

"I'm all right."

"Tell me, Charlie, we aren't going to live it all over again, are we? We can't do it all again, can we . . ."

"No. We're not going to live it over again." I touched her hair with my lips.

"This time that's all over, the variations are all over. This is different, right, Charlie? Everything will be all right now, won't it? After tonight?"

"Yes." Slowly she turned to face me. In the darkness, clouds over the moon, I could barely see her eyes but something was missing. "Where are the pearls?" I brushed my fingertip across her soft earlobe.

"I must have lost them somewhere. It doesn't matter. Maybe they'll turn up." She reached out, touched my face, my mouth. I didn't feel a thing. "I knew you'd find me, Charlie."

"Your father wanted me to take care of you."

"Do you think he loved me at the end?"

"I know he did. That's why he wanted me to take care of you."

"I see. Good. Who better than you, Charlie?"

I nodded.

"Then," she said, "this must be the Nichols Variation. I did love you, you know. I've never been happier." She leaned forward and kissed me, her lips cool and dry. Then she leaned back toward the railing, toward the sea, and I couldn't see her face. "Now, Charlie," she whispered. "Now is best . . ."

I closed my hands around her throat. She willed herself to be quiet, to just let go. Finally I couldn't see her at all through my tears. I couldn't see anything. It was midnight. It was very noisy and festive and now she was limp in my arms.

I didn't even hear the splash in the darkness.

I stood by the railing until the shock had passed, until my eyes were dry. Upstairs they were singing "Auld Lang Syne." I went and lost myself in the thousand or so happy people greeting a new year.

Andy Thorne could rest easy now and I hoped to God there was a happy, better place where we are reunited, cleansed and at peace, as fine as we can be. Oh God, how I hope so. Maybe she will be waiting for me there. The Caro I had known and loved, the Caro I'd have died for and killed for.

Yes, that's it. Maybe she'll be waiting for me on that distant shore.

I'm not being entirely fatuous because there is one last bit to the story.

When I got back to London a package arrived for me from Rio de Janeiro.

There was a note.

Dearest Charlie,

I'm glad you're all right, glad you survived me. But I can't say the beard is a great success.

I've been waiting for you to find me. Now that you have, I'm feeling peaceful. I'm in your hands now. I wonder what you'll do. Oh, Charlie, I think I know.

And in case I'm right, well, by the time you get back to London, you may—in some peculiar Charlie way—be missing me, feeling pretty low about things and having no one to talk with about it. So I thought I'd send you this note, in case we don't see each other again. Or not for a very long time.

It was good and bad, Charlie, and it would never have been better. But I know you've handled it the best way for both

of us. So until we meet again and it is better for us I want you to have part of me, a memory of what you loved about your poor, desperate, and foolish girl,

Caro Saberdene

Of course I knew what the little leather pouch contained. And I knew that once I'd emptied them onto my desk, held their warmth in my hand, I would be lost forever in the memory of loving her.

The earrings. Black. Pink.

She is with me always.

Caro.